The Enlightenment
and the
Age of Revolution
1700–1850

Arts, Culture and Society in the Western World
General Editor: Boris Ford

This major new series examines the arts and culture of Western civilization within the social, economic and political context of the time. Richly illustrated, each book is structured around a concept of the age as a whole, integrating the different arts into a single analytical portrait of it. Music, literature and drama will be as important to the argument as architecture and the visual arts. The books will give readers their bearings in the cultural landscape via its major landmarks; but, more particularly, they will also examine the artistic activity of the age for what it can tell us of the preoccupations and priorities of the society that produced it.

Now available:

The Enlightenment and the Age of Revolution 1700–1850
John Sweetman

The Enlightenment and the Age of Revolution

1700–1850

John Sweetman

Longman

LONDON AND NEW YORK

Addison Wesley Longman Limited
Edinburgh Gate,
Harlow, Essex CM20 2JE,
United Kingdom
and Associated Companies throughout the world

Published in the United States of America
by Addison Wesley Longman Inc., New York

© Addison Wesley Longman Limited 1998

First published 1998

ISBN 0 582 08490 3 PPR
ISBN 0 582 08491 1 CSD

British Library Cataloguing in Publication Data
A catalogue record for this book is available from the British
Library

Library of Congress Cataloging-in-Publication Data
Sweetman, John (John E.)
 The Enlightenment and the Age of Revolution / John Sweetman.
 p. cm. — (Arts, culture, and society)
 Includes bibliographical references and index.
 ISBN 0–582–08490–3 (ppr). — ISBN 0–582–08491–1 (csd)
 1. Arts, European. 2. Arts, Modern—18th century—Europe.
3. Arts, Modern—19th century—Europe. I. Title. II. Series.
NX542.S9 1998
700′.944′09033—dc21 97–38887
 CIP

Set by 35 in 10/12 pt Sabon
Produced by Addison Wesley Longman Singapore (Pte) Ltd.,
Printed in Singapore

Contents

General Introduction

In these days of ever greater specialisation, few people who write about the arts venture beyond their particular field, and virtually none dare to stray over the boundary into an adjacent art. This is a serious loss, for the arts in any age are bound to share common ideals and characteristics and they emerge, after all, from the same society even if they address somewhat different audiences. And thus they can illuminate each other, both through their similarities and contrasts.

This series of ten volumes aims to present and study Western civilisation as expressed in its arts, including the social and economic soil from which these arts rose and flourished. The scope (but not necessarily the titles) of these volumes is as follows:

The Greek World
The Roman World
Early Medieval Europe (from the late Empire to *c*. 950)
Romanesque Europe (*c*. 950–*c*. 1200)
Gothic Europe (*c*. 1150–*c*. 1500)
The Renaissance (*c*. 1400–*c*. 1600)
Baroque Europe (*c*. 1575–*c*. 1750)
The Enlightenment and the Age of Revolution (1700–1850)
The Romantic Age (*c*. 1800–1914)
The Twentieth Century

The series as a whole does not resemble an encyclopedia of the arts, with chapters on the separate arts. Built around a concept of the age and its distinctive civilisation, the central argument of each volume is illuminated by a discussion of individual artists and their works, including popular culture; and of how, by looking at their social roles, their conventions and symbolism,

and their formal structures, these works of art may best be understood and enjoyed.

Finally, the series provides a social, political and economic context for these works, and examines the artistic activity of the age for what it can tell us of the preoccupations and priorities of the society that produced it.

BORIS FORD

Preface

This book has been a long time in the making, and its debts are many: not least to students of a course on *Art in Revolutionary Europe 1750–1850* – necessarily extending backwards a little in time to give context – which I gave for many years in the University of Southampton. Students from various departments – indeed faculties – attended it, greatly to its benefit. The period that we were considering, itself one of deep diversity and of much questioning that took little or nothing for granted, easily struck chords of response from students of social sciences and psychology as well as humanities. Each year had a slightly different character, according to the balance of language students, musicians or engineers.

My first thought for the book's title was *Classical Designs, Romantic Desires*, reflecting those basic, ever-present artistic drives which between 1700 and 1850 took on so special a relationship. In the end – because the book is part of a series concerned with successive periods of cultural history – the title was given to the salient ideas of 'Enlightenment' and 'Revolution'. Following where these have led, I gratefully remember conversations on specific points with Professor Paul Hamilton and Professor James Sambrook.

I owe a considerable debt of gratitude for constructive help and encouragement to my editor Professor Boris Ford, and to Andrew MacLennan and Terka Bagley of Addison Wesley Longman. I am grateful to Christine Hardwick for preparing the index, and for help with obtaining illustrations to many friends, including Julian Roberts of the Bodleian and Larry Bass of Philadelphia. It is a pleasure to dedicate this book to David and Barbara Peacock, in recognition of many years' friendship. Mere thanks are an inadequate offering to Pam Dawson, who typed, expertly and imperturbably, a manuscript which over the years seemed trapped in a state of permanent revolution of its own.

JOHN SWEETMAN
8 January 1997

List of Illustrations
(oil paintings on canvas unless otherwise stated)

Notes on the Colour Plates

PLATE I

Facing p. 42: Jean-Antoine Watteau (1684–1721). *The Party of Four* ('*La partie quarrée*'). Oil, 49.5 × 63 cm (orig. 51 × 64.8 cm). About 1713–14. The Fine Arts Museums of San Francisco, Mildred Anna Williams Fund.

The group of four has the economy of French classicism (Fig. 3), but with a play of ambiguity that is Watteau's own. Four figures from the Italian comedy – a Pierrot (the Italian Pedrolino), a Mezzetin (another clown, the Italian Scapino), and two women, one of whom holds a fan, the other a mask – have wandered into a landscape. One woman looks at Pierrot and perhaps invites him to play his guitar; but his face is concealed from us. The artist holds in suspension a moment of private encounter: music – an art which, Watteau's friend Caylus reports, he had so much 'refinement for judging' – seems about to become its catalyst. This ability to convey such moments gave Watteau's *fête galante* subjects special influence among music's advocates in the years that followed. *Text references: pp. 8, 15, 80–1.*

PLATE II

Facing p. 43: William Hogarth (1697–1764). *The Humours of an Election: Scene 2, Canvassing for Votes.* Oil, 101.5 × 127 cm. About 1754. By courtesy of the Trustees of Sir John Soane's Museum, London.

This series of four paintings (and prints) was based on the actual county of Oxford election of 1754. A young farmer is assailed with bribes by agents for Whig and Tory, in a modern version of the classical 'Choice of Hercules' theme.

The central group of six figures follows Hogarth's favoured serpentine curve (concave on the left, convex on the right). Amidst the political divisions, meanwhile, the ship's figurehead to the left, in the form of a lion, asserts national identity by preparing to eat the French fleur-de-lys. *Text references: pp. 11, 185, 187.*

Plate III

Facing p. 74: Robert Adam (1728–92). The Music Room, Harewood House, West Yorkshire. 1772. Reproduced by kind permission of the Earl and Countess of Harewood, and the Trustees of the Harewood House Trust.

The room preserves the essence of Adam's style: lightness of touch with precise definition, variations on the old classical vocabulary of the past combined with overall decorative unity. The urns and roundels in low relief on the frieze are repeated in the wall panels between Antonio Zucchi's evocative ruin-pictures. Painted ceiling roundels by Zucchi and his wife Angelica Kauffman (Fig. 24) are echoed by the shapes within the Axminster carpet design. The chairs and sofas are among the finest creations of Chippendale. All these figures worked with Adam. Musical themes abound: not least in the Reynolds portrait of 'Mrs Hale as Euphrosyne' (1764–6, in a Chippendale frame, above the chimney-piece), taking up the theme of joyous music-making of Milton's poem *L'Allegro*. *Text references: pp. 21, 77.*

Plate IV

Facing p. 75: John James Audubon (1785–1851). *The Golden Eagle*. Watercolour, pastel, graphite and selective glazing on paper, 96.6 × 64.7 cm. 1833. Plate CLXXXI in *The Birds of America* (completed 1838). New York Historical Society, New York.

The great bird artist, trained in France but an American citizen from 1812, said that he spent sixty hours on this painting, longer than any other of his devotedly exact pictures of birds, except that of the wild turkey. The 'king of birds' here launches into space with the burden of the rabbit it has killed. Audubon excelled at depicting moments of high tension in his subjects. Minutely, in the figure below, he appears to have shown himself in buckskins on a bird expedition, inching across a log bridge. *Text references: pp. 132, 161.*

Plate V

Facing p. 234: Thomas Girtin (1775–1802). *The White House at Chelsea*. Watercolour, 29.8 × 51.4 cm. 1800. Tate Gallery, London.

In the broad sweep of this famous watercolour, there is no conventional framework of trees to close the composition. A lightness pervades the work from edge to edge; dark accents of boats are placed on the water, and the carefully-sited white house itself is a blank patch of paper. In its deft economy the technique perfectly matches the momentariness of the light effect. *Text references: pp. 138, 141.*

Plate VI

Facing p. 235: J.M.W. Turner (1775–1851). *Rain, Steam and Speed. The Great Western Railway*. Oil, 91 × 122 cm. 1844. National Gallery, London.

Brunel's viaduct at Maidenhead (1839), shown here, had two elliptical arches, the flattest ever built in brick, and early collapse was predicted. Turner, however, concentrated on an emblematic presentation of present actualities. The foreground hare would be outrun and the ploughman, reflecting the old song 'Speed the Plough', was shown moving in the opposite direction to the train. But the wraith-like old road-bridge of 1780 (left distance) had become almost a memory behind the new. *Text references: pp. 139, 160.*

PLATE VII

Facing p. 250: Philipp Otto Runge (1777–1810). 'Morning' (*The Times of Day*). Oil, 106 × 81 cm. 1808. Kunsthalle, Hamburg.

Naturalism and symbolism are inseparable here. Runge makes the botanically-exact lily plants in the border enclose a mystical vision of a Christ-like baby, new-born in a landscape. The reaching outward of the child, and of the child genii near him, is repeated by the expanding leaves of the surrounding plants, as the whole of nature responds to the sun. An Aurora-like figure holds aloft a symbolic lily, expressing purity. A larger version of this painting was to have joined presentations of 'Noon', 'Evening' and 'Night' as part of an 'abstract painterly fantastic-musical poem with choirs, a composition for all the arts together, for which architecture should raise a unique building.' Runge's hopes for a reborn, unified humanity were also bound up with this ambitious conception. *Text reference: p. 143.*

PLATE VIII

Facing p. 251: Eugène Delacroix (1798–1863). *Cleopatra and the Peasant*. Oil, 97.8 × 127.7 cm. 1838. Ackland Memorial Art Center, Chapel Hill, North Carolina.

Dr Johnson in 1765 had recognized the way that Shakespeare mingled high and low in a single play. But it was for a Romantic critic, Hugo, to see Shakespeare as the 'deity of the theatre' on account of it. Delacroix, enthusiast for both Shakespeare and the Exotic, was not to miss the opportunity provided by this scene of contrasting female beauty, to which Europe had long paid homage as an ideal in art, with the swart, characterful, non-European face of the rustic or 'clown', as he offers Cleopatra the asp. *Text references: pp. 8, 205, 225, 226.*

Acknowledgements

The publishers would like to thank the following for permission to reproduce illustrative material:

Ackland Art Museum, The University of North Carolina at Chapel Hill, Ackland Fund for plate VIII; Algur H. Meadows Collection, Meadows Museum, Southern Methodist University, Dallas, Texas for fig. 62; Barbara Peacock for fig. 28; Bath & North East Somerset Library and Archive Service (Bath Central Library) for fig. 10; Bibliothèque National de France for figs 18 and 32; Bildarchiv Photo Marburg for fig. 5; Bildarchiv Preussischer Kulturbesitz for fig. 17; Bodleian Library, University of Oxford for fig. 32; Bridgeman Art Library for figs 4, 40 and 47; figs 9, 13, 23, 33, 36, 41, 58 and 65 courtesy of the British Library; figs 8, 16, 22, 26, 51, 52, 55 and 57 copyright © The British Museum; Burghley House, Lincolnshire for fig. 24; Courtauld Institute of Art for figs 30 and 69, and supply of photograph for fig. 24; Covent Garden Archives for fig. 27; City of Nottingham Museums, Castle Museum and Art Gallery, Nottingham for fig. 66; Trustees of Dartmouth College, Hanover, New Hampshire for fig. 15; Derby Museums and Art Gallery for fig. 12; The Fine Arts Museums of San Francisco, Mildred Anna Williams Collection, for plate I; plate III reproduced by kind permission of the Earl and Countess of Harewood, and the Trustees of the Harewood House Trust; plate VII © Hamburger Kunsthalle, photo Elke Walford; Historisches Museum der Stadt Wien for fig. 48; fig. 21 © Hunterian Art Gallery, University of Glasgow; Ironbridge Gorge Museum Trust for fig. 43; fig. 50 © 1998 by Kunsthaus Zurich. All rights reserved; James Austin Fine Art Photography for fig. 70; Robert Lautmann/Monticello for fig. 34; fig. 37 Leeds Museum and Galleries (City Art Gallery)/photograph Courtauld Institute of Art; The Library Company of Philadelphia for fig. 44; Metropolitan Museum of Art, New York (all rights reserved) for fig. 11; Musée des Arts Décoratifs, Paris for fig. 2; Musée du Louvre, Paris for figs 1, 25 and 54; Musées Royaux des Beaux-Arts, Brussels for fig. 53; Museo del Prado, Madrid for fig. 63; Národni Muzeum,

Prague for fig. 20; Nationalgalerie, Berlin for figs 39 and 68; © 1997 Board of Trustees, National Gallery of Art, Washington DC for figs 6 (Jean-Baptiste Greuze, *Ange-Laurent de Lalive de Jully*, Samuel A. Kress Collection) and 61 (John Quidor, *The Return of Rip Van Winkle*, Andrew W. Mellon Collection); fig. 35 and plate VI reproduced by courtesy of the Trustees, The National Gallery, London; plate IV © Collection of the New-York Historical Society; Oesterreichische Nationalbibliothek, Vienna/Foto Leutner Fachlabor for fig. 60; Oskar Reinhardt Collection 'Am Römerholz', Winterthur, Switzerland for fig. 64; Phillips Collection, Washington DC for fig. 49; fig. 31 and plate II by courtesy of the Trustees of Sir John Soane's Museum, London; Statens Museum for Kunst, Copenhagen for fig. 3; State Hermitage Museum, St Petersburg/ Bridgeman Art Library for figs 40 and 47; Stiftung Preussische Schlösser und Gärten, Berlin-Brandenburg/Bildarchiv for fig. 14; Tate Gallery, London for figs 45 and 67 and plate V; Uffizi Gallery, Florence/ Scala for fig. 56; Trustees of the Wedgwood Museum, Barlaston, Staffordshire for fig. 7; Yale Center for British Art, Paul Mellon Fund for figs 19 and 38; Yale University Press for fig. 46.

While every effort has been made to trace owners of copyright material, we take this opportunity to offer our apologies to any copyright holders whose rights we may have unwittingly infringed.

To David and Barbara

Introduction: Order, Progress and Protest

The eighteenth century, in which Voltaire wrote on the age of Louis XIV and Gibbon on the Roman Empire, has been credited with the rediscovery of history. It has also been claimed as the period in which we in the modern age begin to recognize ourselves. The French Revolution of 1789, in particular, appears to mark off an almost objectively distinct past that we can learn from but never feel part of, and open up an exposure to the incalculable that has kept us busy ever since. Cutting a swathe between two such very different worlds – the enclosed systems of the court autocracies of Europe, based on the 'Divine Right of Kings', and the fluid and open-ended society which asserted the natural rights of all men to freedom and equality – the Revolution has understandably acquired the status of a turning point.

Familiar images have rounded out this picture: the storming of the Bastille; the crowds marching on the French king's palace at Versailles; Wordsworth, in Paris in 1790, hailing the Revolution as a new dawn; the Revolutionaries resetting the calendar in the first year of the new Republic (1792) at Year One; the ultimate beheading of Louis XVI in 1793. Not everything about the French Revolutionaries' violent course of action was new. Events in Paris had been preceded in 1776, across the Atlantic, by the American colonists' Declaration of Independence from the British Crown, and by the winning of that independence by force of arms in 1783. Republicanism worked out on the basis of a new social contract of equality between constituent states, and freedom of all citizens under the law, had then secured a signal success. Nonetheless, when the move to liberty came in 1789 it was on the continent of Europe, on the soil of what Louis XIV, who had died only seventy years before, had built up into the most powerful of nation-states. The other monarchies of the old continent, and all the sources of authority, secular and ecclesiastical, of what historians have termed the *ancien régime*, were seized as by the shock reverberations of an earthquake.

When the violence and unforeseen effects of the Revolution are taken into account, however, it is its context which provides its greatest interest for the student of the arts. This book is about themes of cultural *continuity* through revolutionary times, and the ways in which they related to new ideas which overlaid them, before and after the great political and social rupture of 1789. The themes will be outlined later in this introduction (pp. 26–7); but the fundamental notion which lies behind them underwrites the entire period from 1700 to 1850, of which the French Revolution forms a midpoint. This is the relationship of authority to individual freedom of action.

Such a concern had been debated in the general context of human affairs for centuries, not least by the ancient Greeks. But the eighteenth century experienced new incentives to disengage from the absolutism of received rules, and test the play of alternatives. Some of these incentives came from existing examples: societies such as those of England and Holland, where individual problem-solving was encouraged by the Protestant ethic. The English constitution, balanced between King and Parliament after the country's Glorious (and bloodless) Revolution of 1688, which installed a Dutch-born king on the throne, confirmed a degree of freedom in the distribution of power which received close attention from continental observers. The French writer Voltaire, visiting England in 1726–28, praised 'that wise Government where the Prince, all-powerful for doing good, has his hands tied for doing evil'. Voltaire, a convinced admirer of Louis XIV's autocratic organization of the French state, devoted two of his *Lettres Philosophiques* on England (published in English in 1733, in French in 1734) to the English system of divided power.

Further incentives came from the shared exercise, in an age imbued with the idea of progress, of the powers of rational and essentially secular enquiry. This happened across the entire Western World, now enlarged to include St Petersburg (founded 1703) in Russia and Philadelphia (1681) in North America. In what a later age was to call the 'Enlightenment', critical evaluation was extended to all institutions, and all received dogma – religious and political – was tempered by a probing scepticism. Spreading from England, a form of theological belief known as 'deism' scanned a God-created universe with a confidence in human reason that many advocates no longer felt in established churches. Non-Christian religions and cultures were increasingly studied (notably those of India, as the West's familiarity with the sub-continent deepened towards 1800), even if, in general, Europe's estimate of its own cultural superiority remained intact and, for many, Christian revelation continued to inspire.

From the century's beginning, characteristic initiatives were being taken in the individually differing cultures of England, France and Germany, which would hasten the spread of the Enlightenment. In England a free press had been allowed in 1695 and was enjoying the first flurries of active life. Though political and social rather than philosophical matters absorbed much of this, press censorship in continental countries made English newspapers and journals the envy of enlightened circles in Europe that were committed to widening the bases of debate. In France, where Louis XIV's long reign lasted till 1715, the royal protocol that had congealed round the courtiers at Versailles was leaving

Paris free not only to consolidate its famous salons, where matters of the day were discussed, but to provide the principal hub for the expression of French contemporaneity in thought and culture across the civilized world. In Germany, not yet a single nation but a collection of autocracies, there was the foundation by Leibniz, in 1700, of the Berlin Academy of Sciences, giving promise of the commitment to international scholarship that Germany was to achieve before the century was out, through its own 'Enlightenment', and hold up as an example to the world in the following century.

The fundamental optimism of most Enlightenment enquiry sat well with the revelations of a universe kept orderly by gravitation, as described by Isaac Newton (1642–1727, see Chapter Three). The English poet Pope (1688–1744) found much to admire in the apparent perfection of the Newtonian model; and so, across the Channel, did the longer-lived Voltaire (1694–1778). But both these representatives of their times reacted with outrage to evident imperfections in their own societies. Pope, a Catholic living in Protestant England under the first two Georges, perceived a corrosive dullness in English affairs. This is condemned at the end of his poem *The Dunciad* (1743), in words of awesome catastrophe:

> She comes! she comes! the sable throne behold
> Of Night primeval and of Chaos old!
> Before her, fancy's gilded clouds decay,
> And all its varying rainbows die away.
> Wit shoots in vain its momentary fires,
> The meteor drops, and in a flash expires.
> As one by one, at dread Medea's strain,
> The sick'ning stars fade off th' ethereal plain . . .
> Nor public flame, nor private, dares to shine,
> Nor human spark is left, nor glimpse divine!
> Lo! thy dread empire, Chaos! is restored;
> Light dies before thy uncreating word;
> Thy hand, great Anarch! lets the curtain fall,
> And universal darkness buries all.

The British way of life so admired by Voltaire appears, in this poem, as in a kind of free fall. Voltaire by contrast, a deist in absolutist France, had specific targets in his sights, many to do with the Catholic Church: not only what he saw as its general indifference to public good, but also its ownership of property and, above all, its religious persecution. While his famous satire on optimism, *Candide* (1759), ended in dark resignation (p. 118), his increasingly outspoken campaigns for the unity of man, and for justice and tolerance, were to draw out all the passion for reform in him, and become international Enlightenment causes.

In the middle of the century a student of individual humanity who was also one of history's great unpredictables, Jean-Jacques Rousseau (1712–78), was carrying enquiry to the very heart of *ancien régime* culture, seeing it (*Discourse on the Arts and Sciences*, 1749, and later works) as overblown, promoting

luxury, and a moral destroyer. His treatises on reforming education (*Emile*), and on the role of the individual citizen in relation to government (*The Social Contract*), appeared in 1762. He was to include Enlightenment figures themselves in his criticism: but the combustibility of his ideas on how men should live – looking forward with the reason they could usefully develop, but also back to the natural light from which they came – made him a beacon figure not only for the Enlightenment but for the entire Romantic age which followed.

Though always beset by censorship, the new habits of enquiry made swift headway with the educated, modifying even the Calvinism of Geneva, the esteemed city-republic where Rousseau had been born, and where Voltaire came to live in the 1750s. Enlightened thinkers speculated on the future of North America, where native Indian and immigrant white societies lived side by side. In turn the republican hopes of the American whites were fed by enlightened thinking. Its humanitarianism even made headway among the old despotisms of Europe, years ahead of the French Revolution. Under its influence Joseph II, Habsburg Emperor of Austria, abolished serfdom in his country in 1781 and torture in 1787. In Russia Catherine the Great (reigned 1762–96) initiated a sequence of major penal reforms as advocated by the Italian legal theorist Beccaria. Ideals of republics of citizens equally protected by enlightened laws led directly to notions of human betterment which became influential after 1800 in the form of the social utopianism of French and British reformists (see Chapter Six). Slowly, too, the movement to end the horrors of the international slave-trade grew in strength and Wilberforce lived to see Britain become the first modern nation to abolish participation in it in 1833.

As the nineteenth century opened Europe was entering a second revolutionary phase, politically less idealistic than the first: the massacres stage-managed by the Revolutionaries in Paris in 1792 and the Terror of 1793–4 had seen to that. Enlightenment hope for the unity of man that simmered, it seems, in Napoleon after his reading of Voltaire, disappeared in his dreams of conquest and the wars that embroiled Europe for twenty years. The *Code Napoléon*, with its provision of legal equality, survived him to give a basis for modern civil law across much of Europe. But the Congress of Vienna of 1815, after his fall, found the leaders of the nations divided by sectional interests and even absorbed in efforts to revive the pre-Revolutionary trappings of royal and priestly power. Austria occupied part of northern Italy and Poland became a vassal state of Russia. Strong nationalisms were aroused which would have marked effects on the arts, as we shall see. The uprisings which seized France in 1830, and Europe more generally in 1848, were the violent outcome of protest. In between the revolutions, as Balzac's novels of Paris life reveal, this was a competitive society in which businessmen and industrialists fought a deadly game to secure political and personal advantage. Russian fiction reminds us (pp. 242–3) of the excesses of a bureaucratic world, in which authority at petty levels could be as death-dealing to individual freedoms and self-respect as it had ever been.

By the early eighteen hundreds, the Industrial Revolution in Western Europe was also offering the starkest evidence of a social upheaval that was no

less powerful than the political, and even more unstoppable in its power of acceleration. Here too we must look to eighteenth-century beginnings in the application of the discoveries of science to technology, an activity in which the English emerged in the lead about 1750. It was also in England, where credit for factory-building was easily obtainable, that a massive investment in industrial productivity took place between 1750 and 1800. France, however (*ancien régime* France, before 1789), had developed civil engineering to the highest scientific standards: and here the abolition of restrictions on labour imposed by the medieval guilds led to expanding local industries promoted by capitalists who employed rural workers. Both countries shared the optimism of this eighteenth-century phase. Even after the venom released under the Paris Terror began to threaten him, a leading Enlightenment figure, the Marquis de Condorcet, would write in 1793 that 'progress will vary, but there will be no turning back'. But the future would be problematic: there was to be no turning back either of population growth, especially in the industrial cities of Britain, as work was sought there by part of an already increasing rural population displaced by land enclosure in the countryside. London's growth was the most spectacular: a population of 600,000 in 1700 had become three million by 1851. Paris, with 250,000 people in 1700, possessed 1,500,000 in 1851: though the population of France, eighteen million when Louis XIV died in 1715, rising to twenty-six million in 1789 and thirty-four million by 1850, remained essentially rural-based. Long before 1800, London and England's northern industrial cities were overcrowded: lodging-houses could not cope with demand for beds by those coming to find work. Dissenting religious beliefs, especially Wesley's popular Methodism, and the millennial teaching of mystics such as Swedenborg – a version of which influenced Blake – flourished in such settings. In the 1830s the plight of children of seven to fourteen years of age working for thirteen hours a day in factories was being taken up by reformers. The many social evils were castigated to moving effect in the novels of Dickens.

The impact of the age of revolutions on the drama, literature, visual arts and music that are our theme will recur in the chapters which follow. Beethoven in Vienna, and Goya in Spain, to name only two practitioners in different fields, working against very different backgrounds, felt it deeply. But something must first be said about the 'two world' view which political and social commentary on the period 1700–1850 has also encouraged in assessments of the arts. 'Before', according to this view, we find a traditional respect for the authority of the past: especially for the classical, 'form-perfecting' civilizations of Greece and Rome, as shown, for example, in England's early eighteenth-century 'Augustan' period of literature. 'After', we see a freedom of outlook that between 1800 and 1850 led to such form-defying extremes as the late painting of Turner or the music of Berlioz. In truth, if the main function of artists for centuries had been to set down what their contemporaries had most keenly wanted to see perpetuated, the revolutionary age could not fail to put that function to the test, in dramatically new ways. The valuable distinction made by the literary scholar M.H. Abrams, in his book *The Mirror and the Lamp* (1953), between an art which objectively confronts the outside world, as a mirror reflects external

'reality', and that which expresses the artist's subjective feelings about that world, as a lamp gives out light, finds support in the broad, generalized spectacle of a 'classical' eighteenth century giving way to a 'Romantic' nineteenth. But it is important to recognize that changes in the arts are never as clear as helpful analogies make out. Wordsworth's invocation to the French Revolution, 'Bliss was it in that dawn to be alive', left untouched the painter David's classically hallowed habit of making nude studies of the figures in his modern subject-pictures and putting clothes on them. Beethoven and Schubert, together with Mendelssohn, Chopin and other composers of the early nineteenth century, all shared in the revival of regard for the formal musical structures which J.S. Bach had been elaborating to such gripping effect close to 1750. Turner and Berlioz themselves – as we shall see – constantly referred back to the 'classical designs' of their predecessors. It is indeed the diverse ways in which artists combine the freedoms of the present moment with the varied forms of authority of the past, the spontaneous with the structured, the openness of desire with the finalities of design, that make the century-and-a-half from 1700 to 1850 so endlessly rewarding. Such combinings had always been made: but never before, perhaps, in circumstances which – as we shall discuss in Chapter Four – left many artists with so strong a sense of their own individuality.

In a period of such diversity and overlaps of style, labels are inevitable but inadequate. Most of them were invented later than the art which inspired them. But their general currency today makes it essential that some attempt be made to give meaning to them, and especially to the relationships of such terms as 'Classical' (as now used of eighteenth-century styles, in much critical literature, with a capital C), 'Baroque' and 'Romantic' to one another.

Baroque to Classical

Long before 1700 'classical' art, embodying the values of Greece and Rome which had been renewed in Italy at the Renaissance, had come to represent for educated opinion a veritable touchstone of distinction by which all other art was measured. It is true that disputes conducted through the seventeenth century had asked whether the knowledge that man had accumulated since Antiquity had put the Moderns in a position of superiority. But Greek and Roman art employed ideals of symmetry, balance, proportion and measurement derived from mathematics. These, clearly, did not 'progress': they carried, rather, a changeless power to satisfy. French classicism, in particular, had recently put down deep, ineradicable roots in both art and poetry. In his *L'Art Poétique* of 1674 Nicolas Boileau had sought to define the qualities that made classical designs so admirable. Reason, he thought, had been their guide, eliminating all inessentials and irrelevancies and enabling the poet to arrive at a perfect, all-coherent statement. In the plays of Racine, who died in 1699, Aristotle's ideal of the tragic drama as an objectively complete whole was upheld by the poet's observation of the unities of time, place and action (the last requiring that all characters should behave in a manner consistent with

their rank, and that decorum should not be infringed). The Academies founded by Louis XIV to watch over the different arts discussed how the mastery of form could enhance content by controlling it: through a writer's intelligible use of words or an artist's command of firm line that brooked no ambiguity, communication at the right elevated level with your audience, it was suggested, would be established.

The logic of such thinking clearly carried its perils: rules objectively built into works of art could – and did – easily become formulas. But around the turn of the century, in books that went through many English editions and which were quickly translated into French and German, Locke was generating interest in the processes by which the mind picks up information: the senses, he claimed, were in fact knowledge's only provider.[1] This was to be a healthy corrective to runaway temptations to 'unpack' a work of art by looking only for what the rules had taught should be there. The composer Rameau's system of harmony (1722), based on relationships between sounds, certainly involved objective mathematical 'laws': but all Lockeians knew that music also entailed the impinging of sounds on the consciousness of *a listener*. This was a perspective that could not, as the century's music developed, be ignored, and which lent its own strength to the Baroque Age of music in which Rameau wrote, and to that of Haydn and Mozart which followed.

To campaigners for classical order in the late eighteenth century, what we now call 'Baroque' art and architecture seemed not only to disregard that order but to rely on its opposite, wildness and excess. A later claim that the word may derive from the Portuguese *barroco*, applied to an elongated (not truly spherical) pearl, has now come to convey a valuable, positive visual image, and also to illustrate a distinctive characteristic of Baroque art: movement in a given direction in preference to the self-contained symmetry or balance of classical design.[2] If we remember this image, Baroque's 'wildness' begins to look like the inevitable, as well as literal, outcome of its structuring purpose. Baroque indeed – as an Italian creation – shares such an intention with classicism. By extension the name is now applied to the whole era, from 1600 into the eighteenth century, which savoured, in a variety of forms, the merits of calculated and sometimes overwhelming movement towards the spectator, notably in the emotional worlds of drama and that most extravagant of arts, opera. This last had originated about 1600 in Italy, but was itself heir to a cult of stage spectacle there which had grown up over a century earlier.

Full use had been made in the seventeenth century of the propaganda value of the visual Baroque: by the Catholic Church of Rome anxious to retain the faith of believers, and convert non-believers, through the sheer splendour and illusion of access to Paradise of Baroque churches; and by Louis XIV and other absolutist monarchs, keen to overawe all who served them as courtiers and who visited them as friends or enemies from other countries. But the Baroque quality of dramatic movement could also be deployed in the treatment of landscape or 'low life' themes, and this factor gave the style added resonance for painters of the following century. The Antwerp painter Rubens (1577–1640), well-versed in the Italian Baroque, was employed by European princes and

churchmen to put over his mastery of human themes in decorative ceilings and altarpieces. But elements which made Rubens's painting (Fig. 1) a natural transmitter of Baroque effects – especially rich colour and variety of brushstroke – were to reassert themselves continually, not least in the painting of Watteau (Plate I) before 1720, Boucher in the 1750s, Gainsborough and Fragonard from the 1760s and Delacroix (Plate VIII) from the 1820s.

While the visual imprint of the Baroque was strongly reinforced by Rubens, in France it had to withstand the authority of the painter Nicolas Poussin (1594–1665). Such a painting as *The Testament of Eudamidas* (*c.* 1650, Fig. 3) has a forcefulness of light and shade that had come to be part of the modern Baroque to which Poussin was sensitive, but its design has a concision and an austerity which proclaim it as a product of French classicism. Poussin's classicism coincided with that of the playwright Corneille, and was mirrored by the crucially important tragic dramas of Racine, which included the most emotionally intense of French plays, *Phèdre* (1677). In his book on tragic drama, George Steiner saw the seventeenth century as the 'great divide' in the history of his subject: the tragedies of Corneille and Racine, seen in the main by cultivated audiences familiar with their tightly-construed classical plots, were succeeded in the eighteenth century by plays which had to attract a bourgeois public with happy endings.[3] We shall see that the classical unities of time, place and action in a Racine tragedy had to give ground as regard for the open structure of a Shakespeare play grew: but it should also be said that, however audiences might change, the boiled-down forms employed by Corneille and Racine and also by Poussin (who worked in Rome, home of classicism) produced a core of ever-fruitful resource for the French. Literary figures in our period from Voltaire to Stendhal wanted to explore in detail how Racine related to Shakespeare, and painters from David to Delacroix to refer back to an age which contained Poussin as well as Rubens.

The contrast between Italian-based Baroque and French classicism, therefore, was expressed primarily through visual media: the Baroque through architecture, sculpture, painting and staged opera; French classicism, essentially, through tragic drama and painting (and some architecture). Both sought *controlled* effects: those of Baroque, however, by the expansive act of taking the spectator over; those of French classicism, characteristically, by compression, by withholding themselves, and by making the spectator wish to follow. When each approach is controlled by a first-rate practitioner, as in the case respectively of Rubens and Poussin, a formidable experience is guaranteed. The 'Baroque'

Figure 1: Peter Paul Rubens (1577–1640). *The Flemish Kermis.* Oil on panel, 149 × 261 cm. About 1622–30. Louvre, Paris.

While Baroque painting was often required to express high, elevated themes, it could also project animated, 'low life' subjects. Though the small-scale figures register here as a cumulative mass (all seen below the horizon-line, as in Bruegel), individual groups have a heroic character. The dynamically balanced couple to the right of the tree caught the attention of Watteau (Fig. 2). Rubens's picture, in France by 1685, was to influence paintings of Paris fairground subjects by Watteau's followers.

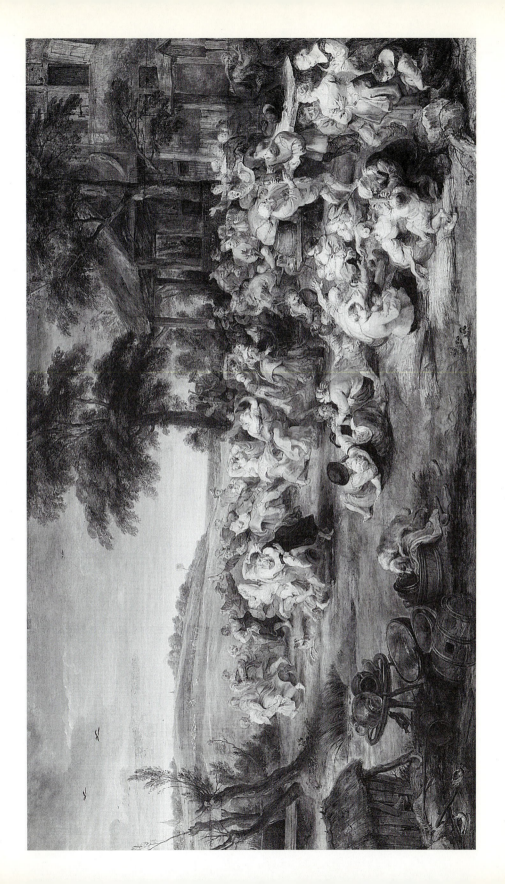

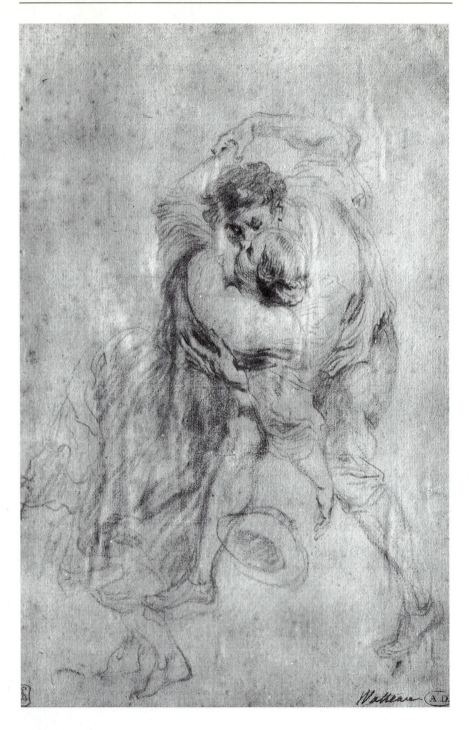

experience of a Rubens painting acts quickly, by overcoming time; that of Poussin is slower: 'a Dance to the Music of Time' is the theme of a painting by him (now in the Wallace Collection, London). Each, however, handles large themes: Rubens love, war, peace; Poussin love, sacrifice, the higher good.

Besides inheriting Italianate Baroque and French classicism, the eighteenth century renewed old controversies on the ability of the arts to affect the emotions. The views of Roman rhetoricians, Leonardo da Vinci (whose notes on the subject were published in Italian and French in 1651), Descartes (*Traité des Passions*, 1649), all provided the background to this. Specific demonstration was hard in the case of music, where matters were bound up with what the Italians called *affetti* (affections, emotions).[4] It was easier to make recommendations in the visual arts. How is fear or hope or despair conveyed through human facial expression or in bodily movement? For the painters of the elevated classical or religious subjects that the Baroque age esteemed, Charles Lebrun, in his *Méthode pour apprendre à dessiner les Passions* (published 1698), codified the study of physiognomy, of facial structure and the way that it revealed feeling. His work, translated into Dutch, German, Italian and English, remained in constant demand throughout the eighteenth century, as 'high art' came up for fresh scrutiny in the light of such works as Hogarth's *Election*, depicting the passions as he saw them working in his contemporaries (Plate II).

While Enlightenment Europe was interested in making physiognomy a science, artists were to find that it helped to create new markets for them. The idea that the face proclaimed a person's character, obsessively stated in the writings of Johann Lavater (1741–1801), was illustrated by him in the form of silhouette profiles.[5] His books quickly attracted Goethe, both scientist and artist. From the 1780s, until the invention of photography sixty years later, silhouette portraits were in popular demand (see also p. 29). And in the same period parallels drawn by Lebrun and Lavater between human facial expression and that of animals lent themselves entertainingly to the growing army of caricaturists (p. 133).

Another of the fields in which the Baroque overlapped powerfully into the eighteenth century was music and dancing for theatrical presentation, an ever-present ingredient of life at the princely courts. In the opera houses of Vienna, Prague and Dresden, the Italian tradition of spectacular architectural sets was also put to full use, and opera itself followed Italian models (see Chapter Two). In France the Italian-born Giovanni Battista Lully (1632–87), himself a dancer,

Figure 2: Jean-Antoine Watteau (1684–1721). Two dancing figures, after Rubens. Red chalk, 23.3 × 14.7 cm. About 1710. Musée des Arts Décoratifs, Paris.
The primitive, disruptive vigour that was conspicuous in the dance movements of country-dwellers attracted northern artists such as Dürer and Rubens (Fig. 1), who strove to relate it to the formal completeness expressed by two 'answering' figures in classical art. One of several studies by another northerner, Watteau, after Rubens's *Kermis*, these whirling figures have, however, the lightness of the eighteenth-century Rococo.

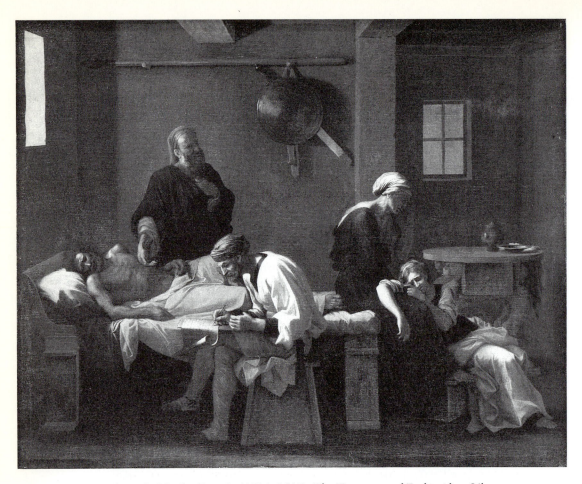

Figure 3: Nicolas Poussin (1594–1665). *The Testament of Eudamidas*. Oil, 110.5 × 138.5 cm. About 1645–50. Statens Museum for Kunst, Copenhagen.

Five figures tell a simple moral story (taken from the Greek writer Lucian). A doctor attends a dying man as he dictates to a scribe his will, which leaves the care of his mother and daughter (right) to friends. The terseness of the message is echoed in the bareness of the interior. Such pared-down brevity not only appealed to Poussin's middle-class patrons in Paris, but became part of the very backbone of French painting, and strongly affected the Neo-classical works of J.L. David in the 1780s. Indeed, Poussin's *Eudamidas*, engraved by Jean Pesne in the seventeenth century, so captivated Napoleon that he took the engraving on his Egyptian campaign.

composed highly effective *comédie-ballets* in collaboration with Molière. Louis XIV, an assiduous patron of opera, and also a dancer, had employed Lully to create an idiomatically French product, incorporating varied metres in recitative (declaimed sections), and the king's personal enthusiasm, ballet. Overwhelmingly formal *in toto* and with classical subjects, Lullian *tragédie lyrique* was carried forward, with dancing as part of it, by Jean-Philippe Rameau

(1683–1764), who also composed *opéra-ballets* (*Les Indes galantes*, 1735). Dancing was to remain a standard element of French opera into the nineteenth century.

In instrumental music, too, the Baroque proved a vital force. The concerto grosso, for grouped players against a full orchestral body, continued from Corelli (1653–1713) to Handel (1685–1759). The pioneer of the concerto for solo instrumental 'voice' against orchestra, Vivaldi (1678–1741), wrote about 230 examples for his own instrument, the violin; many were to inspire J.S. Bach (1685–1750) to transcribe them for harpsichord.

Largely because of its role at the European courts, modern musical histories use Baroque as a style-label for the period extending as late as 1750. This is helpful as a pointer to the broad change that took place around the middle of the century as an ideal of self-contained rather than expansive or cumulative form became established, and the age of Handel (died 1759) merged into that of Haydn (born 1732). Indeed, the climax of the Baroque in music was markedly later than in the visual arts. It was producing some of its grandest statements, especially in the work of Bach and Handel, *after* 1700, in circumstances far removed from those which had encouraged the style in the seventeenth century. The fuel that the Baroque provided for the Catholicism of Italy now nourished the Lutheranism of Bach, and in England Handel, trained partly in Italy and commanding a true Baroque robustness and organic vitality, had to observe the English taste for church anthems. In France, furthermore, a visual derivative of Baroque, introduced in interiors at Versailles about 1700 and later to be called 'Rococo', was to have a highly-effective counterpart in music.

The Rococo is the earliest of the eighteenth century's 'own' styles. Characterized by an essential linear lightness, pitched in phrases rather than paragraphs, it was brilliantly scaled to the small, chamber-like interiors which began to be popular and where 'chamber music' might be played. These were important modifications. In music Baroque grandeur and Rococo intimacy now ran parallel: the date of Bach's *St Matthew Passion* is 1727, and that of the fourth book of Couperin's suites for harpsichord (his 'Ordres') is 1730. In the Bach, bass lines give a richness from below, large-scale choruses in overlapping counterpoint – one of the central interests of the Baroque – point up the lyrical flow of the arias: we have the impression of a realm of religious emotion opening and enfolding us. In the Couperin we are in the company of miniature portraits of people or moods where supple lines move forward punctuated by ornamental detail. It has often been pointed out that in the way that Rococo broke down the larger forces of the Baroque it was preparing the ground for the slim athleticism of the classical age of sonata composition which lay ahead. As Watteau lightened Rubens (Figs 1 and 2), so Watteau's contemporary Couperin, in his shorter pieces, presented an idiom perfectly shaped for his age, bearing still in its ornamentations the stamp of its seventeenth-century parent, but full of unpredictable possibilities.

In the visual field where it had originated, Rococo touched contemporary minds and moods at many points. Though its name was first used by disap-

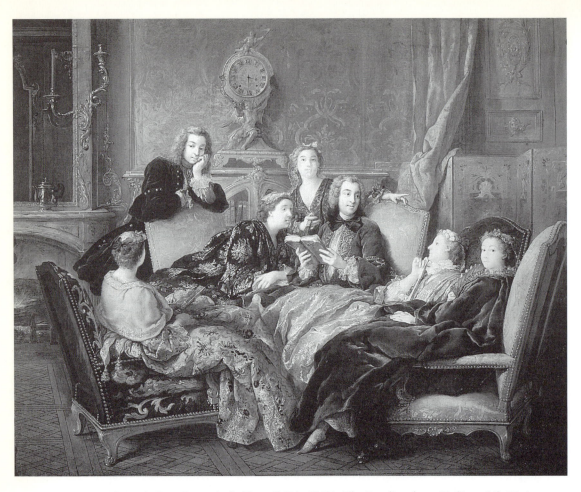

Figure 4: Jean-François de Troy (1679–1752). *The Reading from Molière*. Oil, 72.4 × 90.8 cm. About 1728. Private collection. Photo: Bridgeman Art Library.

De Troy successfully carried the colour and realism of Rubens and the intimacy of Watteau (without his ambiguities) into the French bourgeois drawing-room. This picture, believed to show the apartment of a banker, reflects the up-to-date Rococo taste, with arabesques on the right-hand screen copied from a series of Watteau designs published in 1728. The brocaded dress of the woman on the left is also datable to the 1720s. Everywhere there is informality. The party reclines on easy chairs of a new, low type. The asymmetrical candle-holder breaks the line of the mirror. Across decorated surfaces there is constant movement: between several of the figures, look answers look.

proving classicists at the end of the century, its derivation from *rocaille*, 'rock-work', a word included in the French Academy's dictionary of 1741, pointed to old-established interests in natural and artificial caves or grottoes in gardens. Geological specimens, including shells and fossils, were looked at afresh as the collecting of such items for gardens split away from the time-honoured practice of forming indoor 'collectors' cabinets'.[6] Shell collectors were meeting regularly at Dordrecht, Holland, in 1720 and shell auctions were soon to begin. Besides the promptings of science, the Rococo was nourished still more by desires for fantasy and entertainment, by an appreciation especially well-developed in the French temperament of the irrational alongside the rational, of pleasure together with instruction.[7] While the reports of Jesuit missionaries about an apparent utopia that existed in China were impressing European philosophers, interest in the exotic and the collecting of chinoiserie objects made in Europe in what was imagined to be genuine Chinese taste took on special attractions. As the flourishing East India trade exposed European Rococo to the influence of porcelain – a long-admired Western import from China – Europe found the means (at Meissen in 1708) of manufacturing its own.

The decorative brilliance of the Rococo, in fact, became localized in innumerable crafts and their materials: wood, metal, porcelain and glass. The challenge to craftsmanship – notably in the making of furniture, furniture mounts, and silver – had never been greater, and never more labour-intensive. Furthermore, in addition to classical sophistication, such work drew on a vast repertory of natural effects that the Baroque had largely ignored – such as corals, icicles, flowing and dripping water. Finally, most revealing of all, Rococo design took up with that unclassical ingredient, asymmetry (Fig. 4).

The Rococo spread from France to appear most captivatingly in the palaces and churches of Bavaria and Austria. Away from its transports of spirit or body we may feel that a style which appears to depend so much on small-scale detail, or which breaks the continuity of the wall with mirrors, as in the Amalienburg, Munich (1734–39, Fig. 5), has forfeited all sense of the permanently architectural. But this wonderful room takes the very idea of immateriality to a pitch of fantasy that demands to be evaluated on its own terms. Classical self-containment would return (compare Plate III); meanwhile the Rococo, as a style for occasions, yielded to no competitors. It is no accident that chairs now provided for maximum relaxation (Fig. 4), and music became domestic. This was the period of *Tafelmusik*, 'table-music' – informal divertimenti or serenades which might be listened to or alternatively provide an agreeable background to conversation. Quick movements alternated with slower – but not very slow – ones. It was from experience of composing for these occasions that musicians such as Mozart developed their familiarity with the capabilities of instruments.

As the immediacy brought about by concerted forces in the arts of the Baroque gave way in the Rococo to greater intimacy, there developed an art of private encounter, often enough between ordinary people rather than the famous, which showed them conversing face to face, exchanging letters, listening to a reading or music. The painting of Watteau (Plate I) and De Troy

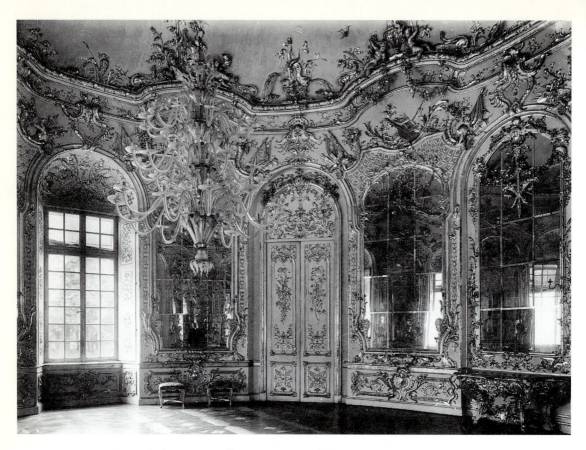

Figure 5: François Cuvilliés (1695–1768). The Mirror Room, Amalienburg, Nymphenburg, Munich. Stucco by Johann Baptist Zimmermann. 1734–39. Bildarchiv Foto Marburg.

The influence of Louis XIV's Versailles quickly spread to the German princes in the eighteenth century, and the Rococo style was pushed to new extremes of brilliance and delicacy. Cuvilliés, born in Brussels but trained in Paris, carried out extensive work at Nymphenburg for Karl Albrecht, Elector of Bavaria. The Amalienburg, a single-storey building in the grounds, is rounded in shape, yet inside large wall-mirrors appear to dissolve the walls. Above an undulating cornice, stucco vegetation sprouts and stucco birds fly: glass chandeliers scatter light. A blue and silver colour scheme (based on the heraldic colours of the Wittelsbachs, the Elector's family) adds to the effect of shimmering insubstantiality.

(Fig. 4), Haydn and Mozart's trios and quartets – often written for amateur players – and the art of the novel, remind us of this (see Chapter Two, p. 83). By mid-century the cult of 'sensibility' (French *sensibilité*) was highlighting differences in the interpretation of human behaviour; how what appeared a well-intentioned action from one point of view might look callous from another. Novels and plays explored Prodigal Son-type family stories of separation and reunion which revealed varying cross-currents of emotion. One of the

most remarkable of Frenchmen, Denis Diderot (1713–84), who wrote such dramas himself, wanted the artist who studied these situations to be both philosopher and, be it noted, musician. Music's capacity to 'affect' the emotions was to be looked at afresh.[8] And two developments bearing on music itself were significant. First, the French word *galant*, connected earlier in the century with Watteau's paintings of couples enjoying each other's company in country parks (the *fêtes galantes*), had become attached to music with a melodic top line unthickened by Baroque counterpoint from below: in the middle of the century, this style came to prevail throughout Enlightenment Europe. Secondly, in Germany C.P.E. Bach was simultaneously projecting *Empfindsamkeit*, or 'sensibility', in dramatic works for solo keyboard (p. 95).

It was in this clarifying atmosphere that music entered its so-called 'Classical Period', the age of Haydn, Mozart and early Beethoven. Music in fact differed from all the other Western arts in the late eighteenth century in that works were now written which for posterity became benchmarks by which everything produced later – or earlier – was to be judged. There were a number of reasons for this. The German-speaking parts of Europe from which this music came were forming a new cultural identity on the map of Europe: the German Enlightenment, different from that of the French, will need more comment in Chapter Four (p. 183). This was against a background of much speculation about early music, but also of ignorance as to what precisely Greek and Roman music had been like. Plenty of guesses were being made, in particular about the music that had been part of the classical theatre. Antiquarian interests were being pursued, and reflected in academies and festivals such as, in England, the Three Choirs Festival, founded in about 1715. But the claims of visible, tangible and learnable classical models, of such moment to eighteenth-century architects, sculptors, painters and poets, did not apply to musicians. Despite the surmise and scholarship, music had no undisputed, playable antique models to respect, and certainly none to live up to. Diderot, at least, saw no problem: the thought occurred to him that the Ancients were likely to have spent more time inventing because they had no Ancients of their own to imitate.[9]

Moreover, it was precisely now, in the middle of the century, that the structural shape of 'sonata form' was determined. This concept was to dominate instrumental music in Europe into the twentieth century. 'Sonata form' is concerned not only with structure but with the unfolding and resolution of ideas within it. In a typical first movement a first theme is stated, then a second, in a different (related) key; there follows a 'development' of one or both, and a 'recapitulation' in which the second theme is 'reconciled' with the first by being brought into the basic key. There are endless possibilities of varying such a basic scheme.

Furthermore, the scheme of a four-movement sonata for one or two instrumental voices (say piano, or piano and violin) could be adapted for combinations of three, four or five players or more (trios, quartets, quintets and so on) and, in the symphony, for larger forces (orchestras). Listening to eighteenth-century chamber music and symphonies, we find content fitting into form with

the closeness of a hand inside a glove: listening to a late Beethoven sonata, quartet or symphony we may be aware of content pushing form to new limits: but the parent discipline is still in charge. The principle of contrast, so fundamental to any dramatic argument, was to be given a special potential in the symphony. The origin of the word is *sinfonia*, the overture to an Italian opera. This was usually in three parts, fast, slow, fast. Transferred to the concert hall it could become a self-contained instrumental entity. Mozart's Symphony No 32 is a ten-minute Italianate *sinfonia*. With the hundred and four Haydn symphonies and the forty by Mozart the *sinfonia* transformed itself, losing its house-warming theatrical origins, investing itself with the formal purposes of sonata form, and acquiring the substance and inner resource that placed it, with the string quartet, at the heart of musical achievement in the nineteenth century.

Music in the eighteenth and early nineteenth centuries, in fact, created its modern mode of speech, unhampered by the past it drew upon. In its very sonorities it turned a corner: the harpsichord, brilliant in ornamentation but with its sounds produced by quills, was succeeded by the piano, worked by hammers directly responsive to finger-touch, and therefore capable of greater dynamic variation; the light-sounding fortepiano in turn gave way to the flexible concert instrument used by Beethoven in his late maturity, and by Chopin. Among wind instruments, the recently-developed clarinet added its distinctive voice. After 1800 the symphony orchestra was enriched by brass instruments fitted with valves, which enabled them to play a full range of tones and in any key. French horns and trombones built with this advantage made possible the sound-world of Wagner.

One final suggestive fact about music's eighteenth-century Classical Age is the way in which the more 'original' Romantics of the next century – notably Berlioz and Wagner – felt not merely the need to refer back to it, but enthusiastically saw their own work as part of a direct development out of it. Berlioz, himself a revolutionary, was inheritor of the revolution in attitudes to the role of music as exponent of dramatic situation that had taken place in the 1770s. For him, the 'classical' in music was expressed by Gluck who, as part of a reform of opera, had put music of a classically-shaped, restrained kind to the service of deep emotion (see Chapter Two, p. 96).[10] Gluck had died less than

Figure 6: Jean-Baptiste Greuze (1725–1805). *Ange-Laurent de la Live de Jully.* Oil, 117 × 88.5 cm. Probably 1759. Samuel H. Kress Collection, National Gallery of Art, Washington DC.

La Live, the wealthy son of a *fermier-général* (one who collected indirect taxes for the Crown), held the court post of Introducteur des Ambassadeurs. Greuze shows him as musician and connoisseur: a portfolio of prints and drawings is beside him. He sits on a chair *à la grecque*, of a kind which he had commissioned, as one in close touch with the latest fashion for severe line and antique pedigree: the style now known as Neo-classicism. These qualities were to contribute spectacularly to the distinction of French furniture throughout the remainder of the century, and into the Empire period under Napoleon.

Figure 7: Tureen and cover. Queensware, transfer-printed in black with 'Bewick' landscapes. Ht 28 cm, diam. 35.6 cm: Mark: WEDGWOOD. About 1791. Wedgwood Museum, Barlaston, Staffordshire (England).

Josiah Wedgwood (1730–95) combined close attention to the technical production of ceramics with exceptional insights into marketing the results. While cream-glazed earthenware had been made in England before mid-century, Wedgwood's creamware with white body was perfected by 1765. Known as 'Queensware' – Queen Charlotte commissioned a service in that year – it was an unprecedented success both at home and as export to the Continent. Not only was it within the financial reach of middle- as well as upper-class buyers, but the elegant Neo-classical shapes that Wedgwood increasingly used were ideally suited to production-line manufacture.

The tureen relays another source of popular cultural diffusion in its 'picturesque' decorative rustic scene, transfer-printed from a wood-engraving in the style of Thomas Bewick (though not directly traceable to him).

twenty years before Berlioz was born and the French composer's *Memoirs* show that he regarded his completed opera *The Trojans* (1858) as a direct descendant. Berlioz saw another spiritual father in Beethoven. In their operas both he and Wagner were concerned to apply the dramatic qualities of the Beethoven symphony to the stage.

Besides the Classical Style in music, there grew up after 1750 a movement in the visual arts now known as 'Neo-classicism', which aimed to abolish the fanciful Rococo and, backed by the fervour of the Enlightenment, reinvigorate the use of classical models. It took a variety of forms, some displaying con-

siderable powers of re-invention and adaptation (see Chapter Three, p. 124f.). In the more venturesome architecture of Robert Adam (1728–92), which came to maturity in Britain in the 1760s and 70s and ultimately reached as a style as far as Russia and America, the Roman language of proportioned column, wall and ornament was turned to what Adam called 'novelty and variety'. Standard proportions were narrowed or widened, grammatical 'correctness' in matters of detail was set aside, and yet the overall effect managed to look both calculated and comfortable to the eye. The Adelphi, a Thamesside housing scheme built by Adam and his brothers in 1768–72, showed all these characteristics. Adam also created some of the most delightful interiors of this or any other age: sacrificing none of the lightness of touch that the outgoing Rococo had gained, yet disciplining that intimacy with sharply-profiled, low relief classical ornament (Plate III).

Other factors, more intellectually and emotionally challenging, were at work, however, involving not only the disinterment of life-lines from a past that Mediterranean archaeology was literally revealing by excavation, but meditations on a 'true' style, as contemporaries saw it, that these life-lines could ensure for the future. Ancient Greece was the chief focus of this. Baseless Greek columns, and Greek pots (then called Etruscan, as many were dug up in Etruria in Italy) recalled the very origins of classical form and the simplicity which was once visible before later refinements covered it up. The German art historian Winckelmann (1717–68) advised a study of the 'calm greatness' of Greek statues as a future necessity: 'There is but one way for the moderns to become great . . . by imitating the ancients'.[11] This was a gospel with many practical applications in new contexts. Profile heads on monument (Fig. 30) or cameo lent antique authority to the taste for the silhouette. Greek-style motifs appeared in furniture (Fig. 6). Wedgwood (1730–95) adapted the lessons of Greek pottery to his famous basalt ware and creamware (Fig. 7). Classical architectural shapes were transferred to the new America, most signally by Thomas Jefferson (1743–1826), third President, who saw the 'cubic architecture' as he called it, of the Maison Carrée, the Roman temple at Nîmes, as the only true choice for his Capitol building at Richmond, Virginia (p. 129).

The Inspiration of Nature; the Move to Romanticism

In contrast to Neo-classical certainties, new horizons were widening, not only in America but in Europe. There too they could have about them the appeal of the unfamiliar, even the disturbing. Some were geographical – India, as the English East India Company took up the administration of Bengal in the 1760s; or Egypt, especially after Napoleon's archaeological initiatives following his expedition in 1798. Others were mental. The excitements long offered by the storm paintings of the Italian Salvator Rosa (1615–73) were now joined by the exhilarating appeal to the imagination of Garrick's acting of Shakespeare, or by the 'Sublime', which Edmund Burke discussed in 1757. To the ancient writer

Longinus, 'sublime' oratory conveyed exultation: by describing the effects of terror on the emotions, in examples from Shakespeare, Milton and the Old Testament, Burke gave the term new life.[12] Even the Royal Academy's President, Reynolds, student of the 'terrible' in Michelangelo rather than in Rosa, made a 'sublime' *Macbeth* painting for Boydell's Shakespeare Gallery in London (opened 1789); his successor, the American history painter Benjamin West (1738–1820) also explored this ground. Romantic landscapists, such as Turner (Figs. 8, 45) and Martin, could extract the utmost danger from the sublime.

It is no coincidence that landscape painting, firmly established before 1700 by Claude Lorrain (1600–82) in terms of a timeless, light-filled Arcadia, and by Dutch painters conscious of their immense skies which could so quickly change, took on special importance in the late eighteenth century. The human need for the classical Arcadia was still strong: but the rougher aspects of nature, the textural intricacies of wild mountain landscape and buildings in such settings, were coming to be seen as offering pictorial qualities and therefore self-sufficiently 'picturesque'.[13] Awareness of medieval buildings, already strong among clergy and country antiquarians, was advanced by the evidence of what time had preserved or destroyed, and by a desire to record it. Amateur artists – a growing band in this age of drawing masters – might, for instance, draw the ruins of Goodrich Castle as they journeyed down the river Wye. Picturesquely composed rusticity might now be encountered *tout court* on the side of a Wedgwood tureen (Fig. 7). Though picturesque subjects became a cliché, as characters in Jane Austen's novels reveal, they were an undoubted imaginative spur to the young Romantics. Turner was making long picturesque tours all over Britain through the 1790s. One of Constable's earliest acts as an artist, in 1796, was to draw thatched cottages in his native Suffolk, in what has come to be seen as a kind of rural picturesque of 'lowly' subjects.

The vernacular art and building styles of northern Europe made steady gains in reputation in this pre-Romantic period. The term 'Gothic' (remembering the Germanic tribes who had harassed medieval Rome) had already acquired new, favourable meanings and, after a phase of playful alliance of 'Gothick' with the Rococo, more serious impulses were at work in both architecture and literature. Regard for Gothic increased as the Germans, French and

Figure 8: J.M.W. Turner (1775–1851). 'The Fifth Plague of Egypt' (*Liber Studiorum*, Part III). 1808. Etching and mezzotint by J.M.W. Turner and Charles Turner, first published state, plate size 20.9 × 28.9 cm. British Museum.

Turner's *Liber Studiorum* (fourteen parts, 71 subjects) used the print form to advertise his mastery of different branches of landscape. Each composition is placed in a category ('Mountainous', 'Marine', etc): the present example is 'Historical'. Based on a painting of 1800, it brings the violent light and shade of the heroic Baroque into modern focus: contrasting the obvious deadness of the foreground corpse with the free motion of a cloud placed at exactly the same angle above. It also illustrates the continuing potency of the eighteenth-century 'sublime': lightning and hailstones, as described in the Book of Exodus (seventh plague), have extinguished human life – but leave the viewer behind to ponder the fact.

C. Grignion sculp.

British explored their national roots (p. 195). Its power as an imaginative stimulus, however, accounted for much of its general appeal. For adherents of the sublime the leaping forms of Gothic pointed arches expressed a freedom that semi-circular classical arches could not. The excitement of tall Gothic shapes marked Bentley's design for Gray's *Elegy* (Fig. 9). A modern 'Gothic' literature of mystery and the supernatural became fashionable (Chapters One, p. 52; Four, p. 192; Five, p. 220). Even after 1830, when the respective contributions of France, Germany and Britain to medieval Gothic had been soberly analysed by scholars, and one of its keenest students, the architect Pugin (1812–52), came to see it as a style of Christian relevance for his own time, the Romantic associations with chivalry and imaginative adventure continued.

We have reached the last 'label' we need to consider: 'Romantic', the most difficult of all. The word itself presents a clear derivation from the medieval 'romance' of love, chivalry and adventure. The modern meanings were to go well beyond any single ancestor, although the persistent element of imaginative adventure, which had also come to characterize the sublime, prefigured the energy of modern Romanticism. 'Sublimity and genius flash in Shakespeare', observed the French *Encyclopédie*.[14] In the 1770s the German *Sturm und Drang* (Storm and Stress) literary movement, with Goethe (1749–1832) and Schiller (1759–1805) among its proponents and with its high regard for Shakespeare, upheld this view. But if, in this movement, we recognize clear signs of Romantic impatience with classical rules and 'learning', we also have to accept that the beginnings of such ideas are irrecoverably buried in the past. There was much in Baroque painting's kind of direct appeal to the spectator (p. 7 above) that the Romantics could use: Rubens emerged as a powerful influence. Looking away from the authority of Baroque Italy, however, Romantics felt free to range imaginatively and eclectically outwards in space and backwards in time. The old fascination with the 'Noble Savage' was focused for the later eighteenth century by Rousseau's celebration of the pastoral life. Folk tradition, the history of nations, the life of ordinary people, what the 'classical' poet Dryden back in 1700 had referred to in Chaucer as the 'rude sweetness of a Scotch tune': all held out further attractions. Already in 1709 Shakespeare had been described as 'a wonderful genius, a single Instance of the Force of Nature, and the Strength of Wit'.[15] For a Romantic writer like Victor Hugo (preface to his play *Cromwell*, 1827) Shakespeare *was* the drama, mingling high and low, the sublime and the grotesque, in the same scene, like real life. In the

Figure 9: Richard Bentley (died 1782). Illustration to Gray's 'Elegy written in a Country Churchyard', one of six designs for Horace Walpole's Strawberry Hill edition of *Poems by Mr T. Gray* (1753). Engraving by C. Grignion, max. 26.2 × 20 cm. British Library (C57 h5)

This piles up vertical forms: helmet and gauntlets in the left-hand niche; tree, sheaves and agricultural implements on the right. The ribbing of the Gothic vault echoes the branches of the tree, and the chivalric and heraldic elements set outgoing human adventure against the idea of incoming harvest and life's completion, all of which the poem recalls.

intervening hundred years the idea had grown of the artist as uniquely endowed by nature, and of the natural world not so much as something to be imposed upon and organized by him, but as the repository of energies which he felt as part of himself. In the light of this, landscape, and the artist's relation to it, came to assume new importance (Figs. 38, 39 and 45). The decade that launched *Sturm und Drang* saw the births of Beethoven (1770), Wordsworth (1770) and the great landscapists Caspar David Friedrich (1774), J.M.W. Turner (1775) and John Constable (1776). All these would be aware of the frustrations and uncertainties which made it difficult for man to preserve what Wordsworth optimistically saw as

> The gravitation and the filial bond
> Of nature that connect him with the world.
> (*The Prelude* II, 243–4)

Testing the strength of bonds sensed or sought in nature was also to preoccupy the second generation of Romantics, born closer to 1800: Keats, Shelley and in Germany Eichendorff, whose lyrics would inspire some of the finest songs of Schumann.

Other Romantics would respond to other kinds of gravitational pull: backwards in time in the case of Walter Scott (1771–1832), whose novels often recreate historical periods remote from his own; or from beyond Europe, as with Byron (1788–1824) or Delacroix (1798–1863) in their explorations of the Orient. Much public acclaim would be won: but the private wishes of the artist would not always coincide with it. This tension between public and private, and some of the results of the artist's private imagining, form the subjects of Chapters Four and Five.

The chapters which follow do not attempt a single chronological story. This would be impracticable, because the arts never 'march in step'. Equally, because they interrelate, at times even closely, a separate chapter for each seems inappropriate. Instead, the chapters take the form of an interdisciplinary presentation on thematic lines. All themes concern changing perceptions of the arts and their role. Chapter One takes the growth of middle-class patronage, together with the means by which the arts became more widely accessible. Chapter Two considers change in two of the areas – opera and the novel – where the newly-aligned upper and middle-class publics most assiduously put their money; the conditioning effects of sensibility and the role of women are subtopics. No book on a period that includes Haydn's *Creation* and *Seasons* and the finest of all landscape painting can overlook the growth of regard for nature. Chapter Three moves to an aspect of the relationship of authority to freedom – design and chance – which perceptions of nature helped to illuminate. An Interlude concentrates on a more limited but salient outlet for man-made design – the bridge – and contrasts the confidence of the early Industrial Age with certain ambiguities which this most exposed of building forms (always, by definition, built over space) could suggest after 1800.

The next two chapters close in on the artists themselves: Chapter Four on their public activity in an age of advancing nationalisms and on the private role that some found themselves adopting or were glad to adopt; Chapter Five on the Romantic cult of the fantastic and a heightened view of the real as a development of this private role. Finally, returning to the bridge image (and the public arena), Chapter Six looks at the links to a modern culture that are symbolized by certain aspects of technology, art and education, which take on so close a relationship to one another in this period.

NOTES

Place of publication is London unless otherwise stated.

1. John Locke, *Essay Concerning Human Understanding* (1690)
2. For a full range of examples see John Rupert Martin, *Baroque* (1977)
3. George Steiner, *The Death of Tragedy* (1961), p. 11
4. A main task of music, according to Roger North (1653–1734), was to 'move the affections' (a word that conveyed a stronger meaning than at present) as well as to 'excite the passions' (*The Musical Grammarian*, 1728). The association of the ancient 'modes' of music with particular expressive effects (Doric with severity, Phrygian with warlike passion, etc.) provided a well-known foundation for this doctrine. Music of the Baroque age was much concerned with the expression in single movements of single emotions. Codifying the practice, German theorists gave it the name *Affektenlehre*. See also p. 73.
5. For Lavater and background see Francis Haskell, *History and its Images: Art and the Interpretation of the Past* (New Haven 1993), pp. 144f. Lavater's *Physiognomische Fragmente* (Leipzig and Winterthur 1775–8) appeared in many translations and editions
6. John Dixon Hunt, ' "Curiosities" to adorn Cabinets and Gardens', in O. Impey and A. MacGregor, eds, *The Origins of Museums* (Oxford 1985), pp. 193–203
7. Walter Friedlaender put this relationship well in his book *David to Delacroix*, Eng. trans. R. Goldwater (Cambridge, Mass. 1952), pp. 1f.
8. For example in Diderot's *Lettre sur les Aveugles* (*Letter on the Blind*, 1749). For Diderot here, indeed, a musical phrase is one long varying syllable (*une seule et longue syllabe, qui à chaque instant varie d'inflexion et d'expression*). For Diderot's interest in the expressive power of words spoken semi-articulately under emotional stress compared with that of music, see Arthur M. Wilson, *Diderot, the Testing Years* (Oxford 1957), pp. 268–9. Rousseau referred to music's power to 'speak' for an actor, in place of words, in his *Dictionnaire de la Musique* (1767)
9. Earlier treatises on ancient music were now superseded by the *Storia della Musica* (1761–81) by Padre Giovanni Martini. His account influenced vol. I of Dr Charles Burney's *General History of Music* (1776)
10. Hector Berlioz, *Memoirs*, Eng. trans. and ed. David Cairns (1969), p. 79
11. Johann J. Winckelmann, *Gedanken über die Nachahmung der griechischen Werke in der Malerei und Bildhauerkunst* (Dresden 1755), trans. J.H. [Henry] Fuseli as *Reflections on the Painting and Sculpture of the Greeks* (1765), p. 1
12. Edmund Burke, *A Philosophical Inquiry into the Origin of our Ideas of the Sublime and the Beautiful*, 1757. A convenient edn. is that by J.T. Boulton (1958)
13. The term picturesque, popularized in England by William Gilpin (*Three Essays: On Picturesque Beauty, on Picturesque Travel, and on Sketching Landscape*, 1792)

was theoretically defined by Uvedale Price (*Essay on the Picturesque*, 1794, enlarged 1810)

14. Article on *Génie*, by Saint-Lambert, in Denis Diderot and Jean d'Alembert, *L'Encyclopédie; ou Dictionnaire raisonné des sciences, des arts et des métiers* (Paris 1751–72)

15. Henry Felton, *Dissertation on reading the Classics* (1709); quoted by Jonathan Bate, 'Shakespeare and Original Genius', in Penelope Murray, ed., *Genius: The History of an Idea* (Oxford 1989), p. 78

1

Markets for the Arts

Prelude

One eighteenth-century phenomenon which has perhaps received less than
due recognition is the shopwindow. Once improved technology made
possible larger panes of glass, displays behind them could become not only
more visible but more desirable. The fashion began in London and moved to
Paris. In the 1780s the covered arcades round three sides of the Palais Royal
opened as shops glazed in the English way and, with the associated concert
rooms, puppet and silhouette shows, clubs and Turkish baths, became the
most popular venue in Europe. Simultaneously printshop windows across the
Western World were becoming picture galleries for the casual passerby as
well as the interested collector.

This chapter is in part about the wider shopwindow that opened on the
arts in the Western World between 1700 and 1850. It is also about the
vertical permeation of the arts through society, as increased leisure and
spending power within its middle layers created opportunities that had
traditionally been confined to those at the top. In Britain, especially,
conditions of social mobility were able to bring about what has been called
the world's first consumer society, in which both competition and fashion
consciousness would be encouraged at an unprecedented rate. Across Europe
and America, increasing access to information about the arts in newspapers
and books was to create a demand for more. After 1800 the new publics for
the drama, the visual arts and music were to have their tastes extended by
artist-critics such as Berlioz, defending the integrity of a late Beethoven
quartet, or Ruskin, that of Turner's controversial landscape painting.

The Middle-class Public

Among the many factors behind the rise of an arts-conscious middle class, a national language that enables its members to communicate, and share an enriched personal understanding, must claim a high place. Such was the situation in eighteenth-century England: and, despite wide differences in the spoken language across so large a country, in France also.

In 1700, each of these languages was poised to extend its influence. That of France, under the protection of the Académie Française since 1634, was to strengthen its credentials as the principal instrument not only of international diplomacy but also of 'polite' conversation as far away as Frederick the Great's Prussia and Catherine the Great's Russia. Argument sparkled in the women's salons of Paris. Precise definition became the watchword of the great multi-volume *Encyclopédie* (1751–72). Voltaire, Rousseau and the epigrammatist Chamfort became masters of style. Across the Channel, English, simplified in the prose of the 'Augustan' period, 1700–30, also emerged as a polished yet flexible bearer of meaning and ally of cultural progress. Swift in 1712 feared for its decline, and asked for an academy to protect it. Britain, resisting this idea, turned as always to individuals. Johnson produced his wonderfully endearing and enduring *Dictionary* (1755) to the same end: 'Tongues, like governments', he wrote in his preface, 'have a natural tendency to degeneration; we have long preserved our constitution, let us make some struggles for our language'. Concerned similarly with the spoken word, the actor Thomas Sheridan (father of Richard Brinsley Sheridan, great orator as well as playwright) published a pronouncing dictionary (1769, 1780).

Alongside or in place of 'learned' Latin, therefore, French and English were shaped for work of widespread communication, not least of issues to do with the arts. A clear instance is the Epistle *To Richard Boyle, Earl of Burlington* (1731), 'Of the Use of Riches', by the Augustan poet Pope (1688–1744). Drawn as he was to Burlington's fashionable architecture, based on the rules of the great Italian classicist Palladio (1508–80), the flow of Pope's heroic couplets left his English readers in no doubt about the care needed to handle it:

> Yet shall (my Lord) your just, your noble rules
> Fill half the land with imitating fools;
> Who random drawings from your sheets shall take,
> And of one beauty many blunders make;
> Load some vain church with old theatric state,
> Turn arcs of triumph to a garden gate; . . .
> Conscious they act a true Palladian part
> And, if they starve, they starve by rules of art.

He had concluded, from this thoughtless extravagance:

> Something there is more needful than expense,
> And something previous even to taste – 'tis sense.

> (lines 25–30, 37–8, 41–2)

Taste, the great watchword of the day, applied a blanket authority: sense took account of existing conditions, the 'genius of the place'. Here was a crucial and salutary caveat as well as a perfectly-turned argument. The notion of an 'aristocracy of taste' continued to command attention: Burlington's upper-class clients went on sharing the same classical education, reading the same authors, and imitating the same rules. But plainly there was no aristocracy of sense. This sense which preceded a taste founded on copying a fashionable style was, as Pope told Burlington, 'A light, which in yourself you must perceive'. The light of sense revealed whether a building – or a garden gate – actually looked 'right' or not; and this took priority over how expensive taste might dictate it ought to look.

Coinciding as it did with the emergence in Pope's England of a new, moneyed class, with its wealth obtained from commerce, such an appeal was well-timed. Ability to apply a standard of taste would, of course, go on being the hoped-for reward of making the Grand Tour of Italian art and antiquities, the privilege of those of the leisured classes who could finance the journey. But a little independent thinking would show that the parent stem of Italian art, for good reasons, would not 'take' in every soil. In his *Spectator* 29 (3 April 1711), Addison told his middle-class readers how Louis XIV's composer, Lully, had given Italian opera a specifically French form, 'very properly adapted to their pronunciation and accent'. Montesquieu, in his famous *L'Esprit des Lois* (1748), developed his own version of the theory of climate as an influence on national character, and reviewed his experience of the different responses to opera of Italian and English audiences – impassioned in the warm south, less than rapturous in the cool north – in the light of it. A sense of the variety of national character and art was to grow steadily throughout the rest of the century. As we shall see in Chapter Four, the study of artistic roots and racial memories was to be developed particularly by German writers, exploring their own language and communicating with a growing literate public.

THE IMPORTANCE OF LITERACY AND WEALTH

There were, of course, formidable obstacles to acquaintance with the arts. Across Europe, illiteracy and the pressures of survival separated off large sections of the people from any contact with them. Especially was this so in Russia, where there were few town-size social units and society remained divided between an aristocratic minority which became French-speaking and a massive peasant class which was heir, nevertheless, to a rich folk culture and Orthodox religion routed through Greek Christianity.[1] Apart from the problem of literacy, there was also that of national awareness. Although the westernizing cultural policies of Peter the Great and Catherine the Great towards theatre, literature and especially (under Catherine) the satirical magazine (p. 47), produced for the educated some genuinely Russian responses, the lack of a fully-developed literary language that would represent the truly Russian voice had to wait for Pushkin (1799–1837, pp. 89, 208).

At the opposite end of the continent, by contrast, the literate middle classes in both Britain and France were becoming both vocal and self-confident in their approach to the arts. It was a British writer, Defoe (1660–1731), who pointed out in 1709 the chief condition that was needed for this to happen, when he referred to the third in his list of the seven social levels which formed the population in Britain as 'The middle Sort, who live well'.[2] It is true that many people of this growing class who might benefit from the arts were part of the 70 per cent of the population (of just over five million in 1700) that was rural-based, and would not, like many in Defoe's first two social groups, 'The Great, who live profusely' and 'The Rich, who live very plentifully', have been on a Grand Tour and filled a large country house with paintings and sculpture. Patterns of social hierarchy, moreover, predictably hung on in the country. In an age when land was the most conspicuous form of wealth, relatively few owned most of it (Burke, at the end of the century, memorably referred to the 400 major landlords of that time as the 'great oaks that shade a country').[3] But the English tradition of country life brought the newly rich – lawyers, merchants, even manufacturers – out from the towns, and with them, as the century developed, came rising dynasties of bankers, willingly accorded respect and status by many of the older aristocracy who depended on them for loans. Such was the Coutts family, of good merchant stock. John Coutts had married a servant woman, whose later Paris receptions were attended by the British Ambassador. Another banker, Sir Francis Child, was the model of Hogarth's Industrious Apprentice. His grandson Robert (1739–82) was to employ the most fashionable of late eighteenth-century architects, Robert Adam, to carry out interiors at Osterley, near London (which survive). The Bank of England had been founded in 1694, and in the following century Britain was to become the outstanding international home of credit, that other contributing element, besides land, to the success and stability of family fortune.

In Britain, then, it was possible to acquire high status (if not recognition) from relatively obscure beginnings in a relatively short time, provided that ability and luck coincided. It is true that, since credit was so readily obtainable, aristocratic landed families rarely needed to sell land, and so might remain singled out from all lower-born contenders in the possession of that conspicuously prestige-conferring commodity. The essential point, however, is that the portmanteau term 'gentleman' embraced a variety of life-styles, from major landowner to merchant to schoolmaster. The layer structure of social rank was joined by the glue of the 'code of behaviour' that permeated gentleman status. Civilized values could therefore penetrate extensively down the social scale as middle-class incomes rose with the national economy. Georgian architecture was notable not only for the great palaces such as Sir Thomas Coke's Holkham (Norfolk, designed by Burlington and Kent, with Coke's indispensable participation) or Sir Nathaniel Curzon's Kedleston (Derbyshire, by Paine and subsequently Adam), but for small country dwellings built on classical lines for country gentlemen by jobbing builders whose access to books by Palladians, such as that by Isaac Ware (1756), put them in secure possession of the basic information necessary for planning well-proportioned rooms in attractive rela-

tionships to each other. The Holkham farmhouses and farm buildings which survive from later generations share these characteristics. The Georgian style, also taken up in the American colonies, proved a byword for balance and harmony, a model for convenient living.

This integration in Britain of adaptable architectural language and gentlemanly life-style worked wonders to buttress the middle class's sense of itself as a social force in the land. It was not just that royal absolutism was over, or that there were only a few hundred peers in the realm to constitute a governing class. In the streets and crescents of Georgian Bath the rhythms and proportions of classical architecture could not only be recognized by men of fashion who had made the Grand Tour of Italy, but be quietly absorbed by the minor gentry and middle-class families whom the inspired Master of Ceremonies, Beau Nash, was careful to accommodate in his programmes at the Pump Room and the Assembly Rooms. No-one was left out in a minuet: indeed everyone was encouraged to join in. 'I endeavour', said Pope, blissfully happy on his visit to Bath in 1714, 'to become agreeable by imitation'. Nash (1674–1762) presided at Bath for 45 years. By the late eighteenth century, some of the *élan* had departed, though Hannah More wrote in January 1792: 'Bath, happy Bath, is as gay as if there were no war, nor sin nor misery in the world!' The long portions of Jane Austen's novels that use Bath as setting (*Northanger Abbey*, begun 1798, nineteen chapters; *Persuasion*, completed 1816, five chapters) point to the greater snob element in its life by that period; and Dickens's *Pickwick Papers* (1836–37) suggests that it arrived at a certain inanity. But the earlier role of the city under Beau Nash, as a mixing bowl of all the fashionable aspirations of a changing society, was seminal. Its Grand Parade, built in 1740–48, took its place with the contemporary Grand Walk at Vauxhall Gardens in London: Bath's parades, however, looked out to a river backed by hills; nature, as Fanny Burney put it in 1780, was 'always in our view'. A country gentleman and his wife could easily feel comfortable in both Bath and Vauxhall (Fig. 10).

Merchants and manufacturers were a different case, being more dependent on the patronage of the landowning class. But fortunes earned in commerce blossomed, especially in the City of London. For Addison (*Spectator* 69, 19 May 1711) merchants 'knit mankind together in a mutual intercourse of good offices, distribute the gifts of nature, find work for the poor, add wealth to the rich, and magnificence to the great. Our English merchant converts the tin of his own country into gold, and exchanges his wool for rubies'. Defoe saw benefits to the country if landed and merchant families intermarried. Hogarth, in *Marriage à la Mode* (1743–45), a series of pictures concerned with an earl's son being married off to a merchant's daughter to preserve his father's solvency, used the situation to satirize a course of action that was not uncommon. Voltaire, in the tenth of his *Lettres Philosophiques*, felt that the recognition by England's landed classes of the merits of trade had contributed notably to the nation's well-being. A French visitor of 1737, Jean-Bernard le Blanc, recorded in his *Letters on the English and French Nations* (Dublin 1747: vol. I, p. 214) the respect enjoyed by English merchants and farmers, compared

with their counterparts in France. On the English stage the merchant's world could even become the setting of a tragic denouement that in France would have required the presence of 'high-born' characters to handle it. In 1731 George Lillo wrote his tragedy *The London Merchant or the History of George Barnwell*, first performed at Drury Lane. Written in prose, not the verse that was usual for tragedy, the play enjoyed fame for a century and, in the age of sensibility (p. 185), influenced the French writer Diderot (1713–84) and the German Lessing (1729–81).

In France, too, wealth lay primarily in land, but this was largely in the hands of an immensely powerful clergy and nobility who constituted respectively the First and Second Estates (the commoners representing a very unprivileged Third). The old nobility, *noblesse d'épée*, who in fact become more involved in government under Louis XVI than under Louis XIV a century earlier, lived extravagantly, and delayed paying their bills. A newer but still hereditary *noblesse de robe* were hardly less splendid. The clergy controlled much of the press and education. Both First and Second Estates claimed, and largely received, exemption from taxes. It was open to middle-class aspirants to higher status to buy their way up the social ladder, as financiers and lawyers as well as merchant capitalists did by the thousand. But the older nobility preserved the distinctness of a caste: layerings of the three Estates remained essentially fixed and the relationship of the first two competitive.

In 1789 the Third Estate voiced the end of its patience with the existing structure. Some aristocrats who wanted more political power supported them, and it would be wrong to suggest a clean division between the first two Estates on the one hand and the Third on the other. A hundred years earlier Molière had made fun of a seeming contradiction in terms in the title of his comedy *Le Bourgeois Gentilhomme* (1670). 'If you are always dressed as a bourgeois, you will never be called a gentleman', Molière's Monsieur Jourdain had there declared, donning his finery. But while *gentilhomme* continued in the eighteenth century to indicate noble birth, 'bourgeois' could also, among many other shades of meaning, convey breeding.[4]

Figure 10: John Wood the Younger (1728–81). The Royal Crescent, Bath, 1767–75. Engraving from R. Warner's *History of Bath* (1801). Bath Central Library.

The pleasures of promenading and travel by sedan-chair are depicted in a part of Bath that is both urban and semi-rural. The road on the left is made broader, and safer, by wide pavements. Through the eighteenth century a reciprocal relationship between nature (in this city of hills and mineral springs) and classical order was being evolved, largely through the architectural planning of John Wood the Elder (designer of the Circus, 1754–65) and his son.

A short street's-length from the Circus (which was enclosed and paved), the younger Wood designed the half-ellipse of the Royal Crescent. Here, on a commanding site, rose a monumental block of thirty houses behind a two-storey Ionic order, in front of an open downward slope that was grazed by cows. This bold, curving shape – stark in the early days, as Warner's print shows – was to be echoed again and again in Neo-classical town planning, especially in Britain.

The evidence of class correlations in the drama of mid eighteenth-century France is mixed. The social implications of Lillo's *London Merchant* were known to writers for the stage but seventeenth-century expectations of noble behaviour as a prerogative of high-born characters lived on. Even Diderot, who denounced this convention, tended to make the protagonists in his own 'tearful comedies' upper-class. The same is observable in fiction. In Britain the irreverent Fielding (1707–54) made fun of the classical unities, and in his *Modern Glossary* characteristically defined the adjective 'great': 'applied to a thing, signifies bigness; when to a man, often littleness or meanness'. But when his novel *Amelia* (1751) was translated into French, the plebeian hero became a nobleman and his sergeant a lieutenant.[5]

Such pointers help to account for the shock caused by Figaro's words in Beaumarchais' play *Le Mariage de Figaro*, thirty years later (1784). Railing against Count Almaviva, who employs him as valet, this resourceful representative of the lower orders equated human 'greatness' with littleness: 'Nobility, fortune, rank, position! How proud they make a man feel. What have *you* done to deserve such advantages? Put yourself to the trouble of being born – nothing more! For the rest – a very ordinary man!'[6] Beaumarchais' own career demonstrated the continued dependency of most French authors on the patronage of crown and aristocracy. But if bourgeois claims for equality were, until the Revolution, to be made within the existing class framework, the parallel co-existence of Paris, the inexhaustible source of unquiet ideas, and Versailles, with its stratified life-patterns, seems to have made for a combustible set of circumstances. Already in 1688–96 the moralist La Bruyère had noted the opposition of *la ville* and *la cour*. In *la ville*, as it turned out, the artistic concerns of the future were being formed in intimacy rather than formality, in regulation by fashion rather than by protocol, in the unpredictable life of the café rather than the set life of the court. In the French novel which explored this territory, the crossing of social divisions by characters in disguise or wearing masks would be prominent (p. 83).

In Britain, with no art-conscious court to react against, and with economic power increasingly placed in the hands of men of commerce, the situation was different. In the novel the 'ordinary' hero was commonly established by 1750, the year after Fielding's *Tom Jones*. And in the Britain of Fielding and Samuel Richardson, it may even be claimed, the conditions existed for a middle-class public to appraise its own portrayal in art at its true worth, and abandon any residual sense of inferiority in matters of taste.[7] While in painting the monolith of 'polite' taste imposed from above brought its problems (see p. 62), in areas of design such as dress the untutored could keep up with London fashions through newspaper reports or the sight of the latest styles brought back from the capital, and advance in self-esteem. Even their servants could dress fashionably.[8] The financial security that was achievable in Hogarth's England, moreover, was clearly a prerequisite for a middle-class art to assert its true confidence. Such security was by contrast more hardly won in France, in a society without state-operated credit. The prospering Atlantic trade, nonetheless, was

to create appreciable wealth in such ports as Bordeaux and Nantes, counter-parts of Bristol and Liverpool.

SALONS, CLUBS AND SOCIETIES

Besides self-possession, security and funds, and a degree of leisure, the aspiring middle-class follower of the arts did well to be gregarious and live near a town of some size. One of the most persuasive indicators of social change in both Britain and France in the eighteenth century was the determination of small groups in towns to advance themselves. Paris was, of course, to set the pace for France. Leisure-using institutions such as salons and libraries proliferated. Such was the Club d'Entresol, founded in 1724. Here English ideas in particular were discussed and censorship was avoided for seven years. After closure a migration to more unofficial locations such as coffee-houses ensured a continuation. But here also it is initiatives in the provinces which afford more telling evidence of the progress of the arts among the middle class. It was in the wealthy town of Bordeaux, for instance, that magistrates and other laymen, as well as literary figures, were meeting in the early years of the century first to hear music and discuss poetry, and also to debate scientific matters. In 1712 the Academy there was founded: four years later Montesquieu, a native of the region and a future leader of the Enlightenment, became a member. By the 1750s over 20 academies existed in the provinces, and by 1770 every average town of about 2000 inhabitants possessed one. Despite a bias towards the sciences, literary competitions became a feature of academic programmes: it was the Dijon Academy, in fact, which was to receive the epoch-making early works of Rousseau in 1749 and 1752.

The solidarity to be experienced in such associations of the like-minded found a different kind of expression in the Paris salons run by women. These had flourished in the seventeenth century, but their encouragement of urbane social interchange now reached new heights. Even Rousseau, always an outsider figure, was to be counted together with the bourgeois Diderot, the foundling D'Alembert, Marmontel and others among the guests at one of the greatest of them, run by Madame Geoffrin, a bossy, tireless organizer, herself of bourgeois origin, who held receptions for artists and art patrons on Mondays and for literary men on Wednesdays. Horace Walpole described her as 'the epitome of empire, subsisting by rewards and punishments', and preferred her rival, Madame du Deffand. Another salon hostess, Julie de Lespinasse, was famous for her ability to bring out the best in her guests and draw them together. The social ideal that animated the Paris salons became a true microcosm of wider Enlightenment hopes. The French word *cosmopolite*, meaning one who moved comfortably in all societies, had been recorded in 1560. French wit and secular enquiry now extended like quicksilver across Europe. If French was the international language of this enquiry, Voltaire – whose portraits by Houdon (Fig. 11) became ubiquitous sculptural presences through copies – was the international proponent of it, equally at home (despite his private doubts)

in centres of Enlightenment as different and removed from each other and from his own Paris as London, Geneva and Berlin.

Coffee-houses, too, were vital links in the chains of communication by which news was shared and opinions formed. When in Paris Diderot in fact preferred them, especially the Café Procope where he was frequently to be seen indulging his gift for talk. In Britain, gregariousness was particularly expressed by the men's clubs which often originated at coffee-houses or taverns. The Literary Club (1764) was founded by Dr Johnson, another of the century's great talkers. Clubs operated across the whole social spectrum, from artisans' trade-clubs to the aristocratic gaming clubs in St James's, London, such as White's, which first met in a chocolate-house. A number provided social occasions for music on a semi-professional level (the Noblemen's and Gentlemen's Catch Club founded in 1761). In others artists and men of letters foregathered. Such was Old Slaughter's Coffee-House in St Martin's Lane, London, where artist- and craftsman-advocates of the French Rococo met with patrons and publicists in the 1740s as a kind of 'opposition' to officially established Palladianism.[9] Besides particular interests, there were partisan causes to be served by the clubs and coffee-houses; and it seems very likely that a kind of bourgeois public forum was helped into being by institutions that gave such opportunity to conversation and expressions of group feeling.

In Paris the cafés attracted frequenters of theatre or opera, or debaters of social or political issues. Diderot's dialogue *Le Neveu de Rameau* opens in the Café de la Régence. In such surroundings topics of conversation could range infinitely, and ideas could be mooted which the censored press could not handle. In the explosive eve-of-Revolution summer of 1789 Arthur Young provided a vivid glimpse of Paris coffee-houses invaded by 'expectant crowds . . . at the doors and windows' listening to orators 'who from chairs or tables harangue each his little audience'.[10]

In Germany, while value was placed on group discussion of social issues – especially in a part of Europe that was politically so divided – official repression and censorship often turned the results into secret conclaves. The Berlin 'Wednesday Society' (*Mittwochsgesellschaft*), meeting in 1783 to 1798 through

Figure 11: Jean-Antoine Houdon (1741–1828). *Voltaire*. Marble. 1778. Ht 47 cm. Metropolitan Museum of Art, New York. Purchase, Charles Wrightsman Gift, 1972. (1972, 61)

Voltaire, son of a middle-class lawyer, was royalist in his sympathies, a believer in monarchic authority: but his central aim of a good society depended on the existence of an educated middle class 'put . . . in a condition to see it has intelligence'.

Houdon, master of instantaneity in his sculpted portraits, made many likenesses of the great humanitarian and wit, from the seated full-length in the Comédie Française, Paris, to the head alone. Replicas of the busts came to preside over metropolitan *salon* and dusty provincial meeting-room throughout the Western World. The type of the New York bust, dispensing with wig and accessories, offered the most direct access of all, perhaps, to the most mordantly incisive mind of the age. Count Stroganov (Fig. 47) once owned this example.

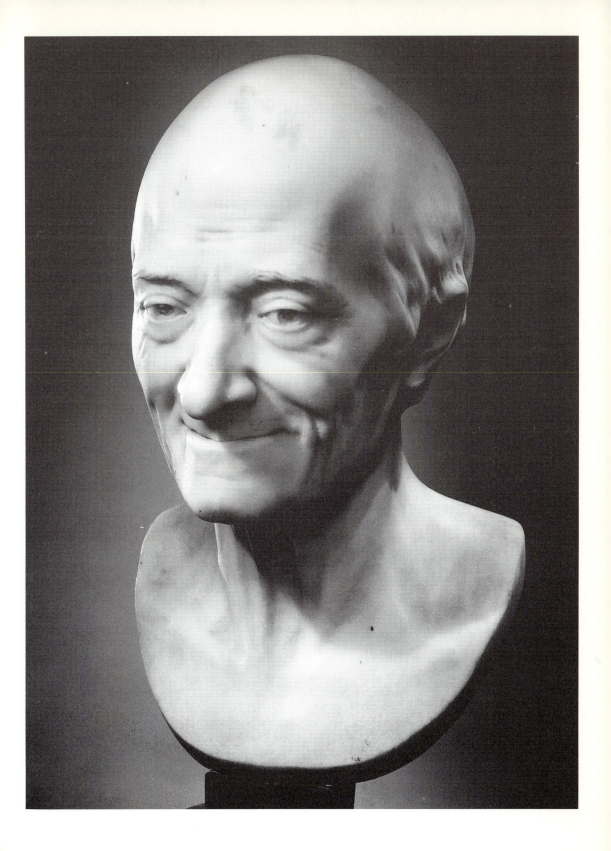

the years of the upheavals in France, consisted largely of members who were both individuals, theoretically concerned for individual freedoms, and public officials, fearful of what might happen if such freedoms were publicly opened up. Such fears led to the conclusion that freedom of the press was appropriate for items of scholarship but not for expressions of opinion that were written for the general public.[11] It was an aspect of an old Enlightenment dilemma: was the desired goal of wider education for all really desirable? To Voltaire there were always, within a nation, people 'inaccessible to the progress of reason and over whom fanaticism maintains its atrocious hold'.[12] Many *philosophes* concluded that while the bourgeois should be educated to think for themselves, the lower orders should be discouraged. There was nothing new, therefore, about the fears of the Berlin Wednesday Society that the public might come to know more than was good for them, and little that was surprising in the Society's commendation of a press that observed the coded decencies of scholarly debate, which only an educated elite would understand. In a country where scholarly criticism would be a special interest, clubs and societies with cultural leanings would in any case multiply. Guidance might largely be under officials and clergy, but (as we shall see later, pp. 57, 59) an energetic press was to be promoted by free agents in the area for which German culture was to show itself most spectacularly unrestrained by officialdom: music. Musical clubs proliferated; and here was a potential for communication which no boundary walls could hold in.

Professional interests were successfully linked with the sense of lay discovery by the learned scientific and literary societies of industrial Britain. The Birmingham Lunar Society, founded about 1775, was prominent here,[13] as were societies at Derby (1784), Manchester (1781) and Newcastle (1784) – all close to the early scenes of the Industrial Revolution. At the meetings of these groups – once a month at the Lunar Society in order to make use of the full moon to light the way home – matters of local interest were discussed. But so also were those of universal import: scientific discovery and its technological application. Some members' interests directly embraced the arts and the imagination. Matthew Boulton (1728–1809) included silverware among the productions of his factory at Soho, Birmingham, but also made toys in immense variety for his customers' children. Josiah Wedgwood (1730–95) revolutionized taste in ceramics from his factory opened in 1769 in Derbyshire. We shall meet Wedgwood later (p. 171, also p. 91).

Figure 12: Joseph Wright of Derby (1734–97). *A Philosopher giving that Lecture on the Orrery, in which a Lamp is put in place of the Sun*. Oil, 147.3 × 203.2 cm. Society of Artists, 1766. Derby Art Gallery.

A group of carefully-individualized adults and children, of both sexes and different ages, and seen in close-up, watches a demonstration of the orrery, a model of the solar system. The planets rotate by clockwork round the sun, represented by a lamp (concealed by the foreground boy). One man notes the facts of the Newtonian universe; the other adults appear to ask where such stupendous order leaves the ordinary human observer. Children are imaginatively involved (see Ch. VI, p. 252).

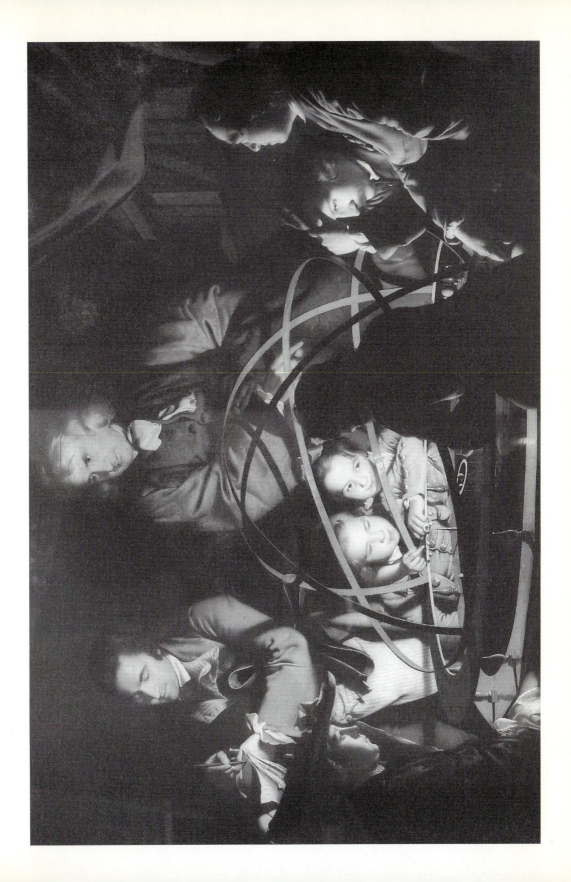

There were close links in the Lunar Society with education and particularly with famous Dissenting Academies (such as that at Warrington, Lancashire, running from about 1697 to 1786 and including in its curriculum science, French, commercial subjects and drawing) and with the Scottish universities. There were contacts with intellectual developments in Europe, notably through the membership which Lunar Society figures enjoyed of academies at St Petersburg, Rotterdam, Paris and elsewhere. Where the continental academies tended to be official, the Birmingham Lunar Society was privately run and relatively informal. At the gatherings of lay people which also took place, the imaginative dimension of scientific discovery could be as clearly brought out as the intellectual. Joseph Wright of Derby (1734–97) caught at this realization in his picture *A Philosopher giving that Lecture on the Orrery* (1766, Fig. 12). Contemporaries here found themselves confronted by a puzzling work that was neither fashionable enough to qualify as a society 'conversation piece', nor trivial enough to fit into the conventional category of everyday subjects (genre). All present in the picture are engrossed by what they are seeing, a working model of the planets in their orbits. Exposure of young and old to such a marvel, in the decade when Rousseau was propounding to parents and teachers his view of education as a mind-enhancing experience founded on curiosity stimulated in childhood (Chapter Six, p. 255), is clearly taken seriously by the Lunar Society. Wright is as alive to this as he is to the beauty of the model.

Shortly before this, Diderot was becoming fascinated with a model of a stocking-machine, which he kept in his study: he drew a parallel between its motions and those of logic (Fig. 13). His growing preoccupation with what he called the 'mechanical arts' found its ideal platform in various articles in the *Encyclopédie*, the great work of reference that he edited with the mathematician D'Alembert from 1751, and from 1759 alone. Renaissance theory had placed painting and sculpture as polite and learned 'high arts' on a summit of their own, playing down their manual side. But Diderot's concern was with the arts as a family of crafts: 'The general purpose of any art,' he wrote, '. . . is to impress specific forms onto the basic element provided by nature'.[14] Amassing first-hand information from craftsmen and artisans on specific materials and processes of all kinds from glass-blowing to papermaking, he aimed in the *Encyclopédie* to create a wider forum for art by defining it to include all shaping activities which involved reason. Glass-blowing and papermaking, on this definition, were as deserving of serious attention as painting and sculpture: and here, side by side, they all appear.

To reflect on these aims, launched under a social system which dictated that people of breeding and fashion should know nothing of technical terms, but use 'polite' and approximate language to talk of art, is to recognize how far Diderot departed from the assumptions of his age. Here, offered to a readership that included middle-class subscribers as well as the old elite (see p. 49), and backed up by the *Encyclopédie's* superb engravings, lay one of the more far-reaching invitations to new thought in the whole astonishing work.

Plate I: Jean-Antoine Watteau. The Party of Four. *See note p. xv.*

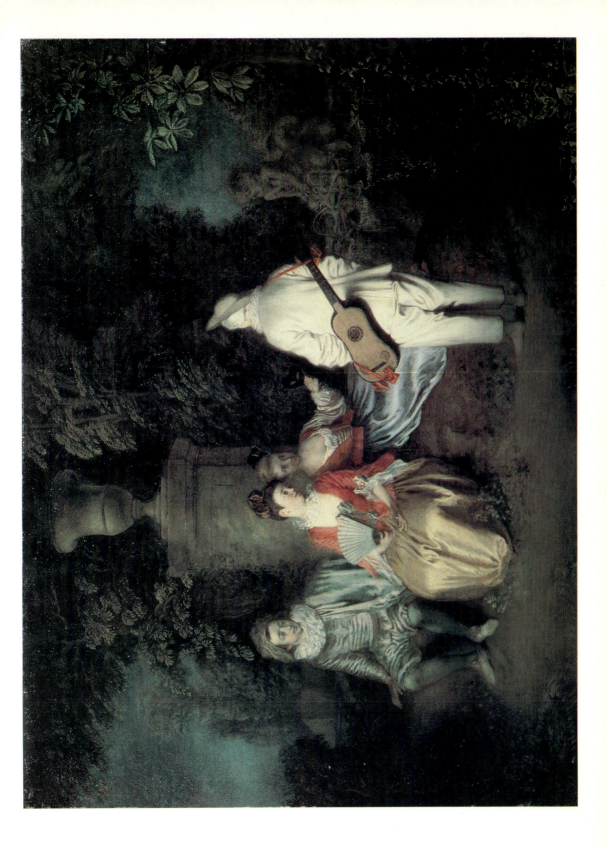

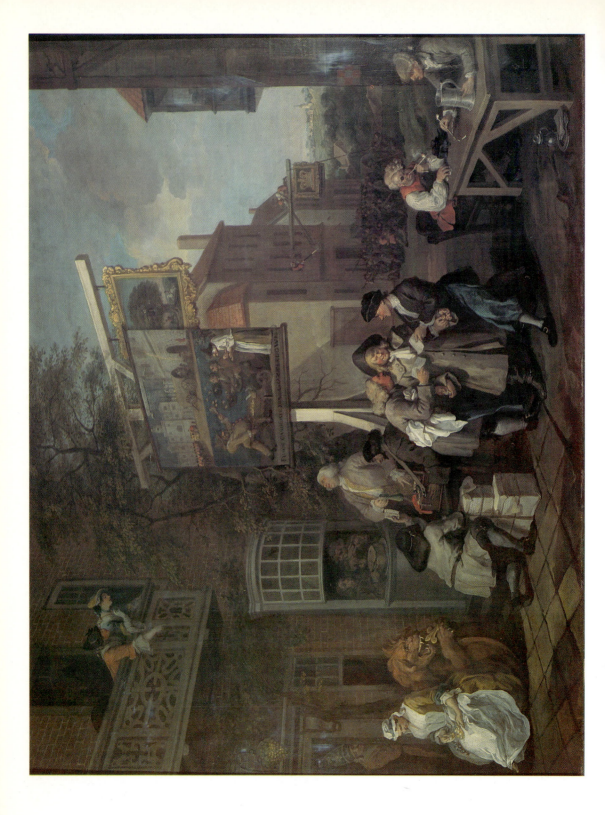

Figure 13: The Stocking Machine, from the *Encyclopédie* of Diderot and D'Alembert (vol. I, article *Bas*, 1751, ed. 1763). Engraving, total spread 27.5 × 40.6 cm. British Library (65g7).

After two hundred years of use, stockings became highly fashionable in the eighteenth century: but it took a Diderot to call attention to the 'intelligence, discernment and consistency' of the process of making them. In many ways this machine, no less than the orrery, epitomized the century's response to rational order. Diderot refers in his article to the stocking machine (which he had taken apart and reassembled) as 'one single and prolonged act of reason'. Building on a general interest in machines which he had expounded in his article on ART, he now examines the workings of one particular machine to produce its end-result, which he calls the 'logical conclusion'.

The method of using illustration to show successive stages in this rational process leads to one of the strangest and most compelling of the *Encyclopédie*'s many beautiful engravings.

Plate II: *William Hogarth*. The Humours of an Election, *Scene 2*, Canvassing for Votes. *See note p. xv.*

Another pointer to the future was the public museum. The age of the private collectors' cabinets or of institutionalized versions of them had now been succeeded by one which entertained broader Enlightenment hopes of public accessibility. Antiquity was served by the Museo Capitolino in Rome, opened in 1734, and after 1750 two popes financed the Museo Pio-Clementino there. Following Pope's *Essay on Man* (1733–34), which recommended the 'well-mix'd [nation] state', there also came secular initiatives. Whatever nationalistic aspiration underlay it, the British Museum's opening in 1759 at once signalled the ethnographical richness of man's past and the intention of placing it in front of the living for their 'advancement and improvement', albeit hedged around by restricted hours of opening and the need for tickets. In Philadelphia, America's largest city – with a population of about 44,000 – C.W. Peale opened his museum of paintings (mainly portraits of patriots and scientists) and natural curiosities (the two ingredients were often combined) in 1786. The idea of the public museum was to go forward as one of the leading motivations of the nation-states of Europe and of America in the next hundred years. The Louvre became the first national art gallery in 1793. In Berlin the great German architect Schinkel designed a vast Neo-classical museum (1825–30) as a symbol of deliverance after the Napoleonic Wars, on the most important site in the town opposite one of the power-bases of the Old World, the Schloss (Fig. 14). The British Museum was enlarged in 1824–27 (again in Neo-classical style) to house George IV's recent bequest from the Royal Library to the nation. In Jefferson's Virginia, a museum of painting, sculpture and natural history opened at Richmond in 1817. The major American developments came after 1850: but Washington's Smithsonian Institution for 'the increase and diffusion of knowledge among men' was inaugurated in 1846.

The question which Diderot had, in effect, put to readers of the *Encyclopédie* – what did the term 'art' really cover? – would recur again and again in the changed conditions of the next century. The relating of the designing arts to the onset of industry on the one hand, and the opening up of the perspectives of man's creative past in museums on the other, were to provide the nineteenth century with some of its most intractable problems. How were traditional crafts to relate to the machine? How did 'beauty' – an ideal which many artists of the Romantic age appropriated for 'high art' – relate to 'utility'? What was the role of the artist to be? The Society for the Encouragement of Arts, Manufactures and Commerce, founded in 1754 in London, had opened up a valuable route through the problems to be posed by factory production. But the deepening effects of the Industrial Revolution were to be obvious and, as we shall see in Chapter Six, it was in Schinkel's Prussia and in industrial Britain that these questions would in particular be asked.

The Periodical and the Book

Whatever reservations have to be made about the extent of the reading public in the years 1700–1850, the multiplication of newspapers and periodicals,

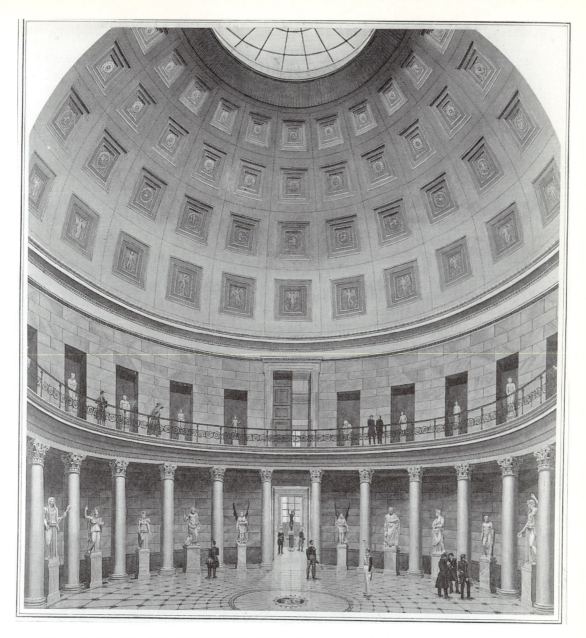

Figure 14: Karl Friedrich Schinkel (1781–1840). The Rotunda of the Altes Museum, Berlin. 1830. Watercolour and body colour, 45.7 × 42.1 cm., by Carl Emanuel Conrad (1810–73). Stiftung Preussiche Schlösser und Gärten, Berlin-Brandenburg Bildarchiv (Aquarell Sammlung No. 3837a).

As so often before, wherever Europe had looked towards classical Rome and the Italian Renaissance, a circular room has been placed at the heart of a major building. Schinkel uses as model the great Pantheon of Rome, with its coffered dome and central opening (here glazed). But in Berlin after the Napoleonic Wars this Pantheon, filled with antique sculptures, carries the old values into a building with a new purpose, a national museum. The classical ideal is again new. Founded and built at the wish of King Friedrich Wilhelm III to house the royal collections, the Altes Museum protects the people's heritage. 'The sight of a beautiful and sublime room', Schinkel wrote, 'must make the visitor receptive'.

together with the increase in the book trade, makes the spread of the printed word by any reckoning one of the period's crucial advances. Reading aloud to an audience, as De Troy suggests (Fig. 4), remained popular. A living cultural continuity was also provided by oral tradition, notably in Germany and Scotland; this, indeed, would become central for the Romantics (pp. 192, 218). But German short stories (Novellen, often folk-based) found a ready market in popular journals after 1800. And there is a link to be noticed, as Watt pointed out in his discussion of the English novel, between the rise of eighteenth-century journalism – a medium of topical communication then wholly reliant on words that made their appearance in *print* – and that of the novel in its modern form of a story based on contemporary life.[15] It is, moreover, noticeable that as periodicals developed their contacts with the literate public at large, nearly all the major creative writers of fiction in the period, from Defoe and Richardson to Dickens and Balzac, took advantage of the opportunity they offered.

PRESS RESTRICTIONS AND FREEDOMS

In England, as we have seen, the existence of a free press since 1695 had created a precious advantage over conditions in much of Europe, where absolutist regimes required newspapers and journals to accept official supervision under licence. The highly-thought-of *Mercure de France* (1724, circulating in 26 French towns in 1748 and 55 by 1774) became the often ultra-conservative organ of official opinion at the hub of information, Paris. The Paris daily, the *Journal de Paris ou la Poste du Soir* (1777) – which, like the *Mercure*, aimed to report artistic events and had Voltaire as one of its subscribers – found that the everyday pressures to find new items brought it into conflict with other publications which had licences to report them. In Germany, where political fragmentation in fact favoured the growth of local papers (often family-owned) in individual towns, severe controls applied: as they did in Frederick the Great's Prussia. Although the Habsburg Emperor Joseph II introduced a liberalizing policy in Austria, where the *Wiener Diarium* had flourished and became the *Wiener Zeitung* in 1780, free debate suffered reverses, as in other parts of Europe, after the outbreak of the French Revolution.

In England too there were restrictions, such as that which lasted until 1771 on reporting Parliament. And there were potential problems: the introduction of a daily newspaper, the *Courant*, in 1702, and of provincial counterparts, spelled the end of patronage of writers by political parties but also the rise of the Grub Street hack. Entrepreneurial publishers, usually booksellers, came to wield a power which amounted to monopoly. Writing was tested out by these men in the market-place, which was also to be the proving-ground of the 'professional' writers of quality as they emerged into being. Many of the better writers now worked for the more 'educational' periodicals: among the earliest and most influential of these was the thrice-weekly *Tatler* (1709–11), followed by the daily *Spectator* (1711–12, 1714), edited by Richard Steele (1672–1729) and Joseph Addison (1672–1719).

The *Spectator* initiated an age. Its two-page sheets (price one penny) used the essay form, 1400 or so words in length, to attract, in Addison's words, 'everyone that considers the world as a theatre, and desires to form a right judgment of those who are the actors on it'. Through the persona of 'Mr Spectator', Addison presented his own 'actors', like Sir Andrew Freeport the city merchant, and Sir Roger de Coverley the country squire who, with other regular 'characters', built up a relationship with the reader as fellow 'club-man'. This recipe for success was enhanced by correspondents' letters, real or invented, which increased still more the sense of rapport. Sir Andrew's purview, as *Spectator* 69 (19 May 1711) revealed, was world-wide. He 'calls the vine-yards of France our gardens; the Spice-islands our hot-beds; the Persians our silk-weavers; and the Chinese our potters'. Sir Roger, when not in town, pre-sides with an iron hand over his estate; and in church 'sometimes stands up, when everybody else is upon their knees, to count the congregation, or see if any of his tenants are missing'. Matters social, political, domestic, philo-sophical, all featured in the periodical essay, upheld by writers of the quality of Fielding, Defoe (himself a journalist), Swift and, after the middle of the century, Samuel Johnson, in his twice-weekly *Rambler* (1750–52) and *Idler* (1758–60). A model in Britain for the burgeoning profession of journalism, the essay persisted as a popular form, as in Hazlitt's celebrated contributions to *The Examiner* (1814 onwards) and Lamb's 'Essays of Elia' in the *London Magazine* (c. 1820).

The repercussions of Mr Spectator were widely felt, in France, where Marivaux produced his *Spectateur français* (1721–24), and notably in Holland, Germany, Russia and America. The German writer and critic J.C. Gottsched (1700–66) studied Addison, and his wife Luise Kulmus translated the *Spectator* (9 volumes, 1739–43). In Russia a liberal initiative by Catherine the Great (reigned 1762–96) led to the training of young writers to produce a weekly miscellany, *All Sorts* (1769), with a 'Mr Spectator' persona figure. This pro-voked the bookseller Novikov's *Spectator*-like *The Drone* (1769), which sur-vived financially for two years. Satirical magazines, together with a few original novels (from 1763), were to give a precarious strength to Russian literary life.[16]

While British periodicals introduced a yeasty freedom into censor-repressed circles in Europe, American counterparts developed under their own special conditions, although the *Spectator* was not forgotten. It is easy to see how a colonial society of tradesmen, craftsmen and professionals establishing them-selves in a new continent found an invaluable focus in newspapers. Licensing ended soon after England had abandoned it, despite misgivings in the mother country. If the English periodical was unthinkable without Steele and Addison, that of America was equally so without Benjamin Franklin (1706–90), printer, publicist, inventor of the lightning conductor and bifocal spectacles, and uto-pian visionary. Having worked with his brother on the *New England Courant*, from 1729 he ran the *Pennsylvania Gazette* from Philadelphia, capitalizing on the attractions of the *Spectator*-type essay. He also took up the almanac, a form of publication concerned mainly with practical matters of medicine, science or agriculture but including some popular moral maxims. Franklin's *Poor*

Richard's Almanac, published annually from 1733 for a quarter of a century, found its way to the remotest frontier settlements of America. But the newspaper remained his central vehicle: almost everything he wrote, apart from scientific papers, appeared there or in magazines.

Besides showing how cheap, printed literature could publicize Enlightenment notions, Franklin's work gave further evidence of the link between printing and the growing profession of journalism, on the one hand, and writing of more than ephemeral interest, on the other. (Two of the century's novelists, Samuel Richardson and Rétif de la Bretonne, were working printers.) Franklin's printing career also testified to a principle which the Enlightenment strove to establish, that of impartiality in debate. In his 'Apology for Printers' (1731), he wrote: 'Printers are educated in the Belief, that when Men differ in Opinion, both Sides ought equally to have the advantage of being heard by the Publick.' Franklin's close links with London newspapers had begun in 1724–26 and were extended on his later visit in 1757. Though writers for the press were often dubious hacks, political debate of an open forum type had now become established. Franklin's America would develop its uses: and the influence of the French Revolution would intensify vitriolic political division amongst the newspapers of Philadelphia and elsewhere.

Together with the Addisonian essay and the Franklinian ideal of impartial debate, 'occasional' publications, notably pamphlets, could offer inspired partisanship of causes. Jonathan Swift (1667–1745) was almost in a class of his own in this field, with his works on Ireland, Church matters, and 'A Modest Proposal for preventing the Children of Poor People in Ireland from being a Burden to their Parents or Country' (1729), which ironically applied the methods of current economic argument to maintain that the best way of dealing with surplus children was to eat them. Voltaire too found the pamphlet form congenial; it enabled him to concentrate his critical body-blows against a clearly-defined target. His *Lettres Philosophiques* (1733, 1734), on England, were burned by officialdom in France. Of his later pamphlets written from his retreat at Ferney, his *Avis au Public* (1766) repudiated the execution of a Protestant merchant Calas for the alleged murder of his son, and made its effect as a civilized, 'reasonable' address to the reader on the vexed question of religious persecution.

THE WIDENING READING PUBLIC

While the habit of reading will certainly have been helped by the topicality of periodicals (particularly as many were available in coffee-houses), reviews and advertisements in them also encouraged the sale of books. In Britain certain books also came out in 'number' form weekly, fortnightly or monthly, and subscribers could have them delivered to them, with newspapers, by newsmen distributors. Defoe's *Robinson Crusoe* (1719) and other novels, and Johnson's *Dictionary* (after the first edition of 1755) and many works of non-fiction, were published in this way. The *Grub Street Journal* remarked in 1732: 'this Method of Weekly Publication allures Multitudes to peruse Books into which

they would otherwise never have looked'.[17] The brief articles and notes in the famous *Gentleman's Magazine* (1731–1914), and similar periodicals, had a similar effect. Demand was evidently strong enough to justify the publication by some newspaper proprietors of compilations of articles called 'miscellanies', a practice which endured through the next century. The instalment idea for books especially favoured the novel as serial story: Dickens's *Pickwick Papers* (1836–37) was the most widely snapped up of a dozen of his novels to appear in green monthly parts over periods of up to eighteen months or two years. He often modified his plots in response to readers' letters as the parts came out. Thackeray's *Vanity Fair* (1847–48), appearing in yellow parts, was a famous rival. In North America, testing out its own brand of purified European culture (pp. 128–9), the Old Continent's sitter-with-book portrait formula took on a new vitality in works by the Boston painter Copley and others (Fig. 15).

As entrepreneurial publishing in the eighteenth century grew, no effort was spared to make it more widely available. The records of French publishing and of the Frankfurt and Leipzig book fairs reveal that by the 1780s scientific and literary subjects had taken precedence over religious ones, at any rate in quantity. Even in Russia the Church's surveillance over the written word was in decline before 1700, as is shown by the number of imported chapbooks that purveyed anti-clerical romances and satires. The novel's move to represent the variety of human experience and motive, and its ready marketability, were clear indicators to publishers as to where their best prospects lay. But the spectrum was a wide one, including popularizations of Christian precepts on obedience, collections of folktales, the French *Bibliothèque bleue*, German stories of village life, books on magic, and 'underground' literature – including seditious tracts and pornography – which were peddled round the towns and countryside of Europe.[18]

Other publishing efforts, inherited from the seventeenth century but now to be transformed in scope, were directed towards producing the encyclopedias. Pierre Bayle's *Dictionnaire historique et critique* (16 volumes, Rotterdam, 1697), became 'the bible of the eighteenth century'. Ephraim Chambers's *Cyclopaedia* (1728) laid foundations on which the crowning event, Diderot and D'Alembert's *Encyclopédie; ou Dictionnaire raisonné des sciences, des arts et des métiers* (28 folio volumes, Paris, 1751–72) was to rest. The first encyclopedia to solicit contributions from specialist writers, this immense work survived the hazards of censorship not only to become available to the rich, but to reach the professional middle classes in quarto and octavo editions.[19] The entrepreneurial Lille bookseller, C.J. Panckoucke, who settled in Paris from 1762 and was involved with the *Encyclopédie*, also began to publish what became a multi-volume *Encyclopédie méthodique*. Other mid-century dictionary encyclopedias issued from Leipzig and Venice. In 1760 the *Encyclopaedia Britannica* began to emerge from an Edinburgh printer's in sixpenny parts. With its appearance in three volumes in 1771 the biggest yet account in English of the world which surrounded Adam Smith's 'Economic Man' (p. 257) was there for him to refer to. A second edition ran to ten volumes (1777–84) and a third (1788–97) to eighteen.

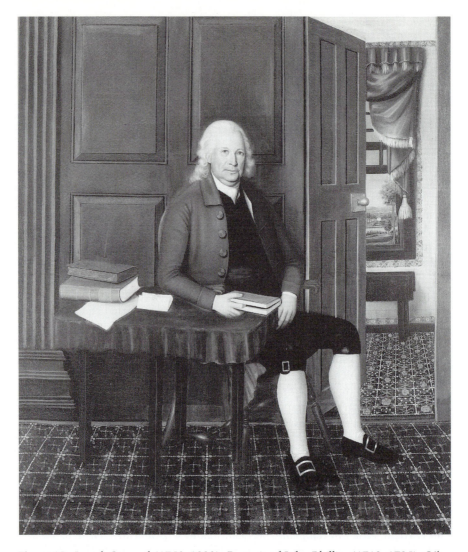

Figure 15: Joseph Steward (1753–1822). *Portrait of John Phillips* (1719–1795). Oil, 201.3 × 174 cm. About 1793. Commissioned by the Trustees of Dartmouth College, Hanover, New Hampshire.

The portrait radiates the self-reliance that characterized the businessman in newly independent America. John Phillips of New Hampshire was a Harvard graduate and founder of the Phillips Exeter Academy in 1781. His head is at the apex of a triangle that includes a book-strewn table. The man of action, suggested by the open door and the view out of the window, is balanced by the man of contemplation, indicated by the finger keeping his place in the book. The perspective of painted canvas floor-cloth squares, leading into the picture, adds to his air of self-possession.

The scope and number of books calculated both to entertain and to inform were therefore considerable. It is estimated (see R. Birn, Further Reading, p. 272) that there were about 1,500 main booksellers in Europe in the later part of the century, not counting those who were primarily local printers. Most of them operated in capital cities or other large towns, an inconvenient fact for country dwellers. Prices could be formidable: at least ten shillings in Britain, up to 1780, for quartos and folios – often the weekly wage of a London journeyman or craftworker – with five shillings for octavos. In France, the equivalent of fifteen shillings could buy a controversial work by Rousseau; but prices could easily quadruple if, as happened with *Emile* and the *Social Contract*, the Government banned it. The young Hazlitt obtained English authors whose work had run out of copyright in sixpenny weekly numbers, allowed under an Act of 1774. Also in 1774, an energetic converted Methodist, James Lackington, opened in London's Fitzroy Square a 'Temple of the Muses', which offered books at half price or even less. The enquiring browser was meanwhile finding bargains at second-hand stalls in St Paul's Churchyard or on the Paris quais. By the time that *The Pickwick Papers* came out in parts in the 1830s the price was a shilling per part.

Circulating libraries had meanwhile come into their own. Private collectors' libraries had long been made open to approved members of the public, at least since Mazarin's initiatives in mid seventeenth-century France; and this practice continued (notably in Germany). But in 1725 in Edinburgh, Allan Ramsay (1686–1758), anthologist and poet, began to lend books for a fee from his shop. London's first library opened in the early 1740s. In France there were *cabinets de lecture*: the novelist Marmontel describes how in the 1730s he and fellow schoolboys borrowed books from a circulating library at Clermont Ferrand. While libraries were sometimes attached to more or less exclusive literary and philosophical societies, others were the outcome of voluntary associations, who provided what Arthur Young terms a book-club. He describes a visit at Nantes, one of France's most thriving commercial towns, to such an institution which offered heated and well-lit rooms for reading and conversation.[20] Similarly, the German states ran what were called *Lesegesellschaften*, 'reading societies'. All such schemes required social standing and ability to pay: for others there were shops which allowed books on hire. The contemporary writer and editor of Rousseau's works, Louis-Sébastien Mercier, indicates that in Paris the rent for the best-selling novel *La Nouvelle Héloïse*, supplies of which ran short, was twelve sous for sixty minutes per volume (there were six).

One of the staples of the circulating library, the novel that conveyed adventure, mystery, romance, and above all emotional involvement in the crises suffered by the main character, was calculated to attract anyone who could read. Following the international success of Richardson's formidably-detailed and morally-earnest *Pamela* (1740), *Clarissa Harlowe* (1747–48) and *Sir Charles Grandison* (1753–54), Europe wept over Rousseau's *La Nouvelle Héloïse* (1761) and Goethe's *Sorrows of Werther* (1774). (All of these are discussed further in Chapter Two.) A flood of sentimental fiction by hack writers then

broke loose. Sheridan, in *The Rivals* (1775, Act I, Scene ii), made his character Lydia Languish comb the libraries of Bath for such titles as *The Reward of Constancy* and *The Mistakes of the Heart*. In 1764 Horace Walpole, remodeller in a medievalizing mode of his villa, Strawberry Hill, produced the first of the 'Gothic' novels, *The Castle of Otranto*, destined to have a copious progeny on the Continent (notably Germany) as well as in Britain. In the 1790s, with the appearance of the culminating works of the genre, by Mrs Ann Radcliffe, the vogue for themes involving the incarceration of vulnerable heroines behind castle walls was confirmed. By 1790 William Lane's Minerva Library in London (founded in 1770) was offering, among its 1000 volumes for loan, a high proportion of 'Gothic' novels of romance and adventure, mainly to well-heeled subscribers. 'Blue books' and 'sixpenny shockers', replete with crudely-coloured woodcuts, emerged to attract those less well provided for down the social scale. But in the dangerous days of the French Revolution heady illustrated stories which emphasised the flouting of parental will and received notions of moral order would provoke anxious official scrutiny, and re-open questions about what it was appropriate for the ordinary man and woman to know.

In the age just before photography, the influence of reproductive prints and book illustration over what ordinary people knew of the world outside their own experience could, of course, be paramount. The ongoing potency in cheap literature of the medieval woodcut technique reminds us of a kind of continuity that had its nearest counterpart in oral tradition itself. But new mass-market techniques, wood-engraving (from about 1780, Fig. 7), lithography (from 1800, Fig. 58) and steel-facing of copper plates (from the 1820s) would more than answer the needs of mushrooming journalism. Britain's *Punch* (1841) or the *Illustrated London News* (1842) depended on them. Robert Seymour's *Humorous Sketches* of sporting life (1833–36), which sparked Dickens's *Pickwick Papers*, were first issued as threepenny lithographs.

Besides modern techniques of illustration, the post-Waterloo world benefited from the steam-press, first used for printing *The Times* in 1814, and destined to supersede hand labour in book-printing by the eighteen forties. Book-publishers had to adapt to ever-greater demand, especially for fiction, and make conditions to meet it. Scott's fame was crucial: his *Waverley* (1814) required eight editions (11,500 copies) in seven years; *Kenilworth* (1821), selling at a guinea and a half, set the economic price for a three-decker novel for decades to come. *Guy Mannering* appeared in French in 1816, the first of a series of translations which produced its own Scott-mania. In Britain John Murray's Family Library (1829) of biography and travel, and Henry Brougham's initiatives on behalf of Useful Knowledge (Chapter Six, p. 256) topped growing markets for non-fiction. There were areas of worry. When, from 1823, the Mechanics' Institutes opened libraries of books on science and technology, which were perceived to be of practical benefit to workmen, the craze for 'Gothic' thrills was long past its peak: but fiction that was thought to be unsettling was excluded. Admission continued to be warily granted through subscription; free public libraries were only to be established after 1850.

Audiences and Critics

It is no surprise that as the Enlightenment sought to analyse, compare and reach conclusions from which society – the audience at large – might benefit, more was to be required of the critic of the arts as cultural mediator. Journalism was to provide opportunities here not only for scribblers, but also for critics of the calibre of Diderot and Hazlitt. In particular the newer kinds of aesthetic experience – the public concert and the exhibition – were to create a need for personal critical comment, which the rise of topical journalism was ideally suited to meet.

THE THEATRE

One of the oldest forms of community art – the drama – also felt this need. But here audience attitudes tended to be fixed by habit and expectation. The French classical stage cast its long influence on 'serious' drama, notably in Germany, where Gottsched (1700–66) pressed its claims in critical journals (1725–29), and where Lessing (1729–81) was to oppose it in the search for a living German experience. Lessing's reforming magazine *Hamburgische Dramaturgie* (1767) had to argue a largely theoretical case. The history of play-acting in Britain reveals how audience predilections might be fed by vulgarized versions of Shakespeare's language, or contrived 'happy' endings to the tragedies (*Lear*'s tragic ending was only to be restored in 1824). Against such conventions, the progress of a broad-based independent theatre criticism was to require both objectivity and vision. Charles Gray, the historian of London theatre criticism in the period to 1795, found that newspapers and magazines only began to make regular space for reviews of specific theatre performances after the middle of the century; Thomas and Hare's researches have confirmed that there was then 'independent comment, which develops into the first true dramatic and theatrical criticism'.[21] Intense factors were now at work: notably, in the age of sensibility, the enhanced interest in picturing complex human relationships and, in the heyday of internationally famous actors, the quality of acting which invited audiences to see characters like Shakespeare's Shylock and Richard III in new ways. However much powerful actors and actresses – as Lessing found at Hamburg – might resent criticism, such factors helped to account for the sense of theatre in these years as the unmissable social art *par excellence*, and therefore for the appearance of a species of theatre critic, concerned with a particular performance as 'occasion', as distinct from the dramatic critic, concerned with a play as literature.

'The Business of the *Theatre* will also come under my Eye; and as the Inhabitants thereof are manifestly the Servants of the Public (while they are paid for it) without Scruple, whenever they deserve it, they shall have my Lash.' So wrote one 'Oxymel Busby' in the first number of a periodical *The Scourge*, 28 November 1752: but in practice his 'criticism' turned out to be little beyond

giving the summary of a plot and anodyne examination as to whether it had been 'moral' or not. His words, and those of countless commentators like him, were directed at audiences which since the very invention of theatre had been used to applying lashes of sorts themselves. The fashion-conscious members of them were likely to be too concerned with being seen to bother; but in the Comédie Française at Paris, and in other theatres, a vociferous public stood in the less expensive part of the house known as the *parterre*, in front of the stage. From here, every moment on the stage was followed, and repeats could be demanded or the action halted. In the London theatre such interventions came most frequently from the 'gods'. Goldsmith's Chinese 'Citizen of the World' (1762, letter XXI) remarks that 'those who were undermost all the day, now enjoyed a temporary eminence, and became masters of the ceremonies . . . indulging every noisy freedom'. Indeed, the contacts made between 'artist' and 'consumer' in the theatre of these years were as raw as they had ever been: the *Public Advertiser* for 13 November 1776 carried a notice from the Drury Lane Theatre management offering twenty guineas to anyone helping to convict for offences against the actors.

It is easy to point to factors that constrained the theatre in this period. In Catholic countries censorship was tight, and Protestant states did not escape. England's Licensing Act of 1737, directed against political satire in the theatre, was to last for a hundred years. Despite constraints, however, the eighteenth-century stage afforded both innovation and experiment. The plays of the Dane Ludwig Holberg (1684–1754), about his own society, were to point the way to other national forms of drama. The formalities of the French classical stage, though still sometimes observed in new writing, were to carry less weight with middle-class audiences who wished to see characters from their own contemporary world being rewarded or punished for choices made pragmatically rather than out of respect for the gods. Sentimental bourgeois comedies using everyday speech flourished; Goldoni (p. 76) put new life into the old Italian *commedia* tradition; R.B. Sheridan (p. 52) at Drury Lane did the same for satire in his *The Rivals* (1775) and *The School for Scandal* (1777). The German national theatre that was being built up from the 1760s registered, in the plays of Lessing, Goethe and Schiller (pp. 184–5), all the subtle motions and nuances of what was to captivate audiences of the time, notably moral dilemma and pathos in northern latitudes – those of Hamlet and Macbeth, in fact, for Shakespeare was the rising star.[22] Classical verse tragedy, meanwhile, was beached on a barren southern shore. Voltaire could draw audiences of 30,000 to watch his *tragédies* in Paris; but Beaumarchais attracted 100,000 to an exceptional run of over 73 performances there of his comedy *Le Mariage de Figaro* in 1784. The French theatre, associated with opera (p. 11), was also famed for spectacle: Arthur Young, in Paris in 1787, preferred the theatre he saw there to his own: 'writers, actors, buildings, scenes, decorations, music, dancing, take the whole in a mass, and it is unrivalled by London'.[23]

The French theatre enjoyed international esteem for its vitality, but Britain was acknowledged by witnesses to have the liveliest acting. After 45 years'

stage experience the Italian actor Riccoboni had said as much in 1741.[24] In the same year David Garrick (1717–79) made his London debut in Shakespeare's *Richard III*. Joint manager at Drury Lane from 1747 to 1775, he was nicknamed 'Shakespeare's priest'. Garrick's naturalism (a contemporary speaks of his 'mobile features and flashing expressive eyes') broke with all modern precedent (Fig. 16). On his third visit to Paris in 1765 he performed scenes from *Macbeth* and *Lear*, which profoundly moved all present, including Diderot and F.M. Grimm, editor of the cultural periodical *Correspondance Littéraire*. After the Olympian years dominated by Sarah Siddons (1755–1831) and her statuesque brother John Philip Kemble, another 'mobile' actor was to appear, Edmund Kean (1789–1833), also a famous Shakespearean, whose Shylock deeply impressed Heine in London, and who was as successful in America as in Europe. In 1827, a year after the death of the great French tragic actor François-Joseph Talma (1763–1826), the English company of Charles Kemble presented Shakespeare in Paris to high acclaim (p. 235).

No conjunction of planets could have been more creative than the coincidence of Edmund Kean's acting career and the theatre criticism of William Hazlitt (1778–1830). The virtuosoship of Kean was such that he could act Othello and Iago on successive evenings (in 1814). Although Hazlitt was to follow Johnson and Lamb in developing a theory that Shakespeare's plays made imaginative demands that only reading could satisfy, he himself owned that he could not read the parts Kean had played without thinking of him.[25] Hazlitt wrote his theatre reviews from 1814 at a high tide of dramatic criticism in Britain, which included the work of Lamb and Leigh Hunt.

Theatre in Europe inevitably took time to recover from the Napoleonic occupation. Napoleon's censorship of new writing (not only in France but in the countries that he conquered) had opened the way to a stream of popular melodrama: although 'serious' theatre was maintained by Kleist (1777–1811) in Berlin and Grillparzer (1791–1872) in Vienna. In Paris the visit of the English Shakespeare company to the Odéon in 1827 proved a catalyst for the Romantic dramas of Alexandre Dumas (1802–70), which delighted audiences with their historical settings (*Henri III et sa Cour*, 1829). In the 1830s the *Journal des Débats* (1791) published some of its most lively *feuilletons* on the arts, and the theatre critic Jules Janin (1804–74) entered his most pungent period of making and breaking reputations.

The first night of the verse-drama *Hernani* by Victor Hugo (1802–85), on 25 February 1830, now secured a lasting place in theatre annals. Here, for the Théâtre Français, the battle-lines between classicists and Romantics were joined. The friends of the author's 'free verse' openly brawled with supporters of the classical unities. Charles Magnin of the *Globe* and most of the youth of Paris declared for Hugo. To the critic Sainte-Beuve (1804–69), who sat with the author, the whole affair seemed, however, like a Napoleonic campaign, leading to a victory, but one secured at some cost: 'I believe it is useless to hope for art to be worshipped in public places: it is asking for trouble', he wrote to Hugo.[26]

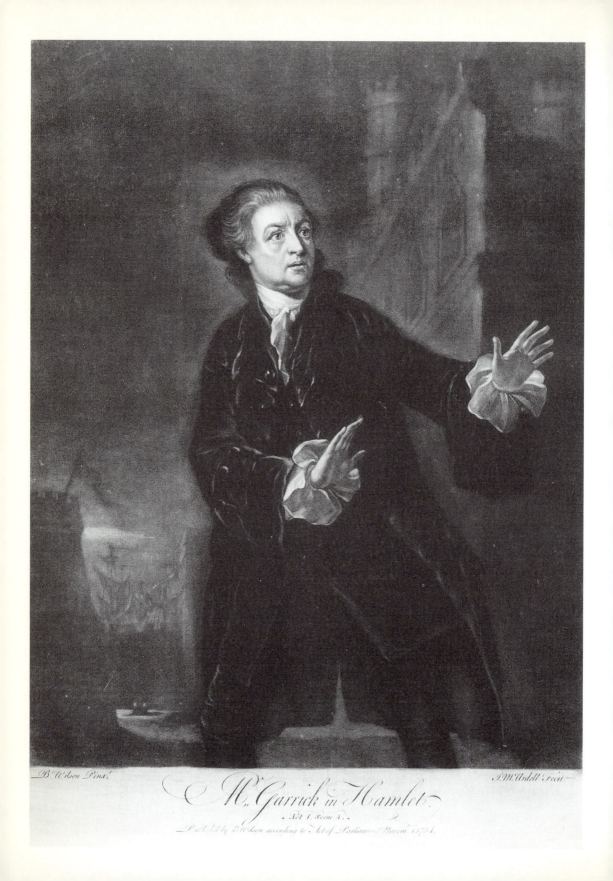

B. Wilson Pinx.ᵗ J. M. Ardell Fecit

Mr. Garrick in Hamlet.

Act I. Scene iv.

Publish'd by B. Wilson according to Act of Parliament Novemʳ. 13 1754.

MUSIC AND THE VISUAL ARTS

The rise to full public outspokenness of the music critic took place only in this same Romantic generation, with composer-writers such as Berlioz and Schumann. The eighteenth century had however laid essential foundations. 'Sensibility' had worked to particular effect on music's appeal. In Germany, where the first European music periodical had begun to appear in the 1720s, critical writing analysed music according to the qualities of feeling that it generated. Reflecting on the change from the Baroque of Corelli and Handel to the modern classicism, Burney ('Essay on Musical Criticism' prefaced to the third part (1789) of his *General History of Music*) considered how it affected *listeners*. As instrumental sounds became so various alongside the vocal tradition represented by opera, music acquired non-vocal performing stars: Burney told of Farinelli, the renowned male soprano, sharing the limelight in a duet with a trumpet-player. In his detailed account of the Handel Commemoration of 1784 in Westminster Abbey, he reported that 'every hearer seemed afraid of breathing'.

Above all, where music-making had been essentially private or for limited audiences of courtiers or nobles, it became public: musicians, amateur and professional, performed for people who had come to listen and to pay for listening. From 1725 the Concert Spirituel series in Paris offered a paying public sacred music on days of religious observance when theatres closed: and secular works were steadily introduced. Public concerts were organized by J.C. Bach and K.F. Abel in London from 1765; other promotions took place in Leipzig, Vienna and Berlin. The Holywell Room in Oxford, opened in 1748 and reputedly the first purpose-built hall for music, prefigured a tradition of intimate concert spaces. Larger halls were needed for orchestras: Leipzig's Gewandhaus opened in 1781 (Fig. 17). The illustrious Haydn was enticed in old age from Austria as far as London in 1791–92 and 1794–95 to attend benefit concerts in his honour. Paris became the centre of operations for hundreds of composers, performers and publishers: a high degree of technical facility was available in the Conservatoire National Supérieure de Musique (founded 1795, and much copied, e.g. at Brussels 1813, Vienna 1817, London: Royal Academy of Music 1822, Leipzig 1843). In Vienna the Gesellschaft der Musikfreunde was founded in 1812, and in the following year a Philharmonic Society was formed in London:

Figure 16: Garrick as Hamlet. Mezzotint by James McArdell (1728–65) after Benjamin Wilson (1721–88). 45 × 34.7 cm. 1754. British Museum.

Garrick played Hamlet ninety times between 1742–43 and 1776, his final season. For many this became a defining theatrical experience. Hannah More, at the last performance, pitied the posterity that would never see it. For G.C. Lichtenberg, the German professor from Göttingen, Garrick's scene with the Ghost and the speech 'Angels and ministers of grace defend us!' – spoken 'at the end of a breath' – was 'one of the greatest and most terrible which will ever be played on any stage'. Wilson's record, in McArdell's sensitive mezzotint, was popular enough for a line-engraved copy to be published in 1769.

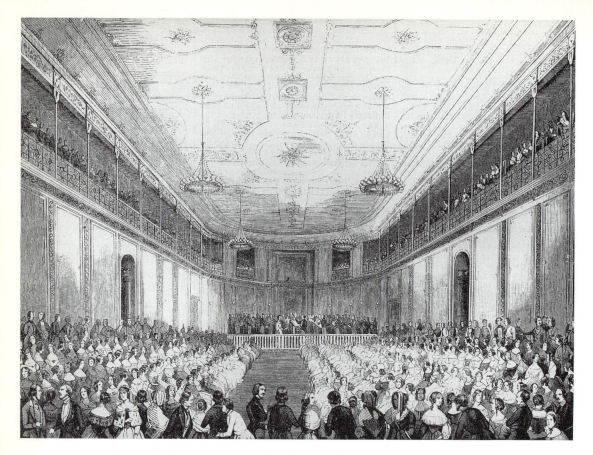

Figure 17: Concert-giving in the old Gewandhaus, Leipzig. Engraving. 1845. Bildarchiv Preussischer Kulturbesitz.

Leipzig, where J.S. Bach's musicians had performed in coffee-houses before 1750, built its Gewandhaus ('cloth hall'), for public concerts by its own orchestra, in 1781. Mendelssohn was to be conductor here from 1835 to 1846, presenting a wide repertoire which included Bach (*St Matthew Passion* in 1841), Schubert (first performance of the Great C major Symphony in 1839), the contemporary symphonies of Schumann, and Mendelssohn's own Violin Concerto in E minor (1844). He appears in this engraving with the singer Jenny Lind. Despite the odd seating arrangements (the women facing each other at right angles to the orchestra, men standing behind), the concerts offered an indispensable foundation on which tastes and critical opinion could be formed.

both put on orchestral concerts. Within three seasons the London Society was earning enough from box-office receipts to pay those members of what was to be Europe's first symphony orchestra.[27]

Two factors became crucial, both concerned with accommodating performances to the larger spaces in which they were now required to be heard. The first was the arrival of the modern piano, and virtuoso performers to play it. Harpsichord sonatas in Mozart's time were sometimes written with violin accompaniment: strings could easily overpower the early fortepiano sound. But

the piano's enhanced capacity for light and shade, compared with the even dynamic of the harpsichord (as noted above, p. 18), had given it an important edge, to be enhanced after 1800 by improvements to the Erard and Pleyel pianos and by the iron-braced Broadwood. Such resonant instruments in a large hall could persuade more and more concertgoers that a single piano might represent qualities which had hitherto been felt to be exclusive to the human voice. Concert tours by pianist-composers therefore flourished: among them Hummel, Thalberg, Chopin and Liszt (though with Chopin, the larger the hall, the more he hated it). Along with the piano, the violin also captured audiences, notably at the concerts of the legendary Paganini (Fig. 49).

Secondly, big, ground-breaking compositions like Beethoven's Third (Eroica) and Fifth Symphonies (1803 and 1808) presented problems of assembling the orchestral forces that were needed for them, and also – a matter that had earlier preoccupied Haydn – of achieving internal co-ordination and balance. The leadership provided by a keyboard player directing a performance according to the older Baroque tradition was inappropriate for such works and for their performance in large halls. The conductor now established himself. The composer Spohr claimed that he took up the baton to conduct at a Philharmonic Society rehearsal in London in 1820. The German opera companies were certainly using a conductor in the 1830s, and Mendelssohn was a famous practitioner. The emergence of such a figure was further evidence of the coming of age of the idea of the musician as interpretative artist, no longer looked on primarily as a paid servant, as he had been in the heyday of the old courts.

The post-Napoleonic world therefore inherited, with this transformed musical scene, a potentially vast musical public that wished to be informed about it. As the reporting of cultural matters of all kinds increased, the German writer Heine, living in Paris, became the first major critic to write on music for a non-musical paper, the *Augsburger Allgemeine Zeitung*: his articles were an influence on the young Wagner. In the *Correspondant* of 1829, Berlioz asserted that modern music had begun with Beethoven's Ninth, and defended the C sharp minor quartet. As outspoken music critic of the *Débats* from 1835, he revealed the web of subterfuges and deceptions which controlled reputations. But there were even more pressing matters to put right in an age when a concert promoter might mix together in one programme the movements of several Beethoven symphonies or an expert might 'correct' them. Berlioz, arguing publicly for the integrity of the work of art, was the man to take these matters up.

How transformed the public image of music had become was also shown in the number of specialist journals which began to operate, most of them run by music publishers. Longest-lasting among these was the *Allgemeine Musikalische Zeitung*, founded in 1798 by J.F. Rochlitz at Leipzig. The *Neue Zeitschrift für Musik*, begun as a platform for modern music by Schumann in 1834, was, in his hands, an impassioned rival. In all, 262 new music journals were begun in Europe between 1798 and 1840, the majority of them intended for the musical public at large, not just professionals.[28]

While critical comment on the visual arts was encouraged in mid eighteenth-century French and English periodicals by the setting-up of public exhibitions,

fully-rounded press criticism arrived only, as with music, after 1800. But visual art had the constraining arguments of a Neo-classical age to reckon with: while few expected the admittedly sensuous art of music to be 'improving', in visual matters there was likely to be a pronounced didactic reason for every swish of a critical scalpel. Already before 1750, a French writer who has been called the first modern art critic, La Font de Saint-Yenne, had suggested that it was only those 'firm and equitable men' of the public, unconnected with artists, who had in their mouths 'the language of truth'. He wanted a morally charged form of history painting to become a 'school of living', and claimed that he was voicing the public's own desire for reform. The idea of the critic as the lay public's mouthpiece or 'representative' (albeit often anonymous, and often opposed by artists themselves) was launched in France on this wave of moral feeling.[29] For Diderot, who reviewed the Paris Salon exhibitions from 1759 (though only for the titled foreign subscribers to F.M. Grimm's journal *Correspondance Littéraire*), the edifying message was vital, even if his habit of befriending such artists as Chardin, master of kitchen scenes and creamily highlighted still life, reflected his own lively curiosity about the expressive properties of paint as such. As attendances at the Salon became more mixed, a sense of objectives widening beyond the approbation of audiences already informed enough to appreciate the Academy's learned subjects persuaded it to include what the *Mercure de France* wrote of as 'a sort of accounting to the public'. David committed his *Oath of the Horatii* (Fig. 25), begun for the King, to working out his own language of truth: ardent, concentrated, devoid of all blandishments of brushstroke, it was hung in the Salon of 1785 (Fig. 18) to great acclaim.

In Britain the spread of lay art criticism was to be channelled through periodicals such as the *Gentleman's Magazine* (1731), the *Monthly Review* (1749), the *Critical Review* (1756) and the famous political review periodicals of the nineteenth century.[30] A forum was created for it with the beginning of regular exhibitions by the Society of Artists in London (1760, name adopted 1761) and the eventual foundation of the Royal Academy in 1768. But in Britain, with the late founding of its Academy, the prime object had to be to establish authority for artists and for painting in the public domain: in France the aim was rather to use painting's established authority to enhance the quality of public response to it. The two briefs were taken up respectively by the English painter

Figure 18: The Salon of 1785. Engraving by Pietro Antonio Martini. Page size 39.5 × 54.5 cm. 1785. Bibliothèque Nationale de France.

The dense hanging methods used in 'official' eighteenth-century exhibitions, with the largest pictures placed high and furthest from the viewer, tended to reinforce the hierarchy of values which put history painting – the painting of human example and achievement – at the top of the scale of importance, above portrait (seen to good advantage here halfway up the facing wall), and both these categories above rustic landscape and genre, the smallest pictures at eye-level. The large painting in the centre – guaranteed prominence as a Crown commission – is David's *Oath of the Horatii*, which made as great an impression on visitors in Paris as it had earlier in Rome (Fig. 25).

Joshua Reynolds (1723–92), in his *Discourses* delivered as President of the Royal Academy, and by Diderot in France, insofar as his art criticism became generally known in his lifetime.[31]

Efforts by an English art establishment to latch native painting onto the 'Great Style' stemming from the Italian Renaissance, and the parallel phenomenon of independent patronage by a newer, very different middle-class taste, created particular problems for artists, critics and audiences in Britain. When George III became king in 1760, the individualist Hogarth was near the despondent end of his career; younger painters, like Stubbs and Wright, were to maintain cool relations with 'official' Royal Academy doctrine. John Barrell and others have discussed the effects of a type of 'civic humanism', which promoted in print a masculine, polite and essentially ruling-class view of public virtue as the goal of the arts – a goal derived from the past – to the disadvantage of those made wealthy by trade and manufactures in the present.[32] English painters seeking to engage with the growing purchasing power of this group found little to help them in the high doctrine spearheaded at the Academy by Reynolds. Maintaining Italian painting as his measure of serious purpose in his 1788 Discourse (late in the canon), Reynolds referred to an 'English School' as still a hope for the future.[33] This was in the year of Gainsborough's death, some five years after that of the first British landscapist of genius, Richard Wilson, and over twenty years after that of Hogarth.

After 1800, as Turner, Constable and then Delacroix freed themselves from convention, critics faced a further problem of explaining, or themselves coming to terms with, the technical and imaginative departures involved. Hazlitt – himself a painter – felt this. In 1815, he was seeing in Turner 'the ablest landscape painter now living' but also, in his pictures of air, earth and water, a process of rejection of form and of return to 'the first chaos of the world'.[34] For most observers concern about 'lack of finish' (see Chapter Four, p. 205) was also an appreciable worry. Turner suffered especially from critical unpreparedness for this. In 1808 John Landseer could observe, in the *Review of Publications of Art*, that Turner, exhibiting in his own gallery, seemed to 'mingle light itself with his colours', accurately reflecting a central interest of this artist. But *The Athenaeum* (founded in 1828, and one of the most widely-read journals) thought that in Turner's *Burning of the Houses of Lords and Commons* (British Institution 1835) 'truth is sacrificed to effect'. The verifiable facts of this scene – the broad river at Westminster and leaping flames fanned by a westerly breeze, above a watching crowd – were the perfect catalyst for the kind of translation into light and void which critics had already remarked as Turner's objective. And the *Athenaeum* admitted that this effect was 'in parts of the picture, magnificent'. Slowly, truth would be seen to coincide with Turner's effect, as, in 1842, it did for the great landscapist's most celebrated interpreter, the critic and artist John Ruskin (1819–1900). 'It began to occur to me', Ruskin later recalled, 'that perhaps even in the artifice of Turner there might be more truth than I had understood'.[35]

The first volume of Ruskin's famous apologia on Turner's art, *Modern Painters*, appeared a year later, in 1843. Without such advocacy, the percep-

tion that a given effect might convey its own truth was a difficult one for the wider exhibition-going public of the period to reach: herein lay one of the greatest contributions that a thoughtful art critic might make to his time. And so it has remained since.

NOTES

1. J.G. Garrard, 'Introduction: The Emergence of Modern Russian Literature and Thought', in J.G. Garrard, ed., *The Eighteenth Century in Russia* (Oxford 1973), pp. 1–21

2. Daniel Defoe, *A Review of the State of the British Nation* (1709), VI, no. 36, p. 142

3. Asa Briggs (compiler), *How They Lived*, vol. III, *An Anthology of Original Documents written between 1700 and 1815* (Oxford 1969), p. 118

4. Robert Darnton, 'A Bourgeois puts his World in Order', in *The Great Cat Massacre and other Episodes in French Cultural History* (1984), p. 139. Darnton describes the relation of 'bourgeois', as interpreted in regard to himself by a citizen of Montpellier, in 1768, to the seventeenth-century *honnête homme*, the term for a well-bred citizen with origins in aristocratic notions of behaviour. By the 1760s this also conveyed self-respect, a quality associated with the bourgeois

5. John Lough, *Writer and Public in France* (Oxford 1978), p. 258

6. Beaumarchais, *La Folle Journée, ou Le Mariage de Figaro*, Act 5. Eng. trans. John Wood (1964)

7. On the ways by which a bourgeois might become a confident 'cosmopolitan' see Richard Sennett, *The Fall of Public Man* (Cambridge 1977), pp. 16–17. Cf. Jürgen Habermas, *The Structural Transformation of the Public Sphere: An Inquiry into a Category of Bourgeois Society* (1962), trans. Thomas Burger with the assistance of Frederick Lawrence (Cambridge, Mass, 1989)

8. See Neil McKendrick's chapter 'The Commercialization of Fashion', in Neil McKendrick, John Brewer and J.H. Plumb, *The Birth of a Consumer Society: The Commercialization of Eighteenth-century England* (1982), pp. 58f.

9. Mark Girouard, 'Coffee at Slaughter's: English Art and the Rococo', *Country Life* **139** (1966), pp. 58–61, 188–90, 224–7

10. Arthur Young, entry for 9 June 1789, in *Travels in France and Italy* (1792, reissue 1976), p. 125

11. E. Hellmuth, 'Towards a Comparative Study of Political Culture: The Cases of Late Eighteenth-Century England and Germany', in E. Hellmuth, *The Transformation of Political Culture* (Oxford 1990)

12. Quoted by Norman Hampson, *The Enlightenment: An Evaluation of its Assumptions, Attitudes and Values* (1968), p. 160

13. *The Lunar Society of Birmingham*, exh. cat. (Museum and Art Gallery, Birmingham 1966); F.D. Klingender, *Art and the Industrial Revolution* (1968), pp. 30–1

14. Diderot, *Encyclopédie*, vol. 1 (1751), *Art*. Reprinted from *Encyclopedia, Selections*, trans. N.S. Hoyt and T. Cassirer (Bobbs-Merrill, 1965)

15. Ian Watt, *The Rise of the Novel* (1957, republ. 1987), pp. 196–8

16. Gareth G. Jones, 'Novikov's Naturalized *Spectator*', in J.G. Garrard, ed., *The Eighteenth Century in Russia* (Oxford 1973), pp. 149f.; Gary Marker, *Publishing, Printing, and the Origins of Intellectual Life in Russia, 1700–1800* (Princeton, New Jersey 1985), pp. 95f., 101

17. R.M. Wiles, 'Middle-class Literacy in Eighteenth-Century England', in R.F. Brissenden, *Studies in the Eighteenth Century* (Australian National University Press, Canberra 1966), p. 59. See also J. Feather, 'The Commerce of Letters: The Study of the Eighteenth-Century Book Trade', *Eighteenth-Century Studies* **17** (1983–4), pp. 405–24. This notes the difficulty of determining how far books reached the lower classes. Millions of chapbooks produced in Britain point to a mass audience capable of reading them; though they were probably also aimed at children of high social class as light relief from 'educational' fare

18. Robert Darnton, *The Literary Background of the Old Régime* (Cambridge, Mass. 1982); Robert Muchembled, *Popular Culture and Elite Culture in France 1400–1750* (Baton Rouge 1985)

19. Robert Darnton, *The Business of Enlightenment: A Publishing History of the* Encyclopédie *1775–1800* (Cambridge, Mass. 1979), Section VI, especially p. 286

20. Arthur Young, entry for 22 Sept. 1788, *Travels in France and Italy*, p. 109

21. Charles H. Gray, *Theatrical Criticism in London to 1795* (1933, New York reprint 1964), p. 1; D. Thomas and A. Hare, *Theatre in Europe, A Documentary History: Restoration and Georgian England 1660–1788* (Cambridge 1989), p. 419. A detailed account of how Lessing combined the theory of drama with critical writing based on actual performances in the Nationaltheater, Hamburg, is given in J.G. Robertson, *Lessing's Dramatic Theory* (Cambridge 1939), especially Part II

22. Walter H. Bruford, *Culture and Society in Classical Weimar 1775–1806* (Cambridge 1962)

23. Arthur Young, entry for 18 Oct. 1787, *Travels in France and Italy*, p. 81

24. Luigi Riccoboni, *Historical and Cultural Account of the Theatres in Europe* (1741), p. 176, quoted in Cecil Price, *Theatre in the Age of Garrick* (Oxford 1973), p. 3

25. William Hazlitt, *Complete Works, Centenary Edn* P.P. Howe ed. (1930–34): (on Kean), vol. XVIII, pp. 191–4; (on Shakespeare), vol. IV, p. 247, V, p. 48. Lamb's essay 'On the Tragedies of Shakespeare, considered with reference to their fitness for stage representation' was written in 1811

26. Letter and translation in context in Andrew G. Lehmann, *Sainte-Beuve: A Portrait of the Critic 1804–1842* (Oxford 1962), pp. 92–3

27. R.P. Locke, 'Paris: Centre of Intellectual Ferment', in Alexander Ringer, ed., *Man and Music. The Early Romantic Era, between Revolutions: 1789 and 1848* (1990), p. 60. Also J. Sachs, 'London: The Professionalization of Music', ibid., pp. 211–12

28. Imogen Fellinger, *Verzeichnis der Musikalischen Zeitschriften des 19ten Jahrhunderts* (Regensburg 1968). Ringer (see note 27) has useful refs, *passim*

29. Reviews of the biennial Paris Salon (held regularly from 1737), appeared either in periodicals or as pamphlets. Anonymity, in an age when infringement of censorship or social proprieties could bring trouble, is described in Richard Wrigley, 'Censorship and Anonymity in Eighteenth-Century French Art Criticism', *Oxford Art Journal* **6** (1986), pp. 17–28. Thomas Crow, *Painters and Public Life in Eighteenth-Century Paris* (New Haven and London 1985), describes (pp. 4–11) the tensions between 'unofficial' critics in France and the state machine (run by the Directeur-Général des Bâtiments), which sought to protect the established academic hierarchy

30. For example *Edinburgh Review* (1802), *Quarterly Review* (1809), *Blackwood's Edinburgh Magazine* (1817), *Fraser's Magazine* (1830)

31. Reynolds, *Discourses on Art*, ed. R. Wark (edn New Haven and London 1997). Diderot, *Salons*, ed. J. Seznec and J. Adhémar, 3 vols (Oxford 1957–63). Diderot's *Salons* were first published after the Revolution, in 1798

32. John Barrell, *The Political Theory of Painting from Reynolds to Hazlitt* (New Haven 1986). For commercial and industrial society as wealth creator see N. McKendrick, J. Brewer and J.H. Plumb, *The Birth of a Consumer Society* (1982); P. Langford, *A Polite and Commercial People: England 1727–1783* (Oxford 1989). David H. Solkin, *Painting for Money: The Visual Arts and the Public Sphere in Eighteenth-Century England* (New Haven 1992).

33. Michael Rosenthal, 'Gainsborough's *Diana and Actaeon*', in John Barrell, ed., *Painting and the Politics of Culture: New Essays on British Art 1700–1850* (Oxford 1992), p. 189

34. William Hazlitt, in his essay 'On Imitation', included in *The Round Table* (1817); see *Complete Works*, P.P. Howe ed., (1930–34), vol. IV, p. 76

35. John Ruskin, in his autobiography *Praeterita*, II, iv, 73; see *Works*, E.T. Cooke and J. Wedderburn, eds, vol. XXXV (1908), p. 310

2

Traditions, Innovations: Opera and the Novel

Prelude

For Samuel Johnson – as we learn from Boswell's *Life* (11 April 1776) – Italy was still the provider of 'what it is expected a man should see'. Italy has a prominent place in the following chapter: but the main object must be to set these expectations of the classical South against the bold responses that artists of all kinds would be making north of the Alps. As we saw in the Introduction, the eighteenth century inherited an internationally viable style, the dynamic Italian Baroque. Its adaptability and continuing vitality far from home were visible in 1710, when Wren completed his Anglican cathedral of St Paul in London in a style that was in the main coolly classical, but also imbued with Baroque inflexions. It was evident in 1711, when the German composer Handel staged, also in London, his first Italian opera for the English, *Rinaldo*: musically and scenically a larger-than-life success, though not without its English detractors. In Paris, Couperin's music and Watteau's painting used the Baroque (Fig. 2, and pp. 8 and 13) to their own purposes. In Hamburg, where the ever-remarkable Telemann was director of music from 1721 till 1767, and in central Germany, where Bach worked in court and civic employment as organist and composer until 1750, the style attained high and at times sublime levels of religious and secular celebration.

The arts never 'keep pace', however, as we noted (p. 26). The choral masterpieces of Handel and Bach – including Bach's inspiring *Matthew Passion* (1727) – took the musical Baroque to its peak when the 'modern' fictional heroes Crusoe (1719) and Gulliver (1726) had already appeared. While the perspective of history has always favoured the innovating Enlightenment writers, it has tended to play down the contemporary agents of artistic conservatism – the courts and the churches. But they need to be remembered.

The new forms and feelings were nonetheless irresistible. In the theatre contemporary plots established a popular presence remote from the aristocratically-approved Baroque. In Mozart's *Marriage of Figaro* (1786), comic opera acquired its own larger-than-life but recognizably human, proletarian hero Figaro, adapted from Beaumarchais. In fiction, inherited boundaries were likewise overrun, not only in the internationally-read letter-novels of Richardson and Rousseau and historical romances of Scott, but in the insights into human relationships of women writers who found a natural home in this genre. In the climate of incoming Neo-classicism, ahead of the Romantics, music became the far-reaching vehicle of 'sensibility' for Bach's son Emanuel (p. 95) and of dramatic effect for Gluck in his operas. While Rossini and Verdi, after 1800, maintained internationally the dominance of Italianate sung line, German opera, enriched by Beethoven's symphonic ambition, moved from his *Fidelio* (1806, 1814) into Weber's forest Romanticism and on to Wagner.

German literary and musical culture, indeed, was now a key presence. In her book *De la Littérature* (1800), analysing the relationship between societies and their cultures, Germaine de Staël contrasted the southern poet who mixed images of 'coolness, wooded glades, clear streams', and the emotions of life around him, with his northern counterpart whose imagination ranged freely beyond all limits. In *De l'Allemagne* (*On Germany*, 1810, pulped by Napoleon and finally published in London in 1813), she identified a Germanic temper that, in contrast to that of the south and the big, community-shaping impulses of the classical world, was introspective and religious. The self-immersion of the Christian Coleridge in the 'Nature Philosophy' of his German contemporaries – notably Schelling – reflected this clear intellectual kinship. Even a poet with so Mediterranean an outlook as the atheist Shelley was drawn to translate parts of Goethe's *Faust* (p. 218).

Giving invaluable backing, moreover, to a German-based internationalism was its strong Jewish dimension, identified with Lessing's friend Moses Mendelssohn (1729–86). The poet Heine, a German Jew turned Protestant Christian, expounded this Jewishness – indeed, for all his ironies, also represented it. In music there was Moses Mendelssohn's grandson Felix, another Jew turned Christian, reviver and international performer of Bach, and a man of cultivation who was as at home in Victorian Scotland as in Italy. Writing of the cosmopolitan Paris cultural scene for the *Augsburger Allgemeine Zeitung* in the 1830s and 40s, Heine noted the impact of Felix Mendelssohn in the city of Rossini.

In the distance that separated Johnson's expectations of classical Italy from Heine's of Romantic Germany much, indeed, was implied.

Italy North of the Alps

London in the later eighteenth century, the largest and most thrusting mercantile city of its age, was frequently compared to ancient Rome (Fig. 42).

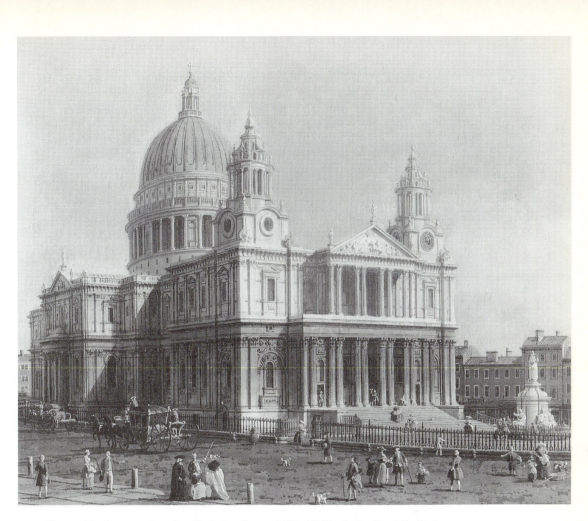

Figure 19: Antonio Canal, called Canaletto (1697–1768). *St Paul's*. Oil, 52.0 × 61.6 cm. 1754. Yale Center for British Art, Paul Mellon Fund.

The forms – classical columns at the entrance beneath a pediment, a great dome over a colonnaded drum – were old; but in England, in the first cathedral of the Anglican liturgy, they acquired added authority. Wren's west towers terminated in a play of Baroque convexes and concaves; in 1710 his central lantern rose to a golden ball 375 feet above the pavements. The statue of Queen Anne added its own sanction. Forty years later, the Venetian painter Canaletto, sensitive to effects of theatre, recognized the cathedral's pervasive presence in this dramatically-lit view, showing a fashionable coach, a humdrum cart and a group of admirers having the building's finer points pointed out by a man with a stick.

When Wren's St Paul's was painted by Canaletto in 1754, it had dominated the skyline for forty years (Fig. 19). Inside too, the great dome united and centralized its surroundings. Wren (1632–1723) was of a learned generation which expressed itself with ease in Latin; he thought of classical architecture as having a grammar like that language. When he referred in a letter to the planning of St Paul's, and to the 'satisfaction and pleasure I have taken in the contrivance, which aequalls that of poetry or compositions in Musick', he was

almost certainly thinking of the way that each word fits precisely into its place in a Latin poem. An age like ours, when both classical architecture and the Latin language have become remote, finds it hard to make the connexion. We can follow Wren more easily in his musical analogy: but even here we are unlikely, without prompting, to think of 'musical proportions', like octaves and fifths, which played such a significant part in Renaissance architecture based on that of ancient Rome. Our response is more likely to be emotional: suggested perhaps by hearing actual music in the acoustic of St Paul's. About 1800 certain German writers were apt to see classical and Gothic architecture as 'frozen music'.[1] The notion has nowadays lost some of its edge: but its popularity at the time indicates the attractions of evaluating the 'fixed' art of architecture in terms of music, the most dynamic and emotionally direct art of all. The road that connects the satisfaction of Wren, working intellectually inside a Roman and Italianate tradition of 'contrivance', to the German Romantics' awareness of a musical architecture which speaks straight to the emotions, runs through the eighteenth century. It is a main highway. A number of other roads run into it; but music, as Heine noted, was to be at the heart of the ultimate destination.

WORDS AND MUSIC, THE ROLE OF *OPERA SERIA*

When Wren was building, Latin and Greek literature was seen to abound in models of how to express ideas with eloquence and precision. Some of the works that most influenced the eighteenth century, including Newton's *Principia*, were written in Latin. But Voltaire noted that hardly anyone who was not a scholar could read them. Even so Latin remained for literary men who practised modern languages the testing-ground of style. Lorenzo da Ponte, poet and Mozart's librettist, wrote of his need to 'transfer into Latin the noblest passages of our [Italian] authors . . . trying my hand repeatedly at every style of metre and composition, striving to imitate the most beautiful thoughts, to use the most agreeable phrases'.[2] This process reversed, in fact, what Wren had done when he adapted the classical vocabulary of architecture to such 'modern' forms as churches (the western towers of St Paul's, for instance).

But if style was important, so also was sound-quality. If Da Ponte strove to think in Latin on one day, he wrote in the words of its modern descendant, Italian, on the next. His craft of libretto-writing was closely bound up with a language which for musical qualities needed no recommendation. In the early eighteenth century a revival of Dante, the poet of Tuscany whose language became modern Italian, was under way in Italy as a result of the advocacy of Vincenzo Gravina (1664–1718). Italy itself was not yet a nation; but in matters of language Dante's Tuscan had relegated all its rivals in the peninsula to dialect status. It had also revealed a singular capacity to be set to music. Its mellifluous qualities had been proved for generations in direct comparison with dialect in the productions of the *commedia dell'arte*, in which the lovers spoke in Tuscan and the *zani* or clowns in their own local tongues. On the stage,

the bright consonants were a powerful aid in declamation ('recitative') while its characteristic of open-vowel word-endings made it uniquely valuable as a medium for song. The concerns of poet and musician were combined in Gravina's protégé, the poet Pietro Trapassi, whose name he translated into Greek as Metastasio (1698–1782).

Metastasio's was one of the longest and most productive life-times of the century, and he was still seen as the most influential exponent of pure Italian into the 1820s when Macaulay was accusing students of the language of reading little else. But Metastasio's most outstanding achievement was to write libretti for the *opera seria*. This was the form of Italian opera prestigiously associated with royalty and the nobility, based mainly on stories of classical gods and heroes, and involving sumptuous architectural stage settings derived from generations of aristocratic Italian taste for spectacle (Fig. 20). Some of Metastasio's texts were set over sixty times: although many were translated, the euphony of the original Italian phrases virtually sanctified the idea of Italian as the pre-eminent language of opera. Moreover, as court poet at Vienna for over fifty years from 1730, he stood to influence the numerous composers who worked for the Habsburg court. Opera in Metastasio's Italian spread not only to such German courts as Munich and Dresden but to London, Stockholm (also the famous royal theatre at Drottningholm) and St Petersburg.

Metastasio's influence on the classical *opera seria* plot was all the greater because of the consensus that the power of music to express feeling was greatly increased by the human voice and specifically by words. Handel's friend Johann Mattheson declared that music was sound-speech *(Klangrede)*, and that its ultimate aim was 'to excite all passions as successfully as the best orator'. The traditional view, following Aristotle, that the role of art was to imitate nature, granted music an imitative task, to reinforce the sense of an orator's words. 'The sound', said Pope, 'must seem an echo to the sense'. Ironical lines in his *Essay on Criticism* (1711) recalled different motives:

> Her voice is all these tuneful fools admire,
> Who haunt Parnassus but to please their ear,
> Not mend their minds; as some to church repair,
> Not for the doctrine, but the music there.
>
> (lines 340–3)

While the remarkable powers ascribed to music in antiquity – Orpheus charming animals, Timotheos moving Alexander – did not escape modern observers, Plutarch's assertion that both these achieved their effects by words as well as music was also remembered, as was Plato's disapproval of the separation of music from words. And while Claude Perrault, writing of architecture in 1683, had drawn attention to the self-evident nature of musical harmony (the least sensitive ear is shocked by a discord and pleased by a concord, whereas knowledge is needed to respond to proportioned classical architecture), the yoking of music and poetry under the banner of Measure was insistent.[3] Milton, the son of a musician, had done this in his invocation to the 'Blest Pair of Sirens'

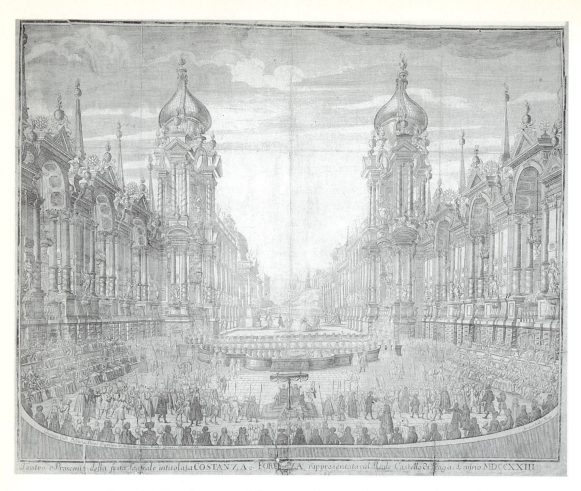

Figure 20: A performance of *Costanza e Fortezza* (*Constancy and Strength*), *opera seria* by Johann Joseph Fux (1660–1741) at Prague Castle, 1723. Set design by Giuseppe Galli-Bibiena (1696–1756). Engraving by Birkardt. Národni Muzeum, Prague, photo Olga Hilmerová.

The power of Italianate Baroque stage-design to create a whole, engulfing environment was well brought out here by one of the internationally-famous Galli-Bibiena family of stage-designers. This opera by Fux, Kapellmeister who served three Habsburg emperors at Vienna, was given in the open air in honour of the newly-crowned King of Bohemia, Charles VI. The seated royal presence in the centre foreground projects a formality which is echoed by the performance on stage.

and his praise of the composer Henry Lawes for making music's task 'to span words with just note and accent'.

Music entered the eighteenth century in a variety of forms that were predominantly vocal: Requiems, Passions, cantatas, oratorios, as well as opera and secular song. Though the earlier polyphony had voices declaiming words separately, with the result that they were 'lost' in overall sound, the group of composers and writers known as the Camerata at Florence had, before 1600,

stressed the single melodic line as the most effective way of heightening the meaning of the words. From this would flow the move to monody ('solo song') and recitative in the dramatic context of opera.

In opera, music's role was of two basic kinds. With the rise of melodic line in recitative (the more functional, story-telling part of the work) and more especially in the aria (the display piece for the singling out of emotion, which followed each recitative), two different contributions were being made: the first a sung statement, the second a song with enhanced musical interest. Moreover, within the limits of the convention of making music convey the spirit of the words, a character could, in his or her arias, be presented with all the dramatic resources at music's command. Handel, writing operas in London on classical subjects such as Julius Caesar (1724), delights in revealing different aspects of Cleopatra's character in successive arias that have varied instrumental accompaniment according to the emotion she is expressing, initial love for Caesar, then grief when she believes him dead, then devotion: it is the *affetti* we noticed earlier (p. 11) brought to life in sound. In Italy Metastasio's libretto for the story in which the Roman emperor Titus forgives those who have plotted against his life afforded similar scope: it was set by over twenty composers, most notably by Mozart in his last opera, produced at Prague in 1791.

Words and music enjoyed a relationship in Germany which was especially helpful to the music. If the south German courts had placed Italy high in the cultural stakes, the early eighteenth-century Baroque in north Germany had found a vigorous brand of 'Germanness' in the Protestant culture that was nurtured by the Lutheran conscience. This had strong links with the people, for whom Luther had provided a translation of the Bible. Luther himself had laid great stress on music, especially on hymns or chorales which would be sung by his congregations: he was said to have conquered more souls in this way than with his translated Bible. Music thus took root in Lutheran communities. There it showed itself as the most accessible and non-exclusive of the arts, a form of expression which could not be privately possessed or restricted to people of education but which, on the contrary, was based on emotional responses which were common to all, including the illiterate. This sense was of immense significance to a people as aware as the Protestants of their responsibility for their own spiritual lives. Bach, weaving Luther's well-known chorale tune *Ein' feste Burg* into almost every movement of his Cantata No. 80, knew the force of it, given out now by the chorus, now by the high trumpet, now by the soprano voice, and last of all as a full statement in which all the congregation would join.

This rooting of music in the independent spiritual life of the north German people was a condition from which Johann Sebastian Bach (1685–1750) drew strength, and which he in turn strengthened, as an incomparably skilled if provincially-based organist who was also a true international. Bach's interest in relating non-German musical styles – Italian, French, Polish – to his own, made each of his places of employment (the courts of Weimar, 1708–17, and of Cöthen, 1717–23; the city of Leipzig from 1723 to his death) a major point of creative confluence as both composer and working musician: from his harpsichord he

led instrumentalists, cued in singers and played demanding solo parts, such as that in the fifth of his six Brandenburg concertos (1721). The closely inter-woven textures of such works pointed to a mastery of counterpoint which, though an older device, became one of the glories of the Baroque.

Bach's surveillance of the musical scene in Leipzig involved him in secular concert-giving as well as intensive church responsibilities. From 1736 he held a title at the Catholic court of Dresden: the B minor Mass (1749) was written for the Catholic Church. The ability of Italian Baroque composers to compre-hend sacred and secular – explicit in the simultaneous flowering of oratorio and opera in the work of Alessandro Scarlatti (1660–1725) and others – had a scintillating counterpart in Bach as composer of liturgical works and of secular masterpieces such as the Coffee Cantata (c. 1734–35, concerned with the habit of coffee-drinking). Whether or not his linking of soprano voice with trumpet obbligato in Cantata 51 (*Jauchzet Gott in allen Landen!*) was prompted by Italian precedent, other liturgical works exploit the drama of the Italian opera that he seems to have heard in Dresden. Bach's singers can sound like classical heroes (Cantata 147) or, following their long, interweaving vocal lines, like operatic lovers (Cantata 78); his Protestant Passions have invited staging.

Coming at the culminating stage of the musical Baroque, between 1710 and 1750, Bach's music combined creative intensity with learnedness: it set itself problems. His most extended harpsichord work, the *Goldberg Variations* (1741), draws both aspects uniquely together. His work also satisfied that desire for system which is endemic to much German creative genius. *The Well-Tempered Clavier* (1722 and c. 1740) has forty-eight preludes and fugues in every possible key; *The Art of Fugue* (1740s) comprises multiform fugues – simple, double, triple, quadruple – and some capable of reversal. That he treated the 200-year-old fugal form so comprehensively, at the time when it was already going out of fashion, is evidence of his position at the end of a tradition. His reputation – like that of Wren in English architecture – waned as a more concise classicism followed: but the musical world he left could never be the same. And, like Wren, his problem-solving independence had longer-term effects: his interest in improvising at the keyboard (a capability greatly valued by Frederick the Great when Bach visited Berlin in 1747) was to pass to his son Carl Philipp Emanuel (1714–88, p. 95), who in turn passed it to the Romantics.

While Bach remained all his life in central Germany, taking an essenti-ally backward-looking style to a pitch of inspiration that made it a timeless resource, his compatriot Handel, by contrast, extravertly straddled Europe. Trained in Italy, he eventually (1710) settled in England where he implanted the Italian *opera seria*, with Italian words. Opera was unfamiliar in England, despite Purcell's exquisite *Dido and Aeneas* (1689). Handel's ever-resourceful operas had fashionable success in London; but a greater strength was his re-cognition of the English potential of non-stage works which linked Christian subject-matter, patriotism and the sense of a public (often secular) occasion. Besides the Coronation Anthems as such, the Hallelujah Chorus from his most

Plate III: Robert Adam. The Music Room, Harewood House. *See note p. xvi.*

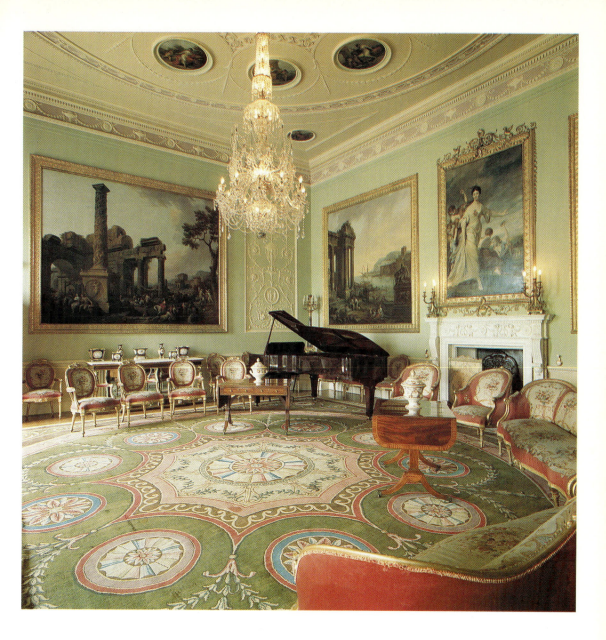

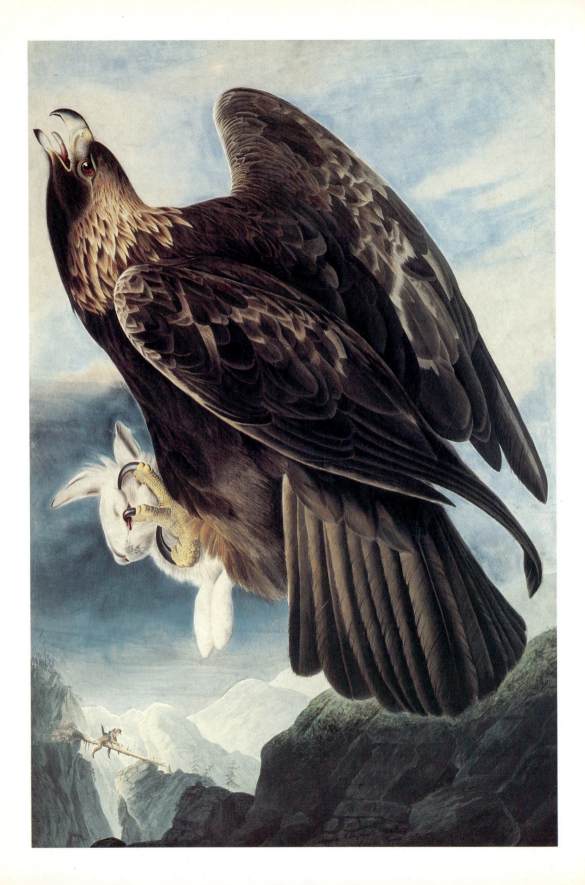

famous oratorio *Messiah* (1742) has been seen as a coronation anthem in all but name. Appealing to amateurs as well as professionals, much of Handel's instrumental music was also aimed at the home public: the last movement of No. 7 of his twelve great concerti grossi (1740) was a hornpipe. His organ concertos, played by him in the intervals of his oratorios in 1735, further enlarged his audiences.

No impassioned Lutheran, indeed, like Bach, Handel could summon up near-religious effects congenial to a landscape-minded age aware of change, mystery and dramatic effect in nature. The ability was an element in his continued fame even after the lean lines of classical sonata form had made the Baroque look ornate. Such a chorus as 'The clouded scene begins to clear', from the oratorio *Athalia* (1733), may well have been in the painter Joseph Wright's mind when, in 1794, he decided that the 'stupendous' scenes of the Lake District were 'to the eye, what Handel's Choruses are to the ear'. Ten years earlier Handel had counted (p. 57) sufficiently as a national institution to warrant a major Commemoration.

Opera seria, however, with its noble classical types and heroic conflicts, had by then long become old-fashioned. Although the Italian words were so good to listen to, the characters who sang them were remote from contemporary reality. The conventional aria, written in a symmetrical form with a first section contrasted with a second and repeated in a third (*da capo*, 'from the head'), could form a marvellous climax to a scene for an aristocratic character: the star singer for whom it had been written – the male *castrato* or the female *prima donna* – could then leave the stage to applause. But dramatic continuity was sacrificed.

COMIC OPERA, ITS APPEAL TO THE BOURGEOISIE

More importantly *opera seria* had had to face up to rival ideas about opera itself. The main thrust of these was to favour lower-class, comic themes. In France plays with music, often in the form of popular tunes (*vaudevilles*) and with roots in the Paris fairs, became consolidated as *opéra comique* by the early eighteenth century. In London, spoken plays with songs led to the ballad opera, notably *The Beggar's Opera* (1728) with libretto by John Gay and music composed and arranged by Johann Pepusch. Substituting lively and often ribald English for the Italian of Handel's *opera seria*, this entertainment attracted the nobility as well as the bourgeoisie. It was heard in Kingston, Jamaica, in 1733 and New York in 1750. In Germany, the comparable *Singspiel* (play with songs) became popular from mid-century, and encouraged the establishment of opera in the vernacular. In Spain, from 1760, the earlier form of entertainment known as the *zarzuela* had similar effects.

New growing points were also to be seen in Italy itself, behind the old wood of *opera seria*, as comic scenes were put on, in the spirit of the Renaissance 'intermezzi', between the acts of the main opera. An early masterpiece, *La Serva Padrona* (*The Servant as Mistress*, 1733), by Giovanni Battista Pergolesi

Plate IV: John James Audubon. The Golden Eagle. *See note p. xvi.*

(1710–36), was staged at Naples between the acts of a now forgotten *opera seria* by the same composer. Of the three characters, only two sing: a middle-class, amorous bachelor (singing bass, a vocal colour often overshadowed in *opera seria*) and a maid who lures him into marrying her (the third is a mute manservant who acts and mimes). Dialogue is delivered in rapid recitative and there are formal arias and duets, but the music is both light-footed and limpidly reflective of each character: nothing could be further from the solemn world of *opera seria*. Embedded in Paris between the acts of a Lully *tragédie lyrique* in 1752, and delivered by an Italian *buffo* (comic) troupe, this lively opera sparked off the famous 'buffoon war' (Quérelle des Bouffons) on the rival merits of opera in French and Italian. The pro-Italian faction had a doughty champion in Rousseau, whose own light opera *Le Devin du village* (*The Village Soothsayer*, 1752) had Italianate recitatives linked to a bucolic setting. This work was performed in Moscow in 1778, and inspired a folk-based Russian variant, *The Miller Magician*, a year later. It was also parodied in France, in which form it attracted the 12-year-old Mozart to write his Singspiel *Bastien et Bastienne* (1768).

Besides the contribution of Naples, further impetus to *opera buffa* (comic opera) was to come from that city of republican individualism and pleasurable living, Venice. Venice now had a population of over 100,000 inhabitants, about a third of that of Naples. Decaying as a seat of empire, its vitality appeared undimmed to tourists who flocked to it for the six-month-long Carnival and the spectacle of its processional life and water pageants. Here were seven theatres, and from 1637 the first opera house in Europe to admit the ordinary public. Though *da capo* arias sung by idolized performers became the norm here also, nothing was quite the same in Venice. Audiences could be inattentive; but Burney thought in 1770 that the free admission to the opera that was accorded to the *gondolieri* led to their singing 'in a superior manner' all over the city.[4] The sense of an operatic experience even extended to the concerts put on in the famous convent schools (Ospedali), where libretto-like leaflets were handed out, together with the names of soloists.

Venice was also the birthplace of Carlo Goldoni (1707–93), the prolific librettist of *opera buffa*. Here was a man with an ear for the latest gossip on the Rialto as well as a knowledge of the story-lines and throwaway techniques of the *commedia dell'arte*, which for decades, inside and outside Italy, had put on plays with simple but expandable plots, a small number of recognizable standard characters and improvised humour. Harlequin, Columbine, Scaramouche, the stock types, had reached Paris (Plate I) and become Frenchified. But Goldoni wanted sophistication, not clowning; believable characters, not stereotypes; and full scripting, not improvisation. Writing for Venice, and from 1761 for Paris, he put together 250 situation comedies which reduced to a few basic types of plot, but which explored basic human attitudes too: man's idolizing of woman and his possessiveness towards her (in a version of the Don Juan story, later taken up by Mozart), pairs of lovers who adopt disguise, the servant who takes on two masters. With such qualities of incisiveness and recognizability in contemporary settings Goldoni's plays were a gift to the European theatre of the day, influencing Diderot and Beaumarchais in France and providing the close-

knit substance of *opera buffa*, which quickly developed its own specialities. Notable among these was the ensemble finale, where characters commented on their situation or were involved in quick exchanges of dialogue, punctuated by asides, against a complex bed of orchestral sound: Mozart took this to its culmination in Acts Two and Four of *Figaro*.

Besides Goldoni, Venice had another major literary figure in Carlo Gozzi (1720–1806), a patrician who retaliated against what he saw as the bourgeois drift of Goldoni's writing. By contrast, Gozzi's plays presented characters in mask, and many had fairy-tale plots (*fiabe*) which gave scope for improvisation. The fairy-tale element was to appeal to Lorenzo da Ponte, himself born in the Veneto, and be woven into his own libretti.

Gozzi was to have his greatest influence on the German Romantics after Schiller had translated him (p. 222). But the accessibility of *opera buffa* helped to take Goldoni's name immediately all over Europe: Baldassare Galuppi (1706–85), another master of the operatic finale, had successes with Goldoni plots in London and St Petersburg; Haydn's setting of Goldoni's *Il Mondo della Luna (The World on the Moon)* was produced at Esterháza (Austria-Hungary) in 1777; Niccolò Piccinni's Goldoni-based opera *La buona Figliuola* (*The Good Daughter*), after a successful run in Rome from 1760 to 1762, was heard in the King's Theatre London in 1766 – something of a home-coming, as the story-line was borrowed, in altered form, from Richardson's novel *Pamela, or Virtue Rewarded* (1740, to be discussed later, p. 85). And Italian libretti continued to inspire: Bertati wrote a Don Giovanni (Don Juan) play which Da Ponte used for Mozart's *dramma giocoso* of 1787, and provided the text for what became the most successful of all *opere buffe*, *Il Matrimonio Segreto (The Secret Marriage)* by Domenico Cimarosa (1749–1801), encored by the Emperor at Vienna in 1792, and leading in spirit direct to Rossini (Fig. 27).

The effervescing plots and close-knit ensembles of *opera buffa*, therefore, made an engaging appeal, especially to bourgeois elements in eighteenth-century audiences, that *opera seria*, with its stressful intrigues involving 'noble' characters, could never rival. Intrigues certainly abounded in *opera buffa*: but they were expressed through comic situations which were based on everyday life and which actively involved members of the lower orders. Mozart was to gain immeasurably from the *buffa* presence: but so, too, would he gain from the steady move to a wider, 'feminine' culture, which we must next consider.

Sensibility, the 'Female World' and the Novel

The link between sensibility and music, and the role of women as intermediary, had wide application in the eighteenth century (see the Reynolds portrait in Plate III). So too did that between sensibility and the novel, another form in which women were to be much involved, not only as readers but as writers. At a time when women held no political power in their own right, their access to areas of influence such as these, which were to move an age, was of great moment.

Little sign of these possibilities was visible in 1700. It is true that, in Britain, the man-about-town of Addison's club, Will Honeycomb (*Spectator* 2, by Steele, 2 March 1711), had 'all his conversation and knowledge ... in the female world.' Moreover, Defoe had satirized male chauvinism in *Good Advice to the Ladies* (1702), a title owed to *A Serious Proposal to the Ladies* of 1694 by the leading campaigner for women's education, Mary Astell (1666–1731). The fortunate recipients of the letters of Lady Mary Wortley Montagu (1689–1762) were aware of a refreshingly candid and penetrating force at work on behalf of her sex. But it was not easy for a woman in this period to win on matters either of what was expected or not expected of her. Lady Mary herself had reservations about the value of book-learning for women. And even her blue-stocking cousin, Elizabeth Montagu, condemned Lady Mary for travelling abroad without her husband. The century's assumption that the highest good of woman was to satisfy the needs of men in the state of matrimony exposed the apartness of those women who aspired to something else, or who were obliged by circumstances to follow a different course. Chardin (1699–1779) memorably sums up this situation (Fig. 21).

Music, nevertheless, had a way of turning such apartness to women's advantage. Of the activities that upper-class girls were urged to fill their time with before marriage – music, dancing, drawing, needlework – music had special value as domestic recreation. That it was an activity which bypassed normal male concerns with competitiveness and goal-getting, and could even afford wives a degree of temporary equality with husbands, is suggested by a letter in the *New Lady's Magazine* of 1786 (p. 136) telling of the 'ease of all anxiety' that it provided in the country: 'while I join my fiddle [a typical male instrument] to my wife's harpsichord [considered especially suitable for females] there is scarce any trouble that is not for a while forgotten.' Here (Fig. 22) was a situation which would favour the cause of women and of music: particularly as the keyboard, perceived as appropriate to females, was to intensify its emotional language so dramatically as the piano took over from the harpsichord ahead of the Romantic period. But women's keyboard affinities remained confined to the home: even the famous harpsichordist Mrs Delany (1700–88) only performed to her own circle. Leppert's researches on female music-making in eighteenth-century England have shown that, while women were seen as having the time and 'cultural "permission" to study music seriously', they were not, in general, free to develop any aptitude for it outside the drawing-room.[5]

Nonetheless, deprived as a woman might be of the freedom of action granted to a man, the marginalized world she inhabited had its own positive value for herself. Richardson's novels, as commentators have noticed, dwell on images of female seclusion: Pamela and Clarissa writing letters in their closets.[6] Watt long ago accurately pointed to the suburb as the enclosing unit that was most favourable to the arts of secluded living, particularly as practised by women with enforced leisure: letter-writing and reading, mainly of devotional literature and novels. Richardson himself, a London printer with two country bolt-holes in Fulham, read his own novels to audiences mainly of women, in

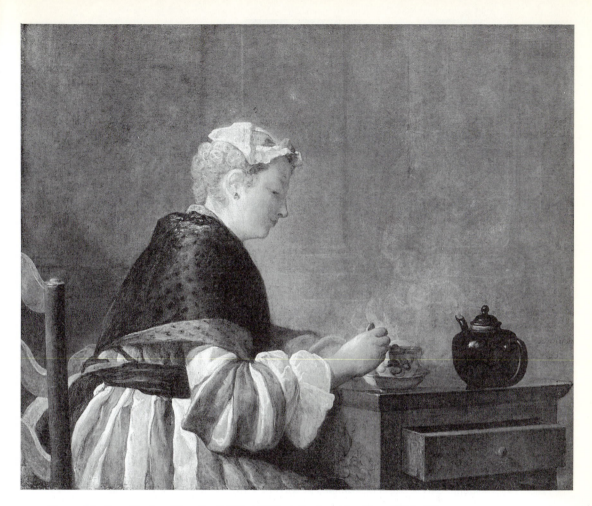

Figure 21: Jean-Siméon Chardin (1699–1779). *A Lady taking Tea.* 1735. Oil, 80 × 101 cm. Hunterian Art Gallery, University of Glasgow.

An engraving of this picture (not by Chardin) is inscribed with an amatory verse, but the companion painting (private collection), showing a boy building a house of cards, suggests a meaning concerned with life's impermanence and uncertainty. The solitary woman appears to be reminded of this by the steam rising from the exquisitely-shadowed, blue-and-white teacup. The picture was acquired by Dr William Hunter at the London sale of the Prince of Carignan in 1765.

such a retreat. Moreover, in many instances, women went on from such experiences to writing diaries of their lives and perhaps novels themselves.

Before we come to the novel about and by women, something more must be said about the opportunities afforded to women as well as men by music. The suburb was to come fully into its own after 1800, but earlier moves to the country were being stimulated, as the eighteenth century opened, by the growing popularity of gardens and the lightness and involvement with nature of the Rococo. From about 1715, architectural follies began to make their appearance at Popincourt near Paris and, after the death of Louis XIV in that year,

Figure 22: Thomas Gainsborough (1727–88). *Study of a Music Party*. Red chalk and stump, 24.1 × 32.4 cm, trimmed at corners. Early 1770s. British Museum.

Gainsborough, himself a keen amateur musician, made a number of portraits of his musical friends. This lively drawing from life probably shows the violinist Giardini, together with members of the Linley family, at their house in Bath. Though music might tune the mind (in Mrs Delany's phrase), and bring the sexes together in equality, men expected musical women – even the accomplished Elizabeth Linley – to perform only in private.

the breakaway of the seigneurs to some degree to their own estates brought further enclaves into being. At Montmorency, the leading art connoisseur of the Régence period, Pierre Crozat, held his own court, invited artists to stay, and arranged concerts at which not only professionals but also amateurs, of both sexes, performed. Here, and in other country parks round Paris, some of the most deft and telling comments on the relationship of men and women in this period were made: in the painting of Watteau (1684–1721).[7]

It is of some interest that many of Watteau's canvases evoke a world of retreat and seclusion not so much of the letter-writer or reader as of the off-stage actor or inwardly-communing musician. In the *fêtes galantes* of a painter who was himself a musician, men and women meet on equal ground and here

– through this most accessible and non-exclusive of arts – the sound of a guitar may silence all else. Alternatively, a mask is raised, a fan inclined, and the guitar-player remains mute (Plate I).

SENSIBILITY IN MANNERS

Between 1700 and 1750, as the lighter *galant* style in music (p. 17) was replacing Baroque weight in a new appeal to audience emotions, a forward momentum was given to Watteau's *fêtes galantes* after his early death. Furetière's *Dictionnaire universel* (1690) had defined a *galant* as a man who seeks to please, a *galante* (woman) as one who knows 'how to live . . . how to choose and entertain her social world'. Such ideas are provocatively realized in the work of Watteau, where men and women foregather and pair off (Plate I), and where the 'types' of Mezzetin or Pierrot, French versions of characters derived from the Italian *commedia dell'arte*, are visited by individual feelings. Masks may be shed: in the theatre, we are told, French audiences liked to see the emotions on the actors' faces.[8] Moreover, while the majority of the comedy parts required type costume, some, notably Harlequin's female counterpart, Columbine, offered scope for wearing contemporary fashions: so setting free choice against stock expectation. At a deeper level, for artists familiar with the traditional Italian comedy, where pantomime-movement on stage was vital to the effect, there were comparisons to be made with the role of gesture and body-movement in real life. In Watteau's painting, the line dividing theatre and real life could be hard to draw. Now in the 1700s the old idea of the world as a stage took on a new piquancy. A generation after Watteau's death Fielding in *Tom Jones* (1749) was comparing the two. Early pictures by Hogarth of *galant* subjects of seduction and surrender were followed by his famous 'modern moral subjects', series like *The Rake's Progress* (1734) and *Marriage à la Mode* (1743–45), in which named characters enacted 'real-life' stories in what he called a 'dumb show'.

Hogarth was to concentrate on vivacity of effect expressed by free movement rather than by studied composure, and in his book *The Analysis of Beauty* (1753) ridiculed the stiffness of pose that results from excessive regard to deportment: his French dancing master in scene II of *The Rake's Progress* is a figure of fun. Yet his protest points to the emphasis that society placed on matters of deportment in public. At no time in the modern world had the study of bodily movement been more highly developed than in fashionable circles, in France particularly, but also in England. Skills such as dancing came in for close attention: but the etiquette manuals make recommendations for both sexes on every eventuality, from how to remove a hat to how to enter a room (Fig. 23). 'If you will be pleased to observe,' wrote Lord Chesterfield to his son, 'what people of the first fashion do with their legs and arms, heads and bodies, you will reduce yours to certain decent laws of motion.'[9]

The fascination for the artist of this staking out of positions which regulated human relationships in public was to observe the ways in which the dividing lines could become blurred or even erased in private. Montesquieu, in

Figure 23: Offering a gift (man). Illustration by Bartholomew Dandridge (1691–?1754) to François Nivelon's courtesy-book *The Rudiments of Genteel Behaviour* (1737), plate 5. Engraving by L.P. Boitard, 19 × 14.3 cm. British Library (1812a 28).

The fine points of deportment were dealt with in numerous illustrated courtesy-books. Insofar as it depended on bodily rhythm and the marking-out of space as well as time, it related to the dance: two of Nivelon's plates illustrate the correct male and female starting positions for the minuet. But for the fashionable classes every day-to-day action of consequence was governed by deportment. Discussing how a man should offer a present, Nivelon specifies that the body must rest on the left leg, with left knee bent and right knee straight, and gives details on how to retreat 'with becoming Decency'.

The minutiae of human relationships, prescribed and improvised, were meanwhile becoming the work of contemporary novelists.

the twenty-eighth of his *Lettres persanes* (1721) – in which a Persian visitor to Europe was imagined writing home with his impressions of life there – commented on a visit to the theatre, and on the uncertainty of knowing who was watching and who was being watched. Hogarth's inclusion, in his *Beggar's Opera* scene, of the real-life Duke of Bolton, gazing at the actress with whom he was carrying on an affair, was to be a well-known example of this. In Paris, if the gentlemen and ladies of the Comédie Française audience could ogle each other from their boxes, with occasional glances at the stage, how much more intimately could the encounters be continued afterwards in the Café Procope opposite. The covert testing out of sexual relationships that we see in the painting of De Troy (Fig. 4) or Fragonard, was long established also in the public arena of the theatre and masquerade. But the intimate art of the novel was to follow its innermost workings. The trajectory of this is particularly clear in France. It began with Marivaux, playwright in the 1720s for the Italian comedy and subsequently novelist, and extended through Stendhal to Balzac, who placed his compendious account of human behaviour (appearing from 1842) into the form of novels. This was after an unsuccessful bid to write for the stage: even so, he gave his great fictional series the overall dramatic title of *La Comédie Humaine*.

THE NOVEL EXPLORING HUMAN CHARACTER AND EMOTION

The plays and novels of Pierre Carlet de Marivaux (1688–1763) are, indeed, a barometer of their age in the way that they distil the play of emotion through the patterning of plot. An early play for the Italians, *Le Jeu de l'amour et du hasard* (*Love is a Lottery*, 1730), in which two lovers test each other's credentials by disguising themselves as their servants and become tied up in the crossed relationships that ensue, prefigures the structured gamesmanship of Lorenzo da Ponte's libretto for Mozart's opera *Così fan Tutte* (1790).[10] If this Marivaux play explores the process of crossing social divisions by means of masks or disguises, and wraps it all up within a formal symmetry – as a stage presentation is so well fitted to do – his later work on the eleven-part novel *La Vie de Marianne* (1731–42) pursues the subtleties of crossing these divisions with all the detailed and extended scrutiny that the novel form can command. Here Marianne uses the figurative mask of *coquetterie*, seen not merely as female play-acting but as a universal device for penetrating the masks of other people without surrendering one's own. While the study of human character in close-up, with or without a mask, becomes the obvious central interest of the novelist, the twin uses of the mask, as a means of covering up the private self and of discovering the masked motivations of others, opens up a world for exploration in the next century and a half. The growing desire for realism can claim human artifice as part of its purview: although the world of the Italian comedians is far from the realities of nineteenth-century Paris that are recounted in the *Comédie Humaine*, Balzac recognizes the metaphorical usefulness of the mask, which people hide behind and change in different situations.

The ambiguities between ordinary reality and how it might appear to an individual observing it had been unforgettably treated in Cervantes' fictional work *Don Quixote* (1605). Here the immediacy of a chivalric dream-world which was intensely real to the hero, causing him to see windmills as a hostile enemy, was presented as a parody of the old-fashioned romance. Cervantes' work had been newly translated into French by Motteux in 1700. The popularity of the adventure story had also been assured by the picaresque novel (Spanish *picaro*, rogue), in which a misbehaving but likeable hero flouts authority and wins reputation. The French novel *Gil Blas* (1715–35) by Lesage, and the English novels by Fielding and also Smollett (who translated *Gil Blas*), met this enduring appeal. But novels by women in the seventeenth century had shown interest in the unusual viewpoint and the isolated victim of circumstance: the black hero of Aphra Behn's *Oroonoko* (1680), abused by British slave-drivers in Surinam (which Behn had known as a child); and the eponymous heroine of Madame de Lafayette's *La Princesse de Clèves* (1678), a faithful wife forced by the attentions of another man to scrutinize her own ideals. The investigation of reserves of character brought to bear against outside pressures was to constitute a special strength of novels by women, and to fortify the study by novelists of both sexes of human beings under duress. The detailed, building-block richness of prose was needed for such work, and the novel in its internalized eighteenth-century incarnation came in on a wave of it. Fielding defined his *Joseph Andrews* (1742) as a 'comic epic in prose': but the sense of the everyday language of the present vividly overrode the reference to the literary lineage of the past.

Here was the background to one of the most famous of all novels, which has more than once been bracketed with *Don Quixote*, though the hero is very different: Defoe's *Robinson Crusoe* (1719). Lacking Quixote's tragic grandeur, Crusoe on his island is set to overcome the physical and mental challenges of isolation and competition from external forces. An immediate success, the book ran to three more editions in the year of its publication, and had reached a seventh by 1726. Imitated, translated into almost every language, and as familiar to children as to adults, Defoe's story took the temperature of successive generations. Well-received in France, it provided the plot of a comedy by Lesage (1732). It was given to Rousseau's Emile (1762, see p. 255). It stimulated Johann Wyss's popular *Swiss Family Robinson* (1813). Finally it helped to release, directly or indirectly, a stream of books (as Martin Green has shown, see p. 273) and opera plots about desert islands.

The success of *Crusoe* can be attributed to three facts. First, the combination of an 'ordinary' hero with the extraordinary circumstance of having to build a life from nothing on a desert island, thus involving the basic instinct for survival. Second, the remarkable descriptive detail that gives verisimilitude and has total power to convince. Third, the first-person narrative, which underscores the self-reliance, and imparts immediacy, even urgency. Crusoe – whose character, it has plausibly been argued, contains much of Defoe's own – therefore becomes one of the greatest representatives of the individualism which the modern novel would explore. Nowhere is the sense of him as individual more

powerfully put over than at the point – exactly half-way through, for lovers of symmetry – where he discovers a naked footprint that is not his own in the sand, and the fear that will make his island shelter into his castle enters the narrative.

A few years after Crusoe told his story, a very different traveller told his. The appeal of Swift's masterpiece, *Gulliver's Travels* (1726), with its many editions and abridgements for children, was founded on Gulliver's experiences among the tiny Lilliputians or the giant inhabitants of Brobdingnag. But the reflective reader was enabled by the use of the first person to come close enough to the hero to feel the deceptiveness of that self-pride that Swift wanted to expose as a general human failing. In the account of the final voyage the satire became ferocious. Gulliver finds rationality vested in a race of horses (Houyhnhnms), and animality uppermost in man-like creatures, the odious Yahoos, whose contemptible nature he recognizes in himself as he looks at his own reflection. But Gulliver remains deluded as he takes up the life-style of the horse: 'My friends often tell me in a blunt way that I *trot like a horse*, which, however, I take for a great compliment' (Fourth Voyage, Chapter 10).

First-person accounts in novels had varied uses. Defoe's *Moll Flanders* (1722) presented the heroine's life-story against the background of the London crime world, Goldsmith's *Vicar of Wakefield* (1766) the account of a family by one of them, the Vicar. But *Manon Lescaut* (1731), by the Abbé Prévost (1697–1763), is subtly oblique: the courtesan Manon only appears through the eyes of her lover Des Grieux, whose first-person account – made to a 'Man of Quality' who introduces it – is a confession of his entanglement with her. His pursuit of Manon – even to Louisiana, whither authority has deported her and where she dies – is the inverse of his recoil from his father and the society in which he has grown up. Manon, however, succeeds in leading him on without depriving him of his sense of being in control. Stories shaped less by external incident than by an individual's psychic desire were to pervade the Romantic nineteenth century, especially in France (Gautier's *Mademoiselle de Maupin*, 1834, Mérimée's *Carmen*, 1845).[11] The simplified lines of them were to invite treatment in the opera-house, as *Manon* was to prove.

The first-person account was to be used over and over again by writers of fictional journals and diaries. But of all the modes of self-revelation the novel in the form of letters exerted the most compelling attraction. Conveying an intimacy unmatched by a third-person or even a first-person narrative, it scored also by presenting its material at first hand without apparent editing (though in fact authors had often spent long hours doing so). It also offered the illusion that the reader was being given privileged access to private confidences.

Of this kind of book Samuel Richardson (1689–1761) emerged as a master: and his genius in making the letter-novel the vehicle for beleaguered fictional women was to light a torch. His *Pamela, or Virtue Rewarded* (1740) has a serving-girl faced by seduction from her employer: the psychological minutiae are recounted by her in her letters, which culminate in the victory of her virtue in marriage to the same employer. A reworking of the Cinderella myth, no personal story could have had greater public impact. *Pamela* was translated into

French, turned into opera and a waxwork, and scenes from the novel appeared on the walls of Vauxhall Gardens, and the fans of society ladies. Fielding promptly wrote a satire based on it, *Shamela* (1741).

No form other than the letter could evoke the hairspring tensions of Richardson's next novel: *Clarissa Harlowe* (seven volumes, 1747–48). In *Clarissa* the pursuit of the heroine by the rake Lovelace winds its way through a marvellously crafted text of gigantic span. Conveyed through letters written almost entirely by four characters who are placed in symmetrical pairs – Clarissa and her confidante Anna Howe, Lovelace and his friend Belford – the story proceeds by successive tugs, some violent, others hardly perceptible, on the thread of one year's time-scale, January to December. But far from reminding us of the classical unities, the narrative proliferates ceaselessly from within. As each letter bears a date, we are held close to the action, seeing masks of self-protectiveness donned and dropped, quarry and predator referring back and forth to their correspondents and one another as ploy follows ploy. Man, Pope had said, was his own proper study, the centre of attention: but Lovelace has gone from here to assert that only he knows what is good for Clarissa. She, for her part, is aware of needing to be herself but simultaneously of being reduced to less than that: 'I am but a cypher, to give *him* significance, and *myself* pain'. His onslaught admits no hindrance: she is drugged and raped, but dies an elaborately-prepared, self-willed death, eluding final capture. He is killed in a duel.

Many reasons account for the success of *Clarissa*. To the age of sentiment Richardson reflected its fuller acceptance of qualities associated with women, notably civility and *tendresse*. By the same token the outrage of the rape (not described) increased its capacity to shock. But above all, no fiction had ever probed in detail such an interdependence as that of its two chief characters. The book achieved the perhaps unique distinction of being praised by figures as diverse as Lady Mary Wortley Montagu, Diderot, Klopstock, Sade, Rousseau, Goethe, Blake, Napoleon, Pushkin and Balzac.

Richardson's third novel, *Sir Charles Grandison* (1753–54), pursuing in letters the study of a 'good man' and the process of self-discovery of the orphan heroine, also had a prodigious readership: like *Clarissa*, it was translated into French by Prévost. In the 1750s and 60s, the 'tearful comedy' (*comédie larmoyante*) was moving the hearts of audiences in the theatres of Diderot's France and Lessing's Germany, but in the matter of moving hearts nothing could equal the novel – especially the letter-novel – about affairs of the heart, read in the privacy of homes throughout the literate West. Moreover, the woman's viewpoint was being revealed as never before. After Richardson's success came two French letter-novels. One, *Lettres de Milady Juliette Catesby* (1759), was the work of a woman, Marie-Jeanne Riccoboni, and was widely translated and pirated.[12] The other, Rousseau's *Julie, ou La Nouvelle Héloïse*, not only created a demand which exceeded supply, but caused readers to write back to him in their hundreds, convinced that his characters were real, and wanting to know how they could meet them.[13]

Rousseau's *Héloïse* takes the form of letters recounting the love of Julie (likened to Héloïse, the medieval abbess who wrote on love) for her former tutor Saint-Preux. After a life of adventure, he becomes tutor to the sons she has borne to her husband the Baron de Wolmar, a sympathetic figure who knows of his wife's early affair. Saint-Preux tries to revive this, but is rejected by Julie. She dies after rescuing one of her sons from drowning: a posthumously-read letter affirms her continuing love for Saint-Preux. The sanction for her choice of the claims of wedlock and motherhood is made not by the Christian Puritan ethic of Richardson, but by Rousseau's deity Nature, whose moral law works within the individual conscience. The rescue of her son from drowning, symbolically suggesting the preservation of the innocent state by the mother – the paramount influence in a child's early life – takes this imperative back to its source. It is nature that 'contains' the story: the title-page tells us that these are the letters 'of two lovers living in a small town at the foot of the Alps'. And the close relationship that links Julie and nature is symbolized by the 'natural' garden that she creates at Clarens: 'Everything is green, fresh and vigorous and the gardener's hand is not visible' (Part IV, letter XI).

After 1750, human susceptibilities were explored in novels at all levels, from the delicacies of Mackenzie's much-read *Man of Feeling* (1771) to the harmless carnality of Fanny Hill. And the nature that had become an alternative sanctioning agent of moral decision disclosed itself also in diverse ways. What to the Rousseauist Bernardin de Saint-Pierre appeared beneficent (although a hurricane in his novel *Paul et Virginie*, 1786, killed his heroine), to the Marquis de Sade was eager for blood (*Justine*, 1791). In a sentimental age, the theme of Eden and the loss of innocence had become tearfully alive: the poem *Der Tod Abels* (*The Death of Abel*, 1758), by the Swiss publisher, pastoralist and etcher Salomon Gessner (1730–88), enjoyed a European reputation, together with his *Idylls* (1756–72), which appealed to Scott, Byron and Wordsworth. The link with landscape was to intensify. While Saint-Preux in *La Nouvelle Héloïse* had sought solace from his problems in mountain scenery, in Goethe's novel *Die Leiden des Jungen Werthers* (*The Sorrows of Young Werther*, 1774), also recounted in letters, the dispossessed hero wanders in a similar landscape seeking the strength of mind that will guide him in his intense love affair with Lotte, who is married to Albert. Yet he finds a scale of destruction in nature which his own actions, in their puny way, merely compound: 'one step shatters the laborious buildings of the ant'. Werther's woes won all hearts; and his dress of yellow breeches and blue coat became a fashion, together with his excessive sensitivity. His suicide was copied by so many in real life that Goethe added a cautionary note to his second edition, and wrote a play *Der Triumph der Empfindsamkeit* (*The Triumph of Sensibility*), which satirized its subject: the desperate hero can only find happiness in an artificial landscape with a doll. But *Werther* continued to roll: weakly translated into English (from the French) in 1779, by 1807 there were no fewer than seven translations. An English chapbook version was soon available at roadsides; in 1785 a waxwork of Werther's death was shown in Fleet Street.

In *La Nouvelle Héloïse* Julie had wrestled with the Enlightenment axiom that personal fulfilment has necessarily to be identified with the collective good. Twenty years later the difficulty of reconciling the two took on a baleful reality with the publication in 1782 (albeit banned in 1824) of *Les Liaisons dangereuses*, the novel by a soldier turned author, P.A.F. Choderlos de Laclos (1741–1803). Laclos depicts the worst of combinations: evil instincts working compulsively from inside the human personality, but made to seem harmless by being deployed through a code of manners upheld by society. The individualism which the eighteenth century had nourished from behind the cover of society's conventions was now released on a stage which highlighted the casualties. Laclos was a declared admirer of Rousseau and his exposure of a corrupt society in his novel confirmed the worst of Rousseau's earlier diagnosis. But while Rousseau believed that society might be renewed, and advanced remedies in his *Social Contract* (1762) and *Emile* (1762, p. 255) Laclos nowhere suggested the hope of cure. Nor did he indicate that society was ready to respond to virtue when it saw it, as Paris society in Marivaux's *Marianne* had responded.

Like Richardson and Rousseau, Laclos makes his characters known to us through the letters they write. There are the innocent (Cécile and Danceny), who are debauched, and the virtuous (Mme de Tourvel), who is shown to base virtue on pride; and there are two agents of destruction, the rake Valmont, a reincarnation of Lovelace, and the Marquise de Merteuil, a predator behind a variety of masks, not least against members of her own sex. This pair are not isolated 'monsters': Laclos indicts the society which not merely nourishes them but which gives them the ability to survive all competition. But as they go about feeding on others they project, in different ways, an extraordinary self-absorption. In a revealing phrase Merteuil writes that Valmont asks after his friends, but does not stay to hear the answer. Merteuil does not make this mistake: she not only stays, but uses the answer to give the screws she is applying an extra turn. In the end, having wrought havoc for their victims, the two plotters fall into traps of their own setting.

The test of knowing how to balance obedience to conscience with resistance to outside pressures had been applied to fictional women, in *Clarissa* and *La Nouvelle Héloïse*, with moving effect. In *Les Liaisons*, with two destroyers, one of each sex, the issue is more one of seeing how far their competitiveness will outweigh their power to co-operate. But all three novels belonged together in implementing the eighteenth-century novel's greatest mutation: while the chronicles about status, possessions, and the externals of life went on, the 'internalized' story, conjured round a handful of characters and psychological in all but name, marked the arrival of a form which could only have arisen in the age of sensibility.

In the mid-eighteenth century 'psychology' was not yet an independent area of study. But interest in how far human behaviour was determined by mental associations arising from individual experience – much discussed by David Hume (*Treatise of Human Nature*, 1739–40) – was helping to create the right conditions for it. David Hartley, in his *Observations on Man, his Frame, his Duty and his Expectations*, published in 1749, a year after *Clarissa*, developed

the notion of a 'Sensorium', a centre of sensations carried by the vibrations of the nerves to the brain, and forming clusters of associations. This was certainly known, and alluded to, by the novelist Laurence Sterne (1713–68), whose eccentric genius produced *The Life and Opinions of Tristram Shandy, Gentleman* (1760–7). No novel – not even *Don Quixote*, which Sterne admired – combines action, as it happens, with so pronounced a stopwatch sense of arresting it and defying time, as memories and asides from Tristram's past life crowd in.[14] The book is the first-person narrative of a writer – Sterne himself embedded in his hero – who wants the reader to sense the accidental nature of these thought-trails of association (compare Chapter Three, p. 120). The wit, unpredictability, sentiment and scatology of *Tristram Shandy* combined to produce an international success. Diderot, Goethe, Pushkin all admired it, and so would Romantics interested in irrationality, accident and the kind of story in which the author includes himself in the plot.

Sterne's travel-fantasy *A Sentimental Journey through France and Italy* (1768) also succeeded resoundingly abroad. The author fills it with impressions of sight, sound (the caged starling's unforgettable call, 'I can't get out') and touch (hand-pressures, pulse-beatings). The painters Joseph Wright and Angelica Kauffman (Fig. 24) memorably evoke the sound-world of mad Maria, who had also appeared in *Tristram Shandy*, and became a veritable symbol of the age of sensibility for artists.

In contrast to the cumulative forward flow of the 'realistic' letter-novels, Sterne's somersaulting internal dialogues, eye-confounding word patterns, and ear-catching phrase-rhythms pushed open the door of experiment. Early in the verse-novel *Evgeny Onegin* (1823–31), the Russian poet Pushkin makes Tatyana's mother refer to the 'English novels', which her Moscow cousin praised in her youth. The 'safe' world of the novels, which Tatyana also knows, is now challenged by her real-life love for Onegin, which he rejects. Years later, by then married into Moscow society and no longer the girl she was, it is she who rejects Onegin. It is a story of correspondence and reversal, marked by painful leaps of memory. Pushkin, an admirer of *Tristram Shandy*, chooses as a poet the medium of verse for his realistic 'novel', but verse with a pattern of varying accentuation within a fixed rhyming scheme set by a fourteen-line stanza. The effect has the unpredictability of Pushkin's own comments on his characters, for this novel, unlike those written in the form of letters, admits its author as observer.

The sentimental English novels referred to in *Onegin* flooded the bookshops and circulating libraries (p. 51) in the late eighteenth century. While, however, the popularity of such fiction, especially with women readers, held down the level of esteem that was accorded to the novel as literature, it was women themselves as writers, coming anyway from a position of low esteem, who were increasingly to contribute to the genre's steady advance. In France the seventeenth-century romances of Mme de Scudéry and Mme de Lafayette had been dismissively treated by the *philosophes*: but other factors were now to give value to fiction written by women, in France but especially in Britain. First, there was Richardson's inestimable highlighting of the basic plot of the

'unknown' woman who advances in society. *Pamela* and *Grandison* were followed by the anonymously-published letter-novel *Evelina* (1778) – subtitled 'A Young Lady's Entrance into the World' – which turned out to be the work of a woman, Fanny Burney (1752–1840). With this, and *Grandison*, the young Jane Austen (1775–1817) found important beginnings. Second, there were feminine insights into social and domestic issues. Maria Edgeworth (1767–1849), who was also admired by Austen, unerringly portrayed, in *Castle Rackrent* (1800), life on an Irish estate as she herself had known it. Austen herself, hardly mentioning the Napoleonic Wars, preferred to concentrate on her faithfully-shaded evaluation of the benefits of the gentry's role which she knew, and wished to see preserved in English life. Thirdly, there was the exploration of female sensibilities in the Gothic novel, which provided Ann Radcliffe (1764–1823), as we saw (p. 52), with a large readership.

Jane Austen responded to Radcliffe also, especially in forming her view of sensibility. In Radcliffe's *Mysteries of Udolpho* (1794), the heroine marries the man of sensibility, not before her father has counselled her about its dangers. Austen also pondered its destabilizing effects, which her mentor Samuel Johnson had darkly linked with 'perturbations'.[15] She satirized the Gothic craze in *Northanger Abbey* (begun 1797, published 1818), and in the work in which she marked down sensibility, the novel *Sense and Sensibility* (begun 1797, published 1811). Here sense, represented by Elinor, keeps in focus the collective wisdom of the past; sensibility, personified by her sister Marianne, is sparked by the headstrong, individual insights of the present. Each has its value: but sense preserves the family, sensibility undoes it.

As with Pushkin later, Austen reserves the freedom to comment on her characters, often with irony and always with point. In chapter eleven of *Pride and Prejudice* (begun 1797, finally published 1813), two characters speculate in conversation about the motives of a third in not joining them in a walk:

> Depend upon it, he means to be severe on us [observes Elizabeth to Miss Bingley, of Mr Darcy] and our surest way of disappointing him will be to ask nothing about it. Miss Bingley, however, was incapable of disappointing

Figure 24: Angelica Kauffman (1741–1807). *Maria.* Oil on metal, 31.1 × 25.4 cm. 1777. Burghley House, Lincolnshire.

The Swiss-born Kauffman was a successful woman artist in a world of male professionals. Working in England from 1766 to 1781, equipped with her wide knowledge of continental artistic practices, 'Signora Angelica' became a founder-member of the Royal Academy in 1768. Her decorative paintings of classical and medieval subjects appealed widely to late eighteenth-century taste.

In Laurence Sterne's travel book *A Sentimental Journey* (1768), Maria is abandoned by her lover; with her small dog as sole companion, she plays her pipe, her melancholy symbolized by her green ribbon. Engraved by Ryland in 1779, Kauffman's image of her had extraordinary success, appearing on a Wedgwood cameo mounted in a cut-steel frame by Boulton, and on decorative articles that included a watch-case, a tea-tray and a pole-screen.

Mr Darcy in anything, and persevered therefore in requiring an explanation of his two motives.

Here, and in the three later novels, the turns and slants of thought have in common with another creation of the Regency, the kaleidoscope, the shift of integral component parts leading to the final overall resolution of a pattern. And Jane Austen, a pianist of accomplishment, is sensitive to that instrument's ability to provide connecting passages, which make the most of her own invaluable appearances as commentator.

Austen's art, little praised by contemporaries, was admired by the period's greatest international success as novelist, Walter Scott (1771–1832). Where Austen wrote only about the society that she personally knew, Scott avoided his own time in all but one (*St Ronan's Well*, 1824) of the twenty-seven Waverley novels that made him famous. He preferred to portray past societies, with a curiosity born of the Enlightenment: Goethe felt he had a 'thorough grasp of every ramification of his material'. But for contemporaries the imaginative grasp was also there: after reading *Ivanhoe* (1819), Goethe told Eckermann (8 March 1831) that he found in it a 'whole new art'. Scott's interest in periods that ranged back to the Middle Ages and in what had united and divided people's beliefs in the past coincided with the nationalisms that we shall discuss in Chapter Four (p. 182f.). But his inmost eye was fixed on his native Scotland, not only a nation but a composite of Highland and Lowland elements, each with a vernacular life that was already fast disappearing in his day. Scott's knowledge of what was being lost tapped a nerve in his compatriots – and notably tested the patience of his illustrators. But his fame was chiefly spread by his characters, of both sexes and from every station of life. One of his richest assemblies, in *The Heart of Midlothian* (1818, set in the 1730s), extends from the real-life English Queen Caroline to the imaginary Madge Wildfire, who sings examples of another of Scott's interests, the traditional Scottish ballad.

The tragic plot of *The Bride of Lammermoor* (1819, also set a century earlier) points to one of the major factors in Scott's success: his ability to co-ordinate dramatic contrasts. Against the antagonism between Edgar Ravenswood, whose aristocratic family is in decline after a long feudal past, and the middle-class William Ashton, whose legal sleight-of-hand has displaced the old family from Ravenswood Castle, is set the love between Edgar and Ashton's daughter Lucy. Against the rational account of the causes that produce social change are set currents of 'auld prophecies', which gather round Edgar's family bolt-hole of Wolf's Crag. And Scott's mastery of symbolism lights up both the prose and the central predicament of the hero as, with Ashton, 'his mortal foe', under his roof, 'he threw open and shut the latticed windows with violence, as if alike impatient of the admission and exclusion of air' (Chapter 14).

For contemporaries the windows unlatched by Scott himself remained spectacularly open. To the French he conveyed what Delacroix called the 'astonishing smell of reality'. Hugo, writing in the periodical *La Muse française* (1823), used the orgy and murder scene from Scott's *Quentin Durward* (1823)

to propose that life was as ugly as it was beautiful, and that it was the artist's task to show this. Berlioz was moved to compose musical portraits of *Waverley* (1827) and *Rob Roy* (1832). Alexandre Dumas challenged Scott's memory with his novels *Les trois Mousquetaires* and *Le Comte de Monte Cristo* (both 1844). For the Germans the enthusiasms which led Scott to translate Goethe's *Sturm und Drang* play *Götz von Berlichingen* (1771, about a sixteenth-century knight), and to produce *Ivanhoe* (1819), in turn ensured Scott's influence on the German tale of knightly character, the *Ritterroman*. To the patriot-novelists of Hungary the glorious past of Transylvania was the equivalent of what Scott had shown Scotland to possess. And in America James Fenimore Cooper (1789– 1851) responded to Scott's setting of old order against new, in *The Bride of Lammermoor*, by writing realistic accounts of confrontation between Indian and pioneer (*The Pioneers* 1823, *The Last of the Mohicans* 1826, *The Prairie* 1827, *The Deerslayer* 1841, all 'Leatherstocking' novels, after the nickname of the tragi-comic figure of the backwoodsman Natty Bumppo).

In Europe itself the modern social novel was further advanced by the Frenchman who called himself Stendhal (Henri Beyle, 1783–1842). Like Scott, whose work he admired, he took up novel-writing in his forties. Unlike Scott, his analyses of human conscience and ambition were presented in two great novels which were resolutely pitched in contemporary times, respectively post-Napoleonic France and Italy: *Le Rouge et le noir* (*Scarlet and Black*, 1831) and *La Chartreuse de Parme* (*The Charterhouse of Parma*, 1839). Each story is set against a dense background of 'small, true facts' (*de petits faits vrais*), often documented from newspaper accounts of events or from legal files. Stendhal's resolve to write fiction after many years as a writer of criticism (notably of music) indicates his sense of where the novel stood after 1815. Admiration for Scott had made him aware of ways of combining description in fiction and – what he particularly wished to do – the psychological recreation of settings through the feelings of characters who (as Starobinski has shown) reflect himself, Henri Beyle.[16] With the passing-away of the old regime, the contemporary world offered itself for such recreation. Romanticism, he declared in his pamphlet *Racine et Shakespeare* (1823), was the art of giving pleasure to people living here and now. It was not classicism, which had given pleasure to their great-grandfathers. Drama still flourished (notably, besides the perennially fresh Shakespeare, melodramas after Ann Radcliffe and *tableaux vivants* after Scott); but for Stendhal human subtlety demanded its fictional due. The novel had come to be a natural choice.

Sometime between 1780 and 1830 (when Hugo's play *Hernani* raised its furore, p. 55), the novel overtook the drama as a creative form. It gained Scott as standard-bearer, could pay better, and could satisfy that humanitarianism which required the detailed documentation of life as it was lived. But it is hard not to connect this impetus with the achievement of women novelists. In the 1780s and 90s, together with the reforming radicalism of male counterparts like Robert Bage and William Godwin, there appeared the outright feminism of Elizabeth Inchbald, Charlotte Smith and Godwin's wife from 1797, Mary Wollstonecraft (author of novels as well as of *Vindication of the Rights of*

Woman, 1792, preceding Godwin's *Enquiry concerning Political Justice*, 1793). In England nervous reaction to the French Revolution reasserted the sexual *status quo* which had held women subordinate. But in post-Revolution France itself, Jane Austen's formidable contemporary Germaine de Staël (1766–1817) was ready to take on any opposition, including Napoleon. Her liberal, auto-biographical novels *Delphine* (1802), which asserted the disadvantages to women of marital laws devised by men, and the even more outspoken *Corinne* (1807), idealistically upheld the claims of female love against social convention. In *Mansfield Park* (written 1811–13, published 1814), Austen herself made her characters act a play about sexual freedoms (by the popular Austrian writer of sentimental drama, Kotzebue) in order, however, to drive home her own very different valuation of feminine loyalties in a family setting.

Whatever the feminist line, the documentation of real life that had become the novel's main task made unavoidable the fact that women's passions, in the interests of their own fulfilment, were every bit as strong as men's. They were further released after 1830 by the characters of George Sand (Aurore Dupin, 1804–76), campaigner for women's freedoms from behind her masculine *nom de plume*. But they also rolled through Victorian England in the pages of *Jane Eyre* (1847) by Charlotte Brontë (1816–55). The undervalued governess in Charlotte flowed into her character Jane, who analyses her hopes for Rochester's love with savage self-criticism, but nonetheless persists in them.

With such issues coursing through it, the novel made spectacular advances in the revolutionary age after 1789. But the almost total lack of restriction that it offered in formal terms, whether in the melting-pot of Romantic imaginings or that of social realism, gave it a protean artistic force also. Its prose could unfold an author's understanding of the intricacies of the English legal system and their effect on human beings, as Dickens's did in *Bleak House* (1852–53), or be as briefly charged and darkly tipped in flight as Emily Brontë's in *Wuthering Heights* (1847). Fiction could probe the weaknesses of a single character, as in Grillparzer's masterly short story *Der arme Spielmann* (*The Poor Street Fiddler*, *c*. 1847), or it could attempt the complete cultural maturing of a single character, as in the idiosyncratic German Bildungsroman (literally 'novel of formation'). This was apt to bend the whole gamut of available resources – the real, the fantastic, verisimilitude, unlikely coincidence – to its purpose.[17]

Though the great Bildungsroman by Goethe on the character of Wilhelm Meister (revised over forty years, 1786–1829) has a male protagonist, the female principle, in many forms, is integral to it. Wilhelm's journey of self-discovery takes him from stage-actor to participant in a real-life community of action (he became a surgeon). But little is predictable. In the first part of the story, the *Lehrjahre* (*Years of Apprenticeship*, 1796, translated into English by Carlyle in 1824), Wilhelm becomes fascinated by a waif-like representative of an instinctive femininity, Mignon. The contrast has an artistic as well as a 'realistic' point. While Wilhelm's story moves slowly, relating everything to him and his development – his character is later likened to a traveller's staff which puts out leaves wherever it rests, but cannot root – Mignon is essentially fugitive, fixed only on her lost past in Italy, as summed up in her song 'Kennst du das Land?'. 'Do

you know the land where the lemon trees bloom?' This was to be set by German composers everywhere, from Beethoven, Schubert, Schumann, Liszt and Wolf down, and give Mignon, along with her almost equally elusive predecessor, Manon, a prominent future in opera.

As Europe moved through the restless early nineteenth century, indeed, it became clear that the novel would be as close to the nerve-endings of writers as it had been in the eighteenth. But if Mignon's song of homesickness for her past became a strand in the Romantic movement's ineradicable nostalgia, its mood was reversed by Jane Eyre's cry of confidence in her future. 'I was weary of an existence all passive', she exclaims in Charlotte Brontë's novel; and later she openly declares to her employer, Rochester: 'It is my spirit that addresses your spirit; just as if both had passed through the grave, and we stood at God's feet, equal, – as we are!'

Transformations of the Classical

Visiting Hamburg in 1772 on his German tour, the English musician Burney heard Emanuel (C.P.E.) Bach playing his favourite instrument, the Silbermann clavichord. It was late at night: the master, Burney records, 'grew so animated and *possessed* . . . he said, if he were to be set to work frequently, in this manner, he should grow young again'.[18] The achievements of Johann Sebastian's second son were very public ones. His compositions for professionals and for amateurs were a staple of music publishing. His sonatas and concertos for keyboard were placing those forms in the centre of German musical thought. But he was known to value personal 'expressiveness'. The *empfindsamer Stil*, 'style of sensibility', he remarked in his book on keyboard playing (1753), was about moving the listener: in order to do it, the *player* must be moved.[19] Vary the metre, he advised, if the expression demanded it; and he included as illustrations experimental practice pieces (Probe-Stücke) and a Fantasia that had hardly any bar-lines. Surprise elements – Tristram Shandy-like pulse-irregularities, changes of key – abounded in his output. But if these forecast Haydn and Beethoven, Burney's account of Emanuel Bach's rapport with his instrument and improvisatory habits of mind pointed even further into the future. Sixty years before a full-blown Romantic such as Liszt took to the keyboard, Emanuel seems to have seen performing as virtually synonymous with creating, and vice versa.

The possibility offered to Bach by his keyboard playing – of becoming young again – was not easy to realize in public forms of art. The developed rules of architecture, decorum on the classical stage, *da capo* symmetries in opera, were harder to ignore, and anyway had their merits. But reforming voices were not lacking. The much-translated essay on opera, *Saggio sopra l'Opera in Musica* (1755), by the art connoisseur Francesco Algarotti (1712–64), called for simpler plots purged of tangled intrigue, to be performed in classically-ordered opera-houses stripped of decorative excess. In his *Dissertazione su le Poesie drammatiche de abate Pietro Metastasio* (1755), the poet Raniero de Calzabigi

(1714–95) asked for Metastasio's ripely-cultured operatic heroes to be replaced by more mettlesome individuals involved in forward-moving plots. French opera, which Algarotti and Calzabigi both studied, seemed to offer a promising flexibility.

NEW IMPULSES IN OPERA AND THE VISUAL ARTS

Calzabigi's libretto for the opera *Orfeo ed Euridice* (Vienna 1762, second version Paris 1774) had music by Christoph Willibald Gluck (1714–87), who also knew French opera in Vienna before his move to Paris. *Orfeo's* tableau-like succession of scenes held together largely by melodic line, without coloratura, made conventional *opera seria* seem merely ornate. With *Alceste* (Vienna 1767, second version Paris 1776), a 'tragedy set to music' with libretto by Calzabigi after Euripides, Gluck offered a preface (published 1769) which set out his aim to 'confine music to its dramatic province'. This sounds like a demoting of music, but in practice it meant that, instead of promoting show-pieces for individual singers, music would underpin the dramatic meaning expressed in the words so closely as to become indispensable to the full appreciation of it. So great, indeed, was Gluck's sense of music's dramatic value that he went on to use it to deny, for dramatic ends, what the words were actually saying. When Orestes sang of his 'calm' in *Iphigénie en Tauride* (Paris 1779), his music was in fact betraying the agitation which he was trying to control. Here was a device which Wagner was also to use to marvellous effect over seventy years later.

The ability to bring inner emotion to the very surface of the containing form was a special strength of Neo-classicism, which Winckelmann's advocacy of Greek art (p. 21) reinforced. The great picture *The Oath of the Horatii* (1784–85, Fig. 25), painted in Rome by Jacques-Louis David (1748–1825), achieves a close consonance with Gluckian ideals in its imposition of calm over agitation. The economical architecture in David's painting – unmoulded arches, columns without bases – helps to point up the tensions in front of it. Neo-classical architecture in essence, however, is the art not only of omitting superficial details but of elementally simplifying the mass of what is left. In 1777 Goethe was to take this process to the point of designing in his Weimar garden a six-foot high stone 'altar' consisting of a sphere on top of a cube. In emblematic terms the sphere of restless desire was stilled by the cube of virtue. Such regular Platonic forms were to obsess the French architect Ledoux (see Chapter Three, p. 125).

Classical Rome itself, which Goethe was not to see for another decade, evoked more complex conclusions. In October 1764 the physically small Edward Gibbon had explored the Forum with a 'lofty step', as he touchingly tells us; and between 1776 and 1788 his *Decline and Fall of the Roman Empire* was recharging the long-standing interest of observers in the ruined evidence of a former greatness. Already before 1750, the extraordinary engraver Giovanni Battista Piranesi (1720–78), Venetian-born but settled in Rome, had begun dramatizing Roman buildings of once-regular bulk by showing them half buried or invaded by vegetation, and dwarfing man. His *Views of Rome* unforgettably deployed the double-edged attitude which relished intellectually the stability of

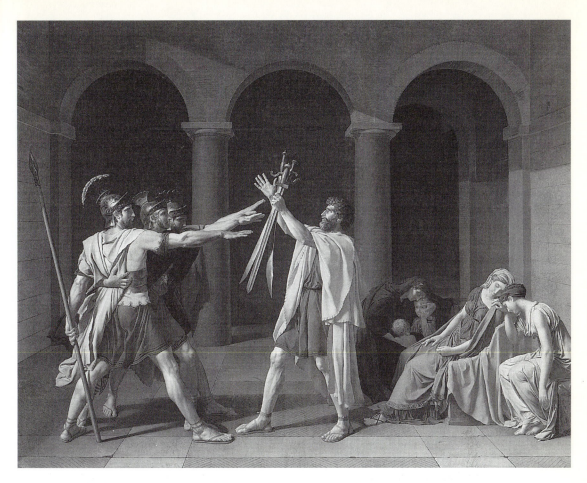

Figure 25: Jacques-Louis David (1748–1825). *The Oath of the Horatii*. Oil, 330 × 425 cm. 1784–85. Louvre, Paris.

There is a small cast of characters – men to the left, women to the right – as in Poussin's *Eudamidas* (Fig. 3). The shadows of the three brothers who have braced themselves to sacrifice their lives for the Roman State, and the father who is proud of the fact, stretch across to the troubled sister and sister-by-marriage and the hero-worshipping boy. All have their parts to play in this conflict of masculine and feminine principles. Perspective lines lead to the point where the swords are to pass from father to sons. Colours (chaste greys, browns and whites enlivened by red) inform the fully-modelled, unflinchingly-lit forms.

Though it was painted for the Crown as a *grande idée morale* (p. 60, see also Fig. 18), this great picture became a document of the Revolution five years later. The pose of the brothers was repeated by the revolutionaries in David's uncompleted depiction of the Oath on the Tennis Court of 1790, which proclaimed the search for a new constitution.

geometry while responding imaginatively to the destabilizing effects of time as it 'undid' that regularity through decay and accident. Piranesi's own imagination led him to contemplate the dissolution of human life in scenes of imprisonment and torture: the nightmarish visions of his *Carceri* (*Prisons*, 1745, 1761, Fig. 26) became icons of Romanticism after 1800, as we shall presently find.

Before these extremes gained ground, glimpses of the timeless accompanied by the knowledge that human beings were creatures of time had a rich significance. Though the classical ideal of what things ought to be like was to be increasingly overlaid by Romantic fears of what they obstinately were, Calzabigi and Gluck drew impressive power from the ancient Greek notion of human characters under stress against the background of hostile nature or the will of 'the gods'. The fundamental importance of their reform was to present characters without obtrusive artifice. This made them modern, just as Garrick's 'natural' acting of Shakespearian roles (which Gluck may have witnessed in London in 1745–56) made these modern.[20] Lessing, indeed, so far from seeing the classical Greek dramatists and Shakespeare as on opposite sides of a great divide (as advocates of the Unities had often decreed), saw them linked by a common, unquiet spirit which made Voltaire's accusation that Shakespeare lacked taste seem unimportant.

The blending of cool calculation with this warm-bloodedness was a difficult feat: but it was achieved incomparably in opera by Mozart. His *opera seria Idomeneo, re di Creta* (*Idomeneo, King of Crete*, Munich 1781) threads a classical story of a king who must sacrifice his son to placate Neptune through vital, winning music. He calculates in a letter that Neptune's part must not be long-winded, but will gain in effect by being brief, and concentrates on the human voices and responses.[21] The god is placated by human love: Idomeneo cedes benevolent rule to his son: Enlightenment principle is upheld.

Of Mozart's three operas with Da Ponte librettos, *Le Nozze di Figaro* (*The Marriage of Figaro*, Vienna 1786) brings together the Count jealous of his rights, Figaro his irrepressible servant, the Countess feeling her husband's neglect, and her lively maid Susanna, whom Figaro loves. The action, confined to a day, gives rise to home-truths across the class divide, and reminders of where people's

Figure 26: Giovanni Battista Piranesi (1720–78). Plate VII from *Carceri d'Invenzione* (*Prisons of Imagination*, 1761). Etching 51 × 44 cm. British Museum.

The 1761 edition of *Carceri* contained reworkings of the original plates of about 1745 and two extra ones. In this later edition a world of menace and nightmare is intensified: massive Roman arches interweave with high walkways, spiral staircases, ropes, chains and ominous instruments of the torture-chamber. Plate VII has a huge drawbridge with tiny people on each leaf: but there is a gap in the centre. The tradition which scaled classical architecture to human proportions is of little account here. Trained as an architect, aware of the work of scene-designers, including the Bibiena family (Fig. 20), and the architect Juvarra, Piranesi translated Baroque stage-craft into a violent personal fantasy which in turn nourished the Romantic bridge painting (compare Turner, Fig. 45), as well as the prison sets of opera (e.g. *Fidelio*, pp. 101–2).

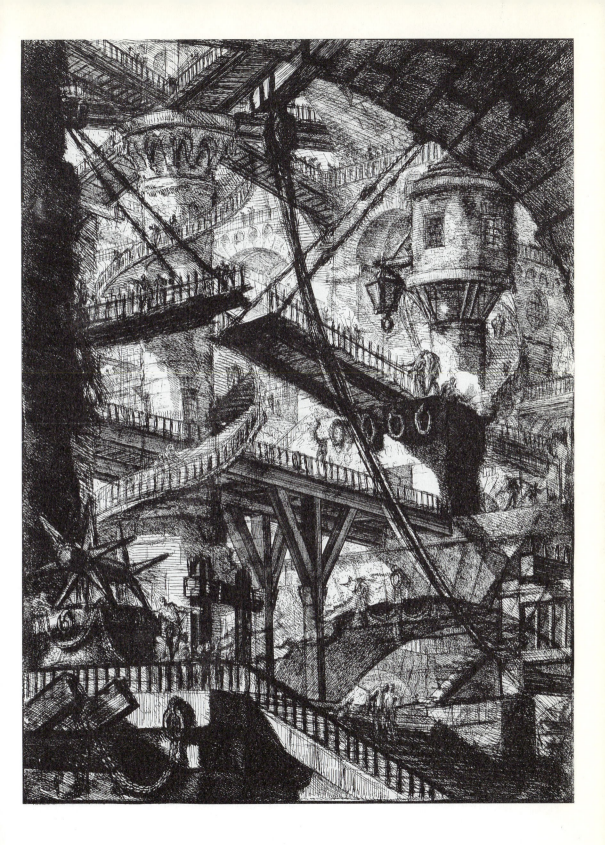

responsibilities to each other lie. Joseph II had banned the German translation of the original Beaumarchais play (as potentially subversive to the bourgeois public who would read it), but allowed the opera, judging that it would do the aristocracy no harm to hear the message, which in any case makes a human rather than a political point.

The other two Da Ponte operas also return to eighteenth-century themes which we have met already. *Don Giovanni* (Prague 1787) rehearses the story of the sexually insatiable rake which, since its first presentation in a play *El Burlador de Sevilla* (*c.* 1606), had attracted Molière (1665) and Goldoni (in a verse-play *Don Giovanni Tenorio o sia Il Dissolato*, 1736). Various debased versions of the story on the popular *commedia* stage had earned it the disapproval of the cultivated: but fascination with the sexual drive as a governing principle in life had grown with the appearance in novels of such characters as Lovelace (p. 86) and Valmont (p. 88), and in real life of Casanova. Da Ponte, adapting a libretto by Bertati, effectively made Seville into a mazy hinterland where all the characters can do is brace themselves against the Don's next onslaught. Dramatic force is therefore given, late in Act II, to one apparently permanent reference point, the statue of the Commendatore, whom Don Giovanni has killed in Act I after raping his daughter. But it proves famously not to be fixed: the statue, presenting itself at Don Giovanni's final banquet and calling on him unsuccessfully to repent, sends him to perdition. Mozart's music, solemn, melting and humorous by turns, perfectly matches the description he and Da Ponte agreed to for the work: *dramma giocoso*. This opera, and the mysterious persona it projected of the Don, lover and self-lover, were to intoxicate Romantics like Hoffmann.

Così fan Tutte (*Women are like that*, Vienna 1790), taking one of its cues from the feminine culture of the novels, holds up calculated ploy as well as genuine sentiment as a vital factor in winning affection. The widely-read Da Ponte will surely have known *Les Liaisons dangereuses*. The plot turns on the pragmatic interplay of the sexes using disguise, an idea found in Marivaux (p. 83), who also used the device of a symmetrical plan of characters. The character behind it, Don Alfonso, holds to a cynical version of the Enlightenment notion of rationalist love (based on mature, unshakeable thought) as an impossibility for women. The ending, though improbable (the lovers are reconciled), also has its Enlightenment message: both couples have gained in worldly self-awareness.

Apart from the relationship of the plots to their times, the Mozart-Da Ponte operas shine in two special ways. First, regard for changing human situation. The liberally-scattered instructions *attacca* (attach) and *segue* (follows on) in *Idomeneo* had betokened a dramatic blurring of recitative into aria in order to push the action forward. In the Da Ponte operas emotion is drawn straight out of each moment of the dramatic situation, not dressed up to draw applause. Second, they embody the full maturity of eighteenth-century Austro-German musical thought. Mozart had heard the outstanding orchestra of Mannheim playing symphonies and the form known as *sinfonia concertante*, which married solo instrumental voices to an orchestral texture; in 1779 he wrote the

greatest example of it himself (for violin and viola). He had an early sensitivity to ordered but surprising key change for dramatic effect: he himself explained how, in the *Singspiel Die Entführung aus dem Serail* (1782), the blind rage of the black steward Osmin moves from F major not to the nearest key D minor but to the more remote (but still related) A minor. Now in *Don Giovanni* the predominating D minor is offset against B flat major, as Beethoven was to do in his Ninth. The Act III sextet in *Figaro*, as Rosen has shown, uses sonata form: the tonic for the characters who begin it moves to the related – but different – dominant when Susanna arrives on stage.[22] Moreover the way that almost any Mozart theme – for an instrument like piano or violin – sounds singable, shows that he was thinking in sung lengths; this applies in all its strength in the operas, as well as the necessary business of fitting music to words.

Mozart's other operatic masterpiece, *Die Zauberflöte* (*The Magic Flute*, Vienna 1791), had a German text by Schikaneder, and was put on for the public, not the court. It presents characters under duress as in *Idomeneo*, but with a different set of symbols: trials of fire, water and love in a confined setting solemnized by ceremonies akin to masonic ritual. These are combined with 'popular' elements: the pantomime of Italian *commedia* and echoes of the 'Turkish' style which had appeared in Viennese opera in the French mode by Gluck, and in Mozart's own *Die Entführung*. Supernatural and natural, comic and serious, are intimately linked. And the formal and exotic qualities are also used in the music to point up the humanity of the hero and heroine: in the end both are delivered and, as in the Orpheus story, the power of music (here in the notes of the magic flute) has its unique role.

What of Mozart's heroines? If the plots of *Don Giovanni* and *Così*, in different ways, place women at a disadvantage, *Figaro* and *Die Zauberflöte* redress the balance, as Levey once argued.[23] The forlorn Countess in *Figaro* has a foil in the pert Susanna: their plan to bring to order the erring Count and Figaro provides the hinge of the final act. It entails changing into each other's clothes: the eighteenth-century habit of disguise had never, perhaps, taken on a greater seriousness. 'I feel it', sings Pamina in *Zauberflöte*, misinterpreting the silence that the high priest has enjoined on her lover to mean that he no longer loves her. Her sadness (like that of Costanza in *Die Entführung*, registered in G minor, the key of the troubled Symphony No. 40) is only temporary, and her resolve is conspicuous in bringing about a happy outcome.

When *Die Zauberflöte*, with its auspicious ending, was first mounted, the French Revolution was two years old. The incarcerations and executions in the Terror that followed were a reminder that the symbolic opening up of the Bastille in 1789 had been overtaken by a new threat. The pure essences of Goethe's daylight garden with its cube and sphere were set to drain into a Piranesian nightmare. Goethe's unfinished sequel to *Die Zauberflöte* celebrates the human power of generation, but the child of Tamino and Pamina is kidnapped. And the Piranesian drama of imprisonment, linked to the theme of release, is relived in the Romantic operas to which, without leaving its Enlightenment atmosphere of wisdom attained, *Die Zauberflöte* so clearly points. Its successor is Beethoven's *Fidelio* (*Leonore*, 1805, in three acts; 1806, in two acts; final

version in two acts, Kärntnertortheater, Vienna 1814). Here – contrary to the Orpheus myth – it is a man, the unjustly imprisoned Florestan, who is rescued by a woman, his wife Leonora.

The libretto to *Fidelio* originated as a French text, *Lenore* (about fidelity in marriage), which claimed to be a true *fait historique* from the French Revolution. But Beethoven wanted more from it than the *dramma giocoso* treatment it had received from other composers. The title became *Fidelio*, the name assumed by Leonora disguised for her rescue bid. For the overture Beethoven composed three heroically-inspired symphonic movements which developed separate existences (as the Leonora overtures 1, 2 and 3), before he arrived at the final, succinct prelude-like version. It is not that the words in this *Singspiel* opera are unimportant: the song of the prisoners as they emerge from prison into the light builds up from broken whispers to an ode of thanksgiving for freedom, one of the greatest moments in opera. But the other great beam of light that penetrates the prison, as Florestan's liberation is signalled by the arrival in Act II of the minister of state, is delivered unalloyed by the trumpet.

Beethoven composed no more operas. The true sequel to *Fidelio* was to be the Ninth Symphony (completed 1824). The ethical idealism of Schiller, which had suffused *Fidelio*, here emerged explicitly in the setting of verses from that writer's 'Ode to Joy' (1785) in the famous choral finale. When the baritone enters, Beethoven makes him apparently reject the instrumental movements that have gone before: 'Not these sounds!'. But it is noticeable that less than half Schiller's words are actually used: the sentiment is expressed no less in the totality of the musical theme and the variations that are rung on it by soloists, chorus and orchestra, than in the actual key words 'Alle Menschen werden Brüder' ('all men become brothers'). Here we have a new mutation of the old word-music relationship, each linked with the other to the point of inseparability.

ROMANTICISM IN OPERA AND *LIEDER*

The 'rescue opera', of which *Fidelio* is an exceptional example, had been acclaimed for a generation. Themes associated with the Gothic novel and with German *Sturm und Drang* of the 1770s (pp. 25, 184) account for much of its power to fascinate; but Enlightenment speculation about the ideal society of the future, reinforcing antiquarian study, had helped to idealize the medieval past, when for heroes like Richard Coeur de Lion or Robin Hood – so it seemed to the later age – problems seemed solvable by simple force of action. Incoming Romantic sympathies for the oppressed individual lent support. Thomas Gray's poem *The Bard* (1769) celebrated the resistance to Edward I's tyranny of the ancient poet-seers of Wales. Similar themes were sounded in the poems of the Caledonian hero Ossian (published by Macpherson in 1762, and in fact his invention). Ossian replaced Homer in the susceptible heart of Goethe's Werther. The voices of the medieval man of action and the bard were united in one of the finest of the early rescue operas, Grétry's *Richard Coeur de Lion* (Paris 1784), which contained a version of a troubadour song. But this is a royalist

opera with no revolutionary aims, and plots which portray the lower classes in this pre-Revolution period do so as an outcome of the sensibility of the *drame bourgeois*, not to subvert.[24]

The Paris revolutionaries of 1789, celebrating republican Rome, also found much to honour in more recent literary heroes. Schiller's play *Die Räuber* (*The Robbers*, 1781), about Karl Moor, who rebels against injustice and tries to set the world to rights, became a symbolic text. In 1791 honorary French citizenship was conferred on Schiller. Scott's prolific life-work set a long-term seal on the attractiveness of medieval subject matter: he used episodes from Goethe's *Götz* (p. 184) in his novels *Ivanhoe* (1819) and *Anne of Geierstein* (1829). In *Ivanhoe*, a detailed study of chivalry and its relationship to the feudal system, he introduced the Robin Hood character of Locksley as representative of the rights of the poor.

French *opéra comique*, meanwhile, used rescue plots which were not at all comic to underline the theme of political freedom. Cherubini's *Lodoïska* (1791), described as a *comédie heroïque*, marked a transition to the world of *Fidelio*. During the Revolution Paris had been galvanized by festivals for which Cherubini (1760–1842) and the ever-surprising Méhul (1763–1817), also a prolific composer of opera admired by Beethoven, had written hymns for the people. Napoleon's climb to power brought the inspirational potential of both worlds into focus. He admired Ossian, and had Ingres paint the subject for his bedroom in the Quirinal, Rome. But he also saw modern Paris, now filled with the classical sculptures and Renaissance painting plundered from Italy, as the successor to Rome, with himself as Emperor and patron of operatic spectaculars. Together with Gros as painter of his battles and his propaganda image (Fig. 54), Napoleon acquired in Gaspare Spontini (1774–1851) an able musical lieutenant from Italy itself. In Spontini's opera *Fernand Cortez* (1809), the main role of the conqueror of Mexico was based on Napoleon, who suggested the theme. The score abounds in military and chivalric gestures: the themes of imprisonment and eventual release are worked to the accompaniment of mighty choruses which anticipate Meyerbeer's full-blown essays in *grand opéra* such as *Les Huguenots* (1836). Spontini also looked back: the lyrical and hymn-like felicities of *La Vestale* (1807) recall Gluck, and the two transforming geniuses of Berlioz (1803–69) and Wagner (1813–83), divergent as they proved to be, were united in their regard for Spontini as a link with the earlier master.

With the collapse of Napoleon came the dethronement of Spontini in Paris: and he moved to Berlin. Although Italians held key posts in all the main German opera houses, national self-awareness produced its first Romantic masterpiece, Weber's *Der Freischütz* (*The Freeshooter*, Berlin 1821). The supernatural (involving a Faustian pact with the Devil) was summoned up in a sound-world deep in a typically German exploration of harmony and of the surrounding forest, as evoked by the horns from the first bars of the overture. But besides the German Wagner, the Frenchman Berlioz was stirred by this music.

New enthusiasms were meanwhile sweeping Europe: for Scott's novels, Byron's poems (p. 262), and Rossini's operas. If Paris had been deprived of

Napoleon and Spontini, the prolific and celebrated Rossini (1792–1868) could, in an important sense, replace both. His *Barbiere di Siviglia* (*Barber of Seville*) was soon conquering audiences to the point of being sung in New York in 1819 and in Russian in 1822 in St Petersburg. In Paris, where he worked from 1823, successive triumphs of his *bel canto*, coloratura and ensemble writing made plain the astonishing ability of his Italian-born singers to render virtuoso effects (Fig. 27). Perhaps it was this demonstrable matching of means to ends, as much as the sparkling wit, which enslaved a Europe struggling uncertainly free of war: together with the famous Rossini crescendo, as infectiously recognizable – as his biographer Stendhal makes clear – in Dresden as in Reggio.

If one side of Romanticism (recognized by Rossini in his *Guillaume Tell*, Paris, 1829, after Schiller) was mirrored in opera's move to greater physical span and large social issues, another was reflected in psycho-physical crises in the lives of individuals. Berlioz's autobiographical *Symphonie fantastique* (1830), to be discussed later (p. 146), is an example. The climax of the two-act opera *La Sonnambula* (*The Sleepwalker*, Milan 1831), by Bellini (1801–35), is when Amina, who alone can establish her innocence to the hero, sleepwalks across a crumbling plank bridge (we return to the bridge as Romantic motif in the Interlude). Donizetti (1797–1848), basing his opera *Lucia di Lammermoor* (Naples 1835) on Scott's *Bride of Lammermoor*, makes it culminate in the mad scene, a mini-masterpiece not only of vocal pyrotechnic but of psychological tension. A dramatic sextet in Act II has revealed the depths of inter-family feud (p. 92). In Act III the mad Lucia (Lucy Ashton) conducts an imaginary love-scene with the absent Edgardo. The spirallings of coloratura in the voice are echoed precisely in the runs of the solo flute, suggesting a 'doubling' akin to schizophrenia, which uncannily matches the heroine's condition.

Although operatic mad scenes had occurred before 1800, notably in Handel's *Orlando* (1733) and in *opera semiseria* (a blend of *seria* and *buffa* elements), perhaps it took the Romantic's appreciation of the *sound* of madness, as part of a wider interest in irrationality (p. 235), to have music not merely recognized for its freedom beyond the constraints of words, but given credit for it. With the mad Lucia, sonority and cadence enjoyed full equality with words.

It was not, of course, that opera librettists were now less important. Metastasio's spirit, as we saw, remained a force in Italian poetry, and in Felice Romani (1788–1862), Rossini, Donizetti and Bellini all knew that they had a

Figure 27: Rossini in Paris. Engraving 1819. Covent Garden Archives.

After inauspicious early performances (its première at Rome in 1816 was a fiasco), Rossini's *Barber of Seville* proved a triumph, notably at Paris's Théâtre Italien in 1819. Rossini-fever, in a France without heroes after Napoleon's fall, was to run even higher than in Schubert's Vienna. Among the *Barber's* many attractions was the trio of the second-act finale between Rosina (sung by Josephine Fodor, also London's first Rosina), Almaviva (Manuel Garcia), and the here cheekily-caricatured popular hero Figaro (Felice Pellegrini). Supporting his famous singers, pockets stuffed with music sheets, the composer heroically straddles as much ground as David's Horatii. Rossini was to become director of the Théâtre Italien in 1824.

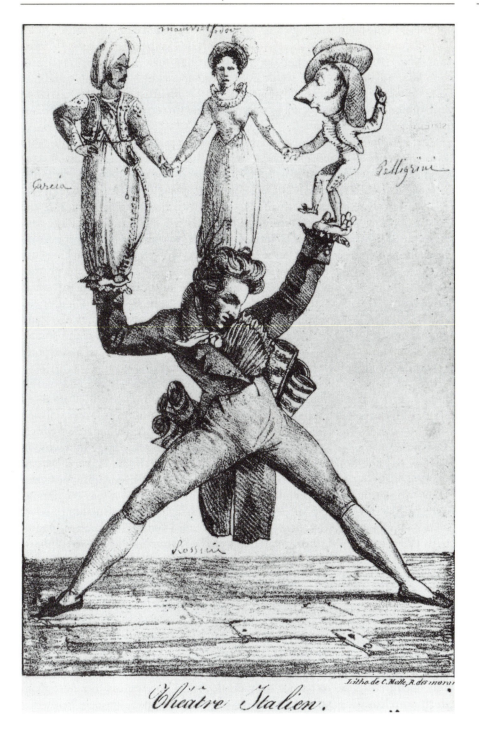

Théâtre Italien.

poet of supreme linguistic elegance. Pronunciation needed care: the future Queen Victoria, accompanying a singer in a duet from Donizetti's *L'Elisir d'Amore* on 3 May 1836, wrote in her diary that 'he has such a fine voice and pronounces so distinctly and so well'. Even in the operas of big ensemble and lavish spectacle of Meyerbeer (1791–1864) and his librettist Scribe, sensitivity to word-sound as such could take in onomatopoeia (the song 'Piff, paff' in *Robert le Diable*, 1831).

Away from the operatic showpieces, however, the intimate relationship between words and accompanying sound, and an increasing willingness of composers to give expressive value to that sound as such, could be explored, as nowhere else, in the German *Lied*. Schubert's song 'Gretchen am Spinnrade' (1814) perfectly matches the anxious words of Goethe's heroine in *Faust* to the restless spinning-wheel of the piano part, and the whole becomes a quintessential expression of Romantic feeling. Composers of song with piano accompaniment had to handle a scale of forces which allowed no side-tracking into the external show that was drawing the audiences for grand opera. Integration of the sense of the words and the sound of the music is total in the songs and song-cycles of Schubert (*Die schöne Müllerin, The Beautiful Maid of the Mill*, 1823; *Die Winterreise, Winter Journey*, 1828–29; see Chapter Five) and Schumann (such as *Dichterliebe, A Poet's Love*, 1840). Here the piano sound, as in Schumann's famous preludes, interludes and postludes which surround the words, could gather to itself the entire sentiment of the song.

On the larger public stage, Italy must be remembered at the end of this chapter, as it was at the beginning. The Austrian yoke that had been imposed after 1815 provoked mounting opposition in the next thirty years, during which Alessandro Manzoni (1785–1873) produced his powerful patriotic novel *I Promessi Sposi (The Betrothed*, 1825–27). This attracted a large following in Italy as well as the praise of Walter Scott and others abroad. Liberty was to be a beacon theme in poetry also, such as that of the short-lived Giuseppe Giusti (1809–50), writing in the popular language of Tuscany. But it was the nationalistic operas of Giuseppe Verdi (1813–1901) that, despite censorship of overt political statement, set light to the cause: *Ernani* (Venice 1844, after Hugo), *Attila* (Venice 1846), *I Masnadieri* (London 1847, after Schiller's *The Robbers*) were followed, in the year of revolutions, 1848, by his *La Battaglia di Legnano* (Rome) celebrating the historical defeat of Barbarossa.

Yet it is what Verdi does with the primary human emotions such as vengefulness and pride, as in *Rigoletto* (1851, after a Hugo story), that really sticks in the memory. No more effective example exists than his depiction of Lady Macbeth's guilt in his opera of 1847 by Piave after Shakespeare. Here was a piece which included the themes of political oppression, of the supernatural, of sleepwalking, that we have met. But this sleepwalker's music is unforgettably anchored to the insistence of guilt: the vocal line returns to a note from which no release is possible, and an instrumental line rises uneasily below it.

Verdi, close to 1850, setting his own language of the people to Shakespeare's freedom of pace and emotion, seems a far cry from Wren, thinking about 1700

of architectural 'Latin' as the only appropriate model for St Paul's (p. 69). The changes that affected music allow us to measure something of this distance. Music, to which Wren compared his 'contrivance' of architecture, had by Verdi's time attained an extraordinary expansion in its own linguistic resources. Throughout this period – from Purcell's setting of English words, Bach's vivid recitative-settings of the Evangelists' stories in his Passions and Mozart's lively recitative-dialogue in his operas, to Verdi's dramatic handling of the librettos he scrutinised so carefully – we can see and hear music acquiring the flexibility of human speech. Together with fictional prose and the writings of women, it had become the modern voice of feeling: so that it was to make German Romantics, about 1800, see even architecture as a frozen version of its movements. It was Madame de Staël and Byron, pulled up by that enigmatic phrase, 'architecture is frozen music', who asked what the Germans had really meant. Once Europe had turned the matter over, it was clear that the aspects of music that would hold the attention of the future were the living ones.

Among these living aspects of music, the Baroque development of opera – formally consolidated in the Catholic courts, but possessed with a capacity to move into traditions and among publics that were remote from it – must rank high. The dramatic vocal writing of Handel in England and of Sebastian Bach for his German Lutherans, drawing directly on *opera seria*, constituted, indeed, with architecture, the greatest achievement of the eighteenth-century Baroque. But any conservatism that might result from this music's attachment to secular and religious establishments was overridden by developments after 1750: above all comic opera, Austro-German interest in sonata form and the orchestra, and that concern for the contemporary stage – both of the theatre and real life – which led to Mozart, Beethoven and beyond.

Beside music's ability to turn connexions with courts and noble patrons to wider public account, went its ancient power to convey private or intimately-shared emotion to individuals at any social level. Such was the effect of Beethoven's song *Adelaïde*, heard by Heine in the Paris salon of a Jewish banker from Hamburg who kept open house for his compatriots.[25] The increasing interest of composers and publishers in bringing songs, songs without words (Mendelssohn produced six volumes for piano in his lifetime: two more came out later), sonatas, impromptus or selections from operas into ordinary middle-class homes relates music to other innovating arts of the period, to the novels – and to the landscape paintings, as the life of nature began to absorb more and more painters and some of the newer collectors. It is these visual concerns in particular that we must consider next.

NOTES

1. Schelling (1775–1854) used the phrase 'erstarrte Musik' ('stiffened music'), in a Berlin lecture of 1802–3 (only published 1859). Mme de Staël relayed the idea to England, where Byron took it up (*The Bride of Abydos*, 1813). See Erika von Erhardt-Siebold, 'Harmony of the Senses in English, German and French Romanticism', *Publications of the Modern Language Association of America* **47**

(1932), pp. 577–92; also Hugh Honour, *Romanticism* (1979), ch. 3. It became a Romantic commonplace to compare Gothic architecture with the music of Bach and Handel: see C.J. Becker, 'Ideen über Baukunst und Musik', in *Neue Zeitschrift für Musik*, 1838, cited in P. Le Huray and J. Day, eds, *Music and Aesthetics in the Eighteenth and Early-nineteenth Centuries* (abridged Cambridge edn 1988), pp. 331f.

2. Lorenzo da Ponte, *Memoirs*, trans. E. Abbott (New York 1907), p. 37

3. Claude Perrault, *Ordonnance de cinq Espèces de Colonnes* (Paris 1683). See Joseph Rykwert, *The First Moderns: the Architects of the Eighteenth Century* (Massachusetts Institute of Technology, Cambridge, Mass. 1980), p. 33

4. See *Dr Burney's Musical Tours in Europe*, ed. Percy A. Scholes (2 vols: 1959), vol. I, p. 138

5. Richard Leppert, *Music and Image: Domesticity, Ideology and Social-cultural Formation in Eighteenth-Century England* (Cambridge 1988), p. 149

6. Ian Watt, *The Rise of the Novel* (1957, 1987), pp. 186–8; Pat Rogers, *The Augustan Vision* (1974), p. 74

7. On the background of the fairs and musical life of Watteau's Paris, and patronage, see M.M. Grasselli and Pierre Rosenberg, eds, *Watteau 1684–1721*, exh. cat. (National Gallery of Art, Washington DC 1984–85)

8. Angelo Costantini, the Italian actor who had made Mezzetin famous in the Paris theatre in the 1680s, acted without a mask. Watteau often abandons the traditional 'floured' make-up of Pierrot, allowing the actor's face to appear. Cf. *Annales du Théâtre Italien* (Paris 1788), vol. I, p. 36

9. Hans Hammelmann, 'A Georgian Guide to Deportment', *Country Life* **143** (1968), pp. 1272–3. Lord Chesterfield, *Letters to his Son and Others*, Everyman's Library (1951 rpt), p. 126 (letter of 14 Nov., O.S.1749)

10. Andrew Steptoe, *The Mozart–Da Ponte Operas: The Cultural and Musical Background to* Le Nozze di Figaro, Don Giovanni *and* Così fan Tutte (Oxford 1988), pp. 132–4. Charles Rosen, *The Classical Style* (1971), notes the links between Marivaux and *Così*

11. On the *femme fatale* aspect of Manon see Naomi Segal, *The Unintended Reader: Feminism and Manon Lescaut* (Cambridge 1986), especially pp. xvii, 135

12. The 'female figure who tells her own tale' is discussed by Susan S. Lanser, 'Plot, Voice and Narrative *Oubli: Juliette Catesby's* Twice-Told Tale', in Frederick M. Keener and Susan E. Lorsch, eds, *Eighteenth-Century Women and the Arts* (New York, Westport, Conn. and London 1988), pp. 129–39

13. Robert Darnton, 'Readers respond to Rousseau, The Fabrication of Romantic Sensitivity', in *The Great Cat Massacre and other Episodes in French Cultural History* (1984), pp. 215–56

14. On the significance for Sterne of Hogarth's use of emblem and 'digression' in his incident-packed paintings, see Ronald Paulson, *Hogarth: vol. III, Art and Politics, 1758–1764* (Cambridge 1993), pp. 276f. See also Ch. 3, p. 120 below.

15. Johnson, *Rambler* **28**. On the sense of destabilizing potential in Gothic novels, which succeeded so well with a popular readership at a time when 'the people' represented a disturbing unknown quantity to traditionalists, see Marilyn Butler, *Romantics, Rebels and Reactionaries: English Literature and its Background 1760–1830* (Oxford 1981), pp. 37–8

16. Jean Starobinski, 'Pseudonymous Stendhal' in *The Living Eye* (1989)

17. Franco Moretti has argued that the *Bildungsroman*, after 1800, becomes a European not simply a German phenomenon, as youth, lacking the stable world-

picture of past generations, is involved in 'giving shape' to the new 'modernity' (*The Way of the World: The* Bildungsroman *in European Culture*, 1987). But the term continues to identify a particularly German concern: see Todd Kontje, *The German* Bildungsroman: *History of a National Genre* (Columbia, South Carolina 1993)

18. See *Dr Burney's Musical Tours in Europe*, ed. Percy A. Scholes (2 vols: 1959), vol. II, p. 219

19. See also Philip Barford, *The Keyboard Music of CPE Bach* (1965), p. 32

20. Daniel Heartz, 'From Garrick to Gluck, The Reform of Theatre and Opera in the Mid-eighteenth Century', *Proceedings of the Royal Musical Association* **94** (1967–68), pp. 111–27

21. Mozart, letter to his father, 29 Nov. 1780. See Emily Anderson, *The Letters of Mozart and his Family* (2 vols: 1966), vol. II, p. 674

22. Rosen, *The Classical Style*, pp. 291–2; Steptoe (see note 10) is illuminating here, pp. 164–5

23. Michael Levey, 'Aspects of Mozart's Heroines', *Journal of the Warburg and Courtauld Institutes* **22** (1959), pp. 132–56

24. F.A. Philidor's opera *Sancho Pança* (1762) ends with a plea for the *status quo*, for everyone to live in his or her proper station. See J. Mongrédien, 'Paris: The End of the *Ancien Régime*', in Neal Zaslaw, ed., *Man and Music. The Classical Era: from the 1740s to the end of the 18th century* (1989), p. 93

25. Reported, with all Heine's ironies and overlayings of social observation, in S.S. Prawer, *Heine's Jewish Comedy: A Study of his Portraits of Jews and Judaism* (Oxford 1983, 1985), p. 653

3

Perceptions of Nature: Design and Chance

Prelude

As we saw, Wordsworth (1770–1850) described the link between man and nature in terms of gravitational pull and 'filial bond'. Interest in nature, in the century since Newton identified gravitation as the force which held the planets in their paths, had become widespread. That quality of close-knit belonging which the Augustans had found in society was increasingly to be looked for beyond it, especially in Rousseau's gospel of nature, proclaimed so eloquently in *La Nouvelle Héloïse* and elsewhere.

It was also a valuable part of the legacy of Newtonian order that Design – one of the sub-themes of the following chapter – had had its authority reinforced for artists. Design, which Johnson defined in his *Dictionary* (1755) as the 'idea which an artist endeavours to execute or express', implied controlling purpose, abjuring the accidents of chance. In the visual arts Italian influence, concentrated round the human figure, had long emphasized the control of contour. Linear rhythms enfolded the dancers in Rubens's *Kermis* (Fig. 1); they now linked the striding women of Fuseli (Fig. 50). The disciplines of drawing that had been used to express the moral messages of Poussin (Fig. 3) were now applied by David (Fig. 25). Design aimed at a shared coherence: in 1792 David himself designed the uniform which should draw together the citizens of the new French Republic. Yet later in the same decade David's Spanish contemporary Goya (1746–1828) wrote on one of his *Caprichos* prints (see Chapter Five, p. 215): 'Chance presides over the festival, and distributes roles according to caprice'. If such a view of humanity was far from David's, it was even more so from Wordsworth's 'filial bond'.

In the following chapter the central theme is, therefore, the visible, investigable world of nature; the ideas of design but also of chance, as they exercise their rival attractions on artists, are sub-themes. In the seventeenth

century the pictures of Claude had projected landscapes of an ideal kind, made permanent by the control that the great artist had exercised over his vision of them. In the eighteenth the sublime in nature (p. 23) came to evoke its powerful emotional message. But at the same time new knowledge about the natural world had begun to open up new questions, not only for scientists but for artists also.

First, we take up the landscape garden and the interest in 'contrived accident' as a step towards a fuller acceptance of the unpredictable. It is easy to see the history of the eighteenth-century garden, in broad terms, as a move from French parterres and formal alleys, based on Italian precedents, to spreads of grass and meandering paths associated, notably in England, with the landscape park. It is less easy to gauge the extent of increasing awareness of fossils and rock formations and what appeared to be design at work in the wider natural world; but revelations of this, together with elements of anomaly that events such as the disastrous Lisbon earthquake (1755) seemed to present, suggested mysterious forces at work in nature which lay beyond man's present ability to explain; and opened up further lines of enquiry into the relationship between the accidental and the planned.

Against such a background of speculation about nature, the objectives of sculptural and architectural Neo-classicism – that search for unassailable simplicity and truth to purpose of which Greek and Roman sculptures and buildings provided visible evidence – took on an added exemplary force. In its pursuit of this Europe contrasts with America, where a new continent posed its special conditions, with nature as part of the challenge; and where Thomas Jefferson sought to use his experience of Europe to raise an architecture which was adapted to that challenge.

Close interest in the natural world linked much scientific work (some of it by Jefferson) on the landscape, flora and fauna of previously unfamiliar parts of the world, to the study of colour by Goethe and others. Colour, in fact, is enabled to take on the authority that academic tradition in the visual arts, based on Italianate preferences for drawing and line, had denied it. Observation of the infinite ways that colour changed under light in the open air was nevertheless to invite new applications of painting method that were capable of dealing with it. Though 'blot' drawing (a technique which demonstrated a further twist in the relationship between design and chance) enjoyed some notoriety in the late eighteenth century, the emergence of the direct watercolour wash in the painting of open-air subjects, and the innovations in oil technique and the use of the oil sketch, in Turner and Constable, led to fundamental developments in the scope of landscape painting. The intensely personal interpretations of nature by these artists, and by their German contemporaries Friedrich and Runge, were to provide the clearest proof of this enhanced scope.

Last of all comes the theme of man and nature in music, notably in Haydn's *Creation*, Beethoven and Berlioz, and in literature. Wordsworth and the young Shelley drew their own very different messages from the natural world: and one of the masterworks of the period, Goethe's *Faust* (1790,

1808, 1831), told of its hero's long, troubled journey, through many landscapes, in search of himself.

The Predictable and the Unpredictable

In his essay *Upon the Gardens of Epicurus* (written 1685, published 1692), Sir William Temple had pointed to the planned disorder of the Chinese garden. But the English also had behind them the great descriptions by Milton, in *Paradise Lost*, of Eden, the first garden, where luxuriant flowers 'broider'd the ground', yet where there was order appropriate to God's paradise.[1] From this ancient question of the relationship of Order to Disorder, of Pre-determined Design to Accident, as revealed in nature, came much of the momentum which carried the eighteenth century towards the Romantics.

Though landscape gardeners were interested in ordering the 'disordered' landscape of nature, it is hard to assess how far interest in gardens encouraged the increased practice of travel, for its own sake, in the open countryside. England, with its gardening interests and the organization of country life round local great houses, certainly had much to offer travelling sightseers and ramblers (the word had more serious connotations then than now). Books, from Defoe's *Tour through the Whole Island of Great Britain* (1724–26), through the writings of William Gilpin and William Combe, notably Ackermann's best-selling publication of Combe's *Tour of Dr Syntax in search of the Picturesque* (1809–12), to Cobbett's *Rural Rides* (1830), provided further incentives to accept the hazards of rough country roads and defective bridges. For his own period Pope is, as always, a useful guide. Designer of his own informal garden at Twickenham from 1719, he became a roving garden consultant, with an accent on roving. 'I am glad to hear', said Swift, 'Mr Pope is grown a Rambler'. Such habits of mind encouraged literal 'deviations', and Pope's references to his 'Rambles' make it clear that, while his long tours were planned, he also liked a degree of improvisation.[2] It is this element of the unplanned, and even the accidental, that is part of our purpose here.

DESIGN AND CHANCE IN NATURE AND SOCIETY

In his poem *Windsor Forest* (1704–13) Pope evoked a comparison with Eden, long vanished but living still in description. His vision was made up of the familiar opposites of hill and vale, woodland and plain, earth and water, 'harmoniously confused':

> Where order in variety we see
> And where, though all things differ, all agree.

The idea of a process of design in nature, which operated by reconciling contraries, had figured famously as the *concordia discors* at the beginning of Ovid's *Metamorphoses*: where the order that was established out of chaos was seen

as leading to a harmonious union. Such a union was to remain an ideal to the garden designers of the eighteenth century, together with the Virgilian notion of man attuned to his surroundings that emerged so eloquently from the landscape paintings of Claude Lorrain (1600–82). The collusion of nature and man had struck Addison on his travels in France and Italy, where he noted large areas of ground covered over with an agreeable mixture of garden and forest. He could not forget the garden aspect: 'why', he asked in *Spectator* 414, 'may not a whole estate be thrown into a kind of garden by frequent plantations that may turn as much to the profit as the pleasure of the owner?'

Addison's remarks were included in essays on the 'Pleasures of the Imagination' (*Spectator* 411–21). He reflected here on the world as it was observed and imagined, following Newton's revelations about what design in nature really entailed. In his *Principia Mathematica* (1687) Newton had, indeed, refocused this breathtakingly for his time by proving that the law of gravitation, which made an apple fall from a tree, also kept the planets in place in their orbits. The universe – still, for Newton, the work of God – operated by natural laws. Addison took this up, admiring the 'worlds, hanging one above another and sliding round their axles in such an amazing pomp and solemnity': but also caught by the seeming infinity of space and put, as he remarks, 'upon the stretch to comprehend it'. Here was the true business of the imagination, which (*Spectator* 412) 'loves . . . to grasp at anything that is too big for its capacity'. Beside the majesty of Newton's universe, how scaled down to the point of impudence seemed the mathematical topiary of the formal garden, the parterres of Versailles: 'I would rather look upon a tree in all its luxuriancy and diffusion of boughs and branches than when it is . . . cut and trimmed into a mathematical figure'.

This interest in luxuriancy and diffusion did not, of course, question the authority of order and design, any more than the classically-minded philosopher Shaftesbury (1671–1713) had done when he praised wild nature. In his 'Philosophical Rhapsody' *The Moralists* (1709, included in his book *Characteristics of Men, Manners, Opinions, Times*, 1711, many editions and translations), the influential Shaftesbury had sought universal harmony in the 'horrid graces of the wilderness', far from the 'mockery of princely gardens' (by which he meant the formal Baroque gardens of the Versailles or Hampton Court type). It was for Addison and Pope, garden designers themselves, to show how far back into nature the discriminatory goal-posts had now been moved. Goal-posts there were: fixed, however, not by an artifice of man's making, but by recognizing a nature that operated with a freedom that was circumscribed by immemorial laws. Contemporaries, Pope thought, do well to study and apply these for themselves as the ancients had done:

> Those rules of old discovered not devised
> Are Nature still but Nature methodized.
> (*Essay on Criticism* (1711), lines 88–9)

He followed this with the famous comparison with that hallmark of the British constitution, Liberty:

Nature, like Liberty, is but restrained
By the same laws which first herself ordained.

(*Ibid.*, lines 90–1)

From such positions there developed the thinking behind the English land-scaped garden, which touched Addison at Bilton and Pope at Twickenham, and which reached its full statement in the work of William Kent and others at the great Whig estates, notably Stowe, Buckinghamshire, in the 1730s. In such parks, house and landscape could be synthesized by contrast, the former crisply classical, objective, symmetrical; the latter leading the eye by means of winding paths, sweeps of lawn and spreads of serpentine lake punctuated by temples and clumps of trees. By man's application of nature's rules, Lord Cobham's park at Stowe was 'methodized'. It was also civilized, by following the ancients and providing architecture and commemorative sculpture. The Temple of Ancient Virtue (Fig. 28) contained statues of Homer (poet), Socrates (philosopher), Epaminondas (general) and Lycurgus (law giver). A touch of nationalism, associating Britain with the value of virtue in public life (missing, Cobham believed, in the contemporary administration of Robert Walpole) was afforded by the Temple of British Worthies, incorporating busts of Whig heroes: King Alfred, Drake, William III among men of action; Inigo Jones, Milton, Locke and Newton among men of thought.

This coupling of thought and action was in turn stressed in literature, much of it widely-read and extending Newtonian ideas into and across society. In his *Essay on Man* (1731–4), Pope argued that by studying himself man can come to know his true place in creation, dependent on the harmony proclaimed by the planets in their orbits. Man's government, likewise, should make all its sub-jects happy: a thesis which Newton's friend J.T. Desaguliers (1686–1744) had maintained in his long poem *The Newtonian System of the World the Best Model of Government* (1729). Nor were the advantages to 'man', in these con-texts, seen as accruing only to the privileged male gender. On the contrary, lay men and lay women were joint beneficiaries. John Harris attempted a lay expli-cation in his *Astronomical Dialogues between a Gentleman and a Lady* (1719, French translation 1738), and Francesco Algarotti published *Il Newtonianismo per le dame* (1737, English translation, *Newtonianism for Ladies*, 1739). Both sexes were present in Wright's *Orrery* (Fig. 12).

Newton's ideas were also popularized throughout educated Europe by the poet James Thomson (1700–48), who wrote a poem sacred to the great man's memory in 1727. But it was in his four-part work *The Seasons* (1727–30, expanded edition 1744, and much translated), that Thomson introduced a host of Newtonian references, to gravitation, light, colour, and the rainbow, as well as to plant physiology and the origin of rivers. Though Newton had explained so much, however, and rational order was to be celebrated in nature, Thomson's most impassioned paeans were nonetheless addressed to God as First Cause:

who, with a Master-hand,
Hast the great Whole into Perfection touch'd.

('Spring', lines 559–60)

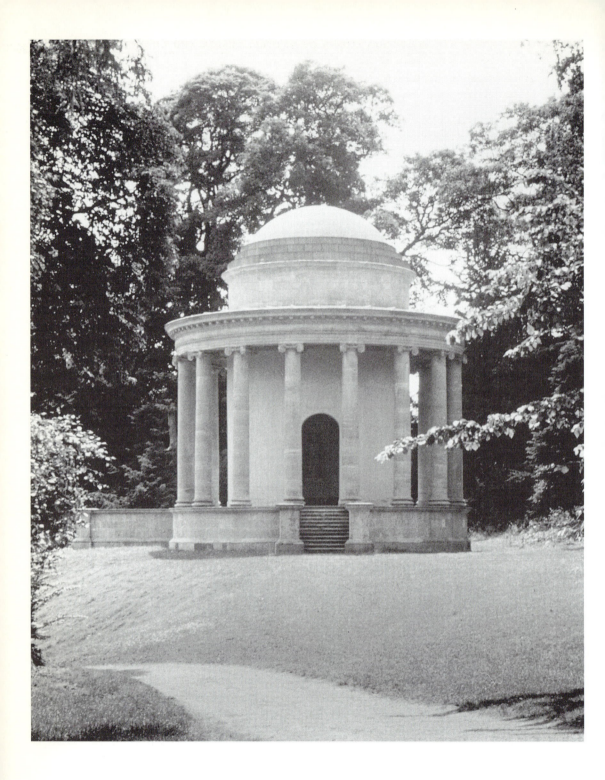

The sense of design at work in nature, then, had had an emphatic confirmation through the work of Newton. The optimism of those who responded to it – notably Pope, in his doctrine of 'whatever is, is right' – also followed on from that of Leibniz, advocating a view of the world as the best of all worlds; best because God, who knew all the possibilities, had set it in motion. The empirical investigation of nature by the reason that God had equipped man with was to engage to the full not only the scientist but the artist. Not only were growing areas of study such as geology and meteorology, botany and zoology to provide new material, but the further anomalies that presented themselves as human reason went about its analytic, classifying work were to have undreamed-of effects on the imagination. Shells, as we have seen (p. 15), stimulated the Rococo, and were themselves collected: and natural forms such as crustaceans and ammonites became 'naturalized' forms of ornament, presented, perhaps, in their physical actuality in a grotto. Deeper lines of enquiry turned up what appeared to be cipher writing or hieroglyphic reminiscent, it was thought, of Hebrew or Arabic, in the crystal formations or fissure systems of rocks.[3] Addison (*Spectator* 414) found his imagination held by 'those accidental landscapes of trees, clouds and cities, that are sometimes found in the veins of marble'. To this source he added 'fretwork of rocks and grottoes': anything where we may recognize 'design, in what we call the works of chance'. A renewed search was on to find art in nature's own effects, an art which Pope saw as residing there unrecognized:

> All Nature is but Art, unknown to thee;
> All Chance, Direction, which thou canst not see;
> All Discord, Harmony, not understood,
> All partial Evil, universal Good.
>
> (*Essay on Man*, Ep. I, lines 289–92)

Here was an approach to chance which was helpful to Newtonians. While many eighteenth-century observers chose to see it as taken care of by Divine Providence, as Pope did here, others saw its workings as perhaps only a temporary blank area in the map of man's control. Might not the calculation of odds yield to mathematics sufficiently to establish the presence of design in what to the casual eye seemed accidental? Statistics on death by various dis-

Figure 28: William Kent (1685–1748). The Temple of Ancient Virtue, Stowe, Bucks. About 1732. Photograph courtesy of Barbara Peacock

Drawing on a wide knowledge as protégé of the architect Lord Burlington, Kent conceived Ancient Virtue as represented by statues of founding figures of Greek civilization, within a circular shape that is closed by a semi-circular dome and ringed by columns.

Looking out from the Temple, we see Kent's park: nature as a great, unfolding design, revealed, as contemporaries would have seen it, by man's controlling hand. As we look back to it, high on a slope, the building literally concentrates and stills the passage of time, as the seasons change in the trees around it. The English landscape garden was to enjoy immense fame and influence in Europe.

eases might enable citizens to gauge the probability or otherwise of their own death from any particular one. In an age fascinated by games – hasard, piquet, faro – and lotteries, books in Dutch, French and English took this study up, among them a work dedicated to Newton, De Moivre's *Doctrine of Chances, or A Method of Calculating the Probability of Events in Play* (1718). But that this was no rarefied pursuit was shown the next year by Defoe, who made Crusoe doubt whether Satan might have placed the mysterious single footprint on the far side of his island: would he have done so when the odds were so great against Crusoe's finding it?[4]

The clash between human ability to control events, and inability to escape a Fate made menacing by the indifference of the gods, had provided much of the substance of Homeric epic. Such dilemmas were now to be refocused, as was debate on received Christian notions of Providence and of man immediately below the angels on the ladder of Creation. The materialist La Mettrie, in *L'Homme machine* (1747), saw a world indifferent to man: 'Perhaps chance has thrown him down . . . on the earth's surface'. For other *philosophes*, the gradual abandonment in some quarters of the idea of the immutable fixity of species, sanctioned by the Bible, would help to open the way to new realizations of apparent purpose in nature, and eventually, in the thinking of Erasmus Darwin, Lamarck and Erasmus's grandson Charles, to the theory of evolution. Meanwhile, age-old notions of earth, water and heat combining spontaneously to create life were tenacious.[5] Building on them, Diderot's dialogue *Le Rêve de d'Alembert* (1769, published 1830) envisaged chance and matter working to produce new structures; and in the imaginative context of a novel, *Jacques le Fataliste* (probably begun 1765), he ridiculed Providence, and against Fate set the freedom of the possible, with all its uncertainties for humankind.[6]

Mid-century thought was, in fact, to be crucial for fresh looks at received opinions. Within weeks of the devastating Lisbon earthquake (1755), which killed over 10,000 people, Voltaire declared that the doctrine of 'whatever is, is right' was an insult to the miseries of earthly existence (preface to 'Poem on the Lisbon Disaster', 1756). Three years later, in his *conte* (fictional story) *Candide, ou l'Optimisme*, his irony savaged the same doctrine, as represented by Pangloss, who sees all disasters as leading to a greater human good. Candide himself finds the world he experiences compromised: all he can settle for is hope and the cultivation of his own garden. Simultaneously the melancholic in Samuel Johnson produced *Rasselas, Prince of Abyssinia* (1759), in which the discontented hero, seeking permanent happiness 'without fear and without uncertainty', learns that 'very few live by choice'. At the end of the story 'nothing is concluded'. The unpredictability of human affairs was to lead the Christian Johnson to observe wryly in 1771: 'The caprices of voluntary agents laugh at calculation'.[7]

DESIGN AND CHANCE IN THE ARTS

New assessments were being made in the visual arts also. In 1753 William Hogarth (1697–1764) had produced his venturesome book *The Analysis of*

Beauty. The Rococo was still in fashion: but Hogarth had grown up smarting under the conventions of *opera seria* and Palladianism in architecture. His title-page announced 'a view of fixing the fluctuating Ideas of Taste'. He was intent on a system: but, being by Hogarth, one that was in no way monolithic in its implications. Indeed it enshrined the movement, versatility and literal open-endedness of the S form already established in the Baroque and in the Rococo (see the candle-holder in Fig. 4), and in the landscape garden (p. 115). The waving two-dimensional S he advanced, with a wealth of examples, as the 'Line of Beauty'; the serpentine three-dimensional S (which moves in depth) as the 'Line of Grace'. The British press was divided about the book; *The World* for 13 December 1753 satirically condemned the 'flat straight line' of fashion for ladies' bosoms, while applauding the efforts of the designer 'Capability' Brown to remove 'straight rows of cut trees' and open landscape to the horizon.

The decorators' manuals of Gothic and chinoiserie ornament had in any case made curving lines popular. But Hogarth's greatest originality in his book was to isolate for special consideration a formal element – the double curve, a characteristic form of the fashionable Rococo style, but one among many – and attempt to draw from it a general conclusion about its appeal. The active mind likes to be employed in *pursuit*, he says in his chapter 'Of Intricacy'. What better than the line that 'leads the eye a wanton kind of chace': calculated and quantified in a work of art, he is careful to add, but nonetheless observable everywhere in nature and contributing infinitely to pleasure and the sense of beauty.

Hogarth's lively if idiosyncratically expressed arguments were translated into German (1754), Italian (1761) and French (1805). In Germany, where the philosopher Baumgarten was simultaneously (1750–8) polishing his newly-coined word 'aesthetic', Hogarth was attentively read. But in France Rococo and the curved line were already under theoretical attack.[8] The straight contours and right angles of the Petit Trianon at Versailles (1761–4), built for Madame de Pompadour by an architect of Hogarth's generation, Ange-Jacques Gabriel (1698–1782), gave no scope for intricacy. Nor, in Britain, were Adam's highly original but disciplined departures from the norms of classical architecture to encourage wanton adventures.

In his essay 'The Grand Style of Painting' (*Idler*, 20 October, 1759), Reynolds criticized reliance on 'detail of Nature . . . modified by accident, at the expense of the 'great and general ideas' which the Italians had used. He would seem the last man to endorse chance. Yet in his Thirteenth Discourse (1786) he came near it, and even suggested that not only painting but also architecture might benefit from 'the use of accidents: to follow when they lead, and to improve them, rather than always to trust to a regular plan'. The 'forms and turnings' of old London streets, he thought, produced 'without any original plan or design', might be preferable – if 'improved', a significant qualification for Reynolds – to 'regular' plans like Wren's unrealized scheme for London after the Great Fire or the new classical layouts of the West End.

The unpredictable was, perhaps, to spring its best surprises where sensibilities, once engaged, were held in suspense: in arts of time like musical

improvisation or the experimental work of C.P.E. Bach (p. 95).[9] In plays and novels, also, writers make characters assume disguise and counter-disguise, which encourages the learning of codes, the playing of games by the rule-book: but the twists and turns of love expose individuals to the risks of an incalculable result. Marivaux (p. 83), in the play *Le Jeu de l'amour et du hasard* (1730), shows what can happen when a disguised character falls involuntarily in love with the 'wrong' person. Departing from the 'types' of the past (as in Molière), he engages his main character Sylvie – Marivaux is that rarity, the eighteenth-century male feminist – in finding out who she really is. The fast-moving plot of Beaumarchais' *Mariage de Figaro* (1784) has Figaro declaring (Act IV, scene i) 'chance determines everything'; and testing the quick-witted Susanna, his fiancée, to find the way out.

Sterne, in his liberties with normal time and form itself in *Tristram Shandy*, went furthest of all, presenting an entirely personal case for the visual workings of chance in a designed context. Association–trails (p. 89) and Hogarth's 'intricacy' informed much of the plot, but in Volume III Sterne asked for an area of 'marbling' to be inserted on both sides of a page in place of letterpress: meeting it is one of the biggest surprises of the book (Fig. 29). The technique of marbling, old-established among the Turks, much used for bindings of books in the West and re-introduced in the 1760s, involved dropping oil colour onto water, combing it into patterns and floating effects on paper. In practice many later publishers of *Tristram Shandy* opted out of Sterne's challenge and simply printed the words 'a marbled leaf was inserted here'. The visually-minded Sterne, however, valued his marbled page, describing it as the 'motley emblem of my work'.[10] The marbler's masterminding of his 'haphazard' material was the visual equivalent of Sterne's masterminding of his.

The increased use of marbling in bookbinding late in the century (when it became commercially available) was in any case an event of note. Its blobs and streaks of colour corresponded to nothing recognizable, as the writer Pluche had noted in his popular book *Spectacle de la Nature* (1732–59, six English editions). But, like the 'blot' technique recommended by the artist Alexander Cozens, it stimulated the imagination, always responsive to shapes that *did* seem to correspond with something recognizable: Addison's landscapes in marble that we noted above (p. 117) or clouds that, as Shakespeare's Antony had put it, might look 'dragonish'. That the seemingly haphazard might conceal design was borne in on Reynolds (Fourteenth Discourse, 1788), reflecting that the scratchy brushstrokes of Gainsborough's portraits merged magically at a distance to form a likeness. This, Reynolds characteristically notes, gave 'the full effect of diligence, under the appearance of chance and hasty negligence.'

Design and chance were meanwhile linked in more transparent ways. The *General Advertiser* of 29 October 1751 announced the Aeolian harp, 'a new-invented musical instrument, which is played by the wind, as described by Mr Thomson, in his *Castle of Indolence*'.[11] Aeolus was the Greek god of the winds: the idea of having nature's breezes, as they ebbed and flowed, play through open strings fixed in a frame was an old one; but the 1740s witnessed

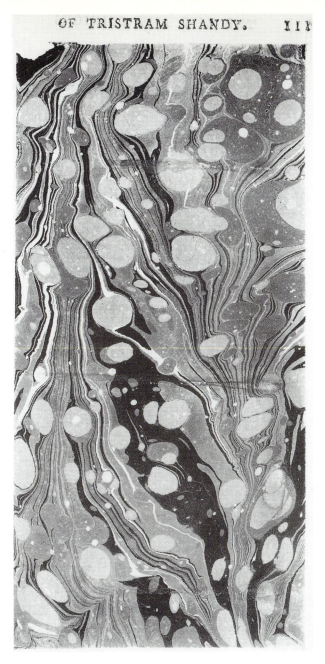

Figure 29: Marbled page from Sterne's *Tristram Shandy*, *The Works of Laurence Sterne* (London, J. Rivington, 1788), vol. II, p. 111. 12.5 × 6.1 cm. Bodleian Library, University of Oxford; Shelf mark Vlt A5e 5819.

Sterne's marbled page occurs between chapters 36 and 37 of the novel. 'Restless', 'volatile', 'unfocused' – all are adjectives applied to the personality of Sterne, and the page might be dismissed as a typically self-indulgent whim. But it takes its place within the wider taste which made *Tristram Shandy* 'the maddest, the wisest, the gayest of all books' for Diderot, whose friend Sterne became and whose speculations on nature's transforming energies (see p. 118) in turn were part of a broad eighteenth-century interest in the relation of chance to purpose.

new interest in it. In his novel *Ferdinand Count Fathom* (1753), Smollett had Fathom use one in an amatory adventure, and commented on the 'wild, irregular variety of harmonious sounds' that it produced. The following year a letter in the *Gentleman's Magazine* told its readers how to make the harp out of catgut and wood and try it out at an open window. The Aeolian harp was to be a persistent presence for the English and German Romantics. Coleridge, who heard the hill-winds of the Lake Country blow through his, was especially affected (p. 148).

Also in 1754, having unexpectedly come across an oriental tale 'The Three Princes of Serendip', which gave him pleasure, Horace Walpole coined the word 'serendipity'.[12] For Walpole the word denoted 'accidental sagacity': reasoning was implied as well as luck. But the straw-in-the-wind process of discovery that is involved looks forward to the kind of happy coincidence of the spontaneous and the accidental which was to have special meaning for many Romantics.

The 'True' Style

Much, in the painting of the Romantic period, would turn on the pleasures of apparently unpremeditated encounter that we have been discussing. The freedom that music could offer through improvisation or the sound-patterns of the Aeolian harp was to be amply reflected in an art which confronted the spectator in one *coup d'œil*, but which was founded on the motion and reading of the brushstroke.

Other arts were not so free. Sculpture, in contrast to painting, required long hours of working and expensive materials such as marble and bronze; and its heavy dependence on models of Greek and Roman statuary proclaimed the reverse of spontaneity. Houdon portrayed living contemporaries such as Voltaire and George Washington; but the Neo-classicists valued sculpture particularly for its long commemorating past. The young Danish sculptor Thorwaldsen (1770–1844) kept the date of his arrival in Rome, 8 March 1797, as his 'Roman birthday' for the rest of his life. Antique sculpture, at the height of the Grand Tour, provided the greatest single yardstick of taste. Winckelmann's inch-by-inch exploration of the *Apollo Belvedere* statue, to be seen at the Vatican and in casts throughout Europe, underwrote the status of what it was general to regard as a sculptural masterpiece. But too many roads had become sacred ways for the good of sculpture. The inwardly-charged Elgin Marbles from Athens, on view in London in 1806, did not dislodge the *Apollo* (then to be seen in Paris, where Napoleon had placed it) in the esteem of the sculptor Flaxman (1757–1826), impressed as he was by them. They came too late to inject immediate new life, despite the admiration of the internationally-celebrated Canova (1757–1822), who saw them in 1815. Sculpture – backward-looking, largely commemorative, and at times wonderfully affecting (Fig. 30) – was, for the moment, to be left behind by painting, which the Romantics were to make prophetic.

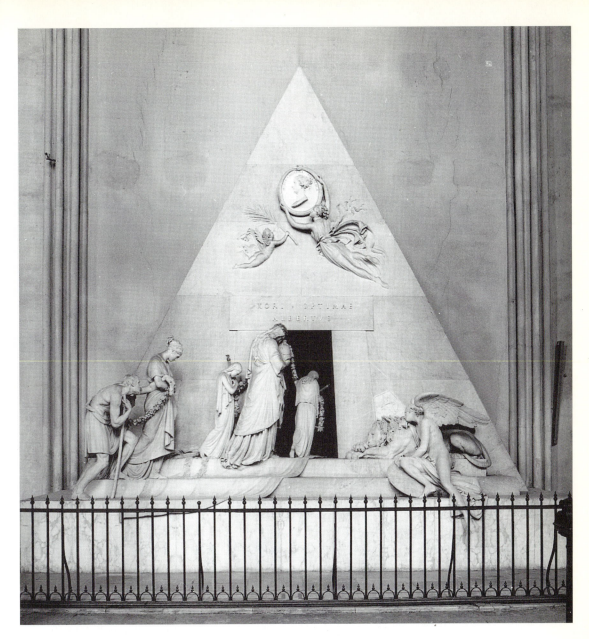

Figure 30: Antonio Canova (1757–1822). Monument to the Archduchess Maria Christina. Marble, height 574 cm. 1799–1805. Augustinerkirche, Vienna. Photograph courtesy of Courtauld Institute of Art.

It was an eloquent reflection of the age of sensibility that commemorative monuments should stress, along with the life-achievements of the dead and the Christian hope of resurrection, the mourning of those left behind. Canova took here the form of sepulchral monument that resonated most anciently in human memory – the pyramid – and imagined the procession of mourners moving into it. The winged genius of Mourning watches with the lion of Fortitude; above, a flying figure of Happiness holds up the dead woman's profile portrait. With childhood, youth, middle life and old age among the mourners, the complete sequence of earthly human life is guided through the door of eternity.

The enduring *presence* of ancient marble sculpture, on the other hand, gave it value in a time of change, and underpinned the work of modern seekers after the classical 'true' style (Introduction, p. 21). Among these Canova, sculptor of the *Three Graces* (1815–17) and other famous works, appeared worthy of a status which Stendhal compared to that of Napoleon and Byron. To foreign contemporaries looking for a return of Italy's former artistic greatness, Canova provided the evidence of it ('such as the great of yore, Canova is today', in Byron's words). To Italian compatriots, mindful that Canova had negotiated the return of the Vatican marbles which Napoleon had removed, his reputation became the stuff of myth. And if more austere northern tastes found his sentiment overdrawn, there was the stern rival vision of Thorwaldsen in Rome.

Architecture also, as we saw, was central to the recovery of the 'true' style. Committed to social usefulness, it was even less free than sculpture to indulge in whims. But in the case of an art which developed from a basic human need for shelter, speculations about origins beyond Greece and Rome were to go particularly deep into the natural world from which those cultures were felt to have derived so much. This primitivism turned the idea (going back to the Roman architect Vitruvius) that temple architecture originated in a simple forest hut constructed on living tree-trunks, into an illustration in a widely-read *Essai sur l'Architecture* (1753, translated into English 1755) by the Frenchman Laugier (1713–69). It behoved modern architects, reflected Laugier, to transfer their thinking to stone in terms of such simplicities.

The result of such concentration on essentials was the search for geometrical form as the basis of natural form, for the simplicity that lay beneath the Greek Doric column and the Roman semicircular arch. A breakthrough was imminent to a world of spheres, cubes and cylinders: Goethe's Altar (p. 96), the triangular groups against unfluted Doric columns in David's *Horatii* (Fig. 25), Canova's pyramid (Fig. 30), showed different aspects of the process of simplification. It was for two French architects, Boullée and Ledoux, to take it to more speculative extremes; and for the American, Thomas Jefferson, to realize aspects of it across the Atlantic in terms of cool practicality.

NEO-CLASSICAL STYLE AND UTILITY IN ARCHITECTURE

Part of the opportunity of the late eighteenth-century architectural scene lay in the interaction between the idealism which led Neo-classical architects to strip form back to bare geometry, and the value placed by modern societies on simplified effects which met particular contemporary needs. These needs could be religious as well as secular, and many of them applied in newly-independent America as well as Europe. As the primitivist ideal gained ground, Anglican churches could be referred to as 'temples'; and it is noticeable that the religious straightforwardness demanded by the Dissenting movements in Britain nurtured a pared-down functionalism in the design of chapels. Here the austerities of Neo-classical style fitly enclosed reformist ideas that were generated against the Established Church. Versions of Wren steeples fronting (or built over) box-like assembly areas seem to have proclaimed to Dissenters a distinct

and positive rejection of the emotionally rich medieval Gothic of Anglican parish churches (compare Hogarth's box-like setting in Fig. 51). For religious 'enthusiasts' who thronged 'meeting houses' the emotion was to be expressed in the service.

The simplicities of design were also sought as towns expanded, new building types evolved and old ones were rethought. Large numbers of hospitals, prisons and dockyards, necessary to modern society but built to fixed budgets, conduced to highly concentrated results. Designs reflected what were seen in the light of current practice as fundamental needs: encompassing, windowless walls for prisons; separate, infection-isolating blocks for hospitals; thick, fire-proof walls for banks. Soane's famous Bank of England designs (1788–1823, Fig. 31) enabled him to turn the need for strong, uninterrupted walls to an exploration of top lighting. Prisons were now thought of as separate and purpose-made, not part of town halls or castles: such was George Dance's severe Newgate Prison in London (begun 1769, demolished 1902). So too with hospitals: in Vienna lunatics were segregated in the Narrenturm, a detached cylindrical tower (1780s), which was part of the General Hospital. In France, the medical thinking behind the freestanding hospital ward produced a design by Boullée's pupil Durand (1809), which had seven parallel wards each side of a central courtyard: the elevation drawing shows trees between them. The practical intention was here nonetheless clearly associated with the idealizing architectural geometry which had been taken up by Boullée and Ledoux.

With Etienne-Louis Boullée (1728–99) and Claude-Nicolas Ledoux (1736–1806) we are conscious of Laugier, but even more of two strong-minded individuals. Totally unconcerned with Renaissance text-book recommendations, Boullée's vision was of an architecture that was primitive, in the sense of being first not only in the past, but in a future that should be stark with moral message. His masterstroke was to offer the Newtonian universe in the form of a gigantic sphere (Fig. 32).

Cubes, spheres and cylinders were never far either from the thinking of Ledoux in his plan for an ideal city near Besançon, published in his book *L'Architecture* (1804). Though not a political revolutionary (he was imprisoned as a royalist in 1794), Ledoux combined a serious social concern (shown in his text and in a plate of a 'poor man' under a tree gazing at the gods above) with a rather chilly passion for an architecture which served the 'propagation and purification of morals'. Plans included a building for the peaceful settlement of all quarrels and a temple for sex-instruction. What he calls 'architecture parlante' expresses itself directly through its forms (Fig. 33). 'Toutes les formes', Ledoux further remarks, 'sont dans la nature'.

In post-revolutionary France the visions of Ledoux for an ideal city, with their intensity and remoteness, were only partly realized. But they were contemporary with the very practical, relaxed, Roman-based yet also imaginative utopian planning of Thomas Jefferson (1743–1826) across the Atlantic. In revolutionary Paris and America alike Republican Rome had been a principal model. In Paris David's paintings of Roman family crises, the *Horatii* and *Brutus*, had been paraded as national icons. Jefferson too read Tacitus all his

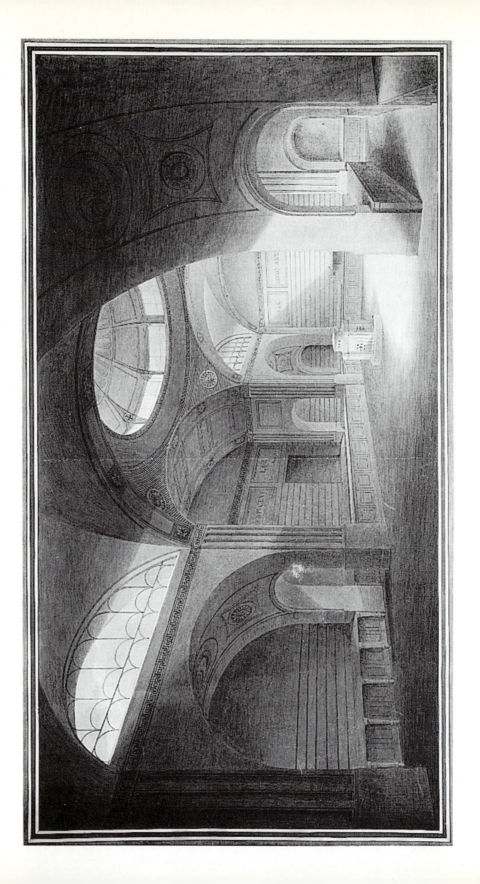

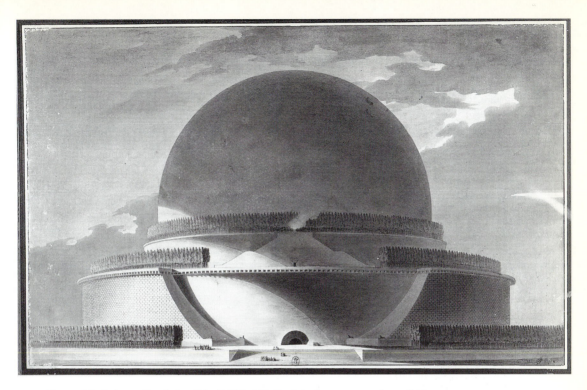

Figure 32: Etienne-Louis Boullée (1728–99). Project for a cenotaph to Sir Isaac Newton. Pen and wash, 73.7 × 49 cm. About 1784. Bibliothèque Nationale, Paris.

The Enlightenment's wish to commemorate great minds, past as well as present, readily took in Newton. He had been buried in Westminster Abbey, fifty years before Boullée began work on this design: but this was to be a cenotaph or 'empty tomb', without Newton's body, but full of his meaning. Conceived as a sphere, apparently on a scale of about 400 feet across (there are figures at the foot), the project remained on the drawing-board. Entrance sphinxes were almost the only reference to man's past as designer. Boullée had in mind the world uncomplicated by human artists, an architecture scaled not to man's bodily size, like a Roman temple, but rather to the distance that the spectator's imagination, as he passed inside, would travel: the interior, lit by perforations in the circumference to simulate stars, was to have evoked the vastness of the Newtonian universe.

Figure 31: Sir John Soane (1753–1837). Stock Office, Bank of England, London. 1792. Watercolour, 56.7 × 93.9 cm. Sir John Soane's Museum, London.

This watercolour helps to clarify two points about Soane's actual buildings: first, the value he attached to sharp, defining line, separating planes from openings as if they were drawn with a knife; second, the counterplay of light and saturating shadow, creating the 'lumière mystérieuse' that he had admired in French churches and mentions in his lectures.

Soane continues his personal reworking of classical shapes for another thirty years at the Bank, and also at Dulwich Art Gallery (1811) and elsewhere. His Stock Office has not survived, but the Bank has recently reconstructed it anew as a museum.

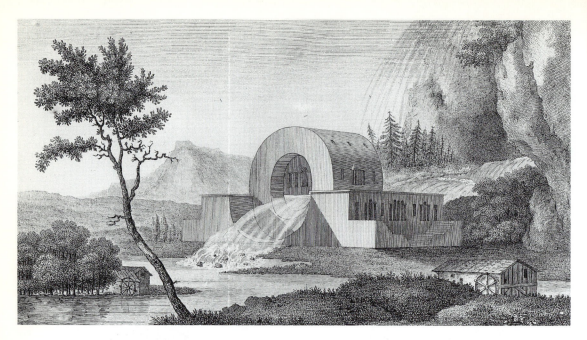

Figure 33: Claude-Nicolas Ledoux (1736–1806). 'The House of the Inspectors of the River Loüe', pl. 6, from *L'Architecture Considérée sous le Rapport de l'Art, des Moeurs et de la Législation* (1804). Engraving, 13.3 × 23.8 cm. British Library (559 *h20).

Ledoux's ideal town, intended for a virgin site at Chaux, near Besançon, was to be an egalitarian paradise. The forms of buildings should provide clues to their function, and ornament was to be all but eliminated. Here, the house of the water authority's directors has the river running through its centre in a cylinder, reminiscent of a gigantic water-pipe. France had led Europe in hydraulic engineering and the co-ordination of tunnel and bridge with landscape (the 150-mile Canal of Languedoc, 1666–81). To the confidence created by such a background, Ledoux added a Rousseauist streak which rejected the traditional built-up city and sought a new Eden. The broad objective of the garden city – if not Ledoux's extreme foreshadowing of it – was to be increasingly pursued as Europe moved into the industrial age.

life for pleasure, and saw in the oppression ascribed by the Roman writer to the post-Republican Roman Empire a parallel with Britain's treatment of her colonists in America. But his devotion was also to his native landscape and the relationship that an artist and architect could make with it. In his *Notes on Virginia* (written 1781, published 1785) Jefferson discussed architecture and also nature: the great 'Natural Bridge', which he owned; the strange shapes assumed by a local mountain, and the use he could make of weather observations from his hilltop home of Monticello (designed by himself): from here, he once said, he could watch clouds, snow and rain in the making below. Here surely was the difference from the Europe of Ledoux, where an old society was trying to renew its ground-rules in nature by turning the clock back to 'pure'

beginnings. By contrast, newly independent America seemed to be an evolving part of a colossal natural workshop. In this situation Jefferson, the chief originator of the precise words of the Declaration of Independence, was the first American to ask himself what was needed from art, 'the first American', as his cultivated French visitor Chastellux put it when he visited Monticello in 1782, 'who has consulted the fine arts to know how he should shelter himself from the weather'.[13]

From 1784 to 1789 Jefferson was based in Paris, where one of the most characteristic images of him is as a walker with a pedometer strapped between waist and knee, enumerating the steps he took: 331 more to the mile, he calculated, in winter, when he walked more briskly. He took away important memories: in Paris of the seventeenth-century classical east face of the Louvre and the new, sharply cubical Hôtel de Salm of 1782; in England of the landscape gardens with the serpentine lines he read about in Hogarth; in Nîmes of the Roman temple known as the 'Maison Carrée', which he described as 'the most perfect model existing of what may be called cubic architecture'. His Capitol design for Richmond, Virginia (1785), after the Maison Carrée, became (with the Madeleine, Paris, 1777–1842) one of a long series of public buildings throughout the Western World to be based on specific Roman temples. It was a significant 'first' for America. Richmond, at Jefferson's wish, had become the new capital, effacing the memory of British rule at Williamsburg. The design – and the move – established the new beginnings.

Jefferson's own Monticello (Fig. 34), built to his designs from 1771, high in its landscape like Palladio's Villa Rotonda, was a 'villa' in the late eighteenth-century sense of a small country- or suburban house. The lucidity of Jefferson's planning for himself was projected also in his preliminary planning of Washington, the United States federal capital: an assignment delivered to the Frenchman Pierre L'Enfant, who evolved a design (1791) with an elaborate gridiron of streets broken by radiating avenues reminiscent of Versailles. Jefferson also brought in the English Neo-classical architect Benjamin Latrobe (1764–1820) to work on the United States Capitol at Washington. Continuing the series of Neo-classical variants of the basic Doric, Ionic and Corinthian capitals inherited from the Greeks and Romans, Latrobe proposed here two capitals that were original to America, based on ears of maize and the tobacco plant.

Jefferson's regard for architecture which was either cubical or spherical did not prevent him from admiring the sequential motif of the colonnade. This was used by him at Monticello to provide dry passage for his slaves and servants, and in his final work for the University of Virginia, Charlottesville (1817–24). Feeling that a monolithic block would be bad for health and too noisy for study, he planned here an 'academical village', composed of small, distinct buildings, each for a separate professor who lived upstairs and taught below, with a covered way providing 'a dry communication between all the schools'. And so, with ten pavilions differing in detail and with little gardens behind, it was built: together with (at Latrobe's suggestion) a focal library, domed and porticoed, at the head of the vista, with capitals for its columns brought from Italy.

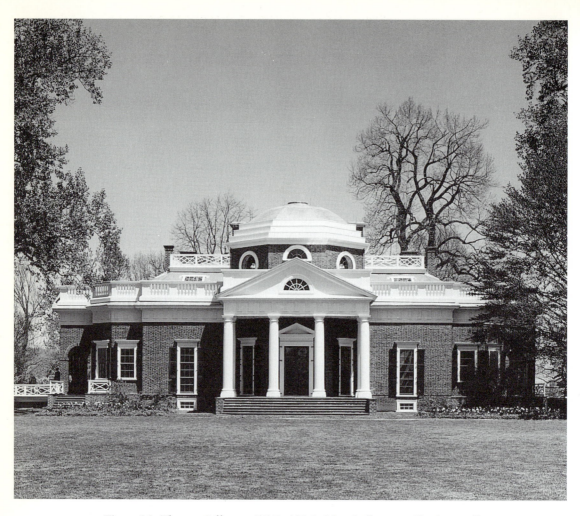

Figure 34: Thomas Jefferson (1743–1826). Monticello, near Charlottesville, Virginia. Begun 1771, remodelled 1793–1809. Photo Robert Lautmann/Thomas Jefferson Memorial Foundation Inc.

During the remodelling, the house received an octagonal dome over the hall: but the overall external effect, almost concealing the top floor behind a white balustrade, is of single-storey simplicity in red brick, sharpened by the white stone of porticoes and entablature. Rising above its gardens, it looks new-minted. Though Palladian proportions regulate the interior, some room-heights vary to accommodate bedrooms above. The house also abounds in ingenious mechanical devices. In fact, as with Wren earlier, Jefferson accepts classical form, but sets himself to think afresh, every step of the way.

Jefferson's University in its landscape represented, perhaps, his own man-made version of Pope's 'order in variety'. Classics and mathematics were accompanied by practical sciences and the study of ideas, including philosophy, literature and the fine arts. There were opportunities to draw and perform music. Just as his intellectual vision was based on the European Enlightenment,

so his own architectural thinking was widely nourished by the Romans and Palladio, reinforced by a taste for the bare geometry of the modern French. Jefferson himself supplied a sensitivity which was allowed, at an unrepeatable moment in American history, to inject forms that were stale in Europe with new life. Here was a fully-equipped 'true' style which, away from the self-purification that was gripping Europe, had not forgotten the human user.

Jefferson's device of covered ways to make life easier for slaves at Monticello and university students at Charlottesville only slightly dramatized the humanitarian who had envisaged men's 'inalienable rights . . . life, liberty and the pursuit of happiness'. The words have been thrown back at Jefferson, who, despite campaigning against slavery, kept slaves himself. He was, by all accounts, a kind employer, and it was probably not just sentiment that put on record the glimpse of him working, when time allowed, alongside blacks making nails in his shop at Monticello. He liked working with metal: and working, it seems, at the master-slave relationship.

Science and Art

While designing the Capitol at Richmond following a Roman model, Jefferson published *Notes on Virginia* (1785). The work assembled, through description and measurement (including the weighing of animals), an array of evidence to rebut the claims of French scientists, notably Buffon and Raynal, that America's apparent lack of large mammals proved that it was a degenerating continent. The *Notes* were not just a vindication of the New World: like Gilbert White's *Natural History of Selborne* (1789) in England, the book provided a record of its chosen locality with a plenitude of observation of a kind which was to enliven countless books and nature calendars in years to come.

Nevertheless, the diverse faces of the Americas were now to challenge as well as to tease European self-satisfaction. Columbus's stature as the discoverer of the New World, and the white settlers' apparent success in establishing themselves against the native Indians, were calculated to puff Europe's pride: but the relative simplicity of Indian life and its closeness to nature gave pause for reflection among men of imagination, recognizing here not only the survival into their own age of the Noble Savage, but a rich storehouse of study-material (ultimately for the science that was to become anthropology). The New Continent's wealth of animals and plants, clearly, could not be ignored. Moreover, as North America was colonized and westernized, Central and South America – largely sealed to Europeans after the Spanish *Conquista* – became attractive. Here mysterious past civilizations – Maya, Aztec, Inca – competed for attention with prodigies of wild life in the forests of the Orinoco and the Amazon. In 1799 Alexander von Humboldt (1769–1859) and a botanist friend obtained permission to trek through hundreds of miles of jungle and climb Chimborazo. Thirty volumes detailing their five-year-long study of human culture, flora and fauna there appeared between 1805 and 1834.[14]

DISCOVERIES IN NATURE: FOOD FOR IMAGINATION

New information on man, animals, birds, the fossils of their ancestors, the earth itself, was also flowing from Asia and Australia. Scientific societies promoted expeditions. English East India Company officials in Bengal made thousands of botanical and zoological drawings. European naturalists penetrated China. Bougainville and Captain Cook explored the South Pacific, including Tahiti. On Cook's first voyage (1768–71), Joseph Banks made botanizing visits to what was to become Botany Bay, in Australia. On his second voyage (1772–75), Cook employed his artist William Hodges to record coastal profiles and weather effects. After the penal colony had been established at Botany Bay in 1788 Banks went on receiving news of plants and animals.

While this flow of information would dramatically reorder the stockpilings of science, it would also recharge the batteries of visual fantasy. It soon became evident from travellers' accounts of kangaroos and fish that could climb trees that what had passed for the 'normal' laws of nature in the Northern Hemisphere need not apply in its Southern counterpart. Sydney Smith's response in 1817 to the kangaroo ('as tall as a grenadier, with the head of a rabbit, a tail as big as a bed-post') made the point.[15] The fantasy art of Edward Lear (1812–88) was in part founded on exact drawings of exotic creatures seen in English menageries in the early 1830s. An eye-opening variety of pose and patterned feather was to be seen in the bird books of the American J.J. Audubon (1785–1851): even species known in Europe took on a new awesomeness (Plate IV).

Recent imaginative bridges between science and art had been built by Erasmus Darwin (1731–1802). Although Linnaeus (1707–78) had classified on the assumption that species were stable over time ('fixity of species', a theory he later somewhat modified), the notion of inter-breeding, late in the century, took on new possibilities: 'a shark's head on the body of a large mullet', as the anatomist John Hunter put it. Darwin, physician and scientist, wrote this example into his book *Zoonomia*, a bold proposal of organic evolution by natural selection, in 1794–95. But by then his poem *The Botanic Garden* (1791), of 1,224 rhyming couplets, with copious notes, was a best-seller. 'The Loves of the Plants', the first part to appear (the second of the whole work), began as a mere versifying of Linnaeus, but changed, as King-Hele showed in his book *Erasmus Darwin* (1963, see also Further Reading, p. 273), into an entirely personal presentation of a particular imaginative idea. Linnaeus had based his classification on the differences between the sexual organs of plants. Darwin saw his plants in terms of an intricate personalized sex-life practised by their male and female parts. The plant *Adonis*, for example, with numerous male and female elements in a single flower, recalled to him the society of the *aeroi* on Tahiti, with 'about 100 males and females who form one promiscuous marriage'. It was part of his method indeed to draw parallels with contemporary topics and issues. The Carline thistle, with its wind-carried seeds, was linked with Montgolfier's balloon ascent of 1783; flax, more prosaically, with Arkwright's cotton mills. Cinchona, Peruvian bark, a popular eighteenth-century medicine,

was connected with the restoration to health of society's convicted prisoners, as campaigned for by the reformer John Howard. Wedgwood, who had been asked by Darwin to read the passages on the slave-trade and prison reform, thanked him cordially for the 'pleasure and instruction' he had received.

The fantasy value of the poem, far from all classical constraint, brought Darwin the congratulations of another of the eighteenth century's unclassifiables, Horace Walpole: 'The Botanic Garden, the Arabian Nights and King's Chapel are above all rules'. Another element which would present problems to Christian apologists – Darwin's tracing of man's religious life back to 'natural' incitements expressed in fertility cults and sexual rituals – was to be taken up by men of the next generation, Peacock and Shelley.

An irreversible process had now begun. So far from looking down on the animals from the 'great chain of being', man might now be seen to belong biologically among them. Even equestrian Western man, however elevated in rank – so the paintings of George Stubbs (1724–1806) seem to suggest – was not necessarily dominant, or even present (Fig. 35). From 1795 Stubbs, author of the internationally famous *Anatomy of the Horse* (1766) and one of the century's major artists, was preparing a new work which compared human anatomy with that of the tiger and the common fowl. The drawings for this (published only in part, 1804–6) put the human through the same poses of walking and running as the other creatures. On the man/ape relationship, Rousseau's earlier speculations about 'natural' man's descent from the orang-utan of Malaya, 'the man of the woods', received endorsement from Lord Monboddo (1714–99): in the course of developing his own 'sagacity and industry' and use of language, man had transformed himself, but his animal ancestry was ineffaceable.[16] In 1784 Goethe, working across an immense range of zoological examples, discovered the human intermaxillary bone, previously thought to be absent in man, though present in apes.

Thomas Love Peacock, in his novel *Melincourt* (1817), which contained footnotes from Monboddo, had a hilarious satirical poke at the man/ape issue, having his main character Sir Oran Haut-ton (a monkey) become an MP, despite inability to use speech and a propensity to uproot trees. The man/animal relationship, always topical (Introduction, p. 11), now produced Rowlandson's own *Comparative Anatomy* (1821–25), which travestied earlier theories and tipped them towards caricature.

Already before Charles Darwin, there were serious implications for artists contemplating human involvement in processes of organic change over time. If design, Johnson's 'idea which an artist endeavours to execute or express', could be seen less as the pursuit of a final configuration and more as a movement through continuous, infinitely complex change, as nature seemed to suggest, the artist's own forming activity could be viewed in a different light. Goethe, searching among the plants in the botanical gardens at Palermo in 1787 for the 'original' (*Urpflanze*), failed to find it, but nonetheless developed a conviction that a single transforming principle, based on the leaf, united them all.[17] It was a strengthening experience for one so concerned, as Goethe was, with drawing and visual analysis. But there was value too, for one so aware of the

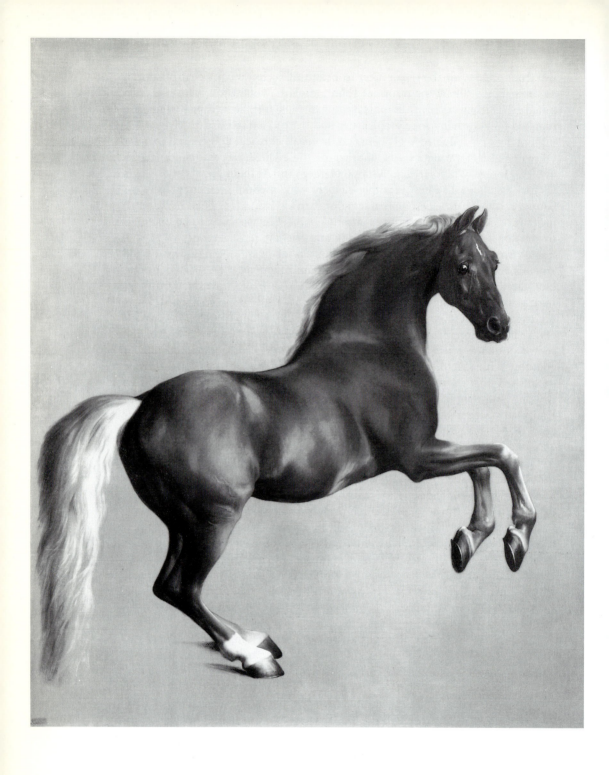

capacity of drawing to transcend its starting point, in the study of transforming process in nature itself. 'I should like to lose the habit of conversation and, like nature, express myself entirely in drawings', wrote Goethe in 1809.[18] The old shibboleth of academic doctrine, that the artist 'imitates' nature by drawing out its ideal, perfect forms, looked cold by comparison.

THE STUDY OF COLOUR

Another area of reassessment was colour. For generations colour had been downgraded in the academies below drawing, and philosophers tended to agree. It was only a secondary quality of objects for Locke: though Addison, who knew his Locke, valued it (*Spectator* 414). Even Rousseau, for once, reflected the conventional view that colour only pleased the eye, while drawing occupied the whole mind.[19] It is true that Newton's *Opticks* (1704), splitting white light with the prism into the seven constituent colours, had raised the rating of what James Thomson, in his poem on Newton (1727), called the 'gorgeous train'. This colour-sequence, fixed in value and arranged in a circle, was not merely to become a resonant image in itself for the Romantics but to present a clear statement of the 'colour primaries' (red, yellow, blue, not obtainable by mixing) and secondaries (green, violet, orange, each the result of mixing two of the primaries). J.C. Le Blon employed a colour process that superimposed the primaries to engrave portraits, before 1738.[20] Observations were beginning to suggest that, although colour experience was subjective, it was not necessarily arbitrary: most people's visual experience indicated a general agreement. In 1786 a paper by Robert W. Darwin – the son of Erasmus – discussed 'ocular spectra' (the appearance on the retina, after the observer had stared intently at a red patch, of a green after-image). It was praised by Goethe, who was to examine the same phenomenon. The relationship between red and green, blue and orange, and yellow and violet, each primary opposed to a secondary in the colour circle, was the basis of recognizing the idea of 'complementary' colours: those which, since they have nothing of each other in their make-up, excite each other to maximum pitch when placed side by side. Redness and greenness in their complementary relationship were proclaimed by two entomologists, Ignaz Schiffermüller in Vienna and Moses Harris, who produced *A Natural System of Colours* (dedicated to Joshua Reynolds).

Figure 35: George Stubbs (1724–1806). *Whistlejacket*. Oil, 292 × 246.4 cm. 1762. National Gallery, London.

In the long tradition of equestrian portraiture in Europe the rearing pose of the horse gave authority to its rider. While Stubbs brings a wide sympathy to human portraiture in his work, in *Whistlejacket* no rider appears. The horse as a species traditionally subordinate to man emerges in its own right – exclusively and magnificently so. Stubbs had already undertaken the eighteen months of dissection and analysis which was to lead to his masterly publication *The Anatomy of the Horse* in 1766.

Figure 36: Woodcut from Goethe's *Optical Essays* (*Beiträge zur Optik*, 1791–92). Enlarged from 5.5 × 9.2 cm. British Library (Cup 900t 10a).

Goethe found in the 1780s that the splitting of light by Newton's prism did not help him to account for his personal experience of colour. In his *Theory of Colours* (1810), the poet developed the view that light was homogeneous, and took colours when modified by darkness or opacity between its source and the perceiving eye. Though this thinking made a more immediate impact on philosophers, it had a wide interest for certain painters, notably Turner (Plate VI) and Runge (Plate VII).

In Goethe's woodcut his eye perceives the rainbow: the prism, for the moment, has been laid aside.

The study of colour quickly became a science, as chemically pure primaries were standardized, especially after 1800. The colour theories of Goethe, the painter Runge (p. 143), the chemist Michel-Eugène Chevreul (1786–1889) and the pigment-maker George Field (1777–1854) all belong to the next few years. The last-named developed a system for quantifying the bright primaries in proportions which produced an overall harmony. This was to be taken up by the architect Owen Jones in his colour scheme for the Crystal Palace in London (1850). It was Goethe, however, who made the most provocative contribution. Where Newton's colours related essentially to the splitting of white light by his prism, Goethe's were those seen subjectively by his eye (Fig. 36). Though he sensed colour in its purity when he looked into a gemstone, as he often did, he was fundamentally interested in colour against colour modified by light and dark as a fact of experience. In a memorable passage in his *Farbenlehre* (*Theory of Colours*, 1810), he related it to painting:

> The eye sees no form, inasmuch as light, shade and colour together constitute that which to our vision distinguishes object from object, and the parts of an object from each other. From these three ... we construct the visible world, and thus ... make painting possible, an art which has the power of producing on a flat surface a much more perfect world than the actual one can be.[21]

Light, shade and colour before form: Goethe makes crucial the immediate message of eye to brain. Turner, who read the *Farbenlehre* in translation in 1840, disagreed on a number of points; but Goethe's vision of colour's part in making a 'more perfect world' was to be formidably realized by him, following his own route.

The Advance of Landscape Painting

Landscape was now beginning its modern phase of development as a subject for the artist. Given a low rating by the older academies because of its remoteness from the human figure, it was now to be celebrated for the very quality which made it remote: an infinite plenitude of small, pullulating details against a humbling vastness. Certain initiatives of teachers at the Copenhagen Academy of Painting were known to encourage it; but it was in England, barely possessed of its Academy, that the conditions existed for the swiftest advances. As professional and amateur artists sought out the sublime and the picturesque, technical practice was to be modified in the light of what they wanted to express. Watercolour, a medium hitherto looked down on by the academies, was recognized for unique inherent advantages – easily carried to the subject, catching momentary effects of light or weather and drying in minutes. In the process what had commonly been essentially a form of tinted drawing was to be transformed by freely- and directly-applied colour. Moreover, a method which might ask for hue intensity and tone to be judged in one or at most two applications of pigment was to play its own part in the enhanced reputation of sketch quality throughout the Romantic period.

The wash medium also conjured with ambiguities along the borderline between design and chance, as relayed in the remarkable propaganda for the 'blot' put out by the artist Alexander Cozens (*c.* 1717–86) in his book *A New Method of Assisting the Invention in Drawing Original Compositions of Landscape* (1786). Nearly three centuries before, Leonardo da Vinci had recommended the artist to look for pictures in walls 'stained with damp'. Convinced that traditional landscape painting had become an affair of stale convention, and reminding his readers of Leonardo's words, Cozens advocated something different, the scattering of blots which would suggest a composition (Fig. 37).

Watercolour, however, its colour washes fluidly disposed on a surface, but its paper support giving them a backlit brilliance, offered exceptional opportunities to artists working, as many were, in the open air. While the drawing manuals and the 'Claude glass' (a convex mirror which 'composed' the view) were invaluable fall-back aids for many amateurs, the possibilities of

Figure 37: Alexander Cozens (*c.* 1717–86). *Italian Landscape with Domed Building,* developed from a blot. Pencil and wash, 9.9 × 16 cm. Leeds City Art Galleries.

'An artificial blot is a production of chance, with a small degree of design', remarks Cozens in his book *A New Method of Assisting . . . Compositions of Landscape* (1786): though he reduces the chance aspect by insisting that the mind possesses itself of a powerful idea first. In fact Cozens, 'almost as full of systems as the Universe', as Beckford, his former pupil, commented, provided twenty types of suitable sky to accompany his blots. But a certain open-endedness about his method is glimpsable: one blot could lead to several different landscapes.

using watercolour's spontaneity to experiment across the paper and in depth, and to seize fleeting and apparently unpremeditated effects of light, had never appeared so great. Traditions of landscape composition would still hold sway in the studio, but artists would also want to deliberate there afresh on the mysterious relationship of the permanent and the ephemeral when broad, direct brushwork was allowed to affect more and more of the outcome. Controlled experimentation became the central achievement of the studio watercolours of Thomas Girtin (1775–1802, Plate V).

The open-air oil sketch, which enabled Constable to make a kind of personal broadside into nature about 1810 and discover himself as an artist, also took the air of experiment into the very heart of entrenched tradition, oil painting. Open-air sketching in oils had been practised before; but with Constable it became indispensably built into his total oeuvre, entered the studio and conditioned what was done there. The greens of nature took over from the studio-bred browns of tradition and what became known as Constable's 'snow'

(dabs of pigment charged with white) involved palette knife as well as brush. Turner, by contrast, experimented with watercolour no less than with oil. After his initial period of 'picturesque' travel in Britain, he was to develop the warm side of the palette, above all the yellows, dragging paint across his surfaces and, in his watercolours, building up light effects out of thousands of tiny globules of colour melted into wet or damp washes, with the highest light sometimes obtained by scratching into the paper.

For both these artists perceptions of nature were bound up in entirely personal ways with perceptions of technique. Constable declared that picture-making was a science and pictures were experiments, nicely holding in balance the elements of calculation and daring. He backed up his sketches of sky forms, notably clouds and the rainbow, by an optical analysis of the latter, and owned books on meteorology. Turner reinforced his natural visual acuity by reading such authorities as Joseph Priestley, Erasmus Darwin and Goethe. But contemporary shock at the extremes of their direct involvement with nature is shown by the accounts which are part of the folklore of each artist: Fuseli gazing at a rainy scene by Constable and feeling that he should reach for his umbrella, Constable himself comparing Turner's atmospherics to 'tinted steam'.[22] The stories bear repeating for they carry a hint of the uncertain and unpredictable that not unsympathetic viewers of these paintings could feel.

But if both Constable and Turner were accused of neglecting 'finish', the artists themselves were clear about their designing intentions. Constable, as he tells us, wanted to relate the effects of cloud formation to shadow-fall on land, so as to note 'the day, the hour, the sunshine and the shade' (Fig. 38). Constable showed his respect for tradition when he put the description 'CHIAR' OSCURO OF NATURE' on the title-page of his *English Landscape Scenery* (1830–32), the collection of mezzotints after his work. While he also had in mind the chiaroscuro (light and shade) of his own life, he was nonetheless exposing the old academic term to fresher air than it had ever known.

Constable's composing strengths flourished best when applied to his native Stour landscape, which 'made me a painter'. Turner's gained from his sense of displacement, particularly the experience of crossing: of the sea, a mountain pass, a bridge. The unstable vortex form in his earliest exhibited oil, *Fishermen at Sea* (1796); scythe-like arcs of snow (based on a Yorkshire memory) in *Hannibal crossing the Alps* (1812); bridge-subjects, also early (Fig. 45), all indicated this. His first visit to Italy in 1819 (delayed until he was 44 by the Napoleonic Wars), brought him that country's living traditions, but above all Mediterranean light stirring up the shadows of a dissolved classical past (*The Bay of Baiae*, 1823). Henceforward his mastery of light was to carry him past all the demands his imagination made of it, even in the catastrophic *Shade and Darkness, The Evening of the Deluge* (1843), one of his two late Goethe-based paintings, and its companion, the benumbed, deceptively hopeful *Light and Colour (Goethe's Theory), The Morning after the Deluge*: awesome, chancy themes which Turner nevertheless subjected to huge, cart-wheeling rhythms. A year later came the celebration of another deluge – part natural, part man-made: the age of steam and speed (Plate VI). With such studio-based

works, and his miraculous late watercolours of Swiss subjects, Turner outpaced his age.

The uninhibited self-saturation in nature at first hand by the Romantic landscapists, in fact, implied no abandonment of the studio (see p. 203). On the contrary, they cherished it no less than academic artists reliant on its north light. But for them it became a sanctum or even a sanctuary, a place where a personal vision informed by nature was given its full imaginative shape.

In 1804, the first show of London's Society of Painters in Watercolours, most of them landscapists, attracted over 11,000 paying visitors in seven weeks. Landscape as a subject for art had found its mass public. Progress had been slow. To classical theorists like Joshua Reynolds in the 1770s, panoramic, idealized landscape, with accidents and imperfections ironed out, was the only form of it that was worthy of art's public aim: defining 'public' to mean that which met the lofty overview of society's needs possessed by the man of taste. By the same token, unidealized landscapes, showing wooded, 'short' views with rural workers ('sunken' views, as Barrell has called them),[23] were seen to belong to a much lower order of invention, a status confirmed by their popularity with the ignorant (as well as the educated). In the early nineteenth century this 'either/or' distinction, implying a landscape art for the elite and another for the less tutored, was rejected (as Barrell has pointed out) by Hazlitt, wishing to enjoy the merits of both. Indeed, much had happened meanwhile. To the connoisseur's enjoyment of Claude's Arcadian harmony were added the strenuous but wide-appealing pleasures of the sublime, of picturesqueness, of a world in which the unpredictable, the unclassifiable and the disruptive (more than hinted at in Salvator Rosa's paintings before 1700) played prominent parts. In addition, the ordinary but nonetheless dramatic *accident* – the way the light *happened* for a moment to be illuminating Girtin's White House at Chelsea (Plate V) – had become a subject for a masterpiece in watercolour.

THE SYMBOLIC POSSIBILITIES OF LANDSCAPE

The popularity of landscape painting had come to stay. But artists were to ask more of landscape, and of seascape, than this. If more was known about the

Figure 38: John Constable (1776–1837). Full-size sketch for *Stratford Mill*, 'The Young Waltonians'. Oil, 131 × 184 cm. 1820. Yale Center for British Art, Paul Mellon Fund.

It was Constable's habit, in this period of his full maturity as artist (one year before the famous *Hay Wain*), to make a full-size sketch of a major six-foot work before painting the final version. He depicts here a rural Suffolk idyll in which the perennial activities of fisherboys and bargemen are presented against an established permanence in nature. Though this is a predictable moment of light-fall close to noon in summer, the landscape has been less predictably shaped over time by wind and water. The large trees have been pushed out of the vertical, he was to explain later to his mezzotinter Lucas, by prevailing winds; further along the bank a tree has died after water has soaked its roots.

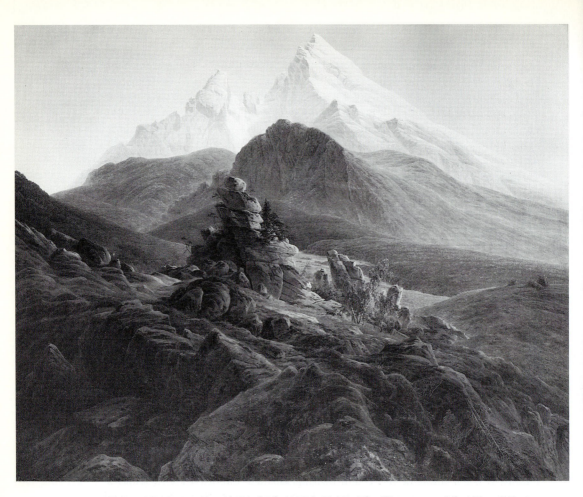

Figure 39: Caspar David Friedrich (1774–1840). *The Watzmann.* Oil, 133 × 170 cm. 1824. Nationalgalerie, Galerie der Romantik, Berlin.

Friedrich's passion for mountain summits had led to controversy in 1808, when he turned a peak with a crucifix upon it into the subject of an altarpiece. Developing his later painting of the Swiss peak Watzmann from a pupil's drawing (Friedrich never visited Switzerland), he composed it, as was his wont, as a piece of religious iconography. No human presence appears. The pile of foreground rocks (taken from his own drawings of another mountain range, his favourite Elbsandsteingebirge, south-east of Dresden) functions as a kind of altar in front of the remote ice-peak. In between comes the distinctively-shaped Erdbeerkopf in the Harz mountains, a range also well known to him. Such assemblages of elements from different locations were common practice with Friedrich, to whom imaginative intention was more important than topography.

natural world in 1800 – after a century of discoveries by explorers, moun-
taineers, geologists and naturalists – nature's capacity to put the imagination,
in Addison's phrase, 'upon the stretch' was, if anything, even greater. The Alps,
hitherto a barrier to travellers, but celebrated in a poem of 1732 by the Swiss
biologist Albrecht von Haller (1708–77), and painted with passion and accu-
racy by the Swiss Caspar Wolf (1735–83), were now an aesthetic goal. For the
painter Friedrich, after 1800, the religious certainty which seemed to have
become compromised in church might be sought in mountain country (Fig. 39),
or in contemplation of a calm sea (Fig. 40). Storms at sea had a special 'sub-
lime' indefinability: the artist Claude-Joseph Vernet (1714–89) was recalled in
1822, in a painting by his son, navigating such a storm; Turner was to por-
tray the dangers with unforgettable enigma in his autobiographical *Snowstorm
– Steamboat off a Harbour's Mouth* (1842). But Friedrich's stillness had, and has,
a particular ability to disconcert. In his *Arctic Shipwreck* (1824) man had not sur-
vived. Inspired by an actual search for the North-west Passage, the work showed
traces of masts and spars of a ship which had been crushed by an iceberg.

If individual man's sense of isolation might be intensified by large-scale,
enveloping landscape or seascape, the success of Erasmus Darwin's work
showed how the opposite could be the result from studying individual plants.
The botanical data collected by Goethe undoubtedly helped him to see affinities
with human life: 'how the plant-world climbs up towards me', he wrote in a
letter.[24] Constable felt similar affinities. There was no trace of life-threatening
entanglement with nature in the wish of Friedrich's fellow German Philipp Otto
Runge (1777–1810) to establish landscape painting – 'Landschafterei', as he
calls it – as the basic resource of the modern artist, to succeed history painting,
which Runge considered dead. Landscape was to be responded to physically
for its botanical and colouristic richness and spiritually for its religious sym-
bolism. Scientist and mystic in Runge united to show others the way 'through
words, sounds or images'. The scientist was uppermost in his book of colour
theory, *Das Farbenkugel* (1810), which gathered all the colours sequentially
onto a sphere between a white pole and a black.[25] He analysed plant-form
with geometrical finality. Like Goethe, but more mystically, he wanted to show
how plants reflected the lives of human beings. Much of his painting, sharing
Schiller's interest in the experiences of childhood (p. 221), celebrates the child's
closeness in particular to the plant world and primitive responses (Plate VII).

Runge's hope to present his *Times of Day* paintings in a special building,
with music, came to nothing. But the idea gave the clue to his entire intention:
to draw human beings together into communion with the principles of life,
growth and transformation in nature, in which all the arts were joined. This
merging of the arts at a deep level of feeling – synaesthesia as it is called – was
to lead to Wagner's notion of the *Gesamtkunstwerk* ('total art work'). But its
plausibility depended on the prior recognition that if one art – music – could
bypass thought for feeling, the others might go the same way. For Runge music
was evidently compelling: he described the open-air sensation of landscape as
harmonizing 'in one great chord'.

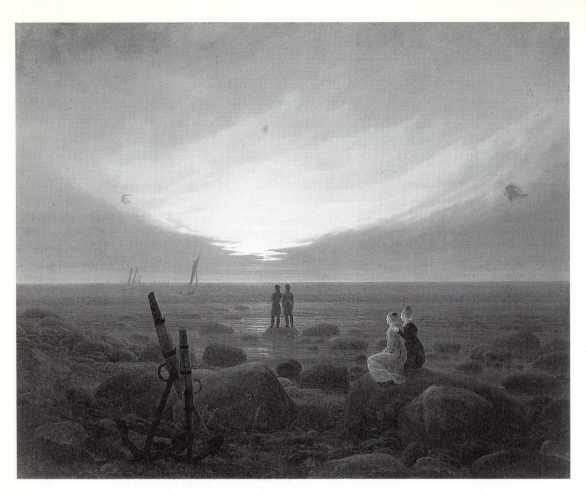

Figure 40: Caspar David Friedrich (1774–1840). *Moonrise by the Sea*. Oil, 135 × 170 cm. 1821. State Hermitage Museum, St Petersburg.

The artist transforms a beach on the Baltic island of Rügen – visited by him, his brother and their wives in 1818 – into a place of spiritual yearning. Seen, as figures so often are in Friedrich, from behind, the seated women and standing men gaze towards two distant sailing ships approaching the shore. Beyond lies the moon, the further goal, which is centrally placed in the picture. The Russian poet Zhukovsky, a personal friend (from 1824) of Friedrich, praised the work in a letter to the wife of the future Tsar of Russia, who bought it. Purchases by the Russian court were to provide important financial support to Friedrich, offsetting dwindling sales at home.

The Composer and the Poet

> Again I hear
> These waters, rolling from their mountain-springs
> With a soft inland murmur.

So wrote Wordsworth near the beginning of *Lines composed a few miles above Tintern Abbey* (1798), recalling an earlier visit to the Wye landscape. Later, in *The Prelude*, he would remember his childhood habit beside Windermere, calling out, 'as through an instrument . . . mimic hootings to the silent owls / That they might answer him'.

Nature in music

The practice of imitating the sounds of nature had, of course, long entered into music. Vivaldi's 'Summer' (*The Four Seasons*, *c.* 1725) had abounded in buzzing flies; Handel had written the exquisite Nightingale Chorus in *Solomon* (1749), and he and Rameau had evoked in their orchestras the sounds of thunder and hailstones. Such allusions addressed a common stock of sense-experience, and tended to confirm a perception of music (despite its centuries-old status among the medieval liberal arts) as essentially little more than an entertainment for the ear. Kant classified music with another evident vehicle of sense-excitement, colour (*Critique of Judgement*, 1790). Claims for links between the two were explored, before and after he wrote, by theorists intent on building a colour-clavichord (in France, *c.* 1725) or, later, a colour-piano.[26] But before 1800 the increased recognition of music as a language with its own powers (see Chapter Two, p. 73) had overtaken such ingenuities. As with colour, any involvement of music in relaying simple, direct human responses to nature was to be seen as a sign of its universality, not as a limitation.

Music was an obvious vehicle of the nature-based, programmatic journey through time. Telemann's fascinating cantata *Die Tageszeiten* (*Times of Day*, 1759) passed from sunrise to night and in successive sections from soprano voice to contralto, tenor and baritone. The theme of music and nature had, however, been put on a new footing by Joseph Haydn (1732–1809) in his oratorios *Die Schöpfung* (*The Creation*, 1798) and *Die Jahreszeiten* (*The Seasons*, 1801), written for Vienna.[27] His *Creation* took a German version of an English text from the Bible and Milton's *Paradise Lost*; the *Seasons* a German reworking of words by Thomson. *The Creation* is in three parts, each concluding with a chorus of praise. 'Natural' sounds recur, such as the tread of 'heavy beasts', and the slithering of the serpent. But such rhythmic 'imitations' take on a unique freshness in the wake of the extraordinary introductory account of the world *before rhythm*, the opening 'Representation of Chaos'. Haydn's approach to this was a subtle one. From an initial unison C to denote the void, he uses 'modern' sonata form – to which he himself had earlier contributed so much – but with the phrase-lengths varied and extended to the point where it becomes impossible to predict where the music is going. There are fragments of what

might be themes: rushing scale passages, evasive harmonies: the basic key is the anxious one of C minor. Seven surviving sketches show how much thought he gave this. We have a sense of the very origin of the design principle. After a recitative the chorus enters in C major with the words 'and there was Light'. From this point there is no doubt about where the music is taking us.

As Tovey pointed out, a popular version of Laplace's theory that the universe originated in a large, nebulous mass had recently appeared. It cannot be known if Haydn had encountered it: but he is known to have visited in England William Herschel, fellow-musician and Astronomer-Royal, who was also interested in nebulae. And in 1797, having played the 'Representation of Chaos' to a friend, Haydn remarked how he had 'avoided the resolutions that you would most readily expect. The reason is, that there is no form in anything [ie. in the universe] yet'.[28]

Haydn's two late choral masterpieces became popular in England (despite Handel's following); and in Austria, where their prestige was strengthened by Beethoven's advocacy. It was Beethoven who provided the sequel: his 'Pastoral' Symphony (1807–8, Fig. 41). The first remarkable fact about this overwhelmingly serene work is that it was written while Beethoven was still engaged on the grandly heroic Fifth with its opening motif of 'Fate knocking on the door', as he is said to have described it. Here in the Sixth was proof of nature's ability, in the high art of the new century, to be as powerful an inspiration as human endeavour. Religiously engaged by nature, like Friedrich and Runge, Beethoven often received ideas on country walks. With the 'Pastoral' Symphony, a full-scale harvest of symphonic thinking returned to its source. The first movement, entitled 'Cheerful impressions excited by arriving in the country', is built largely out of phrases derived from the opening theme: a way of suggesting a general quality of continuing rural life which the running rhythms of the slow movement, 'By the brook', then make specific. Man appears in the 'Merry-making' movement, which is followed by a furious thunderstorm. This is no mere onomatopoeic sound effect, with birds seeking shelter: like Haydn's relating of chaos to order, it is conceived – as Berlioz observed – as a foil to the spirit of the whole work. It depends on its precise setting in the symphony, not only contrasting with what has gone before but providing with its unstable harmonies a pivot, however unsteady, for the resumed flow of country life with the shepherd's hymn of thanksgiving in the finale.

Berlioz, who conducted the 'Pastoral' Symphony on his last foreign tour, to Russia in 1867–68, clearly had a high opinion of it. His own art was too involved with the tumult of human passions ever to give itself up so fullheartedly to external nature: but there is a typically highly-charged pastoral by Berlioz in his *Symphonie Fantastique* (1830). The third of five movements which relate episodes 'In the Life of an Artist', this 'Scene in the Fields' is placed between 'A Ball' and the macabre 'March to the Scaffold'. The Berlioz symphony has a much more precise programme than the Beethoven: it is focused round the hopeless love of the artist and his reactions of elation or despair at his beloved's appearances, which are denoted by a theme, the *idée fixe*. This theme appears in an agitated section of 'Scene in the Fields': before and after,

Figure 41: Ludwig van Beethoven (1770–1827). Autograph sketches for Symphony No 6 (Pastoral), part of first movement. Page 23 × 32 cm. 1808. British Library.

As the personal moods of artists, in the Romantic period, were allowed to show more and more explicitly in their works, autograph sketches became increasingly integral to the final results. With their forward-leaning bar-lines, hastily-inscribed clef-signs and fragmentary indications of instrumentation ('obo', 'clari'), Beethoven's sketches for his Pastoral Symphony give a vivid impression of him intensively at work. They also suggest the difficulty of transcribing these marks into a playable printed score.

however, a hushed horizontality imposes itself on the music, notably in the widely spaced pipings of shepherds in dialogue (on oboe and cor anglais) at the beginning, and in the playing of one shepherd (oboe) answered by thunder (timpani) at the end. This conclusion gives the sense of an ominous imbalance, redolent of the artist's loss of ease and the threat of an indifferent nature. Where Beethoven sees nature reconciling the artist to itself in a classical unity, Berlioz (as he reveals in an explanatory leaflet) uses the thunder to underline a Romantic 'painful isolation'.

NATURE AND POETRY

The optimism which Beethoven derived from nature was shared by his exact contemporary Wordsworth: though questioned, in *Tintern Abbey*, by a famous reference to the 'still, sad music of humanity'. The poem appeared among the *Lyrical Ballads* of 1798, published with Coleridge: an event which has rightly been seen as a landmark of Romanticism. Several of the poems, recalling Crabbe's poem *The Village* (1783), had explored the hardships of the rural poor, in ways that many contemporary reviewers found unsettling. *Tintern Abbey*, however, was the great nature poem of the sequence. While Cowper, before him, had meditated deeply on landscape, Wordsworth here unmistakably presented his own characteristic 'eye made quiet by the power of harmony' to 'see into the life of things'. Above Tintern, five years after his first visit, the poet felt the joy of 'something far more deeply interfused', which 'rolls through all things'. His meaning has kept writers of many complexions busy ever since: a recent survey of the *Lyrical Ballads* cites the differing views of twenty-four modern critics, from psychoanalysts to materialists, on this one poem alone.[29] What is unarguable is that Wordsworth had here taken poetry into a new phase of response to the natural world, which was to appear less the sum of objective and classifiable parts external to the observer and more the seat of powers that moved him to praise – or to anxiety for their preservation. The industrialisation of England was to be a source of vexation to Wordsworth, promoting strong environmentalist views (he argued for more responsible stewardship of the Lake District by appropriate planting) and going some way to explaining, perhaps, why he remained, for a poet of world stature, essentially English in reputation. The intensely backward-searching cast of his later autobiographical work will need comment later (p. 207).

For Hazlitt, in *The Spirit of the Age* (1825), the cataract roared in the sound of Wordsworth's verse. The Aeolian Harp had also been enjoying another surge of notoriety. To Coleridge the instrument made nature's sounds but expressed man's imaginative life, even to the scream in the ode *Dejection* (1802). His earlier poem *The Eolian Harp* (1795) had asked if nature was not made up of 'organic harps diversely framed', and the sweeping of them by the wind became a vivid image of spontaneous creation. In 1808 Bloomfield, the 'natural' poet, whose *Farmer's Boy* (1800) had sold over 20,000 copies in three years, and who made Aeolian harps, published a pamphlet on the instrument entitled *Nature's Music*. In Germany Jean Paul (p. 229) described one hanging in a birch tree, in his novel *Hesperus* (1795), and many other artists, including Scott, Thomas Moore, the poet Mörike, and Berlioz (as late as 1844), referred to it.

The idea of music carried by the wind and its spur to the imagination, however, appeared most strikingly in Shelley's *Ode to the West Wind* (1819). The Aeolian harp image was here magnified to the scale of a rush of air playing on a whole forest as if it were a lyre. But the practice of scientific observation was central to Shelley, modifying even regard for his 'divine' Epicurus, the philosopher who had expounded a material, chance-driven universe. While wind, air, ocean, filled Shelley's imagination, his interest in meteorology gave in this poem

what observers of cyclonic Mediterranean thunderstorms have recognized as a remarkably accurate account of the irregular scud clouds that occur round them, formed out of water evaporated from the sea. 'Shook from the tangled boughs of Heaven and Ocean': a leap in the poet's thought relates the streaming filaments of wind-formed cloud to the hair of 'some fierce Maenad' (one of the demented women votaries of Bacchus). In the last two stanzas, the poet is fallen on thorns and bleeding: in his weakness he calls on the wind to lift him, and through its power be 'the trumpet of a prophecy' – his prophecy: 'If Winter comes, can Spring be far behind?' The rising note of solicitude for seasonal renewal, addressed to the wind that is preserver as well as destroyer, restores the idea of design: made more mysterious, however, for having a question-mark at its back.

The dynamic forces in nature as metaphors of human life or regeneration themselves received new energy from work being done on electricity, a close interest of Shelley's and a useful image for a revolutionary. There were interesting possibilities here. For Goethe, in his novel *Die Wahlverwandschaften* (*Elective Affinities*, 1808), electricity and magnetism were apt symbols of attraction in a plot about natural 'affinities' between two pairs of characters.[30] The German poet Novalis (1772–1801) made the electric current (explained by Volta in 1797) work magically in the fairy-tale episode of his novel *Heinrich von Ofterdingen* (written 1799–1800): a 'flash of life', caused by water flowing into a metal dish, re-energizes the giant Atlas, who has been immobilized by reason.[31] In 1802 the galvanic flash illuminated the popular Royal Institution lectures of the chemist Humphry Davy (1778–1829), whom Coleridge heard. In 1818 it would light up the birth of Frankenstein's monster (p. 232).

Beside the uncertainties of the poet's relationship to nature that *Ode to the West Wind* revealed, Fate or Necessity still hovered: 'What is this world's delight? / Lightning that mocks the night, / Brief even as bright,' wrote the atheist Shelley, for whom Necessity became a self-fulfilling force behind the energy of events.[32] But certain impermanent forms in nature – the cloud, the wave, the chameleon – nevertheless delighted by their elusiveness, the element of chance common to them all. 'The poet worships Chance' wrote Novalis.[33] Writers of *Lieder*, especially, were to mark such impermanences – the rustling wind, the turning weather-vane, the flow of water beneath ice. Schubert's great *Winterreise* (*Winter Journey*, published 1828–9), using Müller's words (p. 235), brings them all before us.

Romantic subject-matter freed poetry and music for fresh uses. Wordsworth and Coleridge increased the ballad's range to admit their imaginative needs. Free verse in Klopstock (a poet of large, cosmic themes) and early Goethe led to the prose-poems of Novalis' *Hymns to the Night* (1800). But not all movement was expansive. Prose itself – a 'free' medium anyway – could be concentrated in the German short story (Novella), with its 'turning-point' designed to keep the reader's attention; or in neatly-balanced aphorisms (such as Blake's, p. 200). Byron's choice of the eight-line stanza for the ebullient subject of Don Juan (16 cantos, 1819–24) reminds us of his eighteenth-century ear for a proven form, as well as his personal glee over an outrageous rhyme. With

Goethe secure in his classicism from the late 1780s, a tremendous force lived on for that tradition's central task of forming and shaping, which Schiller also held up to Europe in his letter-sequence *On the Aesthetic Education of Man* (1793–94, published 1795). In Beethoven, too, with the aid of Maelzel's modern metronome, eighteenth-century regard for measure, focus and overall limits had a powerful advocate.

But the irrepressible Romantic archetypes of non-conformity – Prometheus, who stole fire from the gods for man; Don Juan in his deepest psyche; and Faust, a lifelong subject for Goethe himself – offered few concessions to shaping. The wide variety of verse-structures in Shelley's four-act lyrical drama *Prometheus Unbound* (1820) and Goethe's 12,000-line *Faust* (first a 'fragment', 1790, then expanded, Part One 1808, Part Two 1831) testified to subjects that bristled with organizational problems – and opportunities. Beethoven's conception of the hero in his 'Eroica' Symphony (1803) took sonata-form to breaking-point, substituted a pulsating scherzo movement for the traditional minuet, and culminated in variations on a theme from his 'Prometheus' ballet. Chopin's four-movement B flat minor piano sonata (1837–39) 'grew' from the heroic Funeral March which was composed two years earlier. Byron's *Don Juan* developed in fits and starts, by association and 'licence', as he called it: having involved his hero in phantasmagoric adventures and scene-changes (including an episode adrift at sea, painted by Delacroix), he left the poem unfinished at his death – not the last Romantic masterpiece so to remain.[34]

No more formidable challenge to forming and shaping could be presented than the subject of *Faust*. Goethe began his first sketches in the early 1770s. The story – published in chapbook form late in the sixteenth century, and used by Marlowe and in numerous ways by strolling players and puppeteers – told of the scholar-magician who bartered his soul with the Devil in exchange for worldly fulfilment. Popular versions had invariably ended with his removal to hell. The *Faust* play by the eighteenth-century figure Lessing had not done so: and Goethe's poem, in the spirit of Enlightenment toleration, redeemed the hero. A strong beginning (the pact), and a strong ending (the fate accorded to Faust), had always made the story safe ground for conventional drama. But what had often degenerated into a sagging episodic middle was used by Goethe subtly to explore the most basic of all interdependences, that of Faust – confident, all-enquiring man – and his tempter or *alter ego* Mephistopheles, the spirit of negation. There was to be a strong element of autobiography in Goethe's *Faust*: Fausts he had known, and the Faust in himself. Man succumbing to wrong choices is the central issue. After the pact, Faust's still youthful impetuosity (he is about 30, like Goethe himself, at the beginning) and Mephistopheles' amoral energy join battle: in Part One the crisis is reflected in Faust's seduction and abandonment of Gretchen: in Part Two in Faust's bid to free himself from his errors.

If, however, the complexities of human nature thus opened up in *Faust* favoured variety of formal structure and metre (solo speeches interspersed with songs and choruses), the natural world which Goethe had observed so closely could provide an underlying conceptual framework and a series of symbolic

reference points in the plot. In the scene of Part One called 'Forest, Cavern', Faust's monologue about the access he has been granted to nature's splend-ours (Forest) is succeeded by his recognition within himself (Cavern) that he will betray Gretchen. In Part Two's quest for wisdom we meet, among many references to mountains and water, that metamorphic but shaping and trans-forming power that Goethe studied, as we have noticed, in the development of plant life. While Mephistopheles' experience of the 'very floor of Hell' has permanently conditioned his view of change in nature as essentially blind and violent, Faust's responses in Act IV ('Mountain Height') take a very different line. Further trials of his headstrong pride lie ahead: but here, in words that vividly evoke Chinese thought and landscape painting, the artist in him is given an overview of nature as agent of compensation, balancing out hills and val-leys, and providing verdure:

> Then hills she formed in gentle beauty blending,
> In softened lines to valleys mild descending.
> There verdure teems, a growth that for its gladness
> Needs nothing from your tale of seething madness.[35]
>
> (II, 406–7)

The clash of wills in *Faust* struck instant sparks with the Frenchmen Dela-croix and Berlioz (p. 218). In Britain it drew few admirers, apart from Shelley: Part One was only completely translated in 1833. But the advocacy of Carlyle (1796–1882) and reviews in *Blackwood's* and, from 1826, the *Quarterly*, helped to establish Goethe in the pragmatic English-speaking world as seer and 'man of universal spirit' (Madame de Staël's judgement in *De l'Allemagne*, 1810, English edition 1813). And his passion for natural science was winning con-verts such as, by 1830, the American Emerson (1803–82).[36]

In the 1830s John Ruskin (1819–1900) set out from a background steeped in Christian evangelism and a love of Wordsworth. In him, as in Goethe, poet and scientific observer met: rocks, plants, nature's colours absorbed him, as phenomena to be both studied and possessed. All his own, however, was a power to express in prose the whole plenitude of nature from the largest forms to the infinitesimally small and, from their interrelationships, draw conclusions for human morality and art. In his autobiography *Praeterita* he revived for him-self memories of early travels:

> The rain-cloud clasps her [the Jura's] cliffs, and floats along her fields; it passes, and in an hour the rocks are dry, and only beads of dew left in the Alchemilla leaves – but of rivulet or brook – no vestige yesterday, or to-day, or to-morrow. Through unseen fissures and filmy crannies the waters of cliff and plain have alike vanished, only far down in the depths of the main valley glides the strong river, unconscious of change.
>
> I, ix

Such a word-picture recalls the emotional reach of Turner. And Ruskin's lifelong sense of a dramatic interplay between chance and fate (made specific

in his later book-title, *Fors Clavigera*, 'Nail- or Fate-bearing Chance') also entered into the chemistry with Turner which produced Ruskin's heroic view of him in *Modern Painters* (1843 onwards).

Perceptions of the natural world had multiplied since Addison, in 1712, had looked at his veined marble for the unifying design in what he thought was chance, the art concealed in nature. Constable, studying hedge-bottoms, recognizing that no two leaves were exactly alike, looking to the life of the countryside to suggest a picture, had his own view of the design-chance relationship. 'I always sit', he is recorded as saying, 'till I see some living thing, because if any such appears it is sure to be appropriate to the place. If no living thing shews itself, I put none in my picture'.[37] Here was a sober, down-to-earth statement of serendipity and the expectation of Eden. Constable's wish to control could make no more concession to chance than Turner's. But he was willing to take its free gifts at face value when he could use them.

NOTES

1. Milton, *Paradise Lost*, IV, line 702. Cf. lines 223f. Milton's complex, twin-edged influence on the eighteenth century was concisely expressed by Robert Lloyd's line, 'Thus Milton, more correctly wild' ('A Dialogue', *Poetical Works*, 1774)
2. Pat Rogers, 'Pope's Rambles', *Eighteenth-Century Encounters: Studies in Literature and Society in the Age of Walpole* (1985), esp. pp. 43–4
3. For nature as 'artist' see Barbara M. Stafford, 'Toward Romantic Landscape Perception: Illustrated Travels and the Rise of "Singularity" as an Aesthetic Category', *Art Quarterly*, 6 N.S. (Detroit 1977), pp. 89–124
4. Paul K. Alkon, 'The Odds against Friday: Defoe, Bayes and Inverse Probability', in Paula R. Backscheider, ed., *Probability, Time and Space in Eighteenth-Century Literature* (New York 1979), pp. 29–61. See also Thomas M. Kavanagh, *Enlightenment and the Shadows of Chance: The Novel and the Culture of Gambling in Eighteenth-Century France* (Baltimore 1993) and his study of Casanova's chance-directed career in *Esthetics of the Moment: Literature and Art in the French Enlightenment* (Philadelphia 1996)
5. The Roman poet Lucretius, follower of Epicurus in stressing a chance-driven universe, had written of 'spontaneous generation' in his *De Rerum Natura*, much studied in the eighteenth century. For discussion of 'spontaneous generation', and its lasting influence as an idea, see Dirk F. Passmann, 'Mud and Slime: Some Implications of the Yahoos' Genealogy and the History of an Idea', *British Journal for Eighteenth-Century Studies* 11 (1988), pp. 1–17
6. Diderot's concern for order, and the frustrations experienced in seeking or willing it, are discussed in Lester G. Crocker, *Diderot's Chaotic Order* (Princeton, New Jersey 1974), and in Geoffrey Bremner, *Order and Chance: The Pattern of Diderot's Thought* (Cambridge 1983). On *Jacques le Fataliste* and Jacques' belief in Fate, 'what is necessary' in a world of flux, see P.N. Furbank, *Diderot* (New York 1992), pp. 431f.
7. Johnson, *Thoughts on the late Transactions respecting Falkland's Islands* (1771): *The Political Writings of Dr Johnson: A Selection*, ed. J.P. Hardy (1968), p. 73
8. For example, C.N. Cochin le Jeune, *Supplication aux Orfèvres* (anonymously published in *Mercure de France*, Dec. 1754). This ironical address to goldsmiths and

other designers advises the use of natural forms with 'reason', but also recommends straight lines for furniture and architecture. Cf. E.H. Gombrich, *The Sense of Order: A Study in the Psychology of Decorative Art* (Oxford 1979), pp. 21–2

9. Between 1757 and 1813 over a dozen musical games appeared which enabled marches, minuets, waltzes etc. to be composed by throwing dice, spinning tops or choosing random numbers. Mozart, Haydn and Emanuel Bach all amused themselves with these ways of avoiding the 'norms' of musical form. See Leonard G. Ratner, '*Ars Combinatoria*, Chance and Choice in Eighteenth-Century Music', in H.C. Robbins Landon, ed., *Studies in Eighteenth-Century Music: A Tribute to Karl Geiringer on his Seventieth Birthday* (1970), pp. 343–63

10. Peter J. de Voogd, 'Laurence Sterne, The Marbled Page, and the "Use of Accidents"', *Word and Image*, vol. I, No. 3 (1985), pp. 279–87 (illus). See also Diana Patterson, 'Tristram's Marblings and Marblers', *Shandean, Annual Volume Devoted to Laurence Sterne and his Works*, vol. 3 (1991), pp. 70–91

11. Its modern rediscoverer was Athanasius Kircher (1601–80). Thomson's reference was in Canto I, stanza 40 of his poem: the instrument presents 'Nature all above the reach of Art'. For background see Geoffrey Grigson, *The Harp of Aeolus* (1947) and Stephen Bonner, *New Grove Dictionary of Music and Musicians*, ed. Stanley Sadie (1980), vol. 1, pp. 115–17

12. Walpole, letter to Horace Mann, 28 Jan. 1754. *Correspondence*, ed. W.S. Lewis, vol. IV, pp. 407–8

13. Cited in Bernard Mayo, ed., *Jefferson Himself* (Boston 1942), p. 24. For the meeting of Chastellux and Jefferson see Eleanor D. Berman, *Thomas Jefferson among the Arts* (New York 1947), p. 152

14. See Hugh Honour, *The European Vision of America*, Cleveland Museum of Art (1976), pp. 266f. Humboldt's writings, much translated, were widely read.

15. The 'antipodal inversion' theory is discussed with other contemporary comment on the kangaroo in Bernard Smith, *European Vision and the South Pacific, 1768–1860* (Oxford 1960), pp. 170–3. Sydney Smith's words come from his notice of James O'Hara's *History of New South Wales* (1817) in the *Edinburgh Review*

16. Rousseau, *Discours sur l'Origine de l'Inégalité* (1755); Monboddo, preface, *Of the Origin and Progress of Language* (1773–92); cf. Bk II, ch. v, n. 85. Christopher Frayling and Robert Wokler, 'From The Orang-utan to the Vampire: Towards an Anthropology of Rousseau', in R.A. Leigh, ed., *Rousseau after Two Hundred Years* (Cambridge 1982), pp. 109–29

17. Cf. Charles Coulston Gillespie, *The Edge of Objectivity: An Essay in the History of Scientific Ideas* (Princeton, New Jersey 1960), pp. 193–4. Following Goethe's *Metamorphosen der Pflanzen* (1790), the study of design in plants became a German speciality (e.g. Alexander Braun on the laws of leaf growth, 1831). The lectures and books of John Lindley (1799–1865) publicized similar interests for the English-speaking public

18. Goethe, letter to J.D. Falk, 14 June 1809: included in John Gage, ed., *Goethe on Art* (1980), p. 73

19. The French theorist and artist Roger de Piles (1695–1709), however, had energetically advocated colour and Rubens' use of it (*Dialogue sur le Coloris*, 1673, etc.)

20. *Coloritto: or the Harmony of Colouring in Painting reduced to Mechanical Practice, under Easy Precepts, and Infallible Rules* [1725]. See John Gage, *Colour and Culture: Practice and Meaning from Antiquity to Abstraction* (1993), Figs 124–7

21. Goethe, *Theory of Colours*, trans. C. Eastlake (1840), pp. xxxviii–ix

22. C.R. Leslie, *Life of John Constable*, ed. J. Mayne (1951), pp. 72–3; Graham Reynolds, *Turner* (1969), p. 150

23. John Barrell, *The Birth of Pandora and the Division of Knowledge* (1992), pp. 11f. 43f.

24. Goethe, letter to Charlotte von Stein, 9 July 1786: see *Goethes Leben von Tag zu Tag*, ed. Robert Steiger (Zurich and Munich) Band II (1983), p. 518. The towering splendours of the plants portrayed in Robert John Thornton's famous book *The Temple of Flora* (1807) – much influenced by Erasmus Darwin – were to echo Goethe's words

25. Illustrated in Jorg Traeger, *Philipp Otto Runge* (Munich 1975), pp. 48–9

26. Though the description of music as 'coloured' was already established among the ancient Greeks (who had also applied the musical terms 'tone' and 'harmony' to critical discussion of the visual arts), it was to take on added life as the piano and the instruments of the modern orchestra developed in the nineteenth century. Wagner knew Runge's work: see Traeger (note 25), p. 178. On colour and music see Gage, *Colour and Culture* (note 20 above), ch. 13

27. Nicholas Temperley, *Haydn: The Creation* (Cambridge 1991)

28. Donald F. Tovey, *Essays in Musical Analysis*, vol. V (1937), p. 114. Cf. Temperley, *Haydn: The Creation*, p. 32. The astonishing portrayal of Chaos sounding all the notes of the D minor harmonic scale, that opened Jean-Féry Rebel's suite *Les Elémens* (1737), was an earlier response to the same challenge. Rameau's remarkable overture to his pastoral opera *Zaïs* (1748) also depicted the Creation, using preliminary drum-taps

29. *Wordsworth and Coleridge, Lyrical Ballads: Critical Perspectives*, ed. Patrick Campbell (Basingstoke 1991), pp. 76–83

30. Eric A. Blackall, *Goethe and the Novel* (Ithaca and London 1976), p. 168

31. Novalis, 'Klingsohrs Märchen', *Heinrich von Ofterdingen*, in *Schriften*, ed. Paul Kluckhohn and Richard Samuel (Stuttgart 1960), vol. I, pp. 209f.

32. Shelley, 'Mutability', composed 1821, published 1824

33. Novalis, *Schriften*, ed. Richard Samuel (Stuttgart 1960), vol. III, p. 449

34. See Truman Guy Steffan, *Byron's Don Juan*: vol. I, 'The Making of a Masterpiece' (Austin and Edinburgh 1957), p. 27: also Jerome J. McGann, *Don Juan in Context* (1976), p. 1 and ch. 6. Ideas of 'artistic licence' were never new; and flexibility of view concerning the expected boundaries of a work of art had long been growing. The problematic *Sturm und Drang* figure J.M.R. Lenz (1751–92) wrote the play *Die Soldaten* (1776), in which a series of 'staccato' scenes took charge from overall unity. A generation later Friedrich Schlegel was to assert the impossibility of classical completeness in his own day. He published aphoristic 'fragments' in the Jena periodical *Athenäum* in 1798, and held that the fragment, paradoxically, was a finished form. The implications of the Romantic fragment, and its relation to 'fragmentary' pieces composed by Chopin and Schumann, are usefully discussed in Charles Rosen, *The Romantic Generation* (1995), pp. 48–115. Cf. Fig. 65 below

35. Goethe, *Faust* Part Two, trans. Philip Wayne (1959), p. 217. Cf. his Introduction, p. 14. On the 'Forest, Cavern' scene see N. Boyle, *Goethe: The Poet and the Age*, vol. I (Oxford 1991), p. 457

36. In 1836 Emerson was describing Goethe as 'the truest of all writers'. See Ralph L. Rusk, *The Life of Ralph Waldo Emerson* (New York 1949), p. 237

37. W.P. Frith, *Further Reminiscences* (1888), pp. 319–20

Interlude:
Bridges of Promise?

The bridge between 1700 and 1850 became arguably the most representative building form in the West. Not only did Britain, America and France all develop it to improve internal communications: in the age of Canaletto, and the view-painters who followed, it provided a host of new focal points and vantage points for the view-seeker. These were appealing enough to make the French writer Louis-Sébastien Mercier pace the Paris bridges (cleared of their houses) 'in triumph', as he tells us, in the 1780s; and to invite Wordsworth to compose his famous sonnet on the 'mighty heart' of London in 1802 from the celebrated eighteenth-century bridge at Westminster, the first to be built in the capital since medieval times (a fact in itself of some moment).

But the pleasures of bridge-viewing were not all: there were more solemn thoughts to be had. Byron, in Canto IV (1818) of *Childe Harold's Pilgrimage*, recalled the fateful journeys of prisoners of the Venetian State from freedom to captivity or death:

> I stood in Venice, on the Bridge of Sighs
> A palace and a prison on each hand.

While bridges overcame obstacles, to evident human advantage, some could clearly offer hazard, or even allow no return. Here was an ambivalence which enabled the bridge, as engineers of the railway age tackled the need for it in those parts of the Western World committed to irreversible sociological and industrial change, to add significantly to its scope as symbol. Among painters who conjured with this were two who were young enough to respond to modern engineering marvels, but also old enough to remember the sublime before railways: Turner and John Martin. Among

writers there was the American Nathaniel Hawthorne. There was also Charles Dickens – more interested in people than the bridge, but nonetheless sufficiently sensitive to its sky-spanning properties to include in his famous description of the London fog at the beginning of *Bleak House* (1852–53) an arresting reference to 'chance people . . . on the bridges . . . as if they were hanging in the misty clouds'. Amid the dense atmospherics of modern city life, the symbolic value of the Western bridge, as crossing-point, viewing-platform and – as Dickens well knew – place of disorientation, was set to increase.

Links and Missed Connexions

'Bid the broad Arch the dang'rous Flood contain', wrote Pope in his 'Epistle to Burlington', as part of a series of recommendations which also included roads. The overcoming of distance and natural obstacles was a priority in the communications- and travel-conscious eighteenth century. The evidence of Defoe in his *Tour through . . . Great Britain* (1724–26); the impressive achievements in France of the Corps des Ingénieurs des Ponts et Chaussées (Bridges and Roads), directed from 1763 by the great engineer Perronet (1708–94); the bridge- and canal-building programme of Britain's industrial age, carried forward by men of the calibre of Telford (1757–1834): all testified to the seriousness of Pope's general point.

What the prestigious stone bridges of the age – London's Westminster (1738–50), Blackfriars (1760–69, Fig. 42) and Waterloo (1816–19), and Paris's Neuilly (1768–72) by Perronet – did for their capital cities, was done for the Severn Gorge by the world's first iron bridge, the 100-foot-long arch completed in 1779, in industrial Coalbrookdale, Shropshire (Fig. 43). Artists flocked to depict it. As a product of a changing society it remained a barometer of its optimism until the debit side of industrialism began to weigh on men's consciences in the next century. In 1787, spanning its valley of furnaces, the Iron Bridge had seemed to a visiting Italian, Count Carlo Comasco, a 'gate of mystery'; in 1812 it appeared to the writer of the Shropshire volume of Britton's *Beauties of England and Wales*, the Reverend J. Nightingale, to preside over chaos.[1]

Simultaneously, America became seriously involved with the bridge idea. Settling there in 1774, the English political theorist Thomas Paine (1737–1809) wrote energetically in support of American independence and later, after his return to England in 1787, of the French Revolution. A letter of 1789 from Paine to the botanist Sir Joseph Banks told of his design for a 400-foot single-arch iron bridge planned to cross the Schuylkill River at Philadelphia. The river's ice-flows made a multi-arch structure unwise: Paine's single span was to have thirteen ribs, representing the number of states which had recently united, following American Independence. 'Great scenes inspire great ideas,' Paine wrote, 'as one among thousands who has borne a part of that memorable Revolution I returned with them to the enjoyment of quiet life, and that I might

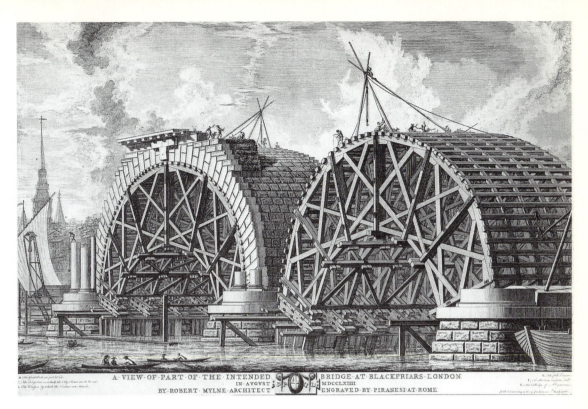

A·VIEW·OF·PART·OF·THE·INTENDED BRIDGE·AT·BLACKFRIARS·LONDON
IN·AVGVST MDCCLXIIII
BY·ROBERT·MYLNE·ARCHITECT ENGRAVED·BY·PIRANESI·AT·ROME

Figure 42: Giovanni Battista Piranesi (1720–78). *Blackfriars Bridge Under Construction*. Etching, 38 × 60 cm. 1764, published 1766. British Museum.

Piranesi had known the Scottish-born designer of Blackfriars Bridge, Robert Mylne, in Rome. From there he produced this dramatic print depicting two of the bridge's nine elliptical arches. Introducing the initials SPQL beneath – echoing SPQR, Senate and People of Rome – he implies that modern bridge-building in London is worthy to stand beside the achievement of Roman architects and engineers. In the way, however, that he shows a timber centre that has not yet received its arch, another on which the masonry cap lies complete, and the tiny but animated figures of workmen continuing the spoke-like lines against the sky, he also conveys the ongoing Enlightenment preoccupation with progress and purpose (compare the claustrophobic frustrations of the *Prisons*, Fig. 26).

not be idle, undertook to construct an Arch for this River.'[2] Though he had showed a model at the Paris Academy of Sciences in 1787, and also in London, his American financial backer failed and the scheme lapsed: Paine's life, as the French Revolution broke out and he rose to defend it against Burke, was to be anything but quiet. A trial rib was shown on a bowling green in Paddington, London in 1790–91, but schemes for his iron bridges to be built in Paris and Dublin as well as over the Thames came to nothing. His book *The Rights of Man* emerged (1791, 1792): henceforward he used the word 'bridge' to refer to his political moves. (Paine's initiative was seen nevertheless at the time to inspire the second iron bridge, that at Sunderland in northern England, in fact built in 1793–95 to a different principle.)

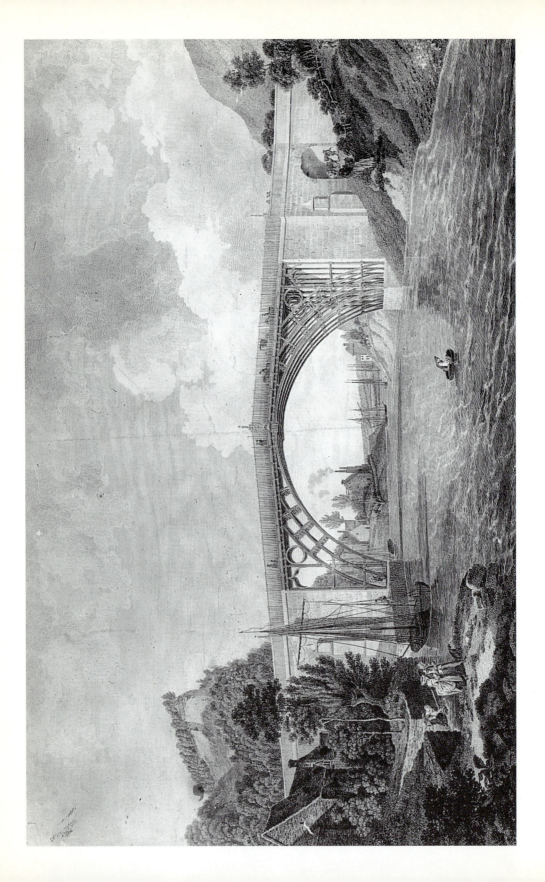

However disappointing the actual outcome, no single building form of the time could have conveyed greater political idealism than Paine's arch for the Schuylkill, in the emotive setting of Philadelphia, national capital during the Revolution, and the chief centre of the American Enlightenment. Had it been realized, the age-old significance of the bridge-form to riverside communities since man first set out to master his environment would have been given a uniquely vivid modern underlining. As it was, further plans were soon proposed. The original Philadelphia, laid out in colonial times (from 1681) on an unusually large grid plan between the Schuylkill and Delaware rivers, apportioned space with a Quaker regard for the inhabitants and their needs: green walks in central squares; freestanding wooden houses in green plots; allotments on the edge of town, but no unnecessary frills. Parallel with the setting up of Democratic Clubs in the 1790s, the principles of utility and structural soundness in building, which had recommended Palladian classicism to Jefferson, were literally to raise the profile of the democratically-useful bridge. 'Great scenes' indeed demanded 'great ideas': but not necessarily elaborate or expensive ones. The eastern States were crossed by wide, fast-flowing rivers, and the Atlantic coast was deeply cut by creeks and inlets. Population was still, to a degree, mobile. Money was not plentiful. So, of necessity, a series of long and inexpensive bridges began to be built, mainly of wood. The bridge-form, indeed, freely discussed in American magazine articles in the period, appears to have become a test-case for a distinctively American utilitarian aesthetic as it established its independence from Europe.[3] At Philadelphia the three-arch 'Permanent Bridge' of wood over the Schuylkill (1805), 550 feet long and covered in at the sides as well as roofed, emerged as a characteristic American 'type'. The 'Colossus', the covered wooden bridge of 1812–13, at nearby Fairmount, achieved an unprecedented single span of 340 feet. In 1811, the year that Thomas Pope published the first book on bridges in America, he proposed for Columbia, New York, a single arch of wood of 1,800 feet (not built but, like an unrealized 600-foot iron arch designed by Telford for London ten years before, an inspiring vision).[4] Within a generation a covered bridge was built over the Susquehanna at Baltimore.

Anywhere else, such bridges would call for little comment beyond the fact of their extraordinary technical accomplishment. But in America these structures, and their successors, met more than simple needs. At a practical

Figure 43: Thomas Farnolls Pritchard (designer) and Abraham Darby III (ironmaster): *Iron Bridge, Coalbrookdale, Salop*, 1779. Line engraving by William Ellis (1747–1810) after Michael Angelo Rooker (1743–1801). 44.6 × 66.1 cm. 1782. Ironbridge Gorge Museum Trust.

The fame of the world's first iron bridge quickly spread: the distinctive arch appeared locally on trade tokens, letter-heads, pottery mugs and round the ash-holes of cast-iron cottage grates; a model of it was presented to the Society of Arts in London in the 1780s; Jefferson hung a view of it in the White House at Washington; and smaller versions of the actual bridge were installed in landscape parks at Raincy in France and Wörlitz in Prussia (the latter surviving).

level they made population movement easier, but they also had symbolic value. All bridges show human use of opportunity, at places of greatest practical and strategic advantage. Emerson pointed to this in his famous Concord battle-hymn (1837), commemorating the start of the War of Independence:

> By the rude bridge that arched the flood,
> Their flag to April's breeze unfurled,
> Here, once, the embattled farmers stood,
> And fired the shot heard round the world.

But just as Venice, centuries before, had been built on water and 'joined up' by bridges so, in the modern spanning of these wide American rivers, an elemental act of cultural keying into nature was being attempted. Aquatinted against the sky from the west, the vigour of the 'Colossus' cut dramatically across the conventions of picturesque topography (Fig. 44).

The great wooden bridges proved short-lived: the Colossus burned in 1838 and the Permanent Bridge in 1875. But metal was establishing itself, in America as in Europe, notably in the suspension bridge. Long used in China, and employed in Yorkshire, England in the 1740s to carry miners to work, its modern revival took place in America: James Finley built one at Jacob's Creek in 1801 and a further eight, including one across the Schuylkill cataracts, in the next ten years.[5] The 'wire bridge' at Philadelphia became a favourite local walk, and was illustrated in Gleeson's *Pictorial Drawing Room Companion* in 1851. Roebling's great Brooklyn suspension bridge was less than twenty years in the future.

The age of the railway, with its call for new bridges and viaducts, was fully underway in the 1840s: by the end of the decade 4,000 miles of track had been laid in Britain. In a celebrated passage in *Dombey and Son* (1847–48, chapter 6), Dickens, for whom railways always retained a malevolent magic, described the Camden Town cutting under construction: 'everywhere were bridges that led nowhere'. John Cooke Bourne (1814–96) became a Piranesi of the new age, detailing the upheavals of earth removal with a beauty of brushwork that in no way diminished their power to shock, and was forcefully conveyed in the form of lithographs.[6] Against this background Turner painted *Rain, Steam and Speed: The Great Western Railway* (1844, Plate VI), showing a train crossing Isambard Kingdom Brunel's new viaduct at Maidenhead (1839).[7] Wordsworth's letters protesting about the railway's proposed invasion of the Lake District dated also from 1844; and his and Ruskin's opposition would be bitter. But from Turner's chosen viewpoint the railway presented not so much the violation of landscape as the visual bonus of the engineer's bridge, shown steeply foreshortened and funnelling travellers to their destinations as no pre-railway age structure had ever done.

Irrational fears had nevertheless always clustered round bridges, and worries about accident and collapse were not to be taken lightly. The rhyme 'London Bridge is broken down', long chanted in play by children at the head of a procession of potential 'victims', was given edge in the mid eighteenth

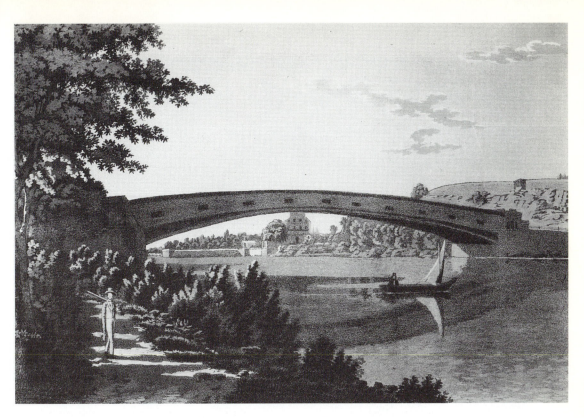

Figure 44: Lewis Wernwag (1769–1843). Upper Ferry Bridge, 'The Colossus', Fairmount, Philadelphia. 1812–13 (burned 1838). Aquatint by George Lehman, 1829. Print area 14 × 24 cm. The Library Company of Philadelphia.

The simple lines of Swiss bridges by the Grubenmann brothers, built of wood in one or at most two spans over Alpine rivers in the 1750s and 60s, greatly attracted Neo-classical architects (notably Soane). The fast river-currents and ice-flows of the north-eastern states of America also encouraged clean, uncluttered single spans in wood. The Colossus bridge at Philadelphia had five parallel laminated arches, each built up of seven thicknesses of timber strengthened by trusses; the whole enclosed two carriageways and two footways. While columned entrances at each end looked back to antiquity, the 340-foot arch – the greatest span hitherto achieved in wood or stone – was uncompromisingly of the New World. Wernwag, of German origin but living in Philadelphia from 1786 to 1813, built thirty-two bridges in America.

century by the actual decrepitude of London's medieval bridge, and it is noticeable that printed versions of the words then appeared.[8] Perilous bridges in wild places had for centuries been attributed to the Devil: generations of travellers to Italy had been unnerved by the narrow single-arch Devil's Bridge on the St Gothard Pass over the Alps. In 1802 this was the subject of freshly-inspired drawings by Turner (Fig. 45). In 1833 the American bird artist Audubon portrayed himself astride a log-bridge in a mountain wilderness (Plate IV). Now in the railway age it was the engineers' turn to test men's nerve. Contrary to expectation, Brunel's Maidenhead viaduct did not collapse. But the risks

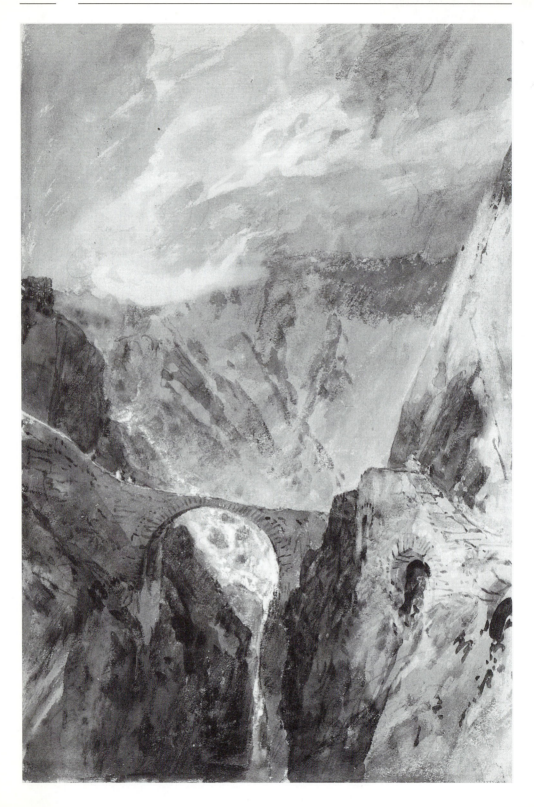

of railway bridges were vividly recounted by Dickens, commenting in his *American Notes* (1842) on immensely long wooden structures just wide enough for the trains but allowing little room for accidents: 'They are startling contrivances, and are most agreeable when passed'. A little later Dickens had an even more startling experience on a horse-drawn crossing of the covered bridge over the Susquehanna. This seemed like a 'painful dream', outside ordinary reality: 'It was profoundly dark; perplexed, with great beams, crossing and recrossing it at every possible angle; and through the broad chinks and crevices in the floor, the rapid river gleamed, far down below, like a legion of eyes'.

This ability of certain natural or man-made structures built out over space or water to impose their own terms on anyone rash enough to commit himself or herself to them was to make the bridge a potent symbol for the Romantics. Piranesi's knowledge of theatrical set design had projected a Baroque drama onto his Roman bridge subjects; but his part-raised drawbridge (Fig. 26) with figures on each half, but unable to cross, was perhaps the most teasing motif in his *Carceri* series. And the bridge could reinforce a mood of disorientation and sublime terror, as in William Beckford's oriental fantasy *Vathek* (written 1782, published in English and in French in 1786). It was surely more than an interest in picturesque detail that made him introduce here, even if only momentarily, the Muslim Bridge over Hell. A 'fatal bridge' crosses a lake, but, it is asked, does this conceal 'an abyss in which, for whole ages, we shall be doomed incessantly to sink?'[9] The notion of the Muslim bridge of Judgement, raised over an abyss, which all sinners had to cross, was matched in solemnity by Milton's description in *Paradise Lost* (Book X) of a 'bridge of length prodigious' built over Chaos by Sin and Death at the order of Satan. John Martin (1789–1854) illustrated it remarkably in 1825.

Dickens put his perception of railway chaos to powerful imaginative use, as is well known, in *Dombey and Son*, where the train became an agent of death and destruction (as, later, in Zola). One of the oddest and unexpected literary uses of the perilous railway bridge, however, in the same decade, came in the short story 'The Celestial Railroad' by Nathaniel Hawthorne (1804–64), included in his collection *Mosses from an Old Manse* (1845). This satire on recent religious trends in Hawthorne's New England is a modern Pilgrim's Progress: but instead of making his journey on foot, as in Bunyan's classic

Figure 45: J.M.W. Turner (1775–1851). *The Devil's Bridge, Pass of St Gothard*. Pencil, watercolour and bodycolour, with scraping out, on white paper prepared with a grey wash, 47.1 × 31.8 cm. 1802. Tate Gallery, London.

This old Alpine bridge on the road from Lucerne to Bellinzona had been celebrated afresh in the eighteenth century (e.g. by J.J. Scheuchzer who had it illustrated in his *Beschreibung . . . des Schweizerlandes*, 1708). But it was only with Turner that the sense of this perilous crossing, between vertiginous rock faces above the foaming river Reuss, was captured in paint. Turner visited the spot in 1802, and made another study from the bridge itself, which he used for a large watercolour (1804). The symbolism of bridge-crossing was to be important to him throughout his life.

(1678, 1684), Christian rides in a train. In this country Hell has been explained away as a half-extinct volcano, gas lamps mark out the Valley of the Shadow of Death, and at Vanity Fair morality is dispensed by machines. Early in the journey the pilgrim's companion Smooth-it-away points out that they are crossing the 'convenient bridge' over the Slough of Despond, and claims it is built on firm foundations of books of French and German philosophy, sermons and scriptural commentaries. The pilgrim senses, however, that the bridge is heaving up and down like the swamp around it. The journey continues: but, as he is about to reach the Celestial City, he finds, 'with a shiver and a heart-quake', that he has been dreaming. Not the least of the many ironies of Hawthorne's allegory – which appeared in the *Democratic Review* of May 1843, and was often reprinted in newspapers – is this turning of the bridge's associations with onward progress, as in Turner's near-contemporary *Rain, Steam and Speed*, into a suggestion of the very opposite.

In the 1840s, the sordid reality of ever-expanding industrial cities and towns, and their degrading effect on the poor, were occupying the minds of novelists and social analysts alike. 'Men, women, children, wan in looks and ragged in attire, tended the engines, fed thin tributary fires, begged upon the road, or scowled half-naked from the doorless houses'. The voice is again that of Dickens, describing the Black Country in *The Old Curiosity Shop* (1840–41). The social commentators Buret (*De la Misère des Classes Laborieuses en Angleterre et en France*, 1840) and Engels (*Condition of the Working Class in England*, 1844) were studying living and working conditions. New York, with a population of a quarter of a million by 1850, was almost as deep in back-street rookeries as London or Paris, or the Liverpool which Hawthorne came to know personally in the next few years.

The metaphorical bridges, technological, artistic, educational, which were being raised by progressive opinion in this appallingly uneven social landscape will be the theme of Chapter Six. One initiative, which involved all three strands, was the national trade exhibition, developed in France from 1798 and leading to the Great Exhibition of the Works of Industry of All Nations, 1851, staged in Paxton's great 'Crystal Palace' in London's Hyde Park. The *Illustrated London News* (17 May 1851) hoped that, besides the well-to-do, 'hordes of working-men . . . will derive the greatest advantage from it'. At a banquet the Exhibition's instigator Prince Albert remarked: 'Nobody . . . will doubt . . . that we are living at a period of most wonderful transition, which tends rapidly to accomplish that great end to which, indeed, all history points – the realization of the unity of mankind'.[10]

A final Dickensian bridge-image is worth recalling alongside this optimism. While light played more or less evenly on the world's goods in the glass-covered Crystal Palace, it was not equal in the corners of London that interested Dickens; and in his novels he caught repeatedly at the dramatic capital that was implicit here. Having placed the fateful encounter between Rose Maylie, Bill Sikes's Nancy and an unseen eavesdropper in the darkness under the recently-renewed London Bridge (*Oliver Twist*, 1837–38), he looked to its immediate neighbour upstream. In *Little Dorrit* (1855–56), the two vital meet-

ings between his heroine and the hero, Clennam, are set on the 'Iron Bridge', John Rennie's celebrated construction (1816–19) at Southwark. At the second, the elevation and freedom of the open bridge are contrasted with the lowly confinement of Little Dorrit's father in the notorious debtors' prison, the Marshalsea; 'To see the river, and so much sky, and so many objects, and such change and motion. Then to go back . . . and find him in the same cramped place'. It is a page that cannot easily be forgotten: especially in the light of Clennam's own incarceration in the same prison, later in the novel.

NOTES

1. For full documentation of the Coalbrookdale Bridge see Neil Cossons and Barrie Trinder, *The Iron Bridge, Symbol of the Industrial Revolution* (1979) and Stuart Smith, *A View from the Iron Bridge* (Ironbridge Gorge Museum Trust, 1979): both illustrate numerous artists' views, and Smith reproduces views on pottery and in enamels. Jefferson's print is in W.H. Adams, ed., *The Eye of Thomas Jefferson*, exh. cat. (National Gallery of Art, Washington DC 1976), p. 62. For Comasco see Barrie Trinder, *'The Most Extraordinary District in the World', Ironbridge and Coalbrookdale* (1977). Nightingale's words are in John Britton and Edward Brayley, *The Beauties of England and Wales*, XIII, i, Shropshire (1813)

2. Paine, letter of 25 May 1789 (now Royal Society, London), almost identical to one sent about the same time (no date given) to Sir George Staunton, in Philip S. Foner, ed., *Complete Writings of Thomas Paine* (New York 1945), 1040–50. Compare discussion of Paine's bridge models in a letter by him of 6 June, 1786 to Benjamin Franklin, in Foner, ibid., 1026–8

3. J. Meredith Neil, *Towards a National Taste: America's Quest for Aesthetic Independence* (Honolulu, Univ. of Hawaii Press 1975), p. 165. The specifically American search for its own republican destiny after the controversies renewed by the French Revolution is discussed in H.F. May, *The Enlightenment in America* (New York 1976), especially ch. 4

4. See Elizabeth B. Mock, *The Architecture of Bridges* (New York, Museum of Modern Art 1949), p. 36 (with illustrations)

5. James Finley, 'A Description of the Patent Chain Bridge', *Port Folio*, N.S. iii (1810), pp. 441–53. Reproduced in *Happy Country this America: The Travel Diary of Henry Arthur Bright*, ed. Anne H. Ehrenpreis (Columbus, Ohio State University Press 1972), p. 100

6. For Bourne see Arthur Elton, 'The Piranesi of the Age of Steam', *Country Life Annual* (1965), pp. 38–40; F.D. Klingender, *Art and the Industrial Revolution* (1968), pp. 133f.

7. John Gage, *Turner: Rain, Steam and Speed* (Art in Context, 1972), p. 24 (illus.)

8. *The Fashionable Lady or Harlequin's Opera* (1730) and *Tommy Thumb's Pretty Song Book* (c. 1744). See Iona and Peter Opie, *Oxford Dictionary of Nursery Rhymes* (Oxford 1951, 1966), pp. 272–6

9. Samuel Henley's note to the 1786 edn of *Vathek*, approved by Beckford, refers to the Muslim bridge

10. *Principal Speeches and Addresses of H.R.H. The Prince Consort* (1862), pp. 110–12

4

The Artist in Public and in Private

Prelude

'My voice belongs only to God and the King of Prussia', said the Italian castrato singer Porporino, working in the 1740s for Frederick the Great. The debt of the artist to hierarchic power, in the period of the *ancien régime*, could hardly be put more clearly. In the major areas of the visual arts and music, such dependence on the Catholic Church or the princely courts could condition whole careers. There were, of course, very different uses to which an Italian training could be put. Handel, in 1710, could leave the court of the Elector of Hanover to compose operas for London. The Venetian painter Pellegrini, in 1716, could move from courtly service in Düsseldorf to paint frescoes in Amsterdam City Hall. But as long as princes, bishops and the nobility saw the value of the Baroque as a vehicle of authority, artists who were proficient in its workings were ready to do whatever was asked of them, provided they were paid enough. Poets, musicians, painters, architects could all be found who were content to devote themselves to the glory of hierarchy.

As social changes (see Chapter One) began to enlist new publics for the arts, greater freedom of manoeuvre became available to those artists who could use it, albeit in uncertain markets. In England, where official patronage exercised less control, writers such as Pope and Johnson struck out for independence from private patrons by developing associations with booksellers. Voltaire's publicity for France improved the image of French authors in their own country. C.P.E. Bach moved from the Berlin court to compose adventurously in the freer atmosphere of Hamburg. In France and England regular exhibitions and public concerts began to provide artists and musicians with outlets to wider audiences. There was a price for this: if obligation diminished to wealthy protectors or exclusive elites, it increased to fashionable critics or dealers. In literature official censorship, except in

England, remained a problem. Rousseau's *Social Contract* (1762), proscribed in Paris, was published in Amsterdam. Moreover, as the patronage of artists and musicians moved further, after 1800, into the hands of an indeterminate 'general public', the need felt by exceptional individuals to express personal authenticity – Beethoven was a prime example – could easily make independence feel like isolation. Byron was an extreme case: his title, reputation and personal magnetism ensured his poetry a following; but his wandering life-style and exploration of private self in relation to public image symbolized, in important ways, a tension which was widely felt, for instance by Pushkin as, chafing under the Russian censorship, he sought the elusive point of balance which would enable him both to work within the system and to fulfil himself.

Before the end of the eighteenth century not only artists, but liberals of all kinds across Europe, were reconsidering their prospects. The old rival identities of Britain and France, each driven by a powerful patriotism, had been joined by a politically-divided Germany in pursuit of nationhood, and the occupied or partitioned countries of Eastern Europe were also rehearsing similar, long-cherished hopes. Here too the private and public worlds of artists and writers were closely involved with each other. While Rousseau and Byron (both wanderers) were profoundly interested in their own identities, each was possessed of an ability to connect with whole societies which were looking for theirs. Besides Rousseau's special relevance for German liberals, there were the Poles, on whose constitution he advised in 1770. For Byron, in particular, there was Greece, where he died in 1824 supporting the people's bid for independence from the Turks. Each writer, in fact – however concerned with his own 'autobiography' – was to contribute closely to that form of a people's autobiography which was implied in 'nationality', one of the Romantic period's new words. Byron's poetry, indeed, was also to become, with the music of the Polish-born Chopin, one of the most powerful influences on Polish nationalism, as it rose up against Russia and further annexation of Polish lands by Austria and Prussia after the Napoleonic Wars.

The following chapter discusses this public/private relationship within the artist – and especially the musician – under the *ancien régime*, and during the transition to a revolutionary era and the age of nationalisms. The distinctive contribution of Germany and the rivalries of England and France form vital cultural strands in this: Hogarth, English caricature, the German and Scottish ballad, and the myth of Napoleon are all relevant here. Finally, beginning with Byron, we look at writers, artists and musicians who, after 1780, take up positions near to the edge of their own society, responding to the experience of seclusion, and sometimes developing intense visionary worlds of their own. Blake and certain German Romantics are crucial figures.

Dependency and Freedom

The universality of Italy remained a fact of life that drew visitors throughout the period of the Grand Tour. 'I have been out to dinner in the country near Prato', wrote Johnson's friend Mrs Hester Piozzi (formerly Mrs Thrale) in 1785; '. . . what a charming, what a delightful thing is a nobleman's seat near Florence! How cheerful the society! How splendid the climate! How wonderful the prospects in this glorious country!'[1] The need felt by educated Italian taste for artists was as strong as ever. Yet as Rome and Venice settled, early in the eighteenth century, into economic decline, and Florence into provincialism, the aspirations of many Italian artists were likely to be best satisfied abroad.

The career of the Venetian painter Giambattista Tiepolo (1696–1770) was a case in point. In 1750, having carried out decorative schemes for palaces and churches in northern Italy, he departed for Germany, where the Prince-Bishop of Würzburg had invited him to embellish his Residenz. Above the great staircase by the palace's architect, Balthasar Neumann (1687–1753), he painted a ceiling-fresco covering an area of nearly six hundred square metres, and showing the four continents paying court to the Prince-Bishop (Fig. 46). The Baroque practice of involving the spectator in its effects found full realization in a staircase that doubled back on itself, leading up to an action depicted on the ceiling as if it were taking place in the spectator's space. Tiepolo's animated masterpiece reflected the buoyant colours of the Rococo and the light of the Enlightenment. After 1763 he worked in Spain, on large-scale works for the royal palaces, where his vision influenced Goya.

Venetian painters were also active in St Petersburg and Moscow. Catherine the Great was to purchase Tiepolo's *Banquet of Cleopatra*, and Italian pictures came to dominate private picture galleries (Fig. 47). The example of Italian Baroque architecture was demonstrated in St Petersburg by Bartolommeo Rastrelli (1700–71) and, under Catherine, by Giacomo Quarenghi (1744–1817). The Polish King Stanislas Poniatowski (reigned 1763–95) had the Italianate magnificence of central Warsaw recorded by his court painter Bellotto (1720–80), Canaletto's nephew.

In music, too, Italians travelled and filled vital positions across Europe. The astonishing Domenico Scarlatti (1685–1757) worked in the royal service in Portugal and Spain, producing over 500 one-movement harpsichord sonatas, little miracles of astringent power: some were published in London in 1738. In Stuttgart Niccolò Jommelli (1714–74) poured out Metastasian *opere serie* for his employer Charles Eugene of Württemberg. In St Petersburg Tommaso Traetta (1727–79) directed music from 1769 to 1774, and Galuppi and Paisiello mounted their operas.

While Italy's seemingly unending provision of talented artists, architects and musicians helped to give competitive edge to the courts, France supplied the *cosmopolite*, the animator of tolerant interrelationships and the civilized ideal. The French language crossed all borders. From Paris, between 1753 and 1773, the German-born Baron Grimm edited his *Correspondance Littéraire* for

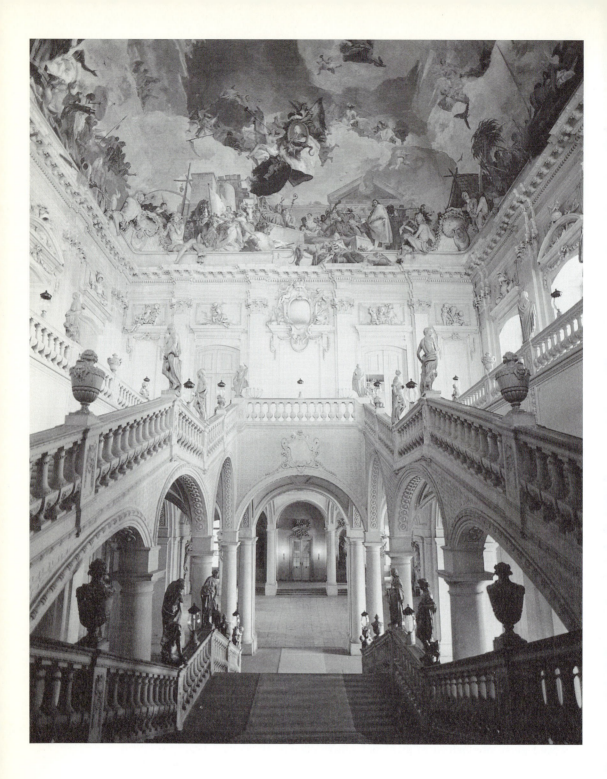

titled subscribers, especially in Germany. In 1745–47 Frederick the Great built a French-inspired Rococo palace, 'Sans Souci', at Potsdam, and in 1750 invited Voltaire to stay in it. And in the many copies of Houdon's various busts of Voltaire (1778, Fig. 11), the great sculptor provided the means for a unique face to become familiar across the entire Western World, from Catherine's Russia to Jefferson's America.

Though the common currency of understanding which French cosmopolitanism appeared to open up had immense intellectual appeal, two major disadvantages were plain: the neglect meted out by the *beau monde* of Europe to independent initiatives; and the domination of fashions – in furniture, in dress, in food, in language – which were accepted without question because they were French. Though English specialities such as flock wallpaper were popular all over Europe, French monopolies applied in luxury furniture, carpets and other textiles. While German Meissen porcelain set standards that even the French imitated, Sèvres (from 1756) and other French ceramics claimed a vast esteem. The craftsmen-entrepreneurs of Britain, where the call to private enterprise was intense in the competitive conditions of the Industrial Revolution, could feel these problems acutely. Wedgwood, as a man of the Enlightenment, was happy to correspond with the French scientist Lavoisier; but, as an industrialist working in ceramics, found himself obliged to pore over the English peerage 'to find out lines, channels and connections', and also pursue 'turns and opportunitys' in the foreign markets. Though his great creamware 'Frog' service was made for Catherine the Great in the early 1770s, he was still noting in 1779 that fashion commanded the market more than merit.[2]

PATRONAGE AND INDIVIDUAL FREEDOM

On occasion, merit was allowed to bring unusual rewards, even at court. Johann Stamitz (1717–57), a Bohemian employed at Mannheim by the Elector of the Palatinate, was given time to compose symphonies – the most substantial before Haydn – and build the court orchestra into a virtuoso group which dazzled Paris itself. Gluck (1714–87) – German-born, but well-versed in Italian and French musical thinking – achieved operatic pinnacles of his own making

Figure 46: Giambattista Tiepolo (1696–1770). Ceiling of the staircase-hall in the Prince-Bishop's Residenz, Würzburg. Fresco. 1752–53. Photograph courtesy Yale University Press.

Above the splendour of Balthasar Neumann's staircase at Würzburg, Tiepolo's ceiling itself has a grand comprehensiveness. Apollo in the centre, and groups of the four continents – Europe, Asia, Africa, America – round the sides, pay homage to the portrait of Karl Philip von Greiffenklau, Prince-Bishop (centre of this illustration), which is held by genii above the female figure symbolizing Europe. In front of her an orchestra plays a Vivaldi concerto, and Neumann, the palace's architect, sits on a cannon, near a large greyhound. (Tiepolo included his own self-portrait between the stucco figures in the left corner). The result is one of the most beguiling of all the century's statements of autocratic power.

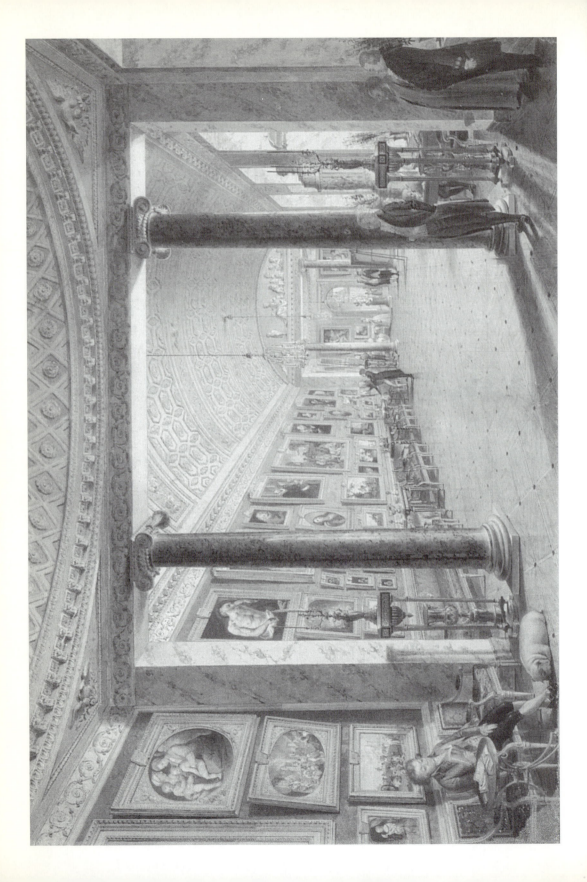

in Vienna and Paris. A Scots architect, Charles Cameron (*c.* 1743–1812), was
enabled to develop his own light, lively style in Russia during his employment
by Catherine the Great from 1779 to her death. The Spanish artist Goya
(1746–1828) grew into his highly individual maturity in the 1790s (see p. 237)
while Painter to the King.

A similar claim could be made for Joseph Haydn (1732–1809), who used
a court appointment to develop international stature as a composer. A musi-
cian's work at court tended, however – by the nature of having to play in con-
certs and other performances – to be more routine than a painter's. Only the
level of Kapellmeister, the highest accolade, offered scope for composition.
Leopold Mozart (1719–87), Wolfgang's father, spent most of his life in the
service of the Archbishops of Salzburg, rising from fourth violinist in 1742 to
deputy Kapellmeister in 1787. Wolfgang, visiting Vienna in the Archbishop's
suite in 1781, found the system repellent: 'the two valets sit at the top of the
table, but at least I have the honour of being placed above the cooks'.[3] For
those who, unlike Mozart, remained in court service, such conditions hardly
encouraged ambition or inventiveness. Hasse, much-admired court composer
at Dresden from 1731 to 1760, established excellent standards of playing there,
but his numerous operas stayed mainly with Metastasian convention.

Haydn's achievement, therefore, appears all the more remarkable, and for
the rest of this section we shall stay with musicians. Though closely associated
with Vienna, like Mozart, Beethoven and Schubert, Haydn worked largely for
the princes of the Esterhazy family at their country estate, from 1761 to 1804:
he retired after 38 years as Kapellmeister. As a house officer, he wore uniform
and had many administrative responsibilities, but also found personal fulfil-
ment: 'I could, as head of an orchestra, make experiments . . . I was set apart
from the world . . . and so I had to be original'.[4] He was not himself anxious
to travel, but he was certainly intent on reaching a wider public. In 1774 a set
of sonatas for harpsichord was published by a Viennese bookseller: from 1780
the renowned publisher Artaria took up his work, which drew commissions
from all over Western Europe.

The symphonies, too, established him internationally in the 1760s. With
musical instincts deeply rooted in folksong, Haydn transformed popular Austro-
Hungarian material into symphonic movements which were acclaimed not only

Figure 47: Andrey N. Voronikhin (1760–1814). *Count Stroganov's Picture Gallery,
St Petersburg.* Watercolour, 42.2 × 55 cm. 1793. State Hermitage Museum,
St Petersburg.

The magnificent apartment in the town house of the Stroganovs, designed by the
Italian Rastrelli, is shown containing a number of Italian paintings, all labelled, like
the others, at the tops of the frames. Voronikhin was the count's protégé, and
architect as well as painter. His picture also shows the count's French furnishings, his
great Russian stove, and what is perhaps an English bull-dog. Even more strikingly
it evokes the *ancien régime* in Russia: ramrod-like – four years after the French
Revolution at the opposite end of Europe – the count's servants await his
instructions.

in the concert room at Esterháza but also in London and Paris. The early German symphony, with its make-up of pastoral elements (in the andantes), courtly minuets contrasting with more 'popular' trios, and often frankly rustic finales, provided an extraordinary range of sources from which all listeners, however uninformed about music, could derive something. If the breadth of these sources helped to place the Haydn symphonies on an international stage, the composer's inexhaustible imaginative fertility and famous musical wit kept them there. Among the masterpieces of the early 1770s No. 44 in E, the 'Trauer' (Mourning) symphony, assimilates courtly dance to abstract structure in an astonishing minuet in canon. No. 49 in F minor (La Passione), written earlier than its number might suggest (in 1768), explores various faces of a sublime, Gluckian agitation. Of its four movements, the first is slow throughout as in the old Italian 'church sonata': all are in the minor. Haydn's concern to make minor more than a relief from major in a symphony showed a wonderful advance here. Around 1770, indeed, Haydn deployed his own 'Storm and Stress' style (away, however, from the slightly later literary movement in the German north, and not formally connected with it). The six symphonies written in 1785–86 for Paris's newly-founded music society, Concert de la Loge Olympique (whose large orchestra contained forty violins), further enlarged the emotional range; and the last twelve symphonies for London (1791–95), the first he had written expressly for a paying audience (at the Hanover Square Rooms), found him pouring an energy that was positively youthful into the task. All except one begin with a slow introduction, but each is individual and each has its innovations; No. 103 in E flat, for example, begins with a long drum-roll which recurs later. The London concerts, attended by Haydn himself, were enormous personal triumphs. But he chose not to stay in London, but to return to his tied post, and Vienna, where he enjoyed an illustrious Indian summer composing oratorios and masses (Fig. 48).

PLAYING TO AUDIENCES: THE IMPORTANCE OF POPULAR SUCCESS

Mozart (1756–91) was by this time already dead. His fame began, as is well known, as a child prodigy, when in the 1760s he toured Europe under the supervision of his father. Paris heard him in 1763 and 1765, London in 1764–65, playing the harpsichord and performing amazing feats of memory and improvisation. Recognition as composer was more fitful: there were difficult years at Salzburg in the 1770s, when church music was curtailed, the university theatre was closed and the ambitious Mozart was made to feel a vassal of his employer, the archbishop. While Haydn's genius was long nourished in the remote countryside of Esterháza, Mozart's found fulfilment only from 1781 in Vienna, where he lived as freelance composer, performer and teacher. Here income seems to have been in the main adequate, though not guaranteed before, in 1787, he became *Kammermusikus* to Joseph II. Much depended therefore on the success of his concerts. Mozart's keyboard popularity remained a vital

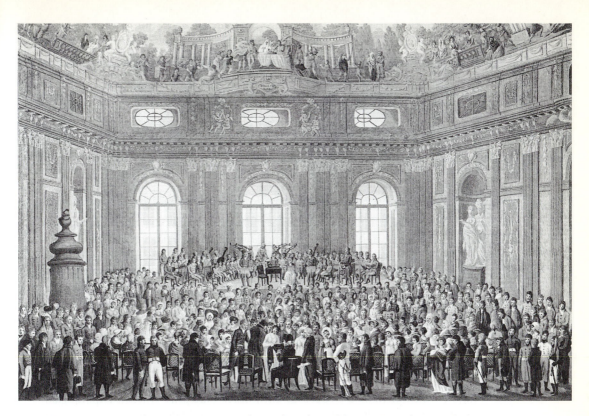

Figure 48: Copy of a miniature (original now lost) by Balthasar Wigand, painted on the lid of a casket presented to Haydn on his 76th birthday, 27 March 1808. Historisches Museum der Stadt Wien.

The allegorical ceiling-painting of Vienna University's Old Hall preserves the Baroque tradition: but the gathering beneath honours the father figure of music's modern 'Classical Age'. The seated composer listens (centre foreground) as a special fanfare is played for him before his oratorio *The Creation* (1798, see p. 145) is performed.

With its record of what was to be Haydn's last public appearance at a concert, the painted casket was presented to him by its instigator, Princess Herminegild Esterházy, a member of the family for whom Haydn had worked for most of his life.

element in this, and it is noticeable that between 1784 and 1786 he produced twelve of his 27 piano concertos: in the latter year, however, revenue from his concerts fell away.

Mozart's desire to write operas was encouraged by Vienna and Prague in this last decade of his life. Such work took up much time and paid erratically. Complex issues of patronage were also at work. Joseph II exercised close concern over productions in Vienna, as is revealed in memoranda to his director of court theatres. He chose performers, and often fixed their stipends; he encouraged comic opera at the expense of *opera seria* and, enthused with the idea of a National Theatre, promoted opera in German, including Mozart's *Die Entführung aus dem Serail*, successfully produced at the Burgtheater in

1782. But Joseph's control was shared with the will of the theatre- and opera-going public: this enjoyed *Die Entführung* but preferred the Italians, who were back in 1783, and were subsidized by Joseph until, in 1788, the cost of the Turkish Wars and other problems made this impossible. By then, Mozart and Da Ponte had produced operas with Italian words. Even so, *Le Nozze di Figaro* succeeded more spectacularly at first in Prague. Joseph II, who had told Mozart that *Die Entführung* had 'too many notes', claimed that singers agreed with his complaint about the stage works: 'he deafens them with his full accompaniment'. But at Prague, in January 1787, Mozart notes: 'Nothing is played, sung or whistled but "Figaro" ... Certainly a great honour for me!'.[5] From 1789, after successful Vienna performances, the opera was given throughout Germany, as was *Don Giovanni*, the latter often in German translation, and with dialogue, not recitative, as *Don Juan, ein Singspiel*. The movement in favour of opera in German was strong enough for a middle-class welcome at a suburban theatre in Vienna to be given to Mozart's *Zauberflöte* in 1791. The stature of the Mozart operas became apparent to the world: though war-time conditions postponed the first London production of *Figaro* until 1812, and it only reached New York in 1824.

Mozart's earliest popular success, indeed, was rather in instrumental works for public performance. The later piano concertos, conveying every mood from happiness to regret, established a form of discourse between orchestra and soloist which combined respect for each other's integrity with an unparalleled interdependence. Viennese piano-makers could provide a perfect vehicle for them. The concerto and quintet written for the clarinettist Anton Stadler placed a recently-developed instrument at the centre of musical awareness. So, for the clarinet's relatives, did the works for wind-band or *Harmonie*, formed in Vienna in 1782 to play music from operas. Mozart's masterly wind serenades in C minor, E flat and B flat gave new status to wind playing, so often limited previously to background entertainment out of doors.

The symphony's stature by 1800 was apparent in Mozart's last work in this form, No. 41 in C (1788), especially in its finale. Here short, memorable motifs are stated, contrasted, treated fugally and finally superimposed on one another with an elegance only surpassed by the sheer energy that informs the movement from beginning to end. The sense of being placed at an ideal distance in front of the parts of a working whole had perhaps never been conjured so consummately in the history of sonata form. A nickname 'Jupiter', invented in England soon after the first performance of the symphony and printed on Clementi's piano arrangement of 1823, testified to the comparison that the work invited, and stayed with it.[6]

By then Beethoven (1770–1827) was occupied with his last symphony, his Ninth: this work, lasting over an hour – twice as long as the 'Jupiter' – marked another mutation of the form. Beethoven too came out of a salaried background, in the service of noble patrons in Bonn and, from the 1790s, in Vienna; and like Mozart he was in demand as a pianist, playing in salon concerts sponsored by high society. But his early piano writing (the F minor Sonata, Op. 2 no. 1, for instance) revealed an impatience with the boundaries of form which

betokened a bid for artistic independence. The inverse of this fierce self-reliance was also characteristic: an attitude which accepted patronage on his terms. Beethoven's concern to sustain a heightened character in his symphonies, sonatas and quartets did not exclude (as the Pastoral Symphony showed) a sense that his roots remained deep in popular experience. But he was writing for a level of critical discernment that was not of the people. Writing to an Edinburgh publisher in 1806, he refuses to lower his sights even for avowedly 'popular' Irish Melodies. 'I will take care to make the compositions easy and pleasing, as far as I can and as far as is consistent with that elevation and originality of style which, as you yourself say, favourably characterize my work and from which I shall never stoop'.[7] He had been asked for simple works; he would not put them beyond an amateur's capacity: provided that the composer was allowed to be himself.

Years before the Ninth was composed, Beethoven was subjecting listeners' expectations to this condition. In his set of six songs, *An die ferne Geliebte* (*To the distant beloved*, 1815–16), the last song returns unexpectedly to the melody of the first, thus sealing an overall unity which the piano part, at times taking precedence over the voice, and connecting the songs, has also suggested. Interests in interrelationship and the varying of perspectives across multi-movement spans had declared themselves famously in the Fifth Symphony (1808), where the finale arose without break from what had gone before, impelling the listener into its emotional turbulence. So also in the Ninth's choral finale, with its affirmation of joy and brotherly love after reminiscences of earlier movements (p. 102). In the last five piano sonatas leading to Opus 111 (1823), and the late quartets (1825–27), the composer chose more solitary paths into new territory. That he had gained it emerged controversially in the B flat quartet (Op. 130), with its sinewy mix of popular dance and inward rumination. Six movements here culminated in a giant fugue ('Grosse Fuge', later replaced and made independent). The imaginative scope that E.T.A. Hoffmann, writing about the Fifth Symphony, had claimed for Beethoven's instrumental music, had long since received the tribute of aristocracy itself, in the shape of two princes and the Archduke Rudolf, who settled an annuity on Beethoven in 1809. When he died in 1827, aged 57, posterity was left to ponder an image of indomitable and perplexing will, as well as a body of composition that had transformed the musical landscape.

Notwithstanding his private self-regard, it needs no emphasizing that Beethoven himself – cut off by his deafness from continued success as performer – could not have been more anxious to see his works published and recognized by as wide a public as it was possible to reach. The failure of his proposal in 1810 for an authentic edition of his collected works pointed up the menace of pirated editions of them throughout Europe, a common problem which long made such proposals uneconomic. But public concerts ensured the fame – sometimes delayed outside Germany – of the symphonies and choral works. A French performance of the Fifth in 1829 was received 'with transports of admiration, almost amounting to frenzy'. A deification process, following the composer's death, was simultaneously under way. By the 1840s he was being

compared with Shakespeare in literature and Michelangelo in sculpture and painting. The English Beethoven scholar William Gardiner, hearing Liszt conduct the *Missa Solemnis* (1823) at Bonn in 1848, soberly remarked that 'it will be slowly understood and appreciated'.[8] The gap between the private artist and public appreciation would, in other words, be bridged. And the deification would be completed. But amateur pianists all over the civilized world would also be hard at work attempting to master the *Appassionata* and the *Pathétique*.

Beethoven, living in Vienna after Haydn and Mozart, consolidated the city's key significance in the contemporary musical scene. During and after the Congress there in 1815, many specially composed patriotic works added yet more to his fame in Austria. After the trials of war, however – as with other cities of the German-speaking parts of Europe – Vienna was to enter the period known as Biedermeier, which celebrated relaxed middle-class tastes for intimate domestic furnishings and light music round the piano.[9] The Viennese waltz was rising from earlier beginnings into immense popularity in dance-hall and tavern – wherever its prime creators, the violinist-composers Joseph Lanner (1801–43) and Johann Strauss the Elder (1804–49), performed. Seen by detractors as immoral, because of the physical contact it required between the sexes, it proved the most captivating present ever made by a single city of the Western World to its culture at large. For other artists Vienna in the 1820s was less forthcoming: Beethoven became increasingly detached as he entered his last creative phase; the Viennese-born dramatist Grillparzer (1791–1872) found himself frustrated by nervous official censorship; and the young musical genius Schubert (1797–1828), another native of the city, was faced by the discouragingly fixed expectations of public and music-publishers alike.

The contrast between the triumph of Beethoven and the slow recognition of Schubert is revealing. In part it reflected the difficulties experienced by a composer of remarkable but very different gifts coming immediately behind such a triumph. Though he was not without helpers, it was also Schubert's misfortune to be required to deal with a market avid for his superb part-songs and piano duets, but little else (it was Mendelssohn, over a decade after Schubert's death, who first performed the Great C-major symphony, in shortened form; the now famous 'Unfinished' Symphony of 1822 lay unplayed by an orchestra until 1865). Temperament was also a factor. Unsuited to the public concert that was becoming a proving-ground for the performer, whether soloist or conductor, Schubert was at his best with his intimates, playing his own music at the gatherings known as Schubertiads. His greatest fulfilment came from these friendships, and the music, light and serious, that they generated; and especially from the wonderful songs, some of which we shall notice in Chapter Five.

As the public concert took hold, the well-heralded appearance of a virtuoso performer on a trans-Europe tour could excite the kind of adulation that the opera singer had long enjoyed (p. 75). Supreme technical mastery appeared to pass into the realm of the supernatural in the playing of the violinist Nicolò Paganini (1782–1840), who arrived on the European stage from an appropriately mysterious obscurity in the household of a sister of Napoleon at Lucca. In 1828 he was in Vienna (where Schubert admired his playing), and in 1831–

32 in Paris and London. Everywhere he played to packed houses which had paid double the usual prices. To Viennese cab-drivers the five-florin note was a *Paganinerl*. In 'Paganini, a Fragment', published in his *London Journal* (16 April 1834), Leigh Hunt described

> His hand,
> Loading the air with dumb expectancy,
> Suspended, ere it fell, a nation's breath.

His legend had been fortified by rumours that he had murdered his wife: lithographs hung on the walls of Paris depicted him in prison. In an energetic letter to the *Revue Musicale*, rebutting this, Paganini dwelt with superb irony on another rumour, that he was in league with the Devil. A gentleman at one of his Viennese concerts, he says, 'asserted that . . . he had distinctly seen the Devil near me, guiding my bow arm. The Devil's striking resemblance to myself sufficiently proved my ancestry. The Devil was dressed in red, bore horns, and carried his tail between his legs. You can conceive, Sir, that after so minute an identification it was impossible to doubt the report'. Here was a new ultimate, perhaps, in the public/private dichotomy which confronted the Romantic artist: he could be at his most private when at his most public, in the presence of a large audience. Along, therefore, with the deification of an Olympian figure such as Beethoven, the public concert could also bring before its audience the virtuoso with the powerful charge of sorcerer in his make-up. Delacroix's marvellous portrait of Paganini in performance catches precisely at the play of human and superhuman elements (Fig. 49).

Paganini had been heard in Warsaw by Frédéric Chopin (1810–49), whose own pianistic art was, however, chiefly deployed in the more intimate surroundings of the salons of Paris, where he settled in 1831. The nature of his own compositions was also personal to him as a man of French descent, highly sensitive to effects of formal elegance, and as a Polish patriot conscious of the rich and varied national culture and dance-forms of the country where he had grown up. In the twenty years before Chopin's birth, patriotism had become irreversibly complicated by nationalism – a much more strenuous emotion. In the Europe that was reforming itself after the upheavals of the French Revolution and the Napoleonic Wars, the cause of liberty in Poland was yoked to emancipation, also associated with the demand for action. Such a call for freedom could hardly fail to affect the exiled Chopin.

There were other reasons for Chopin's public success in his own day. In a large output that was almost entirely for the piano, there were captivating dances of Polish origin such as mazurkas and polonaises. But there were also works written with the particular aim of developing the instrument's technical and expressive potential: much as Bach, whom Chopin admired, had done for the clavier. Among these were two sets of twelve Etudes or Studies (Op. 10, 1833 and Op. 25, 1837), each of which explored a different technical problem, but with a beguiling flow, sparkle and power that made the listener forget the fact. For those who wanted more from a recitalist than improvisation, Chopin

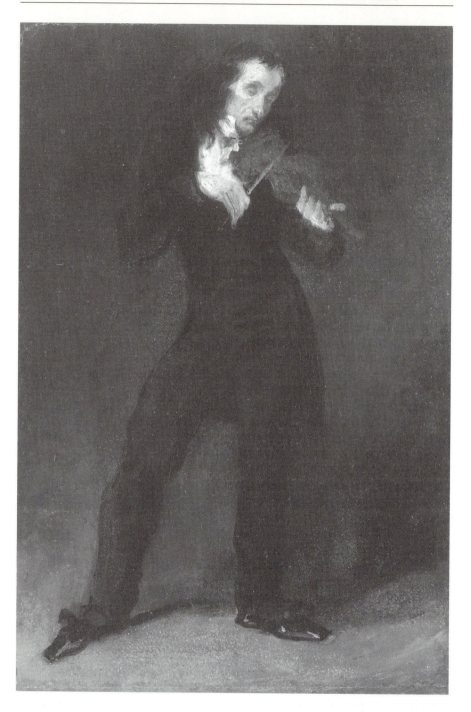

wrote impromptus. Moreover, as the Viennese waltz swept Europe, he composed waltzes. But they were his own, quite un-Viennese; and they left the dance-floor behind. In an age when the piano miniature was flourishing, one of Chopin's waltzes was found to take only a minute to play.

Chopin's piano writing also 'involved' the listener in easily accessible ways. His personal mastery as a pianist was in large part the product of an acute sense of movement forward from the value of one note to the next: contemporaries often refer to the singing (*cantabile*) tone that he could obtain. This quality recalled *bel canto* in opera and was at its most eloquent in his Nocturnes (a form derived from the Irish composer Field). Together with rubato – slight variations in pulse-beat – it thrust a particular responsibility of 'interpretation' on the players who took up his music.[10] These were to include Liszt and Schumann's wife Clara. The need to 'feel through' the music, together with the obvious ambition of the highly personal later mazurkas, and the larger works that Chopin began to write in the 1830s – typically single-movement pieces which he called Ballades, Scherzos or Fantasies – helped to create a unique place for him among the 'modern Romantic' composers, balancing the German-born Mendelssohn and Schumann.

Many of Chopin's finest late works, including the two mature sonatas (1837–39 and 1844), dated from the years of his mysterious life with George Sand the novelist (he wrote little after he broke with her). This suggests that the factor of private recoil from the public eye was as necessary to him as to other Romantics whom we shall discuss later (p. 206f.). But the drive to connect with the aspirations of his compatriots, as Liszt recognized in his book on Chopin (1852), was no less so.

The need of artists to reconcile their public and private lives in this period took a different course if they were women. The achievement of George Sand – the male pseudonym of Aurore Dupin – reminds us that, by careful manipulation of her public identity, a creative literary woman could achieve the freedom of utterance enjoyed by men. For most house-bound, arts-orientated

Figure 49: Eugène Delacroix (1798–1863). *Paganini*. Oil on cardboard, 45 × 30.4 cm. Probably 1831. Phillips Collection, Washington DC.

By the time of Paganini, the adoration or adulation accorded under the *ancien régime* to a prince (Fig. 46) might become the response of a mass public to an artist, albeit one with alleged superhuman links.

The formidable traditions of 18th-century violin-playing, maintained by such men as Tartini, had thrived on master-pupil relationships which both preserved the secrets of technique and elevated the stature of the soloist. Tartini's celebrated dream of a demon playing a 'devil's trill', which he built into a sonata (*c*. 1745), appeared with Paganini to have become reality. 'What tortures dwell in those four strings!', commented the young Liszt, who heard Paganini in Paris on 9 March, 1831.

Delacroix had sketched Paganini at rehearsal before attending the same concert. His memorable painting contrasts the player's loose, swaying stance and the closely-cradled instrument that seemed (as the London *Times* was to remark) 'to be part of himself'.

women in a male-dominated world, however, private life assumed a different meaning. The novel, as we have seen, became a particular feminine speciality: but for musical women the opportunities were less than auspicious, even in musical families. A society which cast women in the role of reacting to circumstances, rather than controlling them themselves, perceived the public role of female musicians – if they were allowed one – as more interpretative than originating. Fanny Mendelssohn, sister of Felix and a composing talent of real distinction, received little encouragement beyond that of performer. Despite the merits of Robert Schumann's pianist wife Clara as composer – merits which he recognized – her family responsibilities remained her main concern. It was as a virtuoso player of the works of others – including, of course, those of her husband – that she became known.[11] To her credit, nonetheless, she bestrode concert platforms in that capacity as far from home as Russia (in 1844).

Images of Nations

Much vitality was given to the arts of Western Europe in the eighteenth century by the circumstance that two of its cultures, those of Britain and Germany, were engaged in demonstrating their own distinctness, in different ways, from that of a third, France. Along with the admiration of French taste in many quarters, there were growing incentives to take the common stock of particular historical experience which gave unity to each society, and use it to national ends.

In Germany, these incentives were all the stronger for being generated in a society which as yet possessed no political identity as a nation. It was no accident that the art that resulted took two forms that were close to the spontaneous life of the people: drama and song. The British and French cultures, and the relationship that each bore to the other, were at a different stage of evolution. Here was an old rivalry of political equals, each now in quest of empire overseas, and drawn into direct competition with the other in faraway theatres of war such as Canada, North America and India. In literature Shakespeare was in the scales against Racine. Britain's strengths included, as we have seen, the novel and Garrick's presentations of Shakespeare, who in 1769 enjoyed his own festival at Stratford. The favourite Georgian mode of satire, together with burlesque and caricature, often aimed at asserting the healthy, contemporary difference of things British from things French. John Bull and Britannia emerged as national icons. Hogarth and then Gillray took the art of visual ridicule to a point without equal in Europe before the age of the Frenchman Daumier (after 1830). As for France itself, secure in its traditions of high art and state patronage, the great Revolution of 1789 precipitated a new national consciousness, but scarcely a ripple on the surface of the nation's regard for its classical past. The Paris of the *Marseillaise* was the Paris of Roman festivals. The classical verities of Poussin entered the fibre of David's revolutionary works and re-emerged in the nineteenth century to give stability for the arch-Romantic Delacroix (*'un pur classique'*, as he described himself).

The theory of a link between the rise of nationalism and that of the Romantic Movement finds support in the spectacle particularly of late eighteenth-century Germany exploring the roots of its *Volk*, but also of Britain building on its age-old national as well as artistic non-conformity: Romantic feeling was well established in both countries before 1800. In France it was different: despite Rousseau and his liberalizing influence and aspects of the work of the painters Gros and Géricault, Romanticism was hardly traceable in any concerted strength until about 1820. Some of its characteristics appear unmistakably, indeed with a nationalist edge, in such a work as Hugo's popular novel *Notre Dame de Paris* (1831). This story '*d'imagination, de caprice et de fantaisie*', as the author described it, told of Quasimodo, the hunchback, against exact descriptions of fifteenth-century Paris as seen from the cathedral towers.

ROMANTICISM AND NATIONAL IDENTITY IN GERMANY AND BRITAIN

The cause of national self-awareness had been advanced in the early eighteenth century by the idea of many different cultures, each individualized in primitive myth, song and language, and deserving attention on its own merits. While the remarkable Italian thinker Vico (1668–1744) had elaborated such notions, apparently in isolation, they were to flourish in Germany as it arrived at its own Enlightenment (*Aufklärung*). Here Immanuel Kant (1724–1804) analysed the qualities of the human mind in his three famous *Critiques* (of pure reason, practical reason and judgement), and advocated an ideal co-operation of outlook of which all humankind might be capable. But another north German, Kant's pupil Johann Gottfried Herder (1744–1803), became deeply involved in the study of what kept men apart. Noting the tendency of societies to group separately round memories which each held in common, Herder gathered evidence from different histories and traditions, notably folksong, which he encouraged Goethe to pursue. This was to be fruitful advice in the specific context of the German past. Indeed, the German Enlightenment's study of personal objectives, defined as *Bildung*, 'formation, self-cultivation', was to derive incalculable strength from the presence of such figures as Goethe and Schiller to give impetus to the greatest period of German cultural creativeness since the age of Dürer. To the rational concerns of the international Enlightenment were added, moreover, indigenous spiritual drives that embraced mysticism. The Königsberg theologian J.G. Hamann countered rationalism with the idea of communion with God which was to imbue the attitudes of German Romantics like the painter Runge.

Certain pathways forward had first to be cleared. The closing decades of the century in Germany make up what has justly been called a 'Classical Age', although by the standards of the French, this classicism was charged with a Romantic momentum – and a certain disquiet – that we have noticed in the 'Classical' achievements of the Austro-German musicians Haydn, Mozart and Beethoven. In German literature the term 'Classical' applies to the characteristic forms by which the modern German temper was to express itself:

particularly the lyric and the drama. But in establishing the basic forms the urgency of the message was not denied. Sources beyond those of the Italians and the French were studied in order to enhance an essentially German outcome. Gotthold Ephraim Lessing (1729–81, p. 53) made the Greek dramatists and Shakespeare into twin bulwarks from which to point out the deficiencies of the Neo-classical French reliance on the rules. Friedrich Gottlieb Klopstock (1724–1803) took up Milton's *Paradise Lost* and mystical writers and laid the foundations of the German lyric. Herder combined his German folk art interests with an admiration of Rousseau, which he transmitted to *Sturm und Drang*. The exponents of *Sturm und Drang* themselves used their knowledge of German translations of Shakespeare (notably those made by Wieland in the 1760s) to produce plays with plots of typically free, long-marching Shakespearean construction, but with heroes from German history, campaigning against injustice: among them Goethe's famous knight, Götz von Berlichingen (1773). Schiller's popular play *Die Räuber* (1781), dealing with the trials of a rebel hero, Karl Moor, amidst betrayal and defeat, quickly followed. In 1788 Goethe completed his play *Egmont*, about the sixteenth-century Dutch freedom fighter, a work which was to inspire some of Beethoven's most passionate music.

There could be no rejecting the insights of ancient classical art, as Winckelmann had seen them, signally, in sculpture. Lessing's essay *Laokoön* (1766) – based on the famous antique group of Laocoon and his sons gripped by snakes, an episode also described by Virgil – drew an instructive line for contemporaries between the poet's cumulative emphasis on Laocoon's suffering in words, and the sculptor's just withholding of it in the very different medium of stone. Goethe and Schiller also studied classical sculpture for its lessons, and Wieland wrote novels with Greek themes. But it was ancient Greece as a lost ideal from which present-day man had become separated which came to infuse the thinking of the Romantic poet Friedrich Hölderlin (1770–1843). The self-projected hero of his fragmentary novel *Hyperion* (1774–99), he responds to the sufferings of the modern Greeks under Turkish occupation.[12]

The epic also made its contribution. The great literary maiden voyages of Europe's past – the *Odyssey* and *Iliad* of Homer, the *Divine Comedy* of Dante – were eagerly shadowed, alongside those of Shakespeare, in the knowledge that the German spirit had long ago launched another. In Zurich, one of the great centres of German letters, the scholar Johann Jakob Bodmer (1698–1783) had in 1755 transcribed the hitherto almost forgotten medieval epic, the *Nibelungenlied*. This story of greed, murder and revenge in a dark northern landscape gave a powerfully national cast to what was quickly to become a recognizably German form of explicit Romanticism, which was ultimately to lead to Wagner's *Ring*.

Initiatives happened all over the German lands: from Hamburg, the free port, where Lessing launched his drama reform based on the work of the National Theatre in 1767–69, to the court of Weimar. Here, trumping the example of Frederick the Great's hospitality to Voltaire, Duke Karl August surrounded himself with great men – Goethe, Schiller, Wieland and Herder – in the half century between 1775 and 1825. Goethe was made minister of state;

bestriding this period as sword-bearer of German letters across Europe, he also took charge of the Weimar Court Theatre for twenty-six years (1791–1817).

Goethe's Weimar years are important on a variety of counts, not least for his own productivity as poet, playwright and scientific investigator. There was also the fruitful association with the younger writer Friedrich Schiller (1759–1805), whom Goethe advised, and who stimulated him in return with criticism of *Wilhelm Meister*. At the theatre, in spite of modest resources and some blind spots (notably regarding the important new plays of Kleist), a wide range of old and new drama and acting style came to be offered. While classical tragedy was in decline in Europe (despite Voltaire's successes, which Goethe admired), mixed Weimar audiences of court and public, including 'common people' in the gallery, watched now domestic comedies by the actor Iffland, who had impressed Goethe; now prose translations of Shakespeare; and above all the verse master-pieces of Schiller of the great period 1798–1804, which included *Wallenstein* (1798–1800) and *Wilhelm Tell* (1804). On these Schiller evenings his elevated seriousness, engaging his heroes with moral challenge and the problem of freewill (particularly in the character of the army commander Wallenstein), probably took the less sophisticated well beyond any experience they will have known. But the language was German, learnable and quotable.[13]

Many of the Germanic elements that we have been discussing are recog-nizable in the artistic personality of the Swiss painter Johann Heinrich Füssli or Fuseli (1741–1825): born in Zurich, a student under Bodmer, much travelled in Germany as well as Italy (1770–79), interested in fostering relations between German and English writers, and continuously resident in London from 1779. Familiar with *Sturm und Drang*, he combined enthusiasm for the older German literature, Homer, Dante, Shakespeare and Milton, which he translated into highly personal, hallucinatory paintings and drawings. A committed exhibitor, pillar of the Royal Academy and contributor of paintings to London enter-prises for galleries devoted to Shakespeare and Milton, he disturbingly related dream-images to the contemporary fashionable scene (Fig. 50).

The combination of fashion with the supernatural in Fuseli's art was personal to him. But in Germany itself the bypassing of French authority in matters of dress and furnishings was being reflected by fashionable magazines such as F.A. Leo's *Magazin für Freunde des guten Geschmacks* (1796). All over Central Europe, this circulated its illustrations of interiors in up-to-the-minute styles (such as Pompeian) and designs for Neo-classical beds with wire bases for extra comfort. It was also a mark of German middle-class taste that it should take cues from England, land of free experiment, not least in the arts, where high and low elements mingled in the plays of Shakespeare, the novels of Defoe, the paintings and engravings of Hogarth. Lessing was strongly drawn to the sentimental bourgeois drama, with its modern French models by Diderot; but in his own play *Miss Sara Sampson* (1755) he sought to implant the kind of authority enjoyed by the classics in a subject drawn from ordinary life. The result had English roots and was a tragedy like Lillo's *London Merchant* (p. 35). And if Hogarth's 'modern moral subjects' and comic histories (Plate II), with their precise documentation of people's lives and surroundings, might

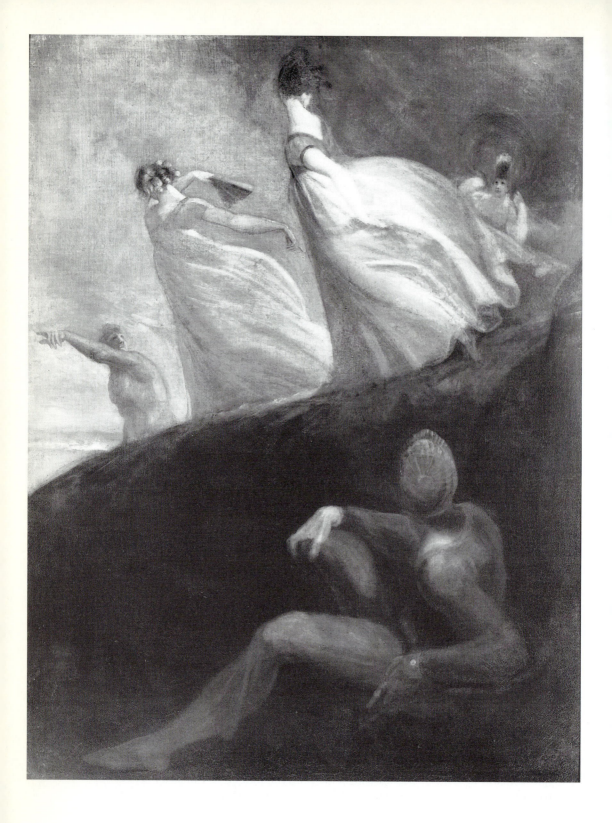

seem as essentially English as the roast beef that he celebrated in his painting, they had an admirer in the Göttingen professor Lichtenberg (1742–99). His commentaries on *The Rake's Progress* and other Hogarth cycles, published in the *Göttinger Taschencalender* (1784–98) proved popular enough with his German public to justify an enlarged and revised version (1794–99).

Hogarth's contribution to the gathering confidence of native British painting was closely aligned to existing British tastes for the novel and the drama. While his friend Garrick pitched his art to the back row of the theatre as well as to the seats of the privileged, Hogarth drew in diverse publics through engraving as well as painting, the linearity of the first and the colour-positioning of the second carefully discriminated so as to catch the attention of the most casual observer: the closer the attention to detail, the richer the yield of meaning. The images appeared both to run with time and to condense it. To Fielding, Hogarth's figures seemed not merely to breathe, but to think; to Lamb, sixty years later, his pictures were books to be re-read; Hazlitt, enjoying in Hogarth's *Marriage à la Mode* 'the expression from face to face, the contrast and struggle of particular motives and feelings', memorably remarked that Hogarth 'doubled the quantity of our observation'.[14] In America too, where independent thinking mattered more than influential connexions, Hogarth was compared to Fielding and Smollett, and his paintings rated well above the master-works of David.

For all his devotion to the detailed exploration of character, however, Hogarth could make quick points about contemporaries, and contemporary delusions, with deadly effect, especially when his aim was to expose shortcomings or excesses in high places. Besides the weakness of the individual, the monstrous power of collective emotion absorbed him (Fig. 51). Averse to being seen as a caricaturist, but intensely patriotic, he was to prepare the ground for the full onset of English political satire in visual form after 1760. The painting of scenes from English history, with which Hogarth and his friend Francis Hayman had decorated Vauxhall Gardens, was then taken up afresh in a resurgence of patriotism after the Seven Years' War (1756–63), in which England gained control of Canada from the French. Caricature flourished in the free cut-and-thrust of British politics as power was secured in India and the

Figure 50: J.H. Fuseli (1741–1825). *The Ladies of Hastings*. Oil, 111 × 80 cm. 1798–1800: also, perhaps, after 1813. Private Collection; on loan to the Kunsthaus, Zurich.

The picture epitomises much in the German-inspired art of its time that was grounded in classicism but was looking towards the Romantic.

A passive foreground figure in the attitude of a Michelangelesque river-god watches dreamlike females striding across the skyline, urged on by a distant figure of ambivalent scale, perhaps Fasolt, the giant who presides over storms in German mythology. The picture suggests folk-tale or myth, but the ladies wear the English fashions of 1798–1800. Fuseli has the classical artist's longing to pass beyond time, but the Romantic's alertness to particular moments: his works abound with vivid interchanges between the two.

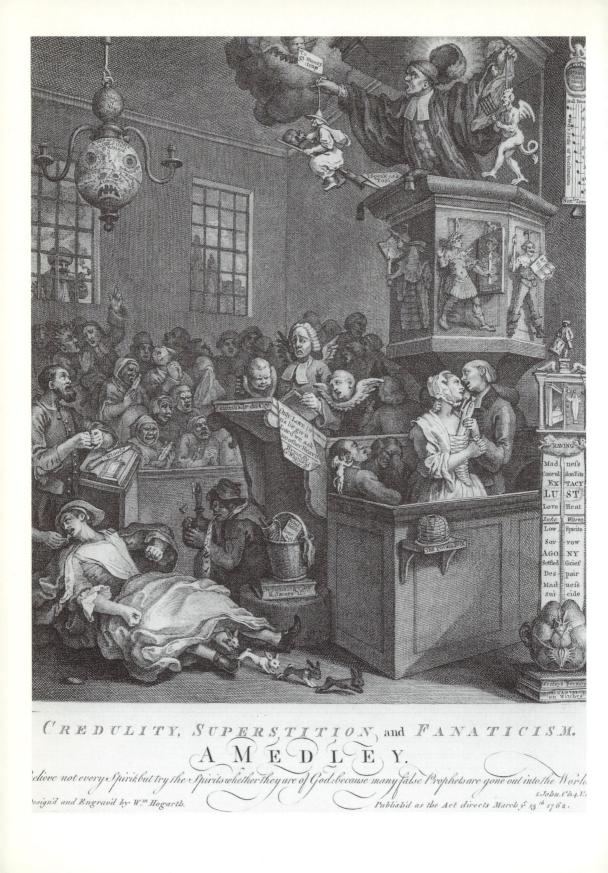

CREDULITY, SUPERSTITION, and FANATICISM.

A MEDLEY.

Believe not every Spirit, but try the Spirits whether they are of God: because many false Prophets are gone out into the World.

1. John. Ch. 4. V. 1.

Design'd and Engrav'd by W^m. Hogarth. Publish'd as the Act directs March y^e 15th 1762.

American colonies were lost. But much of the targeting was against France, perceived both as military enemy and as the cynosure, long railed against by Hogarth and others, of English aristocratic connoisseurship. The wish now to stir up the social self-awareness of the English non-aristocratic classes could find ample scope in the thesis that their rulers or other social superiors were Francophiles, or sycophantic towards the French. The working-out of this idea has recently been traced in the novel from Fielding's *Joseph Andrews* (1742) to Thomas Day's popular *Sandford and Merton* (1783–89).[15] For those of the middle class who did not read novels, and for the non-literate lower classes, the stereotype of the Frenchman as a vain, posturing dandy could be presented in popular prints. Such was the climate which provoked the caricaturists to action. The art was practised on both sides of the Channel: but the French phrase *la caricature anglaise* told its own story. English caricature represented the liberties that the English could take for granted with their freedom.[16] And as the French Revolution and the Napoleonic Wars loomed, a giant among caricaturists appeared: James Gillray (1756–1815), who had no contemporary rival for unbridled ferocity.

One boost to British graphic satire and its popular success came from the type-figures which everyone could respond to: not only political personalities and national stereotypes, but also national images built out of myth. In Britain the patriotic song 'God Save the King' appeared at the time of the Forty-five. It was soon supported by 'Rule Britannia', and from this moment the female goddess-figure with shield and lance lent itself to constant representation as symbol of the nation: triumphant, ravaged, martyred. After 1750 John Bull emerged from a literary prehistory (his sterling qualities had been contrasted with those of 'Lewis Baboon', a thinly-veiled reference to Louis XIV, in Arbuthnot's 1712 tracts) to impersonate the English citizen in drawings, often with anti-Scottish intent. The British lion expressed martial valour or the British king or national honour: the cock, submitting to it, was France (as on Vanbrugh's Blenheim Palace, 1705–25).

Figure 51: William Hogarth (1697–1764). *Credulity, Superstition and Fanaticism.* Engraving, 45 × 34 cm. 1762. British Museum.

The bare, box-like setting, reminiscent of the Tottenham Court Road meeting-house of the revivalist Whitefield, can hardly contain the theme. An earlier, unpublished version, *Enthusiasm Delineated* (1759–60), had cut a swathe through religious observance from Catholic to Methodist, and satirized the mind-swaying oratory of an Anglican preacher, wig flying to reveal a 'Roman' tonsure. He dominates also in *Credulity*, holding over his listeners images of a witch and a devil. But human credulity in general – a sensitive issue for the Enlightenment – is now the subject. The prostrate woman, based via Hogarth's earlier print on a Baroque saint, recalls the famous case of Mary Toft, seriously believed by the royal physician to have given birth to rabbits. Thermometers at the right register (below) degrees of emotional arousal and (above) 'vociferation' levels. A Muslim watches quietly at the window.

Printshops, well-stocked and available, were multiplying. In Britain Hogarth's 1735 Act, protecting engravers from pirating, encouraged print publishing, of which one lucrative branch was found to be satirical prints. 'Caricature' shops indeed, with their eye-catching windows, became picture galleries to all classes of passer-by, including the illiterate, who might have finer points of meaning explained to them by those in the know.

But Gillray, like all great caricaturists, made the most use of what his public could be expected to know, or have views about. This had long been a device of burlesque, an old-established literary and dramatic form descending from Italian comedy and presenting stock characters in plots which humorously exposed pomposity, pretension and hypocrisy. In Britain Samuel Butler's poem *Hudibras* (1663–64, 1678), which derided Puritans, had been illustrated by Hogarth in 1726; *The Beggar's Opera* (1728) had used homegrown ballad forms to mock the taste for Italian opera. Fielding's version of the Tom Thumb nursery story, *The Tragedy of Tragedies, or the Life and Death of Tom Thumb the Great* (1731), with a Hogarth frontispiece, parodied stage tragedy, introducing reminiscences or reworkings of lines from plays with which his audience will have been familiar. All these points: the exposure of what is seen as pretension or hypocrisy, the mockery of things foreign, the harking back to characters from a famous play, are present in one of Gillray's greatest caricatures (Fig. 52).

The strong lighting in Gillray's *Phantasmagoria*, with its dark edges and silhouetted foreground shapes, links with other manifestations of popular culture of the time: the lighted peepshows, plays performed in changing light conditions by lifesize wax marionettes, the *mélanges* of colour, movement and sound associated in the 1780s with the name of Philippe de Loutherbourg and in the 1790s with a new version of the magic lantern which had regaled Paris with apparitions of France's men of fame and notoriety, Voltaire, Rousseau, Marat, Lavoisier. And Gillray's very title had come from the popular show called 'Phantasmagoria', which was put on in London late in 1801 or early in 1802 at the Lyceum Theatre by P. de Philipstal.[17] This involved light passing through a semi-transparent screen, and adjustable lenses which made figures

Figure 52: James Gillray (1756–1815). *A Phantasmagoria – Scene – Conjuring-up an Armed Skeleton*. Etching and mixed techniques, 35.5 × 25.8 cm. 1803. British Museum.

In a composition of subtly-varied symmetry and virtuoso draughtsmanship, Gillray delivers a topical theme: suspicion of concessions apparently made too generously to France by British signatories to the Treaty of Amiens in the previous March. These negotiators are shown as the witches in Shakespeare's *Macbeth* (Act IV, scene 1): Addington, Prime Minister, pouring coin into a cauldron containing the British lion's tail and paw; Hawkesbury, Foreign Secretary, throwing in documents representing Britain's previous strategic advantages; and the Francophile Charles James Fox. William Wilberforce, in the foreground, sings a 'Hymn of Peace'. Near him the French cock stands on the lion. In the background, wreathed in the smoke that rises from the cauldron and frames the word 'Peace', stands Britannia, reduced to a skeleton.

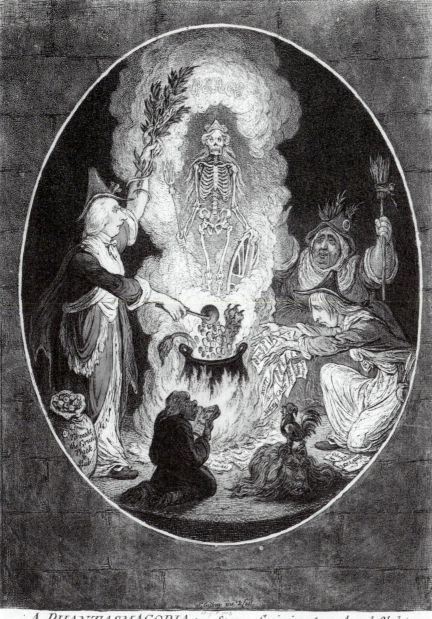

A PHANTASMAGORIA;—Scene—Conjuring up an Armed-Skeleton.

painted on glass appear to advance or recede. Such spectacles were a kind of equivalent to the reading of the 'Gothic' mystery stories that were available from circulating libraries (p. 52).

It was by such means, specifically its capacity to work on the spectator's emotions by an appeal to his sense of the mysterious, that 'Gothic' became a label to conjure with in the years before and after 1800. Apparitions advanced and receded in the pages of Walpole's *Castle of Otranto* (1764), and a descendant of the Ghost in *Hamlet* appeared on the castle battlements in Mrs Radcliffe's *Mysteries of Udolpho* (1794). Both these stories were placed in Italy, but the prevailing atmosphere had a northern darkness. Shakespeare's *Macbeth*, much depicted by Fuseli – notably in a watercolour of Garrick reflecting Macbeth's horror after Duncan's murder, engraved in 1804 – reminds us of another pervasive source. But it was overwhelmingly scenes from German folklore, ripe for translation into other languages, often English, that reinforced the English 'Gothic' thriller. Themes of eroticism, the life of the convent, and violent death revolved in novels and stage melodramas. Matthew Lewis, author of the most daringly shocking of Gothic romances, *The Monk* (1795), won the approval of Sade himself. In 1792 he had studied in Germany; and later he was to write melodramas for the London stage.

While adventure fiction and melodrama connected readily with popular taste, another all-important form of expression, the ballad, also found its mark. Traditionally a song that accompanied a dance, and setting a popular story in short stanzas, it was to form a basis of one of the glories of European music, the German *Lied*.[18] There were other reasons, besides its directness, for the ballad's success now, at many levels of taste. Firstly, the combination of simple words and strophic form made it ideal for domestic music-making, which took on new life after the invention of the piano. Secondly, it met the demand of educated taste for the rusticity of the folk tradition. While its range of subject-matter was large – extending from the patriotic to the domestic – the ballad telling of love, endeavour, adversity, death and loss, often against a country or historical background, or recalling the aftermath of war, became vivid with renewed meaning in the age of sensibility. In Germany G.A. Bürger (1748–94) made his name with a ballad *Lenore* (1773), one of the most pervasive stories of *Sturm und Drang*. A girl awaiting the return of her soldier fiancé from war rides with his armour-clad figure at night. When his vizor is raised, his phantom is revealed, carrying her to her death. Many artists illustrated it, including Ary Scheffer (*c.* 1830) and Horace Vernet (1839), who shows the horse leaping over a recumbent Gothic effigy into the grave, with an owl gazing out of the shadows. Bürger's ballad was given added currency in England by being translated by William Taylor of Norwich (*Monthly Magazine*, 1796) and mentioned in Madame de Staël's book *De l'Allemagne* (1813, Ch. XIII).

Though the story of Lenore came from an English original, *The Suffolk Miracle*, the heritage of native German folksong published in the mixed collections of *Volkslieder* by Herder and others also provided an inexhaustible source. The narratives familiar to oral tradition passed readily into the lyric poetry of Goethe, whose ear for the 'young' German language and its characteristic sound was to call forth the keenest of responses from the emerging

German middle class, and from Schubert and other composers of *Lieder* early in the nineteenth century.

In England the historical ballad 'Chevy Chase', probably of fifteenth-century date, had been celebrated by Addison in *Spectator* 70 as 'the favourite ballad of the common people of England'. The *Beggar's Opera* (1728), as we have seen, deployed the form prominently. While the ballad's rustic sentiments were ridiculed in Sheridan's play *The Rivals* (1775), it was held in affection in such important places as the *Gentleman's Magazine*: and literary antiquarians probing the medieval past set the seal on its reputation. In 1765 Thomas Percy's *Reliques of Ancient English Poetry* (which was translated into German) assembled a quantity of popular verse in edited form, and was followed by Joseph Ritson's *Select Collection of English Songs* (1783). The enthusiasm passed to America, where Longfellow (1807–82) translated examples and published *Ballads and other Poems*, including 'The Wreck of the Hesperus' and 'Excelsior', in 1841.

Scotland's ballad traditions were also long: and among those who used them, Robert Burns (1759–96) – much admired by Wordsworth – made an international impact, especially in France. Besides advocating the watchwords of the French Revolution, he represented Scotland at large to a France that was curious about it, and relayed his native speech in his poetry with an infectious conviction that made the French wish to understand it. In Walter Scott the Scottish ballad also had a doughty advocate: his interest in German literature led him to translate *Lenore* and other ballads, and to collaborate with Matthew 'Monk' Lewis in publishing *Tales of Wonder* (1801). Some of the ballads here were original; but there were also German examples such as Goethe's *Erlkönig* (*Erlking*, see p. 214). Besides the tales of the supernatural, the ballad literature also celebrated ordinary human relationships, as Burns's *Auld Lang Syne* reminds us. Based on a folksong, this indeed created a symbol of fellow-feeling that was to be popularly remembered the world over, at every New Year. Rhythm too – with its equally powerful general appeal – was another attraction. Burns's ear for rhythm was such that he could fit words to pre-existing Scottish dance-tunes with such felicity that they seemed entirely natural.

Burns died in the middle of the 1790s, a few years after the French Revolution, which he supported, and the Terror in Paris, which dashed so many hopes of freedom. Blake wrote *The Sick Rose*. Schiller, fearing a return to barbarism, began his great letter-sequence defining the saving power of art, *On the Aesthetic Education of Man* (published 1795). In France itself, David produced the decade's greatest picture, *The Death of Marat* (1793, Fig. 53). The Roman crises of the *Horatii* and the *Brutus* were behind him: here was David's transcendent response to a real-life, personal crisis. But his search for classical concentration has not relaxed: in some ways he is now even more concise.

FRANCE AT A TURNING-POINT

Although David's Neo-classicism must be seen as a restraining force in French painting, for all the emotion that pushes its surface, no national event of the 1790s – least of all one so momentous for France as its Revolution – could have

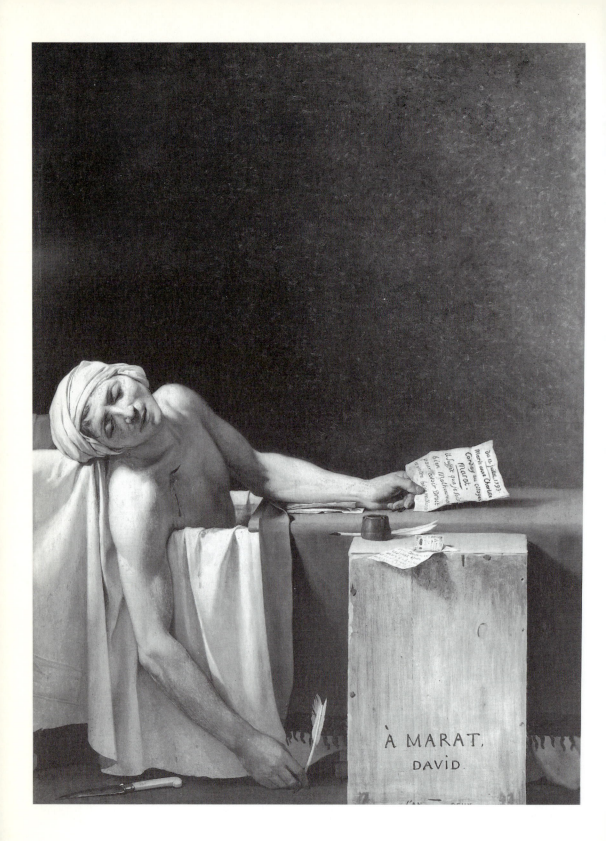

been without Romantic portents. David himself designed revolutionary uniforms and organized popular festivals. Rouget de Lisle's *La Marseillaise* (1792) became the most famous of battle hymns. Perspectives on the remoter French past were revealed with the opening in 1795 of the Musée des Monuments Français, incorporated in 1816 into the Ecole des Beaux Arts: this gathered together emotive fragments of medieval sculpture which were to inspire such men as Chateaubriand (1768–1848) and Jules Michelet (1798–1874), author of the *Histoire de France* (1833–67). Gothic, as the great north European style of medieval architecture, had for a generation become the subject of intense scrutiny in Germany, France and Britain, as part of an international effort to reassess the style and to establish the origin of the pointed arch. But from 1772, the time of Goethe's famous celebration of Strasbourg Cathedral as a Tree of God 'sprung from a plain and vigorous German soul' (see p. 198), emotional responses, often tinged with nationalistic bias, had been an intimate part of the rehabilitating process. The allure of demonstrable pedigrees was to be part of the propaganda put out by the young army general Napoleon Bonaparte. In 1800, already ruler of France, he had himself painted by David as a conqueror in the line of Hannibal and Charlemagne; in 1804, he dignified himself as Emperor of the French.

The eyes of all Europe were inevitably on Napoleon about 1800, and up to his fall in 1814. His likeness permeated the period in every conceivable form from the great icons of the official portraits to barley sugar sticks, 'le Premier Consul's head ... sent down your throat', as an English visitor to France in 1802 observed. The propaganda image was celebrated in David's paintings of Napoleon's coronation and his distribution of the Eagles (battle standards) and in numerous canvases by the principal recorder of Napoleon's campaigns, A.J. Gros (1771–1835, Fig. 54). The classical pedigree-based kinds of architecture and furnishings that Napoleon admired, as developed by his architects

Figure 53: Jacques-Louis David (1748–1825). *The Death of Marat.* Oil, 165 × 128 cm. 1793. Museés Royaux des Beaux-Arts, Brussels.

The revolutionary leader Jean-Paul Marat was murdered by Charlotte Corday in his bath, where a skin disease obliged him to work: he holds the note she has used to gain access.

Many French artists, including David, had recently painted the death of Socrates, showing the Greek philosopher obliged by authority to drink hemlock and surrounded by grieving friends. With David's *Marat* the isolation of Socrates became that of a modern 'ami du peuple'. The artist, a personal friend as well as the hand behind the image, spoke for many with his simple message 'A Marat, David'. In the following months, the work attained a religious status, transcending the political moment. For those who wanted the reminder of revolution as renewal, the packing-case serving as writing table harked back to the primitive: a more relevant image, perhaps, than Laugier's forest hut (p. 124). But the most important revolution, in the setting of French and world art, was the work's intensity as both publicly- and privately-felt document. In 1846 Baudelaire saw here the 'fragrance of the ideal' combined with the realism of a Balzac novel.

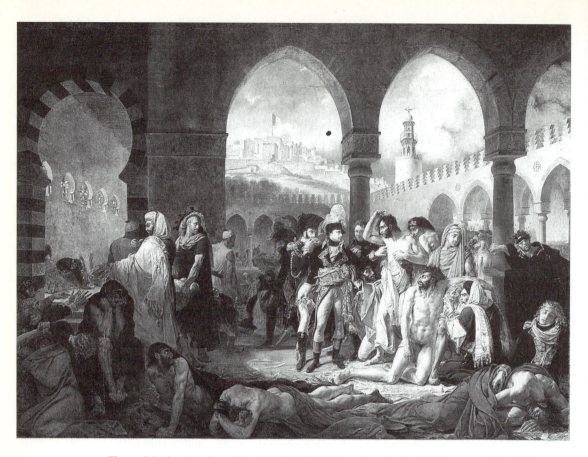

Figure 54: Antoine-Jean Gros (1771–1835). *Napoleon in the Pesthouse at Jaffa.* Oil, 5.32 × 7.20 m. 1804. Louvre, Paris.

The groups are classically balanced, but the arches are pointed; and attention to physical suffering and exotic setting, together with Rubensian warmth of colour, are signals of Gros's willingness to look forward from his master David. The picture commemorates Napoleon's actual visit to the pesthouse in 1799. The officer behind him holds a cloth to his face to quell the stench: Napoleon himself reaches out to the sores of the naked soldiers in a gesture of courage that recalls the myth of royalty's healing touch. The wonder-working effect of this huge picture, as a propaganda piece charged with rich colour, earned it a crown of laurel in the Salon of 1804.

Percier and Fontaine in Paris (Fig. 69), spread across Europe, including Scandinavia.

Different readings from outside France of Napoleon's actions elicited equally varied responses. From Nelson's Britain, Gillray savaged Bonaparte in prints like 'Maniac-Ravings, or Little Boney in a Strong Fit' (1803). When, a year later, Napoleon began to call himself Emperor, Beethoven's attitude to him cooled, though he appears to have continued to admire his rise from humble origins. The philosopher Fichte (*Reden an die deutsche Nation*, 1807–8) called from French-occupied Berlin for Germans to fall back on their spiritual resources. Kleist wrote his anti-Napoleonic battle-song *Germania an ihre Kin-*

der (*Germania to her Children*, 1809), an almost point-by-point reply, deeply pessimistic in tone, to Schiller's 'Ode to Joy' (p. 102): his play *Prinz Friedrich von Homberg* (1810), denouncing the enemies of Prussia, examined fantasy as a spur to action. The disappointment of German hopes for freedom while Napoleon lived, and after the Congress of Vienna in 1815, confirmed Protestant painters like Friedrich in the rejection of politics, and others sought alternative answers in Catholicism. Hope would now be vested in a building rather than a man: the Cathedral of Cologne, part medieval but now, as plans were made to complete it, to become a national as well as a religious symbol.[19]

After Napoleon's fall there were admirers still: Hazlitt, ruminating over the biography that he was eventually to write, and Byron going into his own 'exile' (leaving Britain for ever) a few months after Napoleon went into his. The two exiles, the most famous military conqueror of the day and the most famous literary one, were directly linked in the autobiographical third canto (1816) of Byron's *Childe Harold's Pilgrimage*. Byron compares (lines 377–8) his predicament with that of Napoleon, brought down by lesser men, though weakened by

> a fever at the core
> Fatal to him who bears, to all who ever bore.

Through Harold's eyes Byron sees Waterloo as a field of slaughter which will not make political freedom any more of a reality. Exile has, however, freed him to say what he has to say. The Romantic artist's discovery of how far he had been pushed to the margins, and of his reliance on his private self, was to lead him into a number of extreme positions, and we must look at Byron in the light of these.

The Artist in Seclusion

'No letters today; – so much the better, – there are no answers'. Byron's note in his *Journal* for 23 November 1813 suggests his isolation; but he goes on to announce that he will go out of doors: 'Now for a *plunge* – high life and low life'.

Apart from the pull of love, dalliance and friendship, the eighteenth-century man in Byron was always urging him to make human contact. A satirist by conviction, he admired the Augustans' ability to match social observation to poetic form, and often expressed himself in Popean couplets. Johnson, too, struck a chord, though not always in matters of opinion. Johnson had maintained the view that solitariness led to idleness: to which Byron responded 'Um! – the idleness is troublesome; but I can't see so much to regret in the solitude. The more I see of men, the less I like them. If I could but say so of women too, all would be well'. Already on his first period of travel, at sea off Lisbon in 1809, he had imagined himself 'in the world alone'; and his hero Childe Harold took his place in the succession of famous lone heroes of fiction that ran from Goethe's *Werther* (1774) to Senancour's *Obermann* (1804) and Chateaubriand's

René (1805). Berlioz, in his symphony *Harold in Italy* (1834), made the solo viola portray the pensive hero. And with the strong self-identification of Byron with his heroes, we sense the apartness which he put at its clearest in *Don Juan*:

> The eagle soars alone; the gull and crow
> Flock o'er their carrion, just like men below.
>
> <div align="right">Canto IV, xxviii: 223–4</div>

Solitariness might have its melancholy; but there was also the optimism of self-reliance, which Byron shared with the eighteenth-century Enlightenment. 'Dare to know', Kant had counselled in 1784, in a famous appeal to his readers to stand intellectually on their own feet. Rousseau had dared to look within: his sense of being 'different', explored in his *Confessions*, led him pointedly to ask in his late, unfinished *Rêveries du promeneur solitaire* (*Reveries of the Lonely Walker*), 'What am I myself?' For the artist a view of individual genius as the gift of nature, bearing its own special fruit, offered a route into this problem of selfhood. Goethe's pamphlet *Von deutscher Baukunst* (*On German Architecture*, published by Herder in 1773) honoured the interdependence of national and individual 'genius', which had enabled the builder of Strasbourg Cathedral, 'Master Erwin', to turn it into a 'Tree of God'. The concept of 'genius' had a complex history, defining poetic inspiration and seen by the Enlightenment as operating within the guidelines of precedent and usefulness. In 1719, in his influential *Réflexions Critiques sur la Poésie et sur la Peinture*, the Abbé Du Bos had associated it with spontaneity, and Goethe welcomed it as a spontaneous (though shaping) force, in much the same way that Herder had seen it working nationally at the roots of German song. Though Goethe later came to think of genius as essentially channelled by tradition, it carried this sense of individual, shaping power in *Götz* (1773), *Werther* (1774) and other works of his *Sturm und Drang* period, a time when, finally detached from Christian belief, he was especially preoccupied with the isolating nature of the creative life. His ballad about the mythical Pygmalion (1767), in love with the statue of Galatea that he had made (Goethe had recently been impressed by Rousseau's *scène lyrique* on the theme), gave evidence of this. Still more did his ode and drama about Prometheus (1773), the god-defying solitary who made statues of men and women which came to life (a subject turned into a ballet by Beethoven in 1801).

Now, striking assertion of man's creative relationship with nature had been made before the free-thinking Goethe stood in front of Strasbourg Cathedral. In the unlikely setting of his *Night Thoughts* (1742–46), a work of the grave-yard school of poetry, the English divine Edward Young (1683–1765) had written, memorably:

> Where, thy true treasure? Gold says 'Not in me':
> And 'Not in me' the diamond. Gold is poor;
> India's insolvent: seek it in thyself,
> Seek in thy naked self, and find it there;

> In being so descended, formed, endowed;
> Sky-born, sky-guided, sky-returning race!
>
> *(Night VI,* lines 413–18)

He had resorted to the visual arts for his metaphors:

> Objects are but the occasion; ours the exploit;
> Ours is the cloth, the pencil and the paint
> Which nature's admirable picture draws.
>
> (lines 431–3)

This was three years before the young Joshua Reynolds set out for Rome to study and imitate, as thousands were to go on doing, the treasure that lay in the masterpieces of classical art. In *Conjectures on Original Composition* (1759) – greatly influential in Germany – Young also sought to define the nature of an 'Original' as it rose 'spontaneously from the vital root of Genius'. Such a genius, Young implied, so far from imitating, would not conform: 'Imitation is inferiority confessed; emulation is superiority contested . . . that fetters, this fires'.

INNER WORLDS

In recommending an approach to precedent in a spirit of positive contest, Young did not discuss how his genius figure should conduct himself in society. Insofar as the Enlightenment, concerned to fit all the components of the social mix into place, had referred the artist to a test of social usefulness and obligation, the eighteenth-century background of desired conformity – of what the artist *ought* to be – threw into greater relief, as the century ended, those who conspicuously failed to fit it. But the response to these, even then, was not necessarily hostile: it was recognized that some artists had made a virtue out of being 'different'. A current myth apocryphally depicting the painter Alexis Grimou (1678–1733), the 'French Rembrandt', as persistently drunk and always in debt, could not be squared with Enlightenment ideals. But in a century which took increasing interest in Dutch painting the manifest greatness of Rembrandt – who was often described as 'bizarre' in his private life – helped to make the tendency of some artists not to conform more acceptable.[20] After 1770 even Grimou received appreciations in histories.

In the aftermath of the French Revolution the notion of the artist as rebel received corporate expression. Around 1800 a group of David's pupils known as the Primitifs, the Penseurs or les Barbus, 'the bearded ones', proclaimed their freedom from the classical standards advocated by their master and the reopened Academy of Painting, and from all convention prescribed by society. From the past, apart from the Bible and Ossian, only the very earliest Greek art deserved attention: Homer, not Euripides; primitive vase painting, not Periclean sculpture. To demonstrate the point their leader stalked the streets of Paris cloaked as Agamemnon. They produced little that has survived: but the attitude they stood for was to endure.

For artists who stayed within the social framework, the exploration of personal 'difference', à la Rousseau, had to be reconciled, as we have seen, with problems of changing markets. One approach, typified by the history painter Haydon (1786–1846), was to follow what he believed to be his personal star ('In portrait . . . I feel as a common man; think as a common man; execute as the very commonest.' 'With sublime subjects you muse & have high thoughts, and think of death & destiny, of God & the resurrection, and retire to rest above the world & prepared for its restlessness').[21] An age which knew what was meant by the 'potboiler' threw into relief the inviolability of the artist who, for one reason or another, refused to produce one. Such a man was the painter Géricault (1791–1824). Prosperous enough not to have to worry about sales, he toured his 23-foot-long chef-d'oeuvre *The Raft of the Medusa* in London and Dublin in 1820, after the French State had refused to buy it. Another extreme position was to reject the very idea of patronage as demeaning to the serious task of the artist. 'Patronage! degrading word!', cried the American painter William Dunlap, addressing New York students in 1831. He added that if an artist, especially one who is a republican, 'loves his art, his pecuniary wants will be few': the discerning will provide for his needs: 'in fair exchange of their products for his, as equals, giving benefit for benefit'.[22]

Yet the refusal to conform to what society expected did not necessarily mean indifference to what it was thinking, or to the importance of guiding it in new directions.

The tygers of wrath are wiser than the horses of instruction.

This sentiment – calling for imagination rather than reason to be the guide in the business of life – came from a work by one of the most isolated yet socially-committed poets and artists of the age, William Blake (1757–1827): his *Marriage of Heaven and Hell* (1790–93). The son of a London hosier, Blake saw visions of angels and prophets from earliest years. A seven-year apprenticeship in engraving, which brought him the opportunity of drawing the Gothic tombs in Westminster Abbey, gave him insight into the possibilities of line that he never forgot. Line, imbued with a Rococo lightness, surged through the drawings he printed and 'illuminated' with watercolour as accompanying designs to his poem-cycle *Songs of Innocence* (1789). Blake's response to Gothic line, however, had a vital analogue in his response to the dynamism of revolution, in America and in France. The storming of the Bastille, viewed as an act of liberation by the radical circle to which Blake belonged in 1789 (which included Tom Paine), was denounced by the statesman Edmund Burke as marking a release of ungovernable forces. But when the Terror of 1793 in Paris dealt a blow to Blake's political radicalism, the mystic in him was there to rejoice in the notion of other ungovernable forces, those of the human imagination, which Blake opposed to the cold grip of reason, and which no repression could be allowed to defeat. Continuous renewal from fresh beginnings, not mere improvement, was needed: 'Improvement makes straight roads; but the crooked roads without improvement are roads of genius', he observed. (We might contrast this with Reynolds's

regard for 'improved' roads, p. 119.) With such convictions went Blake's sense of the artist as leader, not conformist: 'The Poetic Genius is the True Man', he said. Such a work as the Shakespeare drawing (Fig. 55) made the point visually.

Fiercely unwilling to compromise his personal visions, Blake remained an enigma to most of the educated exhibition-goers of his day; yet his desire to communicate with the public was so strong as to impel him to sidestep dealers and the usual middlemen, publish his illuminated books and hold his own one-man exhibition in Soho in 1809 (at which a version of the Shakespeare subject was shown). For this he wrote a detailed descriptive catalogue: but there was only one review of the show, and few attended.

Blake's fiery, apocalyptic vision of society spiritually renewed, and his re-interpretation of themes from the Bible (notably the *Book of Job*), Milton (*Paradise Lost*) and Dante (*Divine Comedy*), as means towards achieving this end, created an entirely individual art based on a personal symbolism and charged with a whiplash energy. His condemnation of most post-Renaissance painting recalls Runge (p. 143), who was almost certainly unknown to him, but his primitivism relates to other acts of revolt against conventional academic teaching all over Europe.

In 1797 the German Wilhelm Wackenroder (1773–98) had published a book which, for all its excesses of sentiment, proved something of a landmark for his compatriots. In this work, *Herzensergiessungen eines kunstliebenden Klosterbruders* (*Outpourings of an Art-loving Monk*), the author claimed, like Blake, that art came from feeling not skill, inspiration not knowledge. He also singled out for praise what he saw as the qualities of honesty and spontaneity in medieval art: the Italian artists before Raphael, the native German tradition sturdily represented by Dürer, the craft virtues of an age of unifying religious faith on which, it appeared to him, this art was based. In readable accounts of the lives of early artists based on the famous work of the Italian Vasari (1550, 1568), he stressed the notion of art and nature as revelations of the divine. Music is also discussed: and Wackenroder's musician Berglinger moves from church to concert hall in transports of elation.

Shortly after this, Friedrich Schlegel (1772–1829), soon to become a Catholic, exalted the spiritual qualities that he saw in early north European as well as Italian painting, in essays printed in his journal *Europa* (1802). In the same year Chateaubriand (1768–1848) published his book *Le Génie du Christianisme*, praising the imaginative insights of the medieval artist above the formalities tailored in the classical world.

For all the renewed enthusiasm for Greek art brought about by the Elgin Marbles (in Britain from 1806) and casts made from them, there was much potential succour for the individual artist in this medievalist crusade. First, it set against the levelling skills of academic illusionism the virtues of independent honesty and imaginative candour: Blake and Wackenroder were close here. Second, by focusing attention on group activity such as that of the medieval guilds, secure in their common practical goals, it helped artists to band together and draw individual strength from the shared experience of new challenge. In 1809 a number of German artists formed a Brotherhood of Saint Luke in

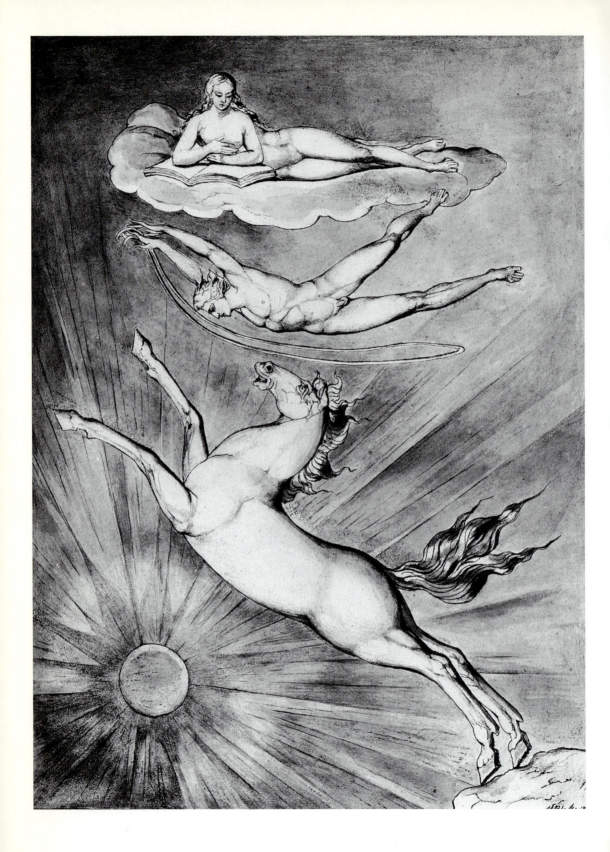

Vienna: they became Catholics and set up in a cloister in Rome where, with their long hair, they were nicknamed the Nazarenes. Third, the common practical goals could be pursued in the forms of a renewed, international Christian art which in England, under the influence of Prince Albert, could be sweetened in a thousand ways and applied to countless devotional paintings and sculptures. The Pre-Raphaelite Brotherhood, formed in 1848, collected together all three strands: but for the sweet naturalism substituted a hard-knuckled concern with raw fact, which aroused intense controversy. (Holman Hunt, Millais and D.G. Rossetti, the original members, had gone their separate ways by 1852, though each had benefited from their association.)

But it was clear in the early nineteenth century that some artists wanted not only to renew their art, but to amend the very manner in which their function was perceived. It was not just that, like the breakaway group of David's pupils, they grew their hair long or recited Ossian. Or that, like De Quincey, they wandered the London markets under the influence of opium. It was rather that the notion was intensifying of artists as traders in the goods of the imagination, a transforming force for Coleridge and Ludwig Tieck, and for Blake the one power that 'makes a Poet'. Some became fascinated by the individual self, as Rousseau had been. Lamartine and Victor Hugo maintained that only by being completely oneself could one move others. And with this belief in the artist living his own life, self-portraits of him in his own surroundings, often gazing out at the spectator (Fig. 56), took on a new intensity.

As we saw earlier (p. 141), the open-air interests of the Romantic landscapists in no way invalidated the pre-eminence of the studio as workplace. It was there that Turner worked up his sketches and evolved his most advanced work, and Constable painted six-foot (full-size) sketches of *Stratford Mill* and other major pictures in order to organize his original sensations in front of nature on the scale of the final painting. The studio-Romantic *par excellence*, however, was Friedrich. There exist several paintings and descriptions by friends, and paintings by Friedrich himself, of the studios used by him at different times during his residence in Dresden. All agree in revealing their bareness of all objects except necessities – a table, a T-square – as if to leave space

Figure 55: William Blake (1757–1827). 'As if an Angel Dropped Down from the Clouds'. Pen and watercolour, irregular, 23.1 × 17.3 cm., on paper 30.8 × 19.1 cm. 1809. British Museum.

The horse, associated for Blake with 'instruction' (frequently subordinated to human control), is rarely celebrated in his art. Here, however, it leaps ecstatically from the barrenness of what Blake calls 'the cliffs of Memory and Reasoning'. The reference is to Shakespeare's *Henry IV*, Part I, Act IV, scene 1, where Prince Henry is likened to an 'angel' descending 'to turn and wind a fiery Pegasus'.

Made for insertion into the Rev. Joseph Taylor's second folio Shakespeare, this is one of Blake's most personal designs. Between the sun's disc and the convex cloud (with its girl reader), his pen line holds springing horse (with closed hind legs and open forelegs) and twisting man (with closed arms and open legs) in a finely-judged dynamic relationship.

intact for the artist's mind to fill it. There, using his inner eye and perhaps his sketchbooks of painstakingly recorded rocks, trees and plants, he went to work. 'Close your bodily eye', he told students, 'so that you may see your picture first with the spiritual eye'.[23] With dabs of colour over drawing, he built up a uniform surface layer of thin paint which would precisely serve his purpose: to transmit the sensation of that veil of mystery in nature that had absorbed the artist. Friedrich's extraordinary habit of withdrawing in this way into his painting had no close parallel, except among his followers. This mystical approach met with little understanding, even from buyers of his work. Already before his death, more accessible paintings by others, based on a relatively everyday approach to landscape, had become popular with the bourgeois taste of 'Biedermeier' Germany (p. 178).

On the other hand, that preoccupation with changing states which made painting, with music, bear so much of the burden of Romantic feeling, was reflected quite differently by Turner, Constable and Delacroix, who wanted to leave the marks of their experience literally in the paint and in the variety of the brushstrokes. So far, indeed, from wishing to close his bodily eye, Delacroix could be sparked into action by the mere sight of pigment: 'my palette, freshly arranged and brilliant with the contrast of colours, suffices to fire my enthusiasm'.[24] His words give notice of a very different kind of approach from Friedrich's: but also of no less intense a rapport with the work in hand (Plate VIII). While Delacroix compared painted sketches to Chopin's improvisations, however, public prejudice about 'finish' – all the more entrenched in a 'static' art like painting – was to hinder wider acceptance of final works that seemed to lack it (see Chapter One, p. 62). Delacroix – who had learned much from Constable's dab-like technique when the English artist's *Hay Wain* was shown at the Paris Salon in 1824 – was seen as the 'chaos man', even by fellow professionals, and suspected of painting with a broom. Artists in their studio sanctums were set to work ahead of the public at large, encouraged by supporters of a kind that became familiar later as the 'avant-garde'.[25]

THE ARTIST'S PERSONAL GOALS

While a conscious avant-garde of the arts was a phenomenon of the late nineteenth century, the related issue of the skewing of an artist's reputation against the timelag of informed public acceptance did become relevant before 1850. Diderot debated posthumous fame in 1765 in a correspondence with the sculptor Falconet. But the aspect of timelag became an issue especially for painters

Figure 56: Tommaso Minardi (1787–1871). *Self-portrait.* Oil, 37 × 33 cm. 1807. Uffizi Gallery, Florence.

The garret-like bareness and disorder of the room highlight the self-absorption of the solitary artist, who has discarded his dividers and privately explores his next course of action. That such a Romantic view is expressed by an Italian-born follower of the classicist David shows how far it has reached by 1807. The two sources of illumination in the room recall northern (especially Dutch) precedent.

who, unlike writers or musicians, needed literally to 'place' their work. The opening of national collections of painting; the more impersonal conditions under which painters were now tending to operate (often looking for buyers on the open market rather than producing to specific commission); the impact of critical reviews: all were factors which could be expected to make artists give thought to the ultimate fate of their work at the hands of posterity. Goya and Turner, for example, were celebrated by supportive patrons who collected their work: Goya from his forties, Turner, an RA at 27, somewhat earlier in life. But both were also concerned about the future. Financially astute, they regularly re-acquired their own 'public' work and made plans for their artistic legacy after their deaths. Goya transferred money and property, including a collection of his pictures, to his son as a deed of gift, instructing him to keep certain works, including the print series *Disasters of War* (published in 1863, after his death). Turner willed his finished pictures to the nation and wanted a special gallery to house them.

It nevertheless remained for future generations to re-evaluate work that even its authors had treated as private, such as Turner's 'Colour Beginnings' – astonishing trial runs which juxtaposed colours without defining a precise 'subject' – or, on a different plane of ambition, Goya's *Disasters of War* and the savagely uninhibited 'Black Paintings', apparently done for his eye alone on the walls of his house (transferred to canvas and first publicly shown, in Paris, in 1878, and given to the Prado, Madrid, in 1881).

Goya, deaf and ultimately opting for exile from Spain, and Turner, living part of his life under an alias as a seaman, both exemplify, in fact, in very particular ways, the life of the artist choosing his own course, now at the centre of his society, now at its edge. Neither died unappreciated. But Romantic regard for the idea that the artist was a special kind of man could mean that even if he might not choose to become unappreciated and marginalized, he might very well be obliged to be seen as such. Thomas Chatterton (1752–1770), the English boy poet, had committed suicide in poverty after a short career in which he had been exposed as perpetrator of a series of pseudo-archaic poems claimed to be the work of a fifteenth-century monk. Recollection of his genuine poetic gifts and tragic end combined to create a myth of genius driven to self-destruction which became powerful for Coleridge, Keats and others. In Alfred de Vigny's play *Chatterton* (1835), however, society was seen to have committed murder: the poet was presented as the victim of mercantilist indifference. The play pleaded, indeed, for government pensions to help struggling artists. Lives marked by drunkenness, poverty and suffering, on the edge of society, now became central to the myth of the artist's Bohemia which took hold in the 1840s, and was canonized in Murger's *Scènes de la Vie de Bohème* (1848).

Before the myth of Bohemia gained currency, writers, painters and musicians were already seen as bound together in the day-to-day successes and failures of real life and creative inspiration. The words 'artist' and 'poet', if not always interchangeable, had long shared common ground. In the dialogue of 1825 by Olinde Rodrigues and Léon Halévy, *L'Artiste, le Savant et l'Industriel*

– three categories (artist, scientist, merchant or manufacturer) into which the social observer Saint-Simon (p. 256) had divided man – the artist is 'the man of imagination' who embraces everything which has 'sensation as its object'. But if the artist was type-cast to the world, to himself he was an elusive subject for self-examination. In his personal journal, the *Zibaldone* (12–23 July 1820), the Italian poet Leopardi (1798–1837) claimed that as the imagination was able to conceive of things that did not exist, it was the provider of man's greatest pleasures: his hopes and illusions. Leopardi's own pessimistic 'rage to live' (he was an invalid) was bound up with his sense of this. Wordsworth's concern with identity was essentially retrospective: in *The Prelude* he reconstructed his early life and the processes by which he arrived at his love for humanity: it ran to lengthy revisions (1805, 1830s). And even among non-writers the keeping of journals or the setting down of personal feelings through the written word became a necessary part of their lives. Runge, as we saw, wrote autobiographically. Delacroix's journal became his confidant. Haydon left both a brilliant autobiography and twenty-six folio volumes that not only recounted day-to-day happenings but allowed him to expand on those hopes for recognition that the outside world had denied him.

Many artists in the period also crossed boundaries between the arts and expressed themselves in two or more of them. E.T.A. Hoffmann wrote fantastic tales in which he appeared: he also composed and painted. Between 1809 and 1820 the composer Weber worked on a novel (unfinished) to be called *Das Tonkünstlersleben* ('Life of a Sound-Artist'). Turner wrote lines of verse which purported to belong to a poem called *Fallacies of Hope*. The French journal *L'Artiste* (founded 1831) printed contributions largely by poets on the subject of painting.

This was a time for artists, either singly or in charmed circles, to 'turn inwards' to imaginative goals of their own: as with the French Primitives (p. 199) to gain solidarity, but even more to present a confident face to the world. The self-portrait might be a family occasion: Runge portrayed himself with his wife and brother as if to suggest that they shared his insights (*Wir drei*, 1804, formerly Kunsthalle, Hamburg, now destroyed). From within the protective shell of a *cénacle* or literary coterie the uncomprehending world could be excluded and also confronted. The word *Philister* (Philistine), used by students at German universities to denote townsmen, came into general use for those who made up that outside world.[26] Artists imagined communities of initiates united to face them: Hoffmann's Serapion-Brotherhood and Schumann's Davidsbund (League of David).

Though Constable and Friedrich never wanted to leave their native lands, the attraction of new beginnings and far horizons might well encourage the Romantic artist to travel. Kleist roved restlessly round Germany. The English-born landscape painter Thomas Cole (1801–48) and the Austrian poet Nikolaus Lenau (1802–50) went to America, though the latter soon returned. The German Heinrich Heine (1797–1856) spent four months in England (p. 233) and over twenty years in France. Adalbert von Chamisso (1781–1838), botanist and author of the famous prose work *Peter Schlemihls Wundersame Geschichte*

(1814, an allegory about a hero who sells his shadow), sailed round the world. Byron, overwhelmingly for his generation, personified the search for that full self-realization which was eluding so many.

The seclusion of the great Russian poet Pushkin, who responded closely to Byron, was nonetheless of a quite different order. Of noble family, he grew up in a country which was endeavouring to become part of Europe, but which had yet to come to terms with Europe's surging cultural competition. Russia laboured under a ruthless autocracy and a virulent censorship, and clung to serfdom. It was rife with secret societies seeking alternative ways of life. But it was nevertheless big enough – a crucial point – to accommodate its exiles in its own vastness. The revolutionary Pushkin read Byron during his first banishment in the Caucasus in 1820 and Shakespeare during his second, at his mother's estate near Pskov in the north, in 1824. But his patriotic hopes for Russia not only drew him back to Moscow and partial if shaky acceptance of the Tsar: they began to weight the literary broadsides which were to surprise the world beyond. His chronicle-play *Boris Godunov* (1825) strikes out from Shakespeare and Schiller to engage with latent Russian realism; his poem *The Gipsies* (1824) circumscribes the fate of the Byronic wanderer within the horizon-lines of an unmistakable Russian steppe; his poem *The Bronze Horseman* (1833) turns on the intimidating as well as the inspiring aspects of the French sculptor Falconet's great equestrian statue of Peter the Great (1782) as, at the height of a Petersburg flood, he makes it pursue the crazed clerk Evgeny, the Russian 'little man'.

For Western Europeans there were also the attractions of Muslim societies. Here too there was the example of Byron who, after travels in the Levant in 1810–11, wrote 'Turkish Tales' located in lands which he himself never reached but felt imaginatively drawn to. The renewed spell of the Orient (a theme of Chapter Five) developed in part through the colonizing involvement of Britain in India and France in North Africa, which gave unique force to the role of these powers in feeding exotic images to their publics at home. At first these were little more than the stereotypes that had existed for centuries: of imagined Arab moral excesses, as well as the ferocity which, for example, Byron built on in best-selling poems such as *The Giaour* (1813). But following Napoleon's invasion of Egypt in 1798, and the subsequent archaeological work there, the Near East with its biblical as well as Islamic associations was to become the subject of close analysis by Europeans who made leisurely tours or took up residence. Among French visitors Chateaubriand, travelling out to Jerusalem in 1805–6, Lamartine, reaching Palestine in 1833, Nerval and Flaubert, on their Eastern journeys respectively in 1842–43 and 1849–50, were crucial disseminators of a view of the desert countries which Europeans at home could recreate in imagination: lands of mystery where, as Chateaubriand remarked, loneliness could release the greatest passions.

The delight in extremes of behaviour which had characterized Beckford's *Vathek* (1786, p. 163), and located the story in a mysterious Eastern realm, made the exotic a paramount theme for the Romantics. So was the Orient's power to suggest origins. Friedrich Schlegel in 1800 thought it was Romanticism's

purest strain: Goethe (*Westöstlicher Divan*, 1819) was put in mind of human-
ity's very beginnings. There were parallels to be drawn between Jewish culture
and that of Germany, where so much of it found a home.[27] German scholar-
ship, in particular, was to revolutionize Western knowledge of oriental peoples
and artefacts. But the strength and scope of the stimulus is suggested by the
fact that literary figures as diverse as Victor Hugo and Baudelaire in France,
the Schlegel brothers and the poet Friedrich Rückert in Germany, and Disraeli
and the adventurer Richard Burton in Britain, all reflect it.

Tastes for the oriental readily joined with the fantasizing that was boosted
by the anthropological, zoological and botanical discoveries of explorers and
naturalists (pp. 131–2). Walpole had seen Darwin's *Botanic Garden* and the
Arabian Nights as beyond all rules. For Romantics the magical images and
transformations found in the *Arabian Nights* – Coleridge says that as a child
he would 'seize it . . . & bask, & read'[28] – and such works as James Ridley's
Tales of the Genii (1766), could feed directly into that most private and personal
region of seclusion, the dream. In Coleridge's opium-assisted 'vision in a dream'
Kubla Khan (1797, published 1816), quick-moving images of contrast emerge
and transmute: a sunny pleasure-dome, caves of ice, the sacred river Alph sink-
ing in tumult to a lifeless ocean, the Abyssinian maid playing her dulcimer and
singing of Mount Abora. The dreams of the opium-eater Thomas de Quincey
(1785–1859) also crowded his images, but added direct menace: 'Vishnu hated
me: Seeva laid wait for me – I came suddenly upon Isis and Osiris: I had done
a deed, they said, which the ibis and the crocodile trembled at'.[29]

Besides the capacity of oriental imagery to confront, amaze and threaten in
dreams, there was also the alien look of oriental scripts, then becoming avail-
able for Western visitors to museums (the Rosetta Stone entered the British
Museum in 1802). European preoccupation with Egypt focused in large part
on hieroglyphics. Maria Edgeworth refers in her novel *The Absentee* (1812) to
the 'Egyptian hieroglyphic paper, with the ibis border to match . . . one sees it
everywhere'. But Keats in *Hyperion* (1818) recalled the mystery: '. . . their
import gone/Their wisdom long since fled'. Hieroglyphics were to be deci-
phered only in 1822. The Romantics meanwhile were 'hieroglyph-conscious',
apt to appropriate the word and the thought to any inscrutable subject which
might yield hidden meaning. Runge and Friedrich Schlegel so used it; and even
Constable, no orientalist, gave thought to it: 'The art of seeing nature is a thing
almost as much to be acquired as the art of reading the Egyptian hieroglyphs'.

A code-cracking intent, indeed, might be said to be roused in the Romantic
artist by unfamiliar experience. Schumann offers a suggestive illustration of it
in a review of 1831. He was looking at the music of a set of variations on a
Mozart aria from *Don Giovanni*, by a composer who was new to him, named
Chopin. He tells us:

> With the words 'Hats off, gentlemen, a new genius!' Eusebius [Schumann's
> name for the reflective half of his own nature] put down a piece of music on
> the stand. We were not to look at the title. I leafed absent-mindedly through
> the notes – a secret enjoyment of soundless music which has something

magical about it. I feel, moreover, that every composer has his own peculiar note pattern for the eye: Beethoven looks different on paper from Mozart, something like the difference between Jean-Paul's prose and Goethe's. Here in this new work it seemed as if strange eyes were staring wonderingly at me – flowerlike eyes, eyes of basilisks, of peacocks, of maidens.[30]

With such words, looking through the real notes of music to the fantasy beyond, Schumann brought his readers to an important frontier station which he was often to pass, and which needs a new chapter.

NOTES

1. Hester Lynch Thrale, *Observations and Reflections made in the Course of a Journey through France, Italy, and Germany* (2 vols, 1789) I, p. 305
2. In a letter to Thomas Bentley, 19 June 1779, Wedgwood sees fashion as a force which has to be reckoned with by the possessor of merit, and is in this respect 'superior' to merit. See Ann Finer and George Savage, *Selected Letters of Josiah Wedgwood* (1965), pp. 58–9. For Wedgwood's marketing methods, including the use of samples and catalogues in his London showroom, see N. McKendrick, 'Josiah Wedgwood: An Eighteenth-Century Entrepreneur in Salesmanship and Marketing Techniques', *Economic History Review*, second series, **12**, iii (1960), pp. 408–33; also, for an analysis which rightly stresses Wedgwood's counter-balancing belief in merit, Jules Lubbock, *The Tyranny of Taste: The Politics of Architecture and Design in Britain 1550–1960* (New Haven 1995), pp. 221–3. See also Adrian Forty, *Objects of Desire: Design and Society since 1750* (1986, 1995), pp. 29f.
3. Mozart, letter to his father, 17 March 1781. See Mozart, *Briefe und Aufzeichnungen, Gesamtausgabe*, ed. Wilhelm A. Bauer and Otto F. Deutsch, Bd III 1780–1786 (Kassel 1963), p. 94; Emily Anderson, *Letters of Mozart and his Family* (2 vols: 1966), vol. II, pp. 713–14
4. G.A. Griesinger, *Biographical Notes concerning Joseph Haydn* (orig. Leipzig 1810), trans. V. Gotwals (Madison 1963), p. 17
5. Mozart, letter to Baron Gottfried von Jacquin, 15 January 1787: Anderson, *Letters of Mozart*, vol. II, p. 903
6. For the nickname see Neal Zaslaw, *Mozart's Symphonies: Context, Performance, Practice, Reception* (Oxford 1989), pp. 441–2
7. A.W. Thayer, *Life of Beethoven*, rev. and ed. Elliott Forbes (Princeton, New Jersey 1964), p. 405
8. William Gardiner, *Music and Friends*, III (London and Leicester 1853), p. 330: see Denis Arnold and Nigel Fortune, eds, *The Beethoven Companion* (1971), pp. 506–7
9. Though Biedermeier as a term was to date from satirical articles in the *Fliegende Blätter* of 1855–57, about a fictional schoolmaster, it refers to middle-class outlooks and attitudes to the arts in Germany and Austria between 1815 and 1848. See Alice M. Hanson, *Musical Life in Biedermeier Vienna* (Cambridge 1985)
10. The relationship between sonata form and the working-out of irregularities developed within it in Chopin is discussed by Jim Samson in 'Extended forms: ballades, scherzos and fantasies', ch. 5 of *The Cambridge Companion to Chopin*, edited by

Samson (Cambridge 1992), pp. 101–23. Chopin's rubato is usefully discussed in Charles Rosen, *The Romantic Generation* (1995), pp. 413–16

11. For much detail see Nancy B. Reich, *Clara Schumann: The Artist and the Woman* (Ithaca and London 1985)

12. See Henry Hatfield, *Aesthetic Paganism in German Literature* (Cambridge, Mass. 1964), pp. 152f.

13. Walter H. Bruford, 'Goethe and the Theatre' in William Rose, ed., *Essays on Goethe* (1949), p. 93. See Marvin Carlson, *Goethe and the Weimar Theatre* (Cornell University Press, Ithaca and London 1978)

14. Fielding, preface to *Joseph Andrews* (1742); Lamb, 'On the Genius and Character of Hogarth', *Works* (1818), vol. I, p. 70; Hazlitt, 'On Hogarth's "Marriage à la Mode"', *The Examiner*, 19 June, 1814

15. Gerald Newman, *The Rise of English Nationalism: A Cultural History 1740–1830* (1987), pp. 65–7, 101

16. H.M. Atherton, *Political Prints in the Age of Hogarth* (Oxford 1974), p. 2

17. For Loutherbourg's show the 'Eidophusikon' (1781), and also the improved magic lantern developed by the Belgian Etienne G. Robert (anglicized to Robertson) and by Paul de Philipstal, see Richard Altick, *The Shows of London* (Cambridge, Mass. and London 1978) pp. 121–7, 217; also Sybil Rosenfeld, *Georgian Scene Painters and Scene Painting* (Cambridge 1981), pp. 61–2, 162

18. Notably, such examples as the English ballad *Edward*, translated by Herder and set by Loewe, Schubert and Brahms. See Otto E. Albrecht, 'English Pre-Romantic poetry in settings by German composers', in H.C. Robbins Landon, ed., *Studies in Eighteenth-Century Music: A Tribute to Karl Geiringer on his Seventieth Birthday* (1970), pp. 24–5

19. The completion of Cologne Cathedral was chiefly advocated by the collector of early German art, Sulpiz Boisserée, aided by the Catholic revivalist Joseph Görres. The nationalism previously proclaimed by the freedom-fighters against Napoleon found its new symbol here

20. George Levitine, *The Dawn of Bohemianism: The Barbu Rebellion and Primitivism in Neo-classical France* (Pennsylvania State University Press, University Park and London 1978), pp. 23f.

21. *The Diary of Benjamin Robert Haydon*, ed. W.B. Pope, vol. II (Cambridge, Mass. 1960), entries for 6 Oct. 1824 and 10 Sept. 1823

22. William Dunlap, *Address to the Students of the National Academy of Design, New York*; cited in Hugh Honour, *Romanticism* (1979), p. 360

23. From a collection of aphorisms written about 1830, quoted from L. Eitner, *Neo-classicism and Romanticism 1750–1850*, vol. II (Englewood Cliffs, New Jersey 1970), p. 53

24. Delacroix, *Journal*, 21 July 1850. See abridged English edn by Hubert Wellington (Oxford 1980), p. 128

25. *Avant-garde*, a term given prominence in military parlance during the French Revolution, was in use by the 1840s to mean a leading group in society (Balzac, *Les Comédiens sans le Savoir*, 1846). For discussion of its early cultural history see Ceri Crossley and Ian Small, eds, *The French Revolution and British Culture* (Oxford 1989)

26. In the eighteenth century 'Philistine' meant an 'enemy' into whose hands one might fall (in Fielding's *Amelia*, 1752, it is the bailiffs). About 1800, it came to mean indifference to 'culture', and then, in the course of the nineteenth century, hostility to it

27. S.S. Prawer, *Heine's Jewish Comedy: A Study of his Portraits of Jews and Judaism* (Oxford 1983), pp. 286f.

28. *The Collected Letters of Samuel Taylor Coleridge*, ed. Earl Leslie Griggs (Oxford 1956), vol. I, p. 347

29. De Quincey, *Confessions of an Opium-Eater* (1822), World's Classics edn (Oxford 1965), p. 73

30. Schumann, *Gesammelte Schriften über Musik und Musiker*, edn ed. F.G. Jansen (4th edn., 2 vols, Leipzig 1891), vol. II, p. 178; trans. Jacques Barzun, *Pleasures of Music: An Anthology of Writing about Music and Musicians from Cellini to Bernard Shaw* (1952), pp. 98–9

5

The Fantastic and the Real

Prelude

The ability to transform the normal into the abnormal, and make it more 'real', is at the heart of Romanticism. Schumann's recognition (p. 209) of the 'eyes of basilisks, of peacocks, of maidens', in the notes of a Chopin score, is a clear example. Here, in the apparent unrelatedness of these things, we enter a region in which fantasy becomes part of a heightened reality. The possibilities that artists of all kinds were to bring before the public in the light of this occupy the next chapter.

The eighteenth century, fully alive to the ability of the human imagination to lead the mind visually in unexplored directions, had debated the issues. Addison's remarks on 'landscapes of trees, clouds and cities' in the veinings of marble (p. 117) were placed before readers of *The Spectator*. Reynolds's Fourteenth Discourse (1788) to students of the Royal Academy in London (p. 60) reflected on the action of the viewer's imagination in 'completing' the sense of a human likeness out of Gainsborough's 'chaos' of strokes, and the power of such methods of painting to excite surprise. There were philosophical questions to be faced: Malebranche, in his much-read *De la Recherche de la vérité* (1769, Book II), pointed out how misleading the imagination could be. Don Quixote's liability to confuse windmills with hostile giants was there to indicate the fact in Cervantes' novel. But as the Romantic artist's autonomy asserted itself, belief in the imagination's power to put the world together in unfamiliar ways received new confidence. The refusal of Don Quixote's imagination to be constrained by humdrum reality could be understood, perhaps, as a strength.

Changing attitudes to Don Quixote (with which the chapter ends) reflected deeper concerns. Eighteenth-century affirmation of reason made its antithesis, irrationality, appear negative; but this remained a disturbing background presence. In 1736–37, in his *Imitations of Horace* (Book II,

Epistle ii, 310–13), Pope ruffled the regularity of the heroic couplet to refer to reason destabilized by irrational fear of the unknown:

> With terrors round, can Reason hold her throne?
> Despise the known, nor tremble at the unknown?
> Survey both worlds, intrepid and entire,
> In spite of witches, devils, dreams, and fire?

Burlesque could soften the terrors: Telemann's French-style musical setting of Don Quixote's attack on the windmills went out into the world (about 1730) as part of his *Ouverture Burlesque de Quichote*. But the sceptical philosopher Hume soberly recognized that human responses were both rationally and irrationally based. And as the century advanced serious interest in irrational behaviour focused positively on states of mind in which reason and normality were suspended and other experiences – manifested in sleep as dreams and nightmares, and in wakefulness as 'reveries' – took over.

Of the ways in which normality was extended by the imagination in this period, two were the result of stimulus from the outside world: the supernatural and the exotic. A third interfered threateningly with the very identity of the artist: that disturbing form of the unknown that involved the splitting of personality. Finally, there was the taking-over of identity, madness itself.

Though Don Quixote was a pervasive influence, the Romantics' main move to link the fantastic and the real came not from Latin Europe but from the Germanic north. For this reason the imaginative world of the German *Lied* has a key place in this chapter. Each section takes as its starting-point a song by Schubert.

The Supernatural

Besides the use of the supernatural in the work of such figures as Fuseli (Fig. 50) and Bürger (p. 192), Goethe himself treated it famously in his poem *Der Erlkönig* (*The Erlking*, written 1780–81). This recounted the Danish legend (collected by Herder) of the forest-dwelling king of the elves, who lures people, especially children, to their deaths. One of the most compulsively forward-moving of all Goethe's early lyrics, its elements – the father riding with his feverish son through the night, the menace of the unknown, the terror of the child – were equally unforgettably caught by Schubert in his song of 1815. As with so many Goethe lyrics which were already so musical, Schubert's task was to balance the words to his melody and the voice with the accompaniment. But what turns the song into a masterpiece is the consummate carrying-over into music of the spirit of the poem, by a stroke of economy which changes the 'everyday' churning rhythm of the horse's hooves into a metaphor of the riders' terror.

The survival of primitive human response to the promptings of magic or devilry was a theme of challenge and controversy to the Enlightenment. As part of a wider study of early human societies – largely undertaken by the Scots – the living evidence to be observed among, for example, the American Indians, was investigated by William Robertson.[1] In his *History of Astronomy* (written by 1758, posthumously published 1795), Adam Smith divided the history of societies into a primitive stage, savage and fearful, in which storms, comets and other phenomena which were irregular in occurrence were attributed to superhuman powers – gods, demons, witches, fairies and spirits – and a stage in which law and reason triumphed and fears correspondingly lessened.[2] That fears remained Fuseli revealed in his famous *Nightmare* painting of an erotic dream (1781) and a drawing of three large-eyed crouching girls; as did Goya in Spain, in his terrifying print series *Caprichos* (1799). No. 12 of this series (Fig. 57), 'The Hunt for Teeth', shows a woman fearfully plucking a tooth from the jaw of a hanged man, in the belief that it will be a charm against sorcery. 'It's a pity', Goya remarks in his note to the plate, 'that common people believe such folly'.

Here we have it: the Enlightenment desire to banish magical practices is met by the hard realization that humanity has a boundless capacity for believing in them. It breeds folly and will not make for happiness. But it opens up outlets for which the imagination will always be pressing: and, as we shall see later, when we discuss madness (p. 237f.), Goya draws part of his own strength from his observation of it.

In Goya's Spain, a place rife with ambiguities, the light of reason is contrasted with the dark corners of the irrational where light barely reaches; the will to assert and balance the self is set against the individual's awareness of his or her own inadequacy. The contradictions are to be noted across a wider spectrum of Europe. They are noticeable, for example, in the overlap of chemistry and the ancient traditions of alchemy. In the 1780s, when the chemists Lavoisier and Priestley were consolidating the modern science, the charlatan Cagliostro (1743–95) was dazzling fashionable society with his elixirs for curing all ills and making people look and feel twenty-five years younger. And while Doctor Faust's magic had featured in cheap accounts for the barely literate for generations, his detailed recipes – for instance that for conjuring up Hell – were still being tested by the educated, for example by Goethe's contemporary, the theologian K.F. Bahrdt (1741–92): the young Goethe himself studied alchemy.[3]

RELIGION AND RITUAL

One powerful prop to the supernatural was, of course, religious conviction, with its access to 'inner light'. Thinking directed against the rational Enlightenment – a Counter Enlightenment – could assemble substantial resources here, as Isaiah Berlin has shown in his work on J.G. Hamann and others. Coleridge's intellectual life was enriched by the discovery of the *Aurora* by the seventeenth-century German Protestant mystic Boehme, translated by another mystic,

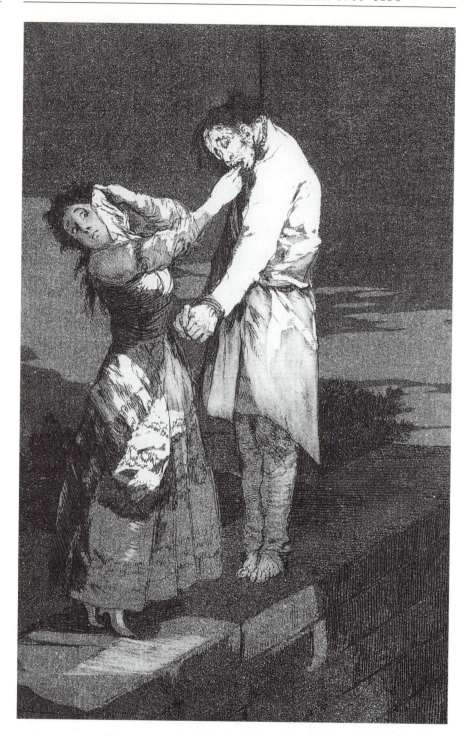

William Law (1686–1761). This sees in Dawn ('Morning Redness') and in the sprouting and sensuous forms of nature that it illuminates, a 'mighty alphabet', a direct connecting of God and Man. The Enlightenment philosopher Bishop Berkeley (1685–1753), in his treatise on the medicinal benefits of tar-water, *Siris* (1744), had also opened up a view of the world as a spiritual field between the two. If other, more turbulent currents of spiritual belief roused Enlightenment suspicion of 'Enthusiasm', they broke out in channels of Dissent, or ran underground. The religiously-inspired poet Christopher Smart (1722–71) might be condemned to a neglected death in the King's Bench Prison: but Smart's unpublished praise of his cat ('For in his morning orisons he loves the sun and the sun loves him. / For he is of the tribe of Tiger'), like Boehme's language, forecast Blake.[4] And Coleridge was to call his younger child Berkeley.

Certain poetic impulses in both Germany and Britain were simultaneously exploring the legendary heritage of the Celts and northern mythology. James Macpherson's prose-poem on the Gaelic hero Fingal (1762), ascribed to the bard Ossian, introduced the ghosts of the dead. In Germany the study of pagan mysteries concentrated on the *Walpurgisnacht*. This celebration of Satanist rituals by witches and warlocks on the heights of the Brocken in the Harz Mountains was associated with the night before 1 May, the day of St Walpurgis, an English nun who had helped to convert Germany to Christianity in the eighth century. The extremes of light and dark, God and the Devil, were here brought into the starkest opposition.

While magic and the occult maintained a baleful openness on the Brocken, they were ritualized within Enlightenment circles by the freemasonry movement, which enjoyed immense influence, as we saw in the case of Mozart's *Zauberflöte* (1791). In the opera the wisdom of Sarastro, high priest and mediator between the supernatural powers and humanity, offsets the sinister influence of the Queen of the Night. In a different field of popular entertainment, it is worth remembering, the magus or wise man had now begun to appear as the professional or amateur 'conjurer'. Astrology too – popular faith in the stars, expressed in Moore's *Almanac* (1743–1820) or even in specialist weeklies – was to provide its perennial escape from drab normality as industrialization tightened its grip on western societies.

It was in Goethe's towering conception of the trials of Faust, however (p. 150), that the elements of the wild supernatural took added meaning for

Figure 57: Francisco Goya (1746–1828). 'The Hunt for Teeth', *Caprichos*, plate 12. Etching and aquatint, 21.8 × 15.3 cm. 1799. British Museum.

Goya's *Caprichos* (eighty prints), targeted 'human errors and vices' that included superstitions, witchcraft, sexual mores and all the forces that the artist found repressive in Church and State. Such a print as this marked a milestone in outspokenness. The tiny irregular aquatint grain across the plate sets up a mood of quivering tension. Separated by the contradictory gestures of the woman's arms, as she both reaches forward and recoils, the two heads contrast almost unbearably, not least by being placed at exactly the same angle. Compare the confident reach of David's Horatii (Fig. 25).

the Romantic period. This was apparent from the moment in the first part of Goethe's unpublished version, the *Urfaust* (drafted by 1775), when Faust seizes his magical book and invokes the Erdgeist (Earth-Spirit). There are two Walpurgis nights in *Faust*, each at a crucial turn of events. In the first, on the Brocken (written by 1801, in Part One), the hero sees a vision of Gretchen, whom he has loved disastrously; in the second, set in ancient Greece (finished by 1830, in Part Two), he is searching for Helen of Troy, the ideal of beauty, but first passes through a nocturnal landscape filled with ghosts. Goethe had earlier written of the first Walpurgis night, with sentinels, disguised as demons, protecting druids as they celebrated the pagan spring festival. This theme was ideally formed for Mendelssohn, whose cantata *Die erste Walpurgisnacht* (*The first Walpurgis Night*, 1843) follows the lines of Goethe's contrast. Berlioz, who heard the piece in rehearsal, was thrilled by it, and in his *Memoirs* singled out, 'as superb examples of two diametrically opposed genres', the 'voice of the priest' rising above 'the din of the decoy demons and sorcerers'. Berlioz himself went back to Goethe's *Faust* epic, the 'marvellous book' which he discovered in 1827, in Nerval's translation, for his dramatic legend *La Damnation de Faust* (1846), based on his own *Huit Scènes de Faust* of 1828. And if the uninhibited abandon of the final Witches' Sabbath in the *Symphonie fantastique* (1830) reflects Hugo's *Ronde du Sabbat* and shares perhaps that poet's admiration for the gargoyles of Notre Dame, the appearance at the height of Berlioz's revels of the *idée fixe* representing the artist's beloved recalls Goethe's vision of Gretchen. This scene formed one of the *Faust* illustrations of Delacroix (1828), together with the airborne gargoyle of a Mephistopheles, Faust's adversary, above the city churches (Fig. 58). Shelley too revelled in Goethe's masterpiece (admiring his atheism) and translated the Walpurgis night scene on the Brocken.

LEGEND AND FAIRY-TALE

Demand also remained high for other stories of the supernatural. The legend of Tam O'Shanter, carried by Scottish oral tradition and telling of a drunken farmer who mocked a witches' sabbath and was chased by them almost to perdition, became internationally famous through Burns's poem (1791). The old German tale of Peter Schlemihl, who sold his shadow to the Devil in exchange for a magic purse from which he could extract gold pieces, became a widely-read novel (by Chamisso, 1814). Stories of phantom ships were turned into plays and novels: the legend of the Flying Dutchman appeared in an article in *Blackwood's Magazine* (May 1821), and a reference to it in De Quincey's first paper 'On Murder' (1827) suggests that it was well-known. Heine in 1834 and Captain Marryat in 1839 also wrote about the Dutchman: Wagner's opera was performed in 1843.[5]

A sea-voyage which changed the whole mental outlook of the main character underpinned the great poem by Coleridge, *The Rime of the Ancient Mariner* (1798, revised 1816). Included in 1798 in the *Lyrical Ballads*, in which he collaborated with Wordsworth, this generated its own unique intensity. A

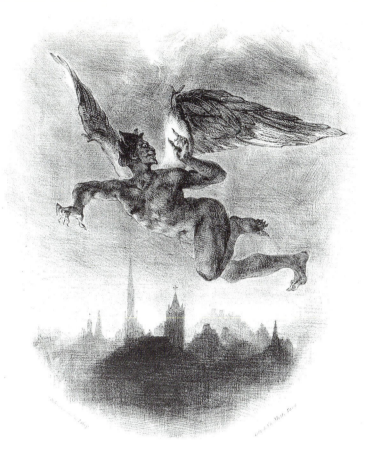

Figure 58: Eugène Delacroix (1798–1863). 'Mephistopheles Hovering Over the City' from French edn of Goethe's *Faust*, 1828, opposite p. 15. Lithograph, print area approx. 26.7 × 22 cm. British Library (1875 b9).

To the French writer Chateaubriand (*Génie du Christianisme*, 1802) Gothic churches conveyed the thrill of the Divine and the spirit of 'l'ancienne France'. In Britain Pugin was later to use a skyline illustration of medieval churches (in his book *Contrasts*, 1841 edn) to uphold his own vision of Christian unity. Delacroix's Paris skyline was meanwhile crossed by the disruptive image of Mephistopheles, from Goethe's famous epic. Delacroix uses the subtle expansiveness of the vignette, fading into the page, and the resources of lithographic chalk to create an effect of light apparently reflected upwards from the churches. The contrast with the dark contortions of Mephistopheles makes this one of the most arresting graphic images of the Romantic era.

neighbour's dream of a skeleton ship provided an initial idea: onto this was hung the story of the Mariner's fatal shooting near the South Pole of an albatross, bird of good omen, with the resulting deaths of the ship's crew after the visitation of the nightmare figures of Death and Life-in-Death. Before the

Mariner's final realization that man's duty is to love and sustain all of God's creation, the intrusion of Death's skeleton ship between him and the Sun (the source of divine energy) had provided a marvellous image of separation:

> And straight the Sun was flecked with bars,
> (Heaven's Mother send us grace!)
> As if through a dungeon-grate he peered
> With broad and burning face.

The Mariner was on his own: and the reader was made to feel it. In 1801 Lamb, borrowing an image from the ancient morris dance, confessed that the poem's early version 'dragged me along like Tom Piper's magic whistle'.

The drawing-power of the supernatural was at its strongest in themes of love, which were to shape some of the quintessential Romantic achievements. The sensuous dreams of Keats, his charmed vision in *Ode to a Nightingale* (1819) of 'perilous seas, in faery-lands forlorn' produced his *Lamia* (1820), with its seduction of the youth Lycius by a beautiful witch, and *La Belle Dame sans Merci* (1820):

> 'I saw pale kings and princes too,
> Pale warriors, death-pale were they all;
> Who cried – 'La Belle Dame sans Merci
> Hath thee in thrall!'

Heine's *Buch der Lieder* (1827) contained his poem on the Lorelei, luring the Rhine boatman onto her rock. In music the seventeen-year-old Mendelssohn, already inspired by fairy plays to write the brilliant Scherzo of his Octet, composed his *Midsummer Night's Dream* overture (1826), a sonata-form masterpiece which enclosed, with four wind chords at beginning and end, the essence of Shakespeare's love-enchanted wood.

Mendelssohn's overture marked the arrival of Shakespeare in the modern concert hall. While the brooding supernatural elements in *Macbeth* and *Hamlet* continued to reinforce melodrama and the Gothic novel, it was Shakespeare's fleeting spirit-world which touched off the true original in Mendelssohn. For Berlioz too, drawn as he was to *Lear* and *Hamlet*, insight into Shakespeare's fairy world produced the shimmering Scherzo of his *Romeo and Juliet* Symphony (1839), depicting Queen Mab, 'the fairies' midwife', and inducer of dreams. There was also the magic island setting and dream-imagery of *The Tempest*, which attracted the Shakespeare scholar August Wilhelm Schlegel, as well as Coleridge and Hazlitt. For Ludwig Tieck, novelist and playwright of the supernatural, who appended an essay on 'Shakespeare's Treatment of the Marvellous' to his translation of *The Tempest* in 1796, this play presented the 'most admirable illusion'.[6] Again it was Berlioz, in the magical chorus of spirits in his fantasy *The Tempest* (1832), who captured this for the concert hall.

The appearance in 1807 of Charles and Mary Lamb's *Tales from Shakespear* (eleven editions by 1831) pointed to another important market that had

grown up in the previous century: that of books for children. Moralists had long opposed 'imaginative' literature for the young: but Gulliver's account of his Travels, with their fanciful topsyturvydom, and Crusoe's of his life on a desert island – though both were originally published for adult readers – made an obvious appeal to all ages. Rousseau's endorsement of *Crusoe* in his book on education *Emile* (1762) did not run to fairy-tales. But the *Arabian Nights* stories, available in Galland's French translation (1704–17) partly rendered also into English, were sweeping Western Europe in editions and formats designed for the nursery as well as the library. The famous *Contes* of Charles Perrault (1628–1703), published in 1697, appeared in English in 1729 as *Histories, or Tales of Past Times, told by Mother Goose*. After 1800, children's books entered a golden age, and with them the literature of the supernatural. The collection of 900 poems – ballads, nursery-rhymes, nonsense verse, marching songs – known as *Des Knaben Wunderhorn* (*The Boy's Magic Horn of Plenty*, compiled by Arnim and Brentano, 1805–8) included the old legend of the Pied Piper of Hamelin, long known in English as well as German. The story of a town's ingratitude to the Piper for ridding it of rats, and his subsequent abduction of the local children, had its moral: but it was the enchantment that struck home. The boy Robert Browning heard the tale from his father: in 1845 he wrote his own poem based on it for the son of the actor Macready, and subtitled it 'A Child's Story'.

The imaginative life of children was unforgettably distilled by Schumann in his *Kinderszenen* (*Scenes from Childhood*, 1838) for piano. The fairy-tale – in German, *Märchen* – offered one of the purest strains of that life, and Schumann and his contemporaries made full use of it. Such tales had, in fact, a long history in adult literature, notably the French romance. From this background came the serpent-tailed fountain-sylph Melusine (Melusina), whose entanglement with a human husband fascinated Goethe sufficiently for her to be included in one of the interludes in *Wilhelm Meister*, and who prompted Mendelssohn to invent a fountain-like theme in the overture named after her. From Perrault's collection came subjects which Ludwig Tieck realized for the German stage: Bluebeard (*Ritter Blaubart*, 1797); Red Riding-Hood (*Rotkäppchen*, 1800) and Hop-o'-my-Thumb (*Däumchen*, 1811). In Germany itself, folklorists were discovering rich native material. Apart from the *Wunderhorn*, there was the landmark collection *Kinder- und Hausmärchen* (1812–15), made by the brothers Grimm, and translated into English in 1823 as *German Popular Stories*, with superb illustrations by George Cruikshank (Fig. 59). The taste for short stories (*Novellen*) in Germany after 1815 – often published in popular almanacs – gave openings for major writers such as Eichendorff (1788–1853) to add to the *Märchen* heritage.[7]

There were widely-varying reasons for the fascination of fairy-stories. In the post-Rousseau era it was felt by many, including Coleridge, that their conceptual lessons made them a valuable part of the child's experience. As childhood was being seen by Wordsworth, Schiller (in his essay *On naive and reflective Poetry*, 1795–96), and others, as the stage of human life that by virtue of its closeness to man's imaginative roots had much to teach adults (children

Figure 59: George Cruikshank (1792–1878). Scene from 'Jorinde and Joringel', from *German Popular Stories*, translation from the Brothers Grimm (1823), opposite p. 80. Etching, print area approx. 11 × 10 cm. British Library (12410 dd 13).

The English edition of Grimm, the first to be fully illustrated, found a place in many a nursery. Cruikshank brought a sympathy to the stories which impressed the Grimm brothers themselves. This illustration is to a story involving the hero's search for a sister whom a witch has transformed into a caged bird. Besides his characteristic emphasis on vertical forms (door, chair-back, bird-cages), Cruikshank has cleverly exploited line as a meshing device, above all in the fan-vault which, most aptly, spreads like a spider's web over the scene below.

'*are* what we *were*', Schiller wrote), the Grimm brothers' painstakingly-prepared examination of those roots was bound to attract notice. But so also could the timeless fantasies of puppet-masters and actors of the *commedia dell'arte* be turned to contemporary account. Not only could the fantastic fairy-stories of Carlo Gozzi (1720–1806), the playwright of Venice (p. 77), provide the Ger-

mans with opera plots, including Himmel's *Die Sylphen* (1806) and Wagner's early *Die Feen* (*The Fairies*, 1833–34). A sophisticated fusion of dramatic traditions with the literary line coming down from Perrault could also be made to produce surprising twists. In his stage realizations of the old French stories, Tieck used the plots as parody, to deride the contemporary German stage and to tilt at Enlightenment rationality. His version of *Puss-in-Boots* invited the audience to take part in the action. In such ways experimental theatre was set to influence the regard for irony which Friedrich Schlegel had been recommending in his critical writings.[8]

Fantasy, therefore, drawing alike on indigenous, primitive roots and on cultivated blooms gathered from later European traditions, found ample conditions for development in Germany around 1800. Its presence was formidable in the country where an inbuilt penchant for the supernatural could embrace the European heritage of the marvellous from France (Perrault), Italy (Gozzi), and England (Shakespeare's *Midsummer Night's Dream* and *Tempest*), and still remain unmistakably German. The irregular runs and rhythms of Schumann's piano miniature 'Prophet Bird' (from *Forest Scenes*, 1849) reflected back almost as much as they foretold.

Fantasy was to be led to new extremes of the unexpected and the various by one of the crucial figures of Romanticism, Ernst Theodor Amadeus Hoffmann (1776–1822). His remarkable short stories of the supernatural will need more comment when we discuss his fascination with the splitting of personality (p. 00). But he was also a composer of substantial music, for him the supreme art. His opera *Undine* (1816), based on a romance by Friedrich de la Motte Fouqué (1777–1843), took up the pervasive Melusina-like theme of the love of a water-spirit for a mortal. Undine receives a soul upon marrying him: but he is unfaithful, and at the end Undine rises from a well and kisses him, fatally. It was a powerful mingling of the real and the fantastic, and Hoffmann was more than a match for it. Some of his best music depicts the sounds of nature, notably Undine's watery world: we have the feeling that the supernatural element actually grows out of the natural. It was an effect which Weber, in the Wolf's Glen scene in *Der Freischütz* (1821), would develop, and which Schubert, with his slimmer resources of voice and piano, also achieved in the 'Erlking'.

The Exotic

From the heritage of European myth and fairy-tale the Romantic imagination could launch its many exploits of pursuit, capture and loss. Schubert's 'Erlking' unerringly tapped the ancient fears of northern forest peoples. But what of his extraordinary song 'Memnon', written in 1817 to a poem by his Viennese friend Johann Mayrhofer (1787–1836)? This depicted the imagined feelings of a stone statue in a totally different terrain – the open desert adjoining the Nile outside Thebes in Egypt – as it faced eastwards towards the sunrise.

The 'Erlking' presented the menace of pursuit and of surroundings that closed round the human protagonists. 'Memnon', by contrast, affords the static image of a hollow colossus that, resonating at the moment that the sun's first

morning rays strike it, aspires to be free of all earthly concerns. From the story of Memnon, son of the Dawn goddess and an Ethiopian prince who had fought heroically in the Trojan War, Mayrhofer develops his account of a loneliness endured on the desert expanses, and of a personality imprisoned within itself until the sun, once every morning, gives it a chance to 'speak'. And also to sing: for, from these promptings, Schubert constructs one of his most moving sound-sequences, in the course of which the key-signature shifts from D flat to the warmer A flat, and finally to a radiant F major as the sun's rays, conveyed by triplets on the piano, meet the yearning in the statue's heart.

The Memnon colossus, one of two of about 1400 BC, still overlooks the Theban Plain: its link with spontaneous music was well-known in the eighteenth century, being mentioned in Akenside's *Pleasures of Imagination* (1744), and Erasmus Darwin's *Botanic Garden* (1791).[9] The Romantic preoccupation with imprisonment and its contrast with freedom gave it fresh currency: but Mayrhofer's poem was no routine statement of this. The work of a poet who at 49 achieved his own release from public neglect by his own hand, the words of Memnon, 'clutched at by the arms of death, snakes writhing in the depths of my heart', had a prophetic ring. In another, unexpected way, the story of Eastern light easing the spirit free of the sculptural mass – which Schubert expressed so vividly with the animating triplet-chords of the final verse – almost becomes a parable of what was actually taking place as more and more artists looked to Asia and to North Africa, away from a Europe emerging from the drag of the Napoleonic Wars and their disillusioning aftermath. Mayrhofer's involvement with the Orient went no further, and Schubert's only to the extent of his settings of poems by the orientalist Friedrich Rückert. But the orientalism of Byron and Delacroix was, like Rückert's, to be lasting.

For centuries a vaguely-understood Orient had affected Europe in ways that were both positive and ambivalent. Eastern artefacts – especially Chinese silks and porcelains, and Islamic carpets – had offered the West revelations of an excellence in particular fields of design and craftsmanship which was recognized as amounting to supremacy. But as Europe's own restless needs impelled it to turn what it imagined the Orient to be like to its own account, rich veins of fantasizing opened up. In Rococo Europe an imagined China was recreated in the forms of chinoiserie, which broke irrepressibly from all classical restraints. Imitations of blue-and-white 'china' occupied the tea-table (Fig. 21). From the 1760s, as British power was established in India, a serious study of Indian art, in both its Islamic (Mughal) and Hindu forms, developed among Europeans.[10] But the fanciful 'Indian Mughal' exterior of John Nash's Brighton Pavilion (1815–22), described at the time as 'Hindoo' and clapped onto Chinese effects inside, showed that the taste for Rococo extravaganza was far from dead. Nonetheless, as increased trade and the need for better communications with India made Western visitors aware of the scale of the Asian desert (the Suez Canal opened as late as 1869), two important Romantic interests – the freedom of the imagination and the uniqueness of the individual response – were met by landscapes and monuments which had power to suggest virtually unlimited expanses of space and time.

THE MYSTERY OF EGYPT

That the sculpture of these Asian lands had a particular inspirational quality is clear from Shelley's familiar sonnet *Ozymandias* (1818). This imagines a stone colossus in the desert, of a once-great tyrant, now shattered ('Round the decay of that colossal wreck, boundless and bare/The lone and level sands stretch far away'). Shelley had never seen Egypt: but he may have been respond-ing to press reports of a giant head of Rameses II, then known as the 'young Memnon', that had recently reached the British Museum from Thebes. This stone head – which Haydon called the 'wonder of travellers' – was given full coverage in the quarterly *Annals of the Fine Arts* (1818–19): De Quincey saw in it a smile 'co-extensive with all time and all space . . . the most diffusive and pathetically divine that the hand of man has created'.[11] Keats, who had been impressed by the Elgin Marbles from Athens at the British Museum in 1817, saw the Egyptian sculpture there two years later: he seems to refer to the giant head in *Hyperion*, and also (ii, 371–7) to the musical stone colossus of Memnon (in the 'dusking East'), which, as Ian Jack explained in *Keats and the Mirror of Art* (1967), he will have known from several sources, among them his friend Leigh Hunt.[12]

Eighteenth-century antiquarian interest in Egyptian artefacts was part of a wider concern with the contribution that Egypt was assumed to have made to the classical civilizations of Greece and Rome. Piranesi put Egyptian motifs to use in inventive designs for fireplaces and other interior features, and Wedgwood marketed 'Egyptian' wares. Egypt's role in the Bible was also relevant: Turner's Plagues of Egypt paintings, about 1800, included the token pyramid that made this connexion (Fig. 8). Napoleon's Egyptian campaign of 1798 had initiated a large-scale French archaeological survey that was detailed in *Voyage dans la Basse et la Haute Egypte* (1802) by Vivant Denon, and the vast *Descrip-tion de l'Egypte* (24 volumes, including 930 engravings, 1809–28). Denon's archaeological zeal, if not his imagination, matched Piranesi's: he provided close-up detail which was to be invaluable for European designers – and painters (Plate VIII) – using the Egyptian style. John Martin's popular paintings of ancient Egyptian subjects invested them with archaeological fact as well as fantasy.

The final deciphering of hieroglyphics in the early 1820s, further expedi-tions to ancient sites (by Robert Hay, 1824–28, Baron Karl von Hügel, 1831, and Richard Lepsius, 1842), together with the archaeologist J.G. Wilkinson's popular book *Manners and Customs of the Ancient Egyptians* (1837), detail-ing domestic life, continued to ensure that what had been a remote civilization, enveloped for centuries in the mystical speculations of philosophers and the-ologians, now gave up important secrets. When Benjamin Disraeli (1804–81) visited Egypt in 1831, he was able to remark that Wilkinson 'can read you the side of an obelisk or the front of a pylon as we would the last number of the *Quarterly*'.[13] Just as with Tutankhamun a century later, however, the central mystery was not dispelled. Schinkel, designer of the *Zauberflöte* sets for Berlin in 1815 – including a well-researched Temple of the Sun with a statue of Osiris

silhouetted against the solar disc – seems to have sensed the power of this style to enhance Mozart's operatic fable, and perpetuate its own.

In important ways this mythic power of Egyptian style gained from what made it different from its Greek counterpart. However emotively Greek figure sculpture was now regarded, its reputation for masterfully-controlled naturalism was still inseparable from its fame. The Elgin Marbles were demanding from Haydon in 1808 drawing sessions of ten, fourteen and fifteen hours at a time, in a bid to understand the selection process that had gone into making the poses so memorable. Egyptian sculpture, by contrast, was wide open to the imagination, urging it to penetrate to what, Memnon-like, the work's inner life was holding back. Was it the afterlife? Confirming the interest of French Neo-classical designers of the 1780s in the Pyramids, Egyptian effects seemed ideally suitable for tombs in cemeteries such as Père Lachaise, Paris (1804) and Highgate, London (from 1839). Or they might offer a lifeline back to a nature-orientated civilization which grew flax, and so connect with the business of textile-making in the 1840s in industrial Leeds, where a mill with an Egyptian-style façade opened in 1842.[14]

Of all the mysteries associated with Egypt for the Romantic generation, the most elusive, perhaps, was the character of Shakespeare's Cleopatra. 'Age cannot wither her, nor custom stale/Her infinite variety'. Quoting these lines, Hazlitt saw in her make-up 'the triumph of the voluptuous, of the love of pleasure and the power of giving it'. Mrs Jameson in 1832 noted how in the Egyptian Queen a hundred qualities 'mingle into each other, and shift, and change, and, glance away, like the colours in a peacock's train'.[15] After Antony's death, Shakespeare confronts her with the lascivious but prosaic clown bringing the asp which she is to use to kill herself. Delacroix made a moving picture of the contrast (Plate VIII).

THE MUSLIM WORLD

Neither Byron nor Delacroix saw Egypt or the Nile. Both, however, found the Orient that they did see impossible to forget. Byron's visit to the Levant (1809–11) celebrated a temporary escape from Europe, and he set characteristic works there, including the best-seller about a Christian operating in the Muslim society of Greece, the poem that he called *The Giaour* (1813: how was it pronounced? asked Austen's character Captain Benwick). Delacroix's visit to Morocco in 1832 recharged a passion for oriental subjects which had previously (in 1827) led him to paint, with extravagant force, the satrap hero of Byron's tragedy *Sardanapalus* (1821), sacrificing his concubines, horses and jewels before destroying himself. While the relish for a rhetorical subject never left Delacroix, the first-hand lessons of Arab traditions in Morocco and the colour that surrounded them were also to be with him for the rest of his life.[16]

The deep-running continuities of a living Islam on Europe's edges, in fact, became ever more attractive as Europeans organized expeditions or took up residence, either as officials or as private individuals, in the lands where its lifestyles held sway. Edward Lane, who lived as an Arab in Egypt from 1825,

wrote the definitive book *Manners and Customs of the Modern Egyptians* (1836, in its fifth edition in 1871). The experience enabled his new translation of the *Arabian Nights* (1839–41) to reflect the fact that, however fantastic the overall story-lines of these tales, with their legendary settings in the Baghdad of Haroun-al-Rashid, they were grounded in Muslim traditions that were still observable in post-Napoleonic Cairo. Lane's translation understandably became one of the most popular of Victorian books.

In Moorish Spain, too, the haunted reputation of the Alhambra, Granada, seen by Hugo in his poem-cycle *Les Orientales* (1829) as a palace 'gilded by genies like a dream', was, if anything, enriched by the first-hand analytical study of its fourteenth-century courtyards and reception halls, which now took place. The architect Owen Jones prefaced his massive, exhaustively-researched book *Plans, Elevations and Sections of the Alhambra* (1842–45), detailing the ordered patterns of the Moors, with the evocative Hugo passage from *Les Orientales*. The American Washington Irving, quartered in the building in 1829, recounted its legends and looked down on the city life below as though from a minaret or a flying carpet. His book *The Alhambra* (1832, numerous English, Spanish, and American editions) was complemented by the many atmospheric views made by visiting artists.

By 1850, with Irving, Owen Jones and the painters, the power of the exotic to excite the imagination had entered another phase. Alhambra-worship had helped to draw attention away from the Egypt of the Memnon colossus, if not from classical Greece. Sculpture had given ground to painting and colour, in which Romantic taste for excess – or for an alternative order based on colour and coloured surface – could be inventively developed.

In another sense, Memnon had moved into the light, as the closing triplets in Schubert's song had forecast it would.

The Ghostly Double

In a striking song of 1828, the last year of his life, Schubert set Heine's poem *Der Doppelgänger*, 'The Ghostly Double'. It is night, the singer stands in front of the house where his lover once lived. Another figure is there wringing its hands in pain. It is himself. The song has been described as 'lyrical declamation': with its four-note theme it achieves an extraordinary solemnity, and inevitably some have seen a premonitory element personal to Schubert in it.

Interest in personal identity, and the Hamlet-like strains imposed on it by divided courses of action, predisposed the nineteenth-century Romantics to develop the idea of the *Doppelgänger*. But self-examination in the eighteenth century had played its own very considerable part. A species of *alter ego* had surfaced in the work of that ever-surprising figure, Diderot. In the dialogue *Le Neveu de Rameau* (*Rameau's Nephew*, begun 1761, first published 1821 in a French retranslation from the German) we meet two characters, the nephew, referred to as *Lui*, and Diderot himself, *Moi*. The nephew is materialistic, cynical, nihilist, fatalist; Diderot defends moral purpose, the goodness and

sociability of man and the need for free choice. It is a balanced Enlightenment exercise, though full of moral question-marks and ending, in this case, without conclusions being reached. Since Freud, the question as to whether Diderot was debating two sides of his own character has been asked (Trilling suggested that *Lui* was Freud's *id* and *Moi* his *ego*).[17] What seems certain is that the dialogue is to be read as a critique of a society from which the nephew appears to have opted out or – as Hegel maintained – become voluntarily alienated, as a being solely motivated by selfish wishes.

In Jean-Jacques Rousseau, as we saw, the results of self-examination were to be exposed more directly. In one of his works, indeed, he split himself into two in order to do it. The private writer of the *Confessions*, his autobiography, produced *Rousseau juge de Jean-Jacques* (published posthumously in 1780), in which he wrote objectively about the experience of 'Jean-Jacques': in public places 'Everyone surrounds him and stares at him'; but all keep their distance.[18]

While the contrast suggested by Diderot's *Neveu de Rameau*, between living responsibly within society and living 'irresponsibly' off it, identified one of the fundamental problems of modern, highly-organized Western societies, Rousseau's dilemma of separation from one's fellows – voluntary or enforced – identified one of the fundamental problems of the modern artist. Byron was sensitive to all the issues: drawn back to the Enlightenment, possessing a strong sense of public duty and longing to play a full part in the politics of Britain, yet obliged by the complexities and contradictions of his character and love-affairs to go into exile; and to see himself as an artist 'born for opposition' to 'cant political, cant poetical, and cant moral'. After 1816 he wandered Europe, pausing to identify with historical figures whom he felt drawn to: Rousseau, beside Lake Leman; Tasso in his cell at Ferrara; Dante prophesying woe to the Florence which had banished him. And yet in important ways Byron remained his own man. His Prisoner of Chillon climbs to his high cell window in a moving attempt to see the mountains:

> I made a footing in the wall,
> > It was not therefrom to escape,
> For I had buried one and all,
> > Who loved me in a human shape.
> > > (*The Prisoner of Chillon*, 1816, lines 318–21)

As McGann (p. 154) and others have shown, Byron's final success in translating his feelings of isolation into a bid to support Greek freedom was possible because he never lost a belief in the value of defiant action. The vigour and realism of this conviction preserved a human shape which was both unitary and complete. Long-distance swimming in Greek waters confirmed it.

The contrast between success and failure in the life of the individual, and between acceptance and rejection in the eyes of the world, had become an absorbing topic by the late eighteenth century, when the variables of 'genius' and 'feeling' were in play. In fictional plots such contrasts could be indicated by two symmetrically-juxtaposed characters, perhaps related by blood, as in

Les deux Cousins (1790), by Sénac de Meilhan (1736–1803). In this study – made more objective for a Western audience by being given an oriental setting – one cousin, Aladin, has natural 'genius' and sensitivity, but is a 'failure' in public; the other, Salem, is an unimaginative materialist who receives worldly acclaim. Sade, on the other hand, tore symmetry as well as received morality asunder by writing separate novels about two sisters, *Justine* (two volumes, 1791), designed to show the failure of a life of virtue, and *Juliette* (combined with *Justine* in a work finally swelling to ten volumes, 1797), describing the success of a life of vice.

In real life genius, sensitivity, personal fulfilment and ability to woo a discerning public could, nevertheless, work together, as we noticed in the persona of Paganini (p. 179), doubled with the Devil. Victor Hugo sustained a long career – which survived changes of fashion and seemed endless to some contemporaries – cultivating a private/public self that he called 'Olympio'; so that it came to be widely accepted that there was Hugo the literary personality as well as Hugo the man. Balzac called him 'a great writer and a little joker'.[19] Hoffmann, government official and from 1808 Kapellmeister at Bamberg, became almost interchangeable with his self-publicized *alter ego*, the musician Kreisler.

Part of the attraction of the *alter ego* to writers of novels and plays, on either side of 1800, lay in the dramatic possibilities of active conflict between the halves of the divided self. The Germans of *Sturm und Drang* were alive to this: in the play *Die Zwillinge* (*The Twins*, 1775), by Friedrich Maximilian von Klinger (1752–1831), a weak elder brother is murdered by his stronger twin: the mirror scene (Fig. 60) rehearses the horror of the event. Schiller's play *Die Räuber* (1781) follows the destinies of two brothers who are mirror-images of each other, the 'noble' hero Karl Moor and the criminally-minded Franz. A century later, this play's presentation of the central problem of good and evil growing from a common root of personality was still the obvious reference point for Dostoevsky's Fyodor Karamazov as he reflected on his sons.[20]

While nineteenth-century writers of 'realistic' fiction, for example Dickens (in a character such as Jonas Chuzzlewit and later the mirror-imaging of Sydney Carton and Charles Darnay in *A Tale of Two Cities*), showed more than passing interest in the double, the German Romantics found its potential for fantasy – of all complexions, light as well as dark – indispensable. Schumann's favourite modern novelist, Jean Paul (Jean Paul Richter, 1763–1825), had the habit of introducing himself into his novels as two characters whose names might verge on pun, as in Vult and Walt Harnisch in *Flegeljahre* (*Salad Days*, 1802–5). In *Titan* (1800–3), Jean Paul probed the relationship between an actor and his parts: how far could they take him over? The masked balls of his stories brought the eighteenth-century masquerade, with its art of disguise (p. 83), to the point of imaginative propinquity at which disguise might conceal a character's own double. Schumann, who loved ciphers and disguises, drew on the *Flegeljahre* for his piano pieces entitled *Papillons* (*Butterflies*, 1829–31), and in *Carnaval* (1834–35), another sparkling piano work, mirrored the identities which wound into and out of a carnival procession. Two movements depicted

what he saw as the contrasting halves of his own nature: the impulsive 'Florestan' and the reflective 'Eusebius'. E.T.A. Hoffmann (1776–1822), taking Jean Paul's play with personality to its ultimate in his story *Prinzessin Brambilla* (1820), made the actor Giglio carry over into real life a second identity imagined on the far side of the footlights.[21]

Schumann's set of eight piano fantasies, *Kreisleriana* (1838), refers back to Kreisler, Hoffmann's self-projected double. Explaining this to a friend, Schumann remarked that only Germans would understand his title. There was truth in this: but Hoffmann's own collection of short stories, *Fantasiestücke* (1814–15), which introduced Kreisler, was soon part of the international currency of Romanticism, attracting non-Germans as diverse as Gogol and Balzac (pp. 243–4). Devotee of Mozart but also perceptive campaigner for the new music of Beethoven, Hoffmann created in Kreisler a symbol of the artist at odds with authority. Kreisler's planned autobiography forms part of a last, unfinished novel, *Lebensansichten des Katers Murr* (*Murr the Tom-Cat's Philosophy of Life, together with a Fragmentary Biography of Kapellmeister Johannes Kreisler on Odd Sheets of Waste Paper*, 1821). Murr, the literate cat, has written his own life-history on the backs of Kreisler's sheets, which he has found on his desk and which are now in the wrong order. Hoffmann writes a preface as editor explaining why episodes of the two life-stories are mixed: and it emerges that Murr is a Philistine – though he signs himself 'man of letters' – while Kreisler is an unhappy and frustrated creative spirit who has been obliged to build defences against the world.

SPLIT PERSONALITIES: GOOD AGAINST EVIL

While Hoffmann's mastery of veiled irony (much of it expressed through Kreisler) made a special appeal to German speakers inured, like Schumann, to Jean Paul, his ability to convey the darkness of a character's 'second self' to an international readership was also formidable. Once the monk Medardus, in the novel *Die Elixiere des Teufels* (*The Devil's Elixirs*, 1815), has drunk the elixir and apparently caused the death of a man who so curiously resembles him, he cannot avoid being 'taken over'. To the self-absorbed Parisian goldsmith Cardillac, in the chilling story *Das Fräulein von Scuderi* (1819), it is imperative that he should murder the people who buy his work. An English version

Figure 60: Illustration to Act IV, scene 5 in Friedrich von Klinger's play *Die Zwillinge* (*The Twins*). Vienna 1791. Engraving by I. Albrecht. Bildarchiv Oesterreichische Nationalbibliothek, Vienna.

The mirror had a long history as a motif in medieval and Renaissance literature and art. Its particular ambiguities – passively reflecting a person looking into it and yet also actively representing a distinct image which was untouchable (beyond the glass) and therefore 'removed' – made it an apt means of suggesting an identity divided against itself. In Klinger's play the stronger twin, shown here, murders the weaker.

of *Die Elixiere* was published in *Blackwood's Magazine* in 1824, the year in which the Scottish writer James Hogg (1770–1835) revealed his own power-ful response to the motif of the criminal *Doppelgänger* in the novel *Confessions of a Justified Sinner*.[22] Hoffmann proved the most resourceful exponent of the split personality before Poe, and Stevenson's Jekyll and Hyde of the 1880s.

It is easy to link part of the fascination of the double with the vogue for Gothic terror expressed in fiction, and also in the kind of popular melodrama which, in the hands of the prolific writer for the Paris theatre, Pixérécourt, so expertly pitched hero against villain.[23] In Gothic fiction the vampire of Transyl-vanian legend was showing its unsurpassed power to shock. Polidori's novel *The Vampyre* (1819), developed from a sketch by his friend Byron, went into *melodrame* form in Paris soon after publication, and afforded the basic plot of Marschner's opera *Der Vampyr* (1828).[24] But the literally one-to-one nature of the double tapped more subtle fears and, as handled by the German Romantics, went well beyond the limits of Gothic fiction and boulevard theatre. Two con-trasting sources of ancient fear gave it special power. One was the mandrake, the animated man-root that was divisible into two; unearthed afresh by the Grimm brothers in their folklore researches, it came into contemporary stories by Arnim (*Isabella von Ägypten*) and Hoffmann (*Klein Zaches*). The other source was the mechanically-constructed automaton, then enjoying renewed popularity in exhibitions, including one at Dresden in 1813, which Hoffmann saw. His story *Die Automate* and the more effective *Der Sandmann* (1816), with its 'human' doll (included in Offenbach's later opera), were the result. Reminding man of his own disturbing skills, the man-made creature that might break away from its maker, and act in defiance of him, was to have a long future; and already, with Frankenstein's monster, it was at large.

CREATED DOUBLES: MONSTERS AND AUTOMATA

The *Doppelgänger* was plainly of the male gender, but it was a woman who created its next conceptual breakaway. This was Mary Shelley's *Frankenstein*. In 1814 Mary had eloped with the poet Shelley, whom she later married. In the wet summer of 1816, with Byron and Shelley in the Villa Diodati, on Lake Geneva, she read German ghost stories and joined in the game of writing new ones, which produced Polidori's *Vampyre*. Her contribution was *Frankenstein, or The Modern Prometheus* (1818). The moribund, often conventional Gothic novel acquired instant new life: the book became a bestseller and several stage adaptations followed. The plot had catastrophic simplicity. Frankenstein, a Genevan scientist, discovers how to create the semblance of another human being from inanimate matter. But it is monster-like and, though it learns lan-guage, unwittingly terrifies everyone it meets. Rejected and miserable, it pur-sues its creator to ask for a companion it can love. When Frankenstein shrinks from this, it murders the scientist's bride. It is Frankenstein's turn to pursue it – to the Arctic wastes – in order to destroy it. But the scientist dies of exhaus-tion, and it vanishes into the distance, intent on its own destruction.

Frankenstein's monster is, therefore, more than an 'imitating' automaton. It has the will to follow its own independent life, but is thwarted by its own sense of incompleteness. Only the deaths of creator and created can end that. The subtitle reminds us of Prometheus: of the rebellious Titan who stole fire from the gods. Here, the scientist has rebelled against nature and invented his own form of life to be 'cast among mankind'. The monster rebels against the circumstances which, once it has been thus cast, prevent it finding companionship. Muriel Spark draws attention, however, to the importance of *or* in the title. Each half of the creator/monster equation contains Frankenstein: as well as the Promethean aspect.[25] And this particular *Doppelgänger* relationship, it might be said, is enlivened at every turn of the story by the changing anything-might-happen nature of its reciprocity. Mary Shelley's account of her initial dream, with its emphasis on 'eyes' and 'opening', foretold this. The 'pale student of unhallowed art' awakes from uneasy sleep: he opens his eyes, 'behold the horrid thing stands at his bedside, opening his curtains and looking on him with yellow, watery but speculative eyes'.

Though Frankenstein's monster is so endowed with explicable human responses as to become the ready object of the reader's sympathy, its origins in a scientist's laboratory carry a clear foretaste of modern man as machine; and it had progeny which were closer to the automaton. Heinrich Heine (1797–1856), as Prawer has shown, based an amusing fable, derived from his English experiences in 1827, on the Frankenstein story.[26] Observing the growing pace of industrialization in Britain, and reflecting on its probable effect on the quality of life, Heine described a machine-man made by one of the evidently ingenious English artificers. This, he discovered, made grating sounds that were just like the speech of an English gentleman. But though its parts performed their motions perfectly, it wanted a soul, and asked its maker for one. The inventor fled, but (another reference to *Frankenstein*) was pursued abroad by his creation.

The ironic point was well made. As cities reached to the horizon and industry set the pace of working life, Elizabeth Gaskell (1810–65) noted that class divisions became more marked. In her novel *Mary Barton* (1848) she analysed the differences between mill-owner and mill-worker. Class confrontations and financial failures make this one of the major periods of emigration and separation from family and friends. For those left in the tight, thrusting world of the English manufacturing towns, the close proximity of the workers to repetitive work brings its own problems. It is Heine again who remarks on this when, in *Ludwig Börne, Eine Denkschrift* (1839), he observes that England is a place where 'machines are like men, and men like machines' (the fears of the German men-and-automata myths are, it seems, being realized).

The even more disturbing psychological fact that the big cities and crowded, impersonal streets of Europe and America enforce a peculiarly intense feeling of isolation, troubles and also excites the imagination of the American Edgar Allan Poe (1809–49). Poe's story 'The Man of the Crowd' (published in 1840) traces twenty-four hours in the life of the narrator as he wanders the crowded streets of Dickens's London, observing the tidal surges of the sea of heads. Exactly half way through the story, Poe's narrator sees an old man in ragged

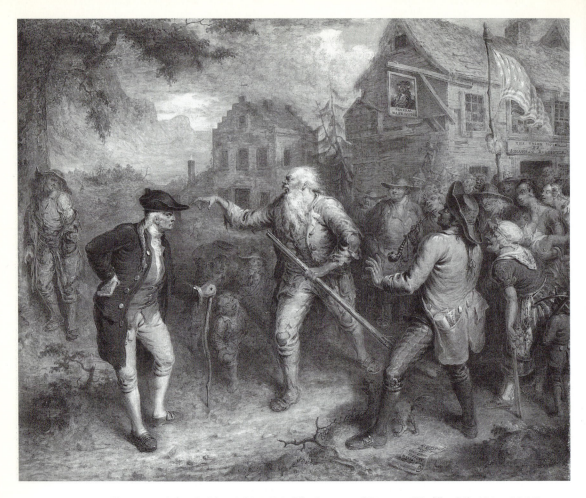

Figure 61: John Quidor (1801–81). *The Return of Rip van Winkle.* Oil, 101 × 126.5 cm. 1829. Andrew W. Mellon Collection, National Gallery of Art, Washington DC.

The theme of a long, enchanted sleep from which a character awoke to find a changed world had precedents from Antiquity (story of Epimenides). After drinking a magic liquor and sleeping for twenty years on a mountain-side in the Catskills, Rip returns to his village, where no-one at first recognizes him, and where, following Independence, George III's likeness on the inn-sign has become that of George Washington (compare Hogarth's attention to factual setting, Plate II). But Quidor, an outstanding fantasizing painter of the new American scene, also shows Rip noticing a figure of himself as he was before his sleep leaning against a tree (left). He later discovers that this is his son; but for the moment he is confounded: 'I'm not myself – I'm somebody else – that's me yonder'.

clothes, whom he feels compelled to follow. It becomes plain that the man cannot stand being alone: he goes on walking with others whom he does not know all night and the next day without stopping for food, and reduces the

Plate V: Thomas Girtin. The White House at Chelsea. *See note p. xvi.*

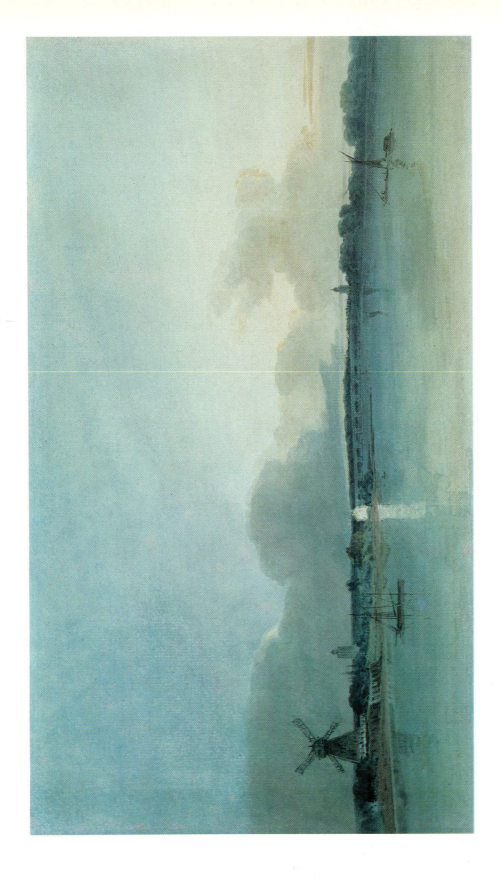

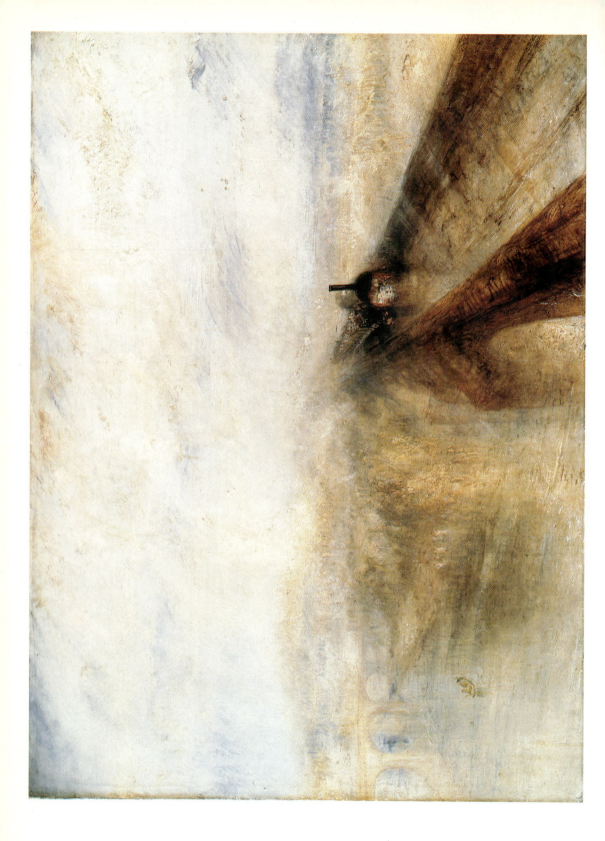

narrator to exhaustion. The old man, it emerges, is in fact the double of Poe's narrator, himself the product of modern city life.[27]

Poe's doubles, which included the notorious William Wilson in the story of that name, came straight out of the European tradition of the *Doppelgänger*. But America's literature had already registered a distinctive variant in Rip van Winkle. This hero of a story of the supernatural in Washington Irving's *Sketch Book* (1819–20) became famous in Europe through the advocacy of Scott and others, and later in a play. As in the Heine poem that attracted Schubert, time-lapse was involved. When Rip returns to his village after a twenty-year sleep he meets his apparent double looking as he had before it (Fig. 61).

Heine's *Doppelgänger* poem and Schubert's personal interpretation of it appeared nearly a decade later. A decade later still, Poe's Man of the Crowd was on the move in an ominously impersonal urban world. Dostoevsky's early story *The Double* (1846) was to take this idea forward. But before coming to it, we must look at larger issues of the irrational.

The Irrational

Between the working careers of Hoffmann (dying in 1822) and Poe (dying in 1849) the interest inherited from the eighteenth century in the irrational, and in the nature of the unhinged mind, became more focused. Schubert presents it in his sombre masterpiece *Die Winterreise* (*Winter Journey*), setting the poems of Wilhelm Müller and published in 1828–29. In the very final song, 'Der Leiermann' (The Hurdy-gurdy Man), the abandoned lover, having wandered in a state of increasing distraction through the winter landscape, meets the old musician, a beggar: he throws in his lot with him and the two go off together. The simplicity of Schubert's two-bar tune, with its plaintive repetitions, strikes to the heart of the situation.

Another distraught country wanderer, Ophelia, had recently taken Paris by storm. In 1827 an English theatre company had played there in *Hamlet* and *Romeo and Juliet*. Charles Kemble had been acclaimed for his Hamlet, and the young Irish actress Harriet Smithson, presenting Ophelia's mad scene, had brought the house down: revealing a 'whole heaven of art' to Berlioz who was in the audience, and who later married her. What is interesting from contemporary accounts is that her performance appeared to be improvised on the spot.[28] Dramatic roles which displayed the tensions of derangement were to find scope in opera in the next few years (p. 104). And the character of Hamlet himself, charged by the ghost of his father to avenge his murder, gripped by introspection and feigning madness, was to become central to the Romantic imagination. In the 1780s Goethe's character Wilhelm Meister, as a young actor, had identified with Hamlet. But in the high Romantic period real-life creative figures were inclined to do so, such as Delacroix, and Berlioz, momentarily, at the funeral in 1854 of his wife who had played Ophelia so unforgettably.

In eighteenth-century Britain, Swift and Cowper had been affected by insanity

Plate VI: J.M.W. Turner. Rain, Steam and Speed. *See note pp. xi–xvii.*

and Johnson threatened by it; as the Romantics came to reflect on the lonely madness of genius, Tasso, the sixteenth-century court-poet of Ferrara, deepened his symbolic appeal. Accused by his Duke of illicit love, Tasso had been left to decline in a lunatic's cell: Delacroix noted that this made him 'incapable of creating', the direst of afflictions for an artist. Already the subject of a recent play (*Torquato Tasso*, 1789) by Goethe – feeling the constrictions of the Weimar court – Tasso became the hero of a *Lament* (1817) by Byron, conscious of 'outrage, calumny and wrong' in his own situation.

The study of nature as source of pantheistic excitement but also of energy, which the influential philosopher Schelling saw as creatively invigorating the artist, was taking fresh stock of the dream and its power to bypass reason. A medical doctor, G.H. von Schubert, wrote in *Ansichten von der Nachtseite der Naturwissenschaft* (*Views on the Dark Side of Natural Science*, 1808) of dreams briefly illuminating the 'dark road' of each individual's buried experience, and praised the painter Friedrich's backward forays along it. Keats's *Ode to a Nightingale* (1819) ended in the fateful question 'Do I wake or sleep?' An important part of the Romantic generation's work in fact, was to turn all experience, including that which formed part of the unconscious, to artistic account. And in this process the freedom accorded to the imagination in matters of art was to benefit from the accepting attitude to mental aberration which developed alongside it.

Already in the eighteenth century recognition of the role of the irrational in human behaviour (p. 214) had begun to erode the traditional explanation of insanity as devil-possession. Foucault has explained how the idea of the rational, responsible member of society (the French *honnête homme*, promoted before 1700, and the Enlightenment man of good sense) had the effect of isolating or literally imprisoning those who failed to fit the norms.[29] 'Religious mania', often exempted from moral stigma, remained a problem, though it might now attract no special pleading: the poet Christopher Smart (1722–71), twice committed to Bedlam, ended up in a debtors' prison. It is true that 'Tom o'Bedlam' vagrants and their continental equivalents, who had wandered the countryside for centuries, would continue to do so.[30] Nonetheless, as 'sensibility' and humanitarian feeling reinforced clinical concern, special asylums were opened by 'mad doctors', who formulated new methods of treatment. There were terrible abuses: legal safeguards to protect inmates were only introduced in Britain in 1774. But even if Rush's Chair, designed by Dr Benjamin Rush of Philadelphia to calm the sufferer, still relied on physical restraint, fundamental shifts of attitude were taking place. The story caught on that, during the French Revolution, the famous doctor Philippe Pinel (1745–1826) removed the manacles from the inmates of the Bicêtre hospital in the belief that freedom of movement, not restraint, was the prerequisite of therapy.

For artists whose unpredictability of behaviour had set them apart there were reassessments, as in the case of Grimou (p. 199). It is possible that Gray's *Elegy written in a Country Churchyard* (1742–50, published 1751) drew part of its success from its apparent celebration of a misfit-poet. The total self-possession of William Blake, misunderstood by the public at large, but strong

in the 'fearful symmetry' of his visions, won him the devotion of a few disciples: you had to know Blake, and follow him. At no time put 'under care', he remained outside the pale of wider recognition for a generation after his death. But long before he died the Romantic view of art as a kind of prophecy – a pointer to new regions of experience – was establishing the idea that madness could be part of its process. John Clare (1793–1864), nonetheless, could still write from Northampton County Asylum in the 1840s the poem beginning 'I am – yet what I am, none cares, or knows.'[31]

THE DEPICTION OF MADNESS IN PAINTING

In Spain, where Goya was painting processions of flagellants, scenes of witchcraft, and in 1800 a marvellous portrait of his employers the Royal Family which made them look like imbeciles – but which did not lose him his job – the lines round what was 'acceptable' in the arts and what was not were more fluid than in other parts of Western Europe. A great tradition of the Spanish theatre had concentrated on plots in which real life led in and out of illusion (Calderón's *Life is a Dream*, 1636–40). In Goya's day plays which satirized or savaged superstitions or other irrational practices took full advantage of fantasy to point up the unpalatable truths of actuality. Such a tradition imparted added force to his own *Caprichos* (1799, Fig. 57), and especially his print 'The Dream of Reason produces Monsters' (*Caprichos* no. 43), which shows an artist asleep, with bats and owls swooping into his unconscious mind. Since 1792 Goya had been deaf, and using his enforced dependence on the facts of sight to paint small pictures of real-life humanity under pressure: such was his *Madmen's Compound* (1794, Fig. 62). Goya's life was lived against the background of such pressure: the Inquisition's secret trials, the political persecution of Spanish liberals and, overwhelmingly, the French invasion of Spain in the Peninsula War (1808–14). This resulted in atrocities which Goya unflinchingly recorded in paintings and his *Disasters of War* prints. In these he repeatedly uses the device of the supplicating figure as it appears in his painting of Christ's Agony in the Garden. However wavering Goya's avowed Catholicism may have been, he emerges as one of the most religiously motivated of all artists: concerned at fundamental levels of feeling with man thrown on the mercy of other men, who are usually unmoved. The titles of his *Disasters*, 'they are like wild beasts', 'it's no use crying out', 'he died without help', tell a story which the late twentieth century can interpret without difficulty.

In the fourteen Black Paintings of 1820–23, carried out inside his house near Madrid, Goya extends the hopelessness of *Madmen's Compound* into a statement of horror that, for the moment, was for his eye alone. Two men bludgeon each other in mud, an old woman grins vacantly behind her eating-bowl with the skeleton head of Death beside her, and the classical subject of Saturn devouring his children (fearing they will usurp him) has a bloodied ferocity that looks ahead to Auschwitz rather than back to Ovid. There is also a witches' sabbath; and the *Romeria* or *Procession on San Isidro's Day*

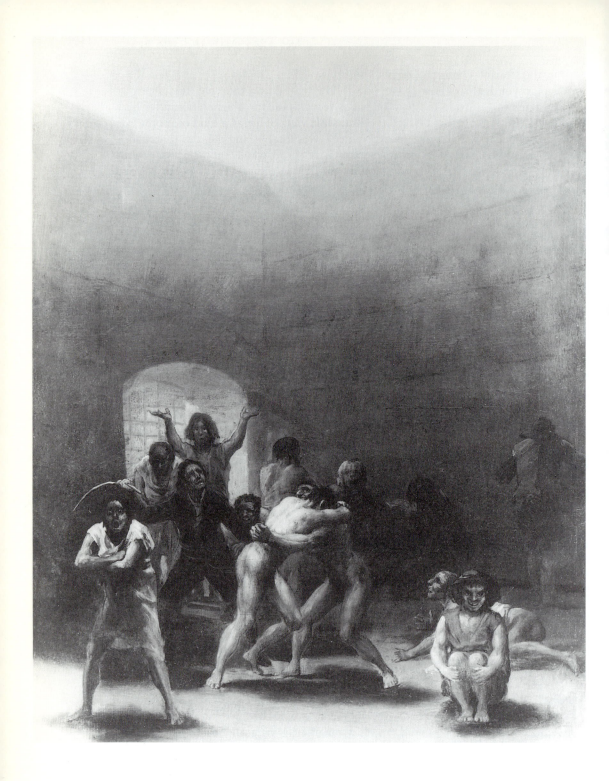

(Fig. 63), the most disturbing of all Goya's many processions – in fact a hideous reminder of mankind's capacity to regress.

What the deaf Goya was discovering about human madness by visual acuity, the French clinicians were disclosing by new methods of diagnosis. So far from being devil-possessed, might not the insane owe their condition to external circumstance: might not social upheaval, war and revolution have exacted their price? Pinel's pupil Jean-Etienne-Dominique Esquirol (1772–1840) developed the view, later taken up by his own pupil Georget, that the record of the harsher events of national as well as personal life could literally be read in the faces of the insane.[32] In his lectures (from 1817, published 1838) he illustrated the history of France from the fall of the Bastille to the Restoration of the Monarchy (1789–1815) through the case-history of one of his patients. He also classified mental conditions such as idiocy, dementia, depression and mania, and pioneered the use of statistical measurements in these areas of study.

Madness attracted attention in the early nineteenth century on two fronts: for the Romantics, as a malady that was associated with genius; and for the professional scientists – psychiatrists as they would be called – as a pathological condition.[33] Hoffmann's character Cardillac, murdering in order to protect his 'genius' as a goldsmith, could be construed as both. Before this professionalism of psychiatry arrived, the inscrutability of the challenge held much of the field. It is the balance between this inscrutability and the new candour in approaching it that is fascinatingly caught in the portraits of the insane by Théodore Géricault (1791–1824). Where Goya had been concerned to show the mad together – albeit in body only – in their confinement, Géricault concentrated on single close-ups, each of which treated, on the basis of the 'real' evidence of his observation, a different form of mental problem, and was concerned to reveal it. These works, originally ten in number and painted in 1822–23, were apparently done for the artist's friend, Esquirol's pupil Etienne-Jean Georget (1795–1828): perhaps as records of case-histories which the doctor particularly wished to remember. The five portraits which survive, now in various collections, illustrate 'monomanias', mental conditions in which the subject's actions are directed by an underlying logic which is nevertheless based on a false view of reality. Besides the kleptomaniac, the gambler, the

Figure 62: Francisco Goya (1746–1828). *The Madmen's Compound (Corral de Locos).* Oil on tin, 43.8 × 32.7 cm. January 1794. Algur H. Meadows Collection, Meadows Museum, Southern Methodist University, Dallas, Texas.

Goya emphasizes the world-within-walls of his madmen by isolating each figure or group within the shadow it casts on the floor. Two figures relate in the centre, but by fighting, and a third, a warder, belabours them. While traditions of pantomime may have influenced this (another of his tinplate paintings shows a seller of marionettes), Goya goes much further. The warder – presumably sane – enacts the same doll-like motions as the lunatic behind him: only he has a whip. But this difference is crucial in human terms: despite the sense of a cut-off, indeed hermetic world at floor-level, Goya also seems to suggest a basic mindlessness between man and man as a universal evil.

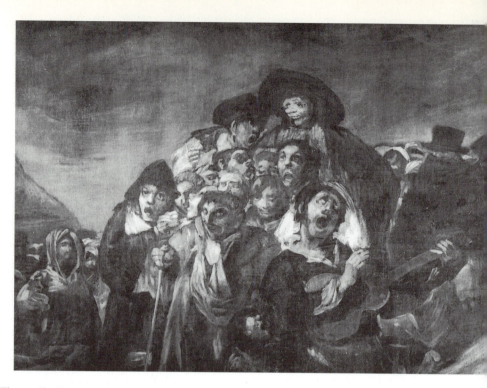

Figure 63: Francisco Goya (1746–1828). *San Isidro's Procession (La Romeria de San Isidro)*. Oil on canvas (formerly on plaster), 140 × 438 cm. 1820–23. Museo del Prado, Madrid.

Most of Goya's other processions have a purpose: none is obvious here. Humanity unwinds across a dark, curdling landscape to where a foreground group crowds up behind a guitar-player. All the heads in this group look in different directions, but have trance or derangement in common. Closely-packed like pins in an invisible pincushion, there is in each a fearsome absence of awareness of the others. Yet each is individualized, each has a lonely identity.

kidnapper, and a case of the monomania of envy, there is the terrifying delusion of military command (Fig. 64).

MADNESS IN LITERATURE

The psychology of the loser, so vividly shown by Géricault in his portrait of the deluded soldier, was also emerging strongly in the literature of Russia. In Pushkin's prose masterpiece *Pikovaya Dama (Pique-Dame, The Queen of Spades*, 1833) it was worked out through the gambling proclivities of the young soldier Hermann. The story turns on the hitherto self-disciplined Hermann's superstitious intent to gain possession of a mysterious secret of winning at cards that an old countess (the 'Queen of Spades') has reputedly learnt in her youth in Paris: confronted by him, she dies from fright before he can learn it. Hermann mistakes the Queen of Spades card for an ace and loses his all: the

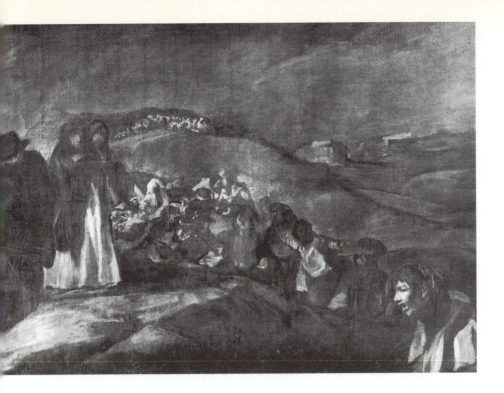

countess's ghost appears to him, and the shock destroys his reason. With its atmosphere of illusory freewill defeated by a designing power that always seems to be a step ahead of Hermann (the Fate or Destiny that haunted Tchaikovsky, who was to make a superb opera out of it), the story distils a distinctive variation on the design-chance relationship that we noted in Chapter Three.

A crisis of personal disintegration in an impersonal world (which, as we saw, attracted the irony of Heine, p. 233) is forcefully presented in the Russia of Nikolay Gogol (1809–52). His 'Diary of a Madman' (1835) rehearses entry by entry the descent into madness of a minor civil servant enamoured by a director's daughter whose marital aspirations are fixed, however, on nothing short of a Gentleman of the Bedchamber. Gogol himself had worked briefly as a government clerk and glimpsed the facts of life of the civil service hierarchy where value was placed on the office rather than who filled it. Poprishchin, keeper of his madman's diary, writes himself into the belief that he is the long-sought-for King of Spain: the St Petersburg asylum to which he is sent becomes for him the Spanish court. Deriving from Hoffmann's fantasy tales, and originally envisaged as 'Notes of a Mad Musician', Gogol's story in its final form achieves a force that is the greater for relating in detail the fantasy-responses of the principal character to the deadening reality of the St Petersburg bureaucracy. In another story, however, 'The Nose' (begun 1834, published 1836), Gogol re-transposes that reality onto a plane of comic fantasy, and gives the most outrageous twist yet to the theme of split identity. The nose of a civil servant goes missing: he pursues it and meets it dressed in the uniform of a State Councillor.

A sequel to Gogol's treatments of madness and split identity was provided by the young Dostoevsky in his story *The Double* (1846). In this the hero Golyadkin, following a soulless existence as a cog in a civil service department, finds his own double has replaced him. But no-one has realized because no-one looks at faces. The story traces how Golyadkin, deprived of his own integrity, recognizes in his double all the elements of nonentity: 'he's such a villain, so fidgety, a bootlicker, a toady; *he is such a Golyadkin*'. The kinship with Poe, and the common root in Hoffmann, are clear.[34]

Away from the Hoffmannesque fusion of fantasy with the stuff of contemporary living, but with its own slants on modern problems, the novel *Melmoth the Wanderer* (1820) by C.R. Maturin (1782–1824) marked, with *Frankenstein*, the late creative stage of Gothicism. Maturin's story describes the predicament of what an unsympathetic writer in the *Edinburgh Review* (July 1821) called 'a modern Faustus'. Having bartered his soul for eternal life, Melmoth is doomed to wander the earth seeking someone who, by taking the bargain from him, will enjoy release from their troubles in this world, in exchange for damnation in the next. Much of the action is set in Spain: Maturin, a clergyman of the Irish Protestant Church, uses his considerable ability to describe physical violence to indict the Catholic Church, with its Inquisition that the restored Spanish monarchy had recently (1814) reintroduced into the country. But if his book is written from the standpoint of a Protestant conservative, there is nothing that is predictable in its pace, range and social detail. In one episode he uses an emotive situation to describe the effects of poverty and its depressive effects on character. The novel therefore found admirers of many diverse kinds, such as Balzac and Thackeray.

The single idea that takes over an individual's mind, Melmoth-like, so that he or she becomes its victim could be effectively symbolized in relation to painters. In Gogol's story *The Nevsky Prospect* (1835) the artist Piskarev, struggling against materialistic society's demands on him, opts fatally for life with a woman whom he looks on as a work of art rather than what she really is, a prostitute. In *The Portrait* (1835) the likeness of an old man (later revealed as Antichrist) steps out of a canvas which an impoverished artist has acquired, to offer him wealth: the artist prostitutes his own art and destroys the honest work of others. Irrational fixation was also to be one of Balzac's most fruitful themes in his analytical tales of French life that culminated in his *Comédie*

Figure 64: Théodore Géricault (1791–1824). *The Mania of Military Command.* Oil, 86 × 75 cm. 1822–23. Oskar Reinhart Collection 'Am Römerholz', Winterthur, Switzerland.

All five of Géricault's surviving portraits of the insane show the eyes gazing beyond or away from the spectator: but in this the glance is directed not into vacancy but to the side at something – or someone – outside the picture space. Dreams of military glory require the acceptance of admirers – and rivals. But instead of the self-possession which had radiated from generations of portraits of soldiers and battle-heroes in the European tradition, we see analysed here the insecurity of suspicion and self-doubt. Géricault's realism brings out the loser rather than the winner.

Humaine (1842–48). We are back to *monomanie*. Balzac's characters Félix Grandet and Facino Cano pursue gold, 'une monomanie', says Cano, 'dont la satisfaction est . . . nécessaire à ma vie'. Balzac wrote a satirical sequel to Maturin's novel entitled *Melmoth reconcilié* (1835), in which he ironically suggested that Maturin's hero would have had plenty of offers from acquisitive Parisians to take over his pact with the Devil.

It may well be that Balzac (1799–1850) was helped to his view of the will that shapes and moulds the lives and events he depicts in his novels from the onward questings of Maturin's Wanderer, or even Frankenstein, since for Balzac the artist's will best achieves its targets when backed by the scientist's knowledge of means. Yet the detailed lives and events of the *Comédie Humaine* evoke a veritable universe, comparable only, in literary annals, to that of Dante's *Divine Comedy*. In the preface to one of the stories in *Scènes de la vie Parisienne* (1834, 1835), Balzac likened the whole of Paris to Dante's Inferno, and identified 'circles' composed of five social groups: the proletariat, the lower and upper middle classes, the fashionable world and the world of artists, each engaged in its round of money and pleasure. Another circle in the mix was occupied by journalists, followers of a trade which Balzac described as the 'great affliction of this century'. In *Un grand Homme de province à Paris* (1839), Balzac created a furore by denouncing the news profession as an underworld for the betrayal of talent and the misrepresentation of truth.

The occult added to the fumes of Balzac's Inferno, and he noted that science was on hand to help to account for them. The notorious Dr Mesmer (1734–1815) had unsettled Paris in 1778 with his theory of 'animal magnetism', a cosmic fluid circulating round the body which required therapy to assist its flow. Balzac himself was sufficiently impressed by the idea of what later became known as hypnotism to base a theory of human volition on it. But Balzac's sense of the fantastic, already developed by reading the *Arabian Nights*, was also to owe something to an 1829 French translation of Hoffmann's *Fantasiestücke*. Hoffmann's story *Der Artushof* had an artist describing in detail his painting of 'Paradise Regained' from a blank canvas in front of him. Can the masterpiece exist before the artist has produced it? Endeavours pitched high enough might prove something: in Balzac's *Le Chef d'Oeuvre inconnu* (1831) a painter claims to have put a masterpiece containing the whole of life onto his canvas. But everyone else sees it as chaos. In another story, *Gambara* (1837), on Hoffmann's own ground, a musician tries by the use of a fantastic invention, the panharmonicon, to found music on new theoretic principles: he produces cacophony, and convinces his audience that he is mad. But there is a satirical edge, inasmuch as the cacophony emerges when he is sober; when he is drunk he not only raves with the average opera-goer of the day at the tunefulness of Meyerbeer, but writes heart-melting melodies himself.

The period of the 'Citizen-King', Louis-Philippe (1830–48), was to provide fruitful ground for the satirist, as talk of the desirable goal of a *juste milieu* ('golden mean'), in life and art, emphasized the extremes on either side which were not easy to reconcile with it. The satiric gifts of Honoré Daumier (1808–78) found a platform here, notably in Philipon's magazines *La Caricature*

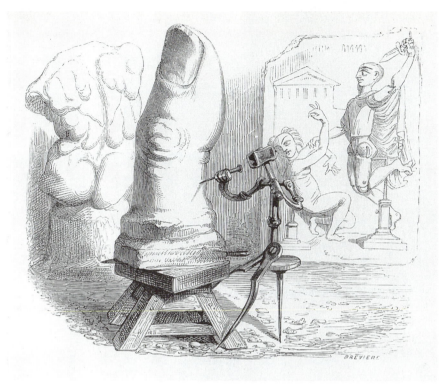

Figure 65: Jean Ignace Gérard, known as Grandville (1803–47). 'The Finger of God', from *Un autre Monde* (Paris 1844). Wood engraving, print area approx. 9.9 × 12 cm. British Library (1458K10)

Grandville's notion of a mechanical brain creating art – creating, indeed, the original artist – finds classical art dead and gone: he includes the Belvedere Torso and a Tarquin and Lucretia scene in the background. Besides satirizing the Romantic 'fragment' (p. 154, n. 34), here was a work which would retain its provocativeness even after the computer revolution of the late twentieth century.

(1830–35) and *Charivari* (1832 onwards): so did the strange genius of J.I.I. Gérard, known as Grandville (1803–47). Grandville's gifts lay in irrational and monstrous transformations, such as humans whose heads have become enormous eyes, and in the illustration of stories which exposed truths from unexpected viewpoints, such as Aesop's *Fables* or Swift's *Gulliver's Travels*. But he was a prolific illustrator of his own books. In his fantasy *Un Autre Monde* (1844) he takes a further step in a direction forecast by *Frankenstein*. A sculptor is carving the Finger of God: but he is a robot (Fig. 65).

The inverted logic of Grandville's fantasy world appeared while Balzac's great *Comédie Humaine* (1842–48) was unfolding real life as he observed it. While Balzac detailed the more dramatic symptoms of madness in Gambara and others, it was by almost unrivalled analysis of the catastrophic implications of irrational behaviour that he assumed his true stature as a novelist.

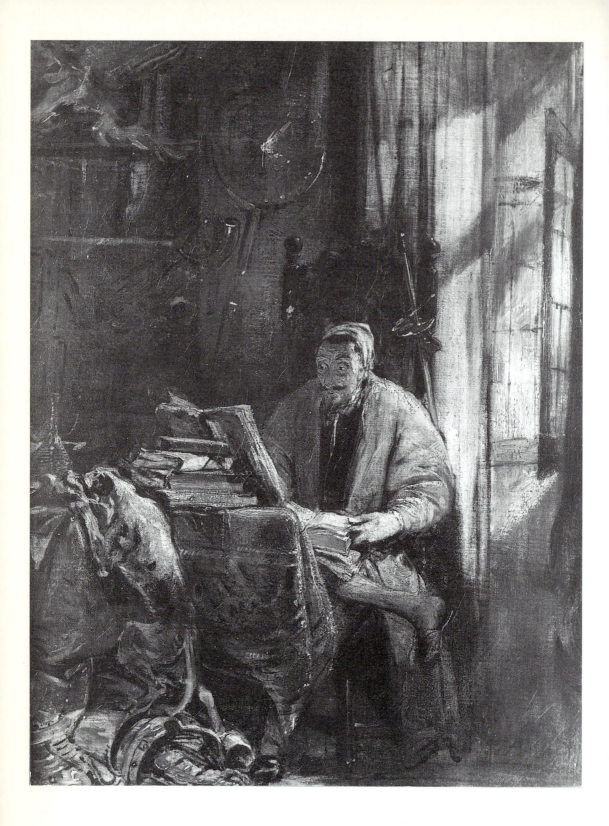

His greatest fool, Old Goriot, approached the dimensions of Lear. The plot of *Le Père Goriot* (serialized in 1834) turns on the ingratitude of daughters, on whose education and marriages Old Goriot, a retired vermicelli-manufacturer, lavishes all his money. Within this *Lear*-like situation there is no Cordelia. Reduced gradually to penury as his daughters strip him of all he has, he rises symbolically from smart first floor apartment to garret in the Paris boarding-house (so minutely described in the novel's opening pages), where he lives. Fantasies assail him, of starting up work again, even in distant Odessa, to meet his daughters' bills. He dies raving, uncomforted by them.

If to show complete disregard for personal well-being in order to satisfy some self-appointed object of devotion might be described as 'quixotic', then in this respect – but in no other – there was something of Quixote in Old Goriot. But if a single personality in fact emerged in this period as its arche-typal martyr, it was Don Quixote himself. Now that the mask that the indi-vidual presented to the world had moved far enough for a value to be set on the irrationality behind it, Cervantes' great creation took on new life. Quixote, seen by the eighteenth century as a madman out of kilter with his society, was for the Romantics a holy fool gifted with a vision that society had misunder-stood. The compassion that attached to the unjustly-treated Tasso was readily accorded to the independent-minded Don, who took on the world for the sake of a dream. In an age which made time for a new look at innocence, Cervantes' hero stood out as a model of integrity. To the Romantics, the buffetings he received were all too characteristic of the martyrdoms suffered by the modern artist. Even in the relationship, reminiscent of the *Doppelgänger*, of the ascetic Quixote to his carnal squire, Balzac recognized a microcosm of struggle, the Knight 'at grips with some Sancho Panza'. In the tales of Balzac's *Etudes philo-sophiques* (1830–31), echoes of Hoffmann's fantastic world are mingled with that of the chivalric code of Quixote, which drives him to follow his ideals, come what may. To those looking for a universality that bound together unlikely companions, Schubert's 'Der Leiermann' offered a moving example: the bond between the Don and Sancho was clearer still. Five illustrated editions of Cervantes' novel appeared in Paris between 1820 and 1824 alone. Daumier, the greatest artist to respond, took half a lifetime before, after 1850, he began the series of paintings which marked forever the visual complementarity of the gaunt, obdurate Quixote and the rounded, adaptable Sancho. Meanwhile, Bonington (Fig. 66) showed Quixote in his study transfixed by old tales of knightly adventure, imagination racing.

Figure 66: Richard Parkes Bonington (1802–28). *Don Quixote*. Oil, 40.6 × 33 cm. About 1825–26. Castle Museum and Art Gallery, Nottingham.

Though it draws on Rembrandt's paintings of solitary scholars and hermits for its dramatic lighting, this work encapsulates Romantic feeling for Don Quixote, as he steeps his imagination in tales of knightly valour before setting out on his own adventures. With such a subject-picture based on a popular novel, Bonington foreshadowed a favourite form of Victorian story-telling art. The many copies and prints after this picture testify to its wide success.

Notes

1. William Robertson, *History of America* (1777) Book IV, in *Works*, vol. VI. For a useful discussion of the work of Scottish writers, see David Spadafora, *The Idea of Progress in Eighteenth-Century Britain* (New Haven and London 1990), pp. 253f.

2. See Adam Smith, *Essays on Philosophical Subjects*, ed. W.P.D. Wightman and J.C. Bryce (Oxford 1980), pp. 49–50

3. Richard Friedenthal, *Goethe, His Life and Times* (1963), p. 497; R.D. Gray, *Goethe the Alchemist* (Cambridge 1952)

4. Smart's words formed part of a poem written between 1759 and 1763. Eventually published as *Rejoice in the Lamb* in 1939, more recent edns have given it its original title, *Jubilate Agni*. See *Poetical Works*, ed. Karina Williamson, vol. I (Oxford 1980), p. 88

5. Heine, *Memoirs of Herr von Schnabelewopski* (1834); Marryat, *The Phantom Ship* (1839)

6. See extracts in English translation by Louise Adey in *The Romantics on Shakespeare*, ed. Jonathan Bate (1992), pp. 60–6

7. Most notably in Eichendorff's lyrical treatment of supernatural figures against mysterious landscapes in *Das Marmorbild* (*The Marble Picture*, written 1817, published 1826)

8. For Friedrich Schlegel irony, which he observed in Shakespeare and Cervantes, ensured the author's self-conscious position vis-à-vis his characters and plots. Prefigured also by Sterne, it might test the sophistication of its readers by turning the very characters against the author, as in Brentano's novel *Godwi* (1800), where they complain about him and complete the story after his apparent death

9. Strabo recorded it (*Geographia* XVII, i. 46). For illustration see W. Stevenson Smith, *The Art and Architecture of Ancient Egypt* (1958), pl. 119. See Akenside, *Pleasures of Imagination* (1744) I, lines 109f.; Erasmus Darwin, *The Botanic Garden* (1791) p. 18 of text, p. 17 of notes

10. See Partha Mitter, *Much Maligned Monsters: A History of European Reactions to India* (Oxford 1977). For the British public the Indian journeys (1785–92) of Thomas and William Daniell had far-reaching results through their 144 aquatinted Indian views of *Oriental Scenery*, published in six folio-sized parts (1795–1808). Some of these, adapted to blue-printed earthenwares and wallpapers, became widely-known. For a useful discussion of the ideas arising out of British involvement with India, including the work of the linguist Sir William Jones (1746–94), see P.J. Marshall and Glyndwr Williams, *The Great Map of Mankind: British Perceptions of the World in the Age of Enlightenment* (Cambridge, Mass. 1982), pp. 74f.

11. *Annals of the Fine Arts*, vol. 3 (1818) X, pp. 494f. and XI, pp. 589f.; vol. 4 (1819) XIII, pp. 178f. De Quincey, *Collected Writings*, ed. David Masson (1889), I, p. 41n

12. Joseph Severn, letter to R.M. Milnes, 6 Oct. 1845, in *The Keats Circle, Letters and Papers 1816–1878*, ed. Hyder E. Rollins (2 vols: Cambridge, Mass. 1948), vol. II, p. 133

13. Disraeli, letter to Sarah Disraeli, 28 May 1831, in J.A.W. Gunn et al., eds, *Benjamin Disraeli, Letters*, I (Toronto 1982), p. 195

14. See James Stevens Curl, *The Egyptian Revival: An Introductory Study of a Recurring Theme in the History of Taste* (1982), pp. 130–3

15. Anna Brownell Jameson (1794–1860), *Characteristics of Women, Moral, Poetical, and Historical* (2 vols: 1832); later edns entitled *Shakespeare's Heroines*

16. See my *Oriental Obsession, Islamic Inspiration in British and American Art and Architecture 1500–1920* (Cambridge 1988), pp. 78, 245–6

17. Lionel Trilling, 'Freud and Literature', *The Liberal Imagination* (1951), p. 36

18. For the complexities of Rousseau's view of his own 'double', see the chapter 'Rousseau and the Peril of Reflection', in Jean Starobinski, *The Living Eye* (1989), especially pp. 63f

19. Balzac, letter of 17 Oct. 1842, in *Lettres à l'Etrangère* (Paris 1899–1900), II, pp. 70–1, cited in Maurice Z. Shroder, *Icarus: The Image of the Artist in French Romanticism* (Cambridge, Mass. 1961), p. 259

20. For the links between *Die Räuber* and *The Brothers Karamazov* see Joseph Frank, *Dostoevsky: The Seeds of Revolt 1821–1849* (Princeton, New Jersey 1976), pp. 60–1

21. The process of Giglio's conversion is recounted in M.M. Raraty's introd. to his edn of *Prinzessin Brambilla* (Oxford 1972), pp. xxxiif.

22. See Barbara Bloedé, 'A Nineteenth-Century Case of Double Personality: A Possible Source for *The Confessions*', in *Papers given at the Second James Hogg Society Conference* (Edinburgh 1985), ed. Gillian Hughes (Association for Scottish Literary Studies 1988), p. 124. On Hoffmann, Hogg, Poe etc. see John Herdman, *The Double in Nineteenth-Century Fiction* (1990)

23. Cf. F.W.J. Hemmings, *Culture and Society in France 1789–1848* (Leicester 1987), pp. 105–7, 143–5

24. The vampire legend had been widely publicized by Alberto Fortis, *Viaggio in Dalmazia* (Venice 1774, translated into German 1776, English and French 1778). In the wake of Byron, Mérimée created a vampire hero in his story *La Guzla* (1825–26). See also Christopher Frayling, *Vampires* (1991), and Ch. 3, n. 16 above

25. Muriel Spark, *Mary Shelley* (1988), p. 161. The creator/created relationship as presented in *Frankenstein* has proved a rich theme for speculation. That the monster's plight is depicted by Mary Shelley as falling short of a vision of perfection that lies beyond its maker's grasp points up the serious moral thrust of the novel, reworking, as it does, the main theme of rebellion in *Paradise Lost*: see Krishan Kumar, *Utopia and Anti-Utopia in Modern Times* (Oxford 1984), p. 116 and p. 449, n. 34

26. Heine, *Zur Geschichte der Religion und Philosophie* (1832–33), Bk II. S.S. Prawer, 'Coal-smoke and Englishmen: A Study of Verbal Caricature in the Writings of Heinrich Heine', the 1983 Bithell Memorial Lecture (Institute of Germanic Studies, University of London 1984), pp. 1f.

27. For Poe as link between 'high' and popular literature see Harriett Hawkins, *Classics and Trash: Traditions and Taboos in High Literature and Popular Modern Genres* (1990), esp. p. 10

28. Berlioz, *Memoirs*, Eng. trans. and ed. David Cairns (1969), p. 95; Jacques Barzun, *Berlioz and the Romantic Century* (2 vols: New York, Columbia University Press 1969), vol. I, p. 84

29. Michel Foucault, *Madness and Civilization*, trans. R. Howard (New York 1965), esp. pp. xi, 44–8. See also Klaus Doerner, *Madmen and the Bourgeoisie*, trans. J. Neugroschel and J. Steinberg (Oxford 1981), p. 14

30. Cf. *King Lear*, Act III, scene iii, and songs such as 'Mad Tom' and 'Old Tom of Bedlam'. See G. Rosen, *Madness in Society: Chapters in the Historical Sociology of Mental Illness* (1968), p. 153; Robert Graves, *The Crowning Privilege* (1959), pp. 47–66

31. John Clare, *Selected Poetry*, ed. Geoffrey Summerfield (1990), p. 311

32. Fig. 64 below might show 'the price incurred by the heroic Napoleonic militarism', see Margaret Miller, 'Géricault's Portraits of the Insane', *Journal of the*

Warburg and Courtauld Institutes **4** (1940–41), p. 163. Such derangement does appear to have increased under Napoleon, ibid., n.4

33. For much detail see Roy Porter, *Mind-Forg'd Manacles: A History of Madness in England from the Restoration to the Regency* (1987). Eighteenth- and early nineteenth-century interest in the mind/body relationship that irrationality highlighted is discussed in G.S. Rousseau and Roy Porter, eds, *The Languages of Psyche: Mind and Body in Enlightenment Thought* (Berkeley, Los Angeles and Oxford 1990)

34. Konstantin Mochulsky, *Dostoevsky: His Life and Work*, trans. M.A. Minihan (Princeton, New Jersey 1967), p. 50

Plate VII: Philip Otto Runge. 'Morning' (The Times of Day). See note p. xvii.

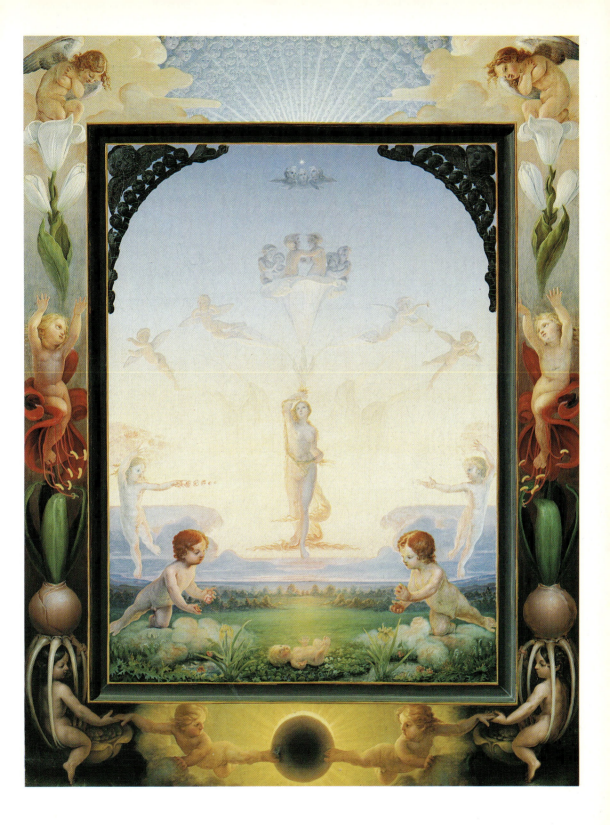

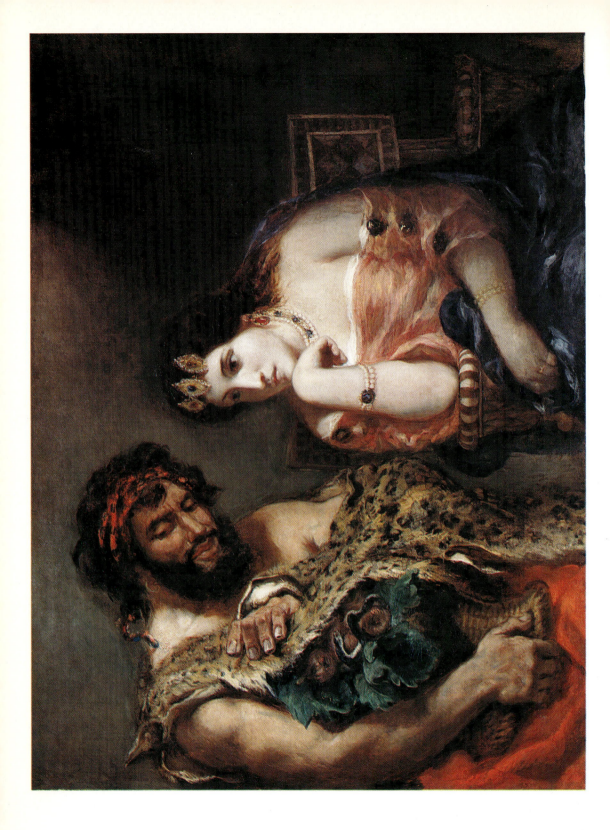

6

Bridges to the Future

Prelude

Throughout the eighteenth century, recognition that the arts encouraged luxury and acquisitiveness provoked much thought. In a trenchant and notorious analysis of the human condition, the writer Mandeville (1670–1733) argued that the pomp and extravagance of the rich arose out of ineradicable human vice, which nonetheless, by stimulating economic competition, worked to the general good (*Fable of the Bees, or Private Vices, Public Benefits*, 1714, six editions by 1733). As the century advanced, the wealth which the arts were 'a most effectual means of circulating', as Joseph Priestley put it, appeared to confirm them as an integral part of society's needs. If, in the age of sentiment, Werther-mania evoked fears of effeminacy, a Handel chorus or the no-nonsense bearing of David's female portraits was there to correct the balance.

The need to balance a given situation – to attend to the pendulum as well as to the forward movement of the clock – was perhaps the most important single message which Voltaire, Rousseau and the eighteenth-century Enlightenment in general might be seen to hold out to the very different revolutionary and industrial age that followed. The pace of living was to quicken and there could be no easy consensus as to what constituted progress. But among the factors which took a belief in it forward were technological advance and hopes for universal education, both of which were to raise hard questions on the role of the arts (p. 44). In a technological age utopian schemes were multiplying, but the practical problem of matching good design and quantity production was to be a difficult one for Western nations. As for education, undeniable progress in the understanding of nature (Chapter Three) left man still uncertain of his place in it. In 1766, Wright's painting, *The Orrery* (Fig. 12), showed adults and children responding to an intensely imaginative experience. But what of the

Plate VIII: Eugène Delacroix. Cleopatra and the Peasant. See note p. xvii.

differences between the response of the child and that of the adult? Wordsworth, in 'Intimations of Immortality' (1806), was to set this difference pessimistically within a famous definition of imaginative loss: while 'Heaven lies about us in our infancy!/ . . . Man perceives it [the vision of nature] die away,/And fade into the light of common day'. How might education in the arts help to redress this? Within Wordsworth's lifetime the benefits of the industrial age were being weighed afresh against the costs: social protest (notably that of Dickens) was rising strongly against the assertions of progress. As Western societies cross the bridges that lead deeper into the nineteenth century, it will be useful to recall the ambivalence of the bridge images of the day, some strong, some precarious (see Interlude, above).

The relationship of artists themselves, of all kinds, to this changing world (Chapters Four and Five) recalls the importance of Byron as international spokesman both before and after Waterloo. Byron was not concerned, like Wordsworth, with childhood's eye, but with himself projected in his heroes, as a man, within the societies through which he passed. He wrote no public autobiography: it was enough for his poems and his persona to enact it. We must nevertheless remember that autobiography – in 1700 a relatively little-known art, which by 1800 had been laid bare in the astounding *Confessions* of Rousseau (1781) – was to be a blazoning activity in the nineteenth century. Well before 1850, the Russian émigré writer and social commentator Herzen (1812–70) had begun to assemble notes for a life-story, known in English as *My Past and Thoughts*, which he compared with Dickens's *David Copperfield* (1849–50) as a personal record of real-life experience. This was no idle comparison: for of all literary forms the modern novel which took shape between 1700 and 1850 (Chapter Two) offered an unparalleled outlet for individual recollection. Defoe, Rousseau, Sterne, Stendhal, Austen, Charlotte Brontë, in varying ways, put themselves freely into their fiction. Balzac claimed the novelist's art as symbolic autobiography: a truth which Proust and Joyce were to demonstrate for a later age.

Technology, Art, Education

How likely was it, one wonders, that the children pictured in Wright's *Orrery* (Fig. 12) would grow to appreciate the painting as well as the orrery that had so obviously fascinated them? Their elders could reflect here on an ingenious, man-made symbol of Newtonian world-order which, as we saw, the Enlightenment mind could apply to government. Human progress seemed assured. If, however, these children survived to complete their appointed life-span – to about 1830 – they would live through the uncertainties for Britain of the French Revolution and beyond Waterloo. They would certainly be affected by industrialization and its associated visual and social upheavals. They would observe the progress of the steam engine from Watt in 1769 to Trevithick in 1804, and

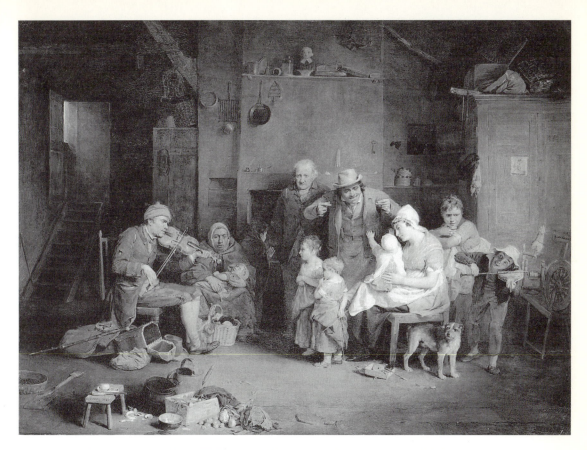

Figure 67: Sir David Wilkie (1785–1841). *The Blind Fiddler*. Oil on wood, 57.8 × 79.4 cm. 1806. Tate Gallery, London.

Wilkie's pictures of Scottish village life, recording traditions with which he had been familiar as a boy, were immensely popular. It is reported that 300 people were waiting to see this picture when the Royal Academy exhibition opened in 1807. The boy on the right apes the fiddler, using a bellows as a violin. The child not so much as a small adult, but as the possessor of its own imaginative world, was already being recognized by Schiller and others (p. 221). Many years would need to pass before child art would be valued for itself: meanwhile a drawing, said to reproduce one of Wilkie's own childish efforts, appears on the right in the background of this picture.

live to see the opening of the Stockton-Darlington railway in 1825. They might have welcomed industrial society with the progressives, or recoiled from it with the social protesters. Other changes, to do directly with the arts, may have passed them by: if they had not visited the Society of Artists in London (where *The Orrery* was shown in 1766), their life-times would nonetheless have seen public art exhibitions establish themselves as an enduring part of modern life. They might, with others of the middle class, have shared in the fashion for Wilkie's paintings of indoor genre scenes – less 'intellectual' than Wright's – after 1800. In *The Blind Fiddler* (included in the Royal Academy of 1807, Fig. 67), children are shown observing and, in the case of the boy on the right,

imitating the fiddle-player. How were children to 'grow' into an increasingly complex adult world? Without realizing it, the *Orrery* children would have lived through half a century of the most fundamental attempts to reassess child education and its relation to adult life that the Western world had seen.

Among the many side-effects of the eighteenth-century technological revolution was its impact on education and the ways in which the visual arts, in particular, were perceived. Traditionally education had focused on the sons of elites and the task of training the reason and the memory through the study of classical authors. Some basis in the calculating sciences had been provided: in Britain John Newbery's book, *Tom Telescope's Philosophy of Tops and Balls* (1761), explaining, 'for young minds', Newton's universe in terms of games and nursery toys, was hugely popular. The lower orders, in general, had prepared for life, including working life, by word-of-mouth learning or copying from fathers and mothers, clergy and friends in the confines of small communities: the baby, responding to the father's rhythmic finger-snapping in *The Blind Fiddler* (Fig. 67), begins early. But modern industrial economies called for ability to find one's way in unfamiliar worlds, with adequate standards of literacy and numeracy. Education for males (not yet, for many generations, females, other than the well-to-do) became a conscious social objective as never before.

The arts held no obvious place in programmes which were essentially to aim at providing facts. But their cause was to be enhanced for fortunate minorities. The opposition of the Jesuits, hitherto powerful in Catholic countries, to new ideas in education was to be reduced (they were expelled from Portugal, France and Spain by 1770). Though most public education remained in conservative hands, private academies, long established in Italy and France, had spread to Britain in the seventeenth century and had increased in number there to over 200 by the 1780s. These provided vocational training in commercial and technical subjects, and also in drawing, painting, music, fencing and sports: taught, of course, as 'accomplishments'. There were also the enterprising eighteenth-century Dissenting Academies (p. 42). Here British moderns, including Sterne, could become part of a taught syllabus: at Warrington and Hoxton the inclusion of 'belles-lettres' even suggests that reading might be done for its own sake. It was a slow crusade. In 1801 Vicesimus Knox, schoolmaster of Tonbridge, writes of arguments in the 1790s with those who wanted reading taught only for 'useful' knowledge. And fifty years later Dickens's Gradgrind, in *Hard Times* (1854), was still advocating from the heart of industrial Coketown: 'Teach these boys and girls nothing but Facts'.

Gradgrind was speaking, nonetheless, at the end of a long period in which very different goals had been pursued from more specialized standpoints. In 1754, exactly one hundred years before *Hard Times*, the newly-founded Society for the Encouragement of Arts, Manufactures and Commerce (now the Royal Society of Arts) had laid down its intention 'to consider of giving Rewards for the Encouragement of Boys and Girls in the Art of Drawing'. Pointing out that Drawing is 'absolutely necessary in many Employments, Trades and Manufactures', and that its encouragement 'may prove of great Utility to the public',

the Society went on to institute prize competitions in 'mechanical' arts such as weaving and cabinet-making: but while it drew a poor response in these fields, many young artists entered for the drawing prizes, among them, over the next century, such brilliant draughtsmen as Lawrence, Millais and Landseer.

Drawing, indeed, the line medium which had formed the basis of a young artist's training in the Italian Renaissance, reasserted its credentials in crucial and contrasting areas of progressive education in the century after 1750. To the Society of Arts it stood as the bulwark subject that permitted no loose thinking, the ultimate discipline in an age of slack design for quantity production. For the professional artist-compilers of the drawing manuals for amateurs that came out after 1800 drawing provided, in the words of one of them published in 1818, 'the essential lines and the forms connected with them'. For Emile, in Rousseau's book of 1762, and for the educational reformers who slowly digested its message, drawing had a yet broader scope: 'to give him exactness of eye and flexibility of hand'.[1]

NATURE AS GUIDE, UTOPIA AS GOAL

In Rousseau's account Emile was guided by his tutor to respond only to what nature had to reveal; to master practical problems as they presented themselves, and to 'grow outwards', free of lessons from books till the age of twelve (and then the book he was given was the sublimely practical *Robinson Crusoe*). Parents followed its precepts (Coleridge's son Hartley was brought up as an Emile) and boarding schools with Emile-inspired programmes quickly opened as far away as Russia. Its practical implications were worked out most fully in German-speaking parts of Europe: in Basedow's 'Philanthropinum', Dessau (1774), a school for working-class as well as well-to-do boys, and in the theories and teaching of the Swiss J.H. Pestalozzi (1746–1827) at Burgdorf (1799–1804) and Yverdon (1802–25), and the German Friedrich Froebel (1782–1854). The 'Nature-philosophy' associated with Herder, Fichte, Schelling, the Humboldt brothers and especially Schiller, who was lecturing at the University of Jena in Froebel's years there (1799–1801), had contributed enormously to this German development. But there was also an ambitious, pragmatic awareness of how far the senses at full stretch could take young children. Form, colour and sound were all brought into service to this end. Froebel gave his children cubes, cylinders and spheres which could be used as building blocks and recognized as basic shapes in nature: and songs were an essential part of his training (*Mutter-und Kose-Lieder*, 1843, translated into English as *Mother's Songs, Games and Stories*). Froebel died in 1854, the year that Gradgrind was emphasizing his Facts: the idea of the *Kindergarten*, Froebel's word for the school-in-nature that involved the young child in building, modelling and other creative activities as well as mathematics and language training, had been in being since 1840.[2] Since 1832, moreover, the American campaigner for musical literacy, Lowell Mason, had been advocating Pestalozzian programmes for Boston schoolchildren.

Fired by individual commitment and supported largely by private philanthropy, such idealistic and experimental endeavours were bound to earn the

distrust and opposition of European governments wary of the implications of the 1848 revolutions: but the same revolutions were to disperse Froebel disciples overseas, notably to America.

The social utopias of this period also saw educational programmes as fundamental to their hopes for success. In 1813–19, a few years after Malthus had published his theory (1798) that populations grow faster than their means of subsistence, Robert Owen (1771–1858) was proposing optimum communities of 800–1200 organized in small towns round a central parkland. John Nash's scheme for Regent's Park, London (from 1811), scenically placing villas in a landscape and terrace-houses round it, in the spirit of the English Picturesque, was going forward. But the new social reformers were interested in the ways in which early experience of environment determined character, and object-based activities for children based on Pestalozzi's model of *Anschauung* (observation) were part of Owen's scheme.[3] In France the followers of C.H. de Rouvroy, Comte de Saint-Simon (1760–1825), building also on Auguste Comte's interest in the rational appraisal of sense experience, included the fine arts as one of three interdependent areas of advanced curriculum (the others being science and industry).[4] The millennialist F.M.C. Fourier (1772–1837) placed education of the senses high among the desiderata of schooling in his ideal realm called 'Harmony': cookery educated smell and taste; sung music – Fourier advocates opera – sight and hearing.[5]

THE PROBLEMS OF AN INDUSTRIALIZING SOCIETY

But practicality demanded that another major rib in the bridge of progressive education should enable adults to 'improve' themselves in the world as they found it. Here also the capacity of the arts to combine learning with pleasure was to give them special value, especially in Britain, where a population (including that of Ireland) of 16 million in 1801 had become 24 million by 1831, and where the Utilitarian philosopher Bentham was advocating the 'Greatest Happiness of the Greatest Number'. A Crusoe or an Emile owed their self-discovery to special circumstances, but those displaced by population-drift, disorientated by depersonalizing conditions of employment or simply aware of their own ignorance would need to be pointed in the right direction. The half-century from 1800 to 1850 is one of societies and associations that involve common people. Among them was the Society for the Diffusion of Useful Knowledge of 1826, founded by Henry (later Lord) Brougham to produce books for the working class (p. 52) and publishing also *The Penny Magazine*, *Penny Cyclopaedia* and *Library of Useful Knowledge*. George Birkbeck's throwing open of his Glasgow lectures to workmen in 1799 led to the Mechanics' Institutes that were established from 1823 (p. 52), with their heterogeneous programmes of geometrical and mechanical drawing, and drawing of ornament, the human figure and landscape.[6]

After the first optimistic phase of the Industrial Age, the nineteenth century met the crux of a problem which especially concerned the visual arts: how to relate the nature of start-to-finish activities based on individual inventive-

ness and uniqueness to that of division of labour working to standardization and quantity production? The example before 1800 of Wedgwood, employing hundreds to produce his creamware, showed how, by a shrewd amalgamation of the Neo-classical shapes he admired with the kinds of handles, lids and decoration that lent themselves to production-line assembly, it could be done. Familiar with the sorts of vase (to cite an example he gives) that 'the Great People have had . . . in their Palaces', and alive to the standards which Adam and others had achieved, Wedgwood channelled his entrepreneurial skills into results which were artistically distinguished as well as commercially successful. But problems abounded. By the 1800s not only were production-lines longer and mechanization more advanced, but multiple styles of art and decoration were available for adaptation, not always successfully, and a less informed, but fashion-driven middle-class patronage was calling for innovation, as Maria Edgeworth's novels give notice (p. 209).[7] In a world of quick profits in which standards of discrimination could easily falter, and success was measured by the extent to which prices were undercut, the arts could be seen by certain Utilitarian thinkers to be irrelevant: by others (often industrialists themselves, like Robert Peel) as meriting urgent revaluation.

From Britain the eyes of many turned to France, where the Académie des Beaux Arts at Lyons was producing distinguished results. Here students who were mainly sons of factory workers undertook a basic course in life drawing and painting and then entered one of six departments, Painting, Sculpture, Architecture, Ornament, Engraving and Botany. The department of Ornament taught its members how to relate pattern to industrial production.[8]

But London's Society of Arts (p. 44) was by now inspiring developments in Prussia, where eighteenth-century measures to make schooling for children compulsory were to be followed by programmes of specialized education that included the relation of art to industry. In a surge of enthusiasm for Adam Smith's theory of a free market economy (as expounded in his famous book, *The Wealth of Nations*, 1776), the Berlin Gewerbe Institut (College of Trade) was founded in 1821 by Peter Beuth with the help of his friend, the architect Schinkel (p. 45), and examples of designs in various applied arts, which included some simple classical shapes, were published for the guidance of craftsmen and manufacturers (Fig. 68).[9] Four 'Trade schools' (*Gewerbeschulen*) opened in Breslau, Königsberg, Danzig, and Cologne. Soundings from these were taken in turn in Britain when in 1835 a Select Committee of Parliament on 'Arts and their connection with manufactures' was convened to enquire into ways of 'extending a knowledge of the arts and principles of design among the people (especially the manufacturing population) of the country'.[10]

In a period of greater cultural enfranchisement of wider sections of society, those recommending priorities in art training in the early nineteenth century had first to decide a thorny question: what to vote for. Official opinions were divided between those, like the vociferous Haydon, who supported the French habit of teaching art basically as fine art (life drawing and figure painting), and those who favoured Prussia's more concerted linking of applied art and industry. Here was revealed a deep cleavage between 'high art' and the enhanced

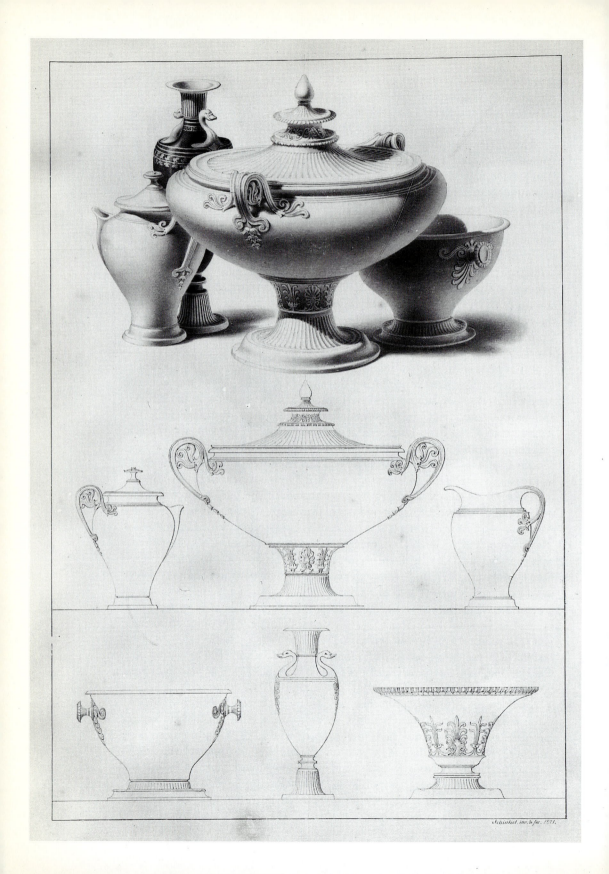

Schinkel, inv. & fec. 1821.

concept of design applied to a 'useful' art such as furniture, metalwork, ceramic and textiles. The Schools of Design that opened in Britain were fundamentally drawing schools aimed at supplying designers for industry, but questions of how far they should train the kind of artist who painted easel pictures for modern exhibitions that had become part of the leisured life of the age continued to recur.

The question as to where art 'belonged' also had its difficulties. The opening of national and provincial collections of paintings and sculpture; the building by the British architect Pugin in the 1830s and 40s of Gothic Revival church interiors charged with the colour and associations of Catholic ritual: such developments took art into special aesthetic latitudes, which many who escaped from the noise and squalor of city streets were grateful to frequent. Yet the view that the visual arts should have a saving role in that ground-level world of noise and squalor was to exercise the minds of many Victorians, including, at mid-century, the architect Owen Jones and, of course, Ruskin.

Architecture, too, presented certain ambivalences. In France, ruled after Napoleon by different kinds of monarchy (inherited and elective), a Second Empire, Second and Third Republics, architecture provided valuable continuity. Despite the Revolution, French cultural ties with the past were as strong as ever. Under Napoleon, institutions which offered both general and specialized education, such as the *lycées* with their modern curricula, the Ecole Polytechnique (1794) and the Ecole des Beaux Arts (1795), reflected new, centralizing impulses. But Napoleon's own artistic tastes were for antiquity, and the highest distinction which a young architect could achieve was still the Grand Prix de Rome. Even if the bareness of Durand's hospitals was relieved by trees, and Ledoux's ideal city designs linked buildings of primitivistic geometry with the shapes of nature (p. 125), civic Paris still advanced the traditional formalities of temple-front, colonnade and triumphal arch (Fig. 69). Even the more obviously 'Romantic' style of Gothic, entering into serious competition as a source style with classicism, was seen in France as essentially 'structural' and rational, a line to be followed by the most influential French architect of the century, E.E. Viollet-le-Duc, after 1850. But in contrast to this, a Romantic eye for 'architecture parlante' (p. 125) might prefer to see a building as a form of social history, a record of human belief. Victor Hugo's theory that archi-

Figure 68: Karl Friedrich Schinkel (1781–1840). Designs for vessels. Pen and ink and wash, 56.1 × 41.3 cm. 1821. Drawing for *Vorbilder für Fabrikanten und Handwerker* (Examples for Manufacturers and Craftsmen), pt II, pl. 29. Nationalgalerie, Staatliche Museen, Berlin (SM 43a, 27).

Schinkel's designs here relay classical influences, especially in the large tureen with high, fluted pedestal, high-profiled body and fluted cover. But English potters, from about 1750, had explored such simple shapes in a thin-walled creamware, less 'aristocratic' than porcelain (compare Wedgwood, Fig. 7). Schinkel reflected their influence in such 'models' as these for the guidance of taste in his own day. Individual sheets were distributed free to libraries, craftsmen, artists and schools of drawing. Single-volume collections of these *Vorbilder* appeared in 1830 and 1837.

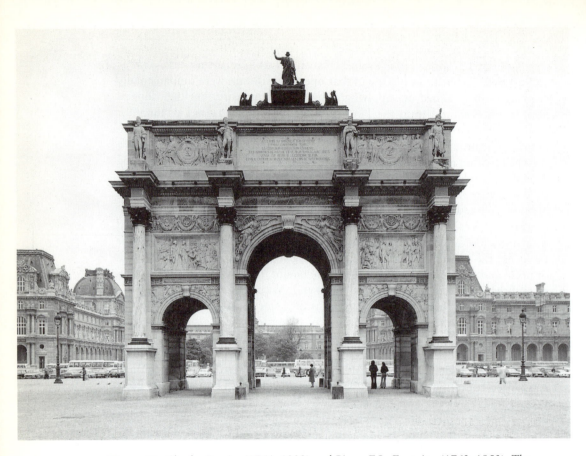

Figure 69: Charles Percier (1764–1838) and Pierre F.L. Fontaine (1762–1853). The Arc du Carrousel, Paris. 1806–8. Photograph courtesy of Courtauld Institute of Art.

Napoleon found in Percier and Fontaine ideal exponents of his tastes in architecture and decoration. Under his patronage they undertook the first great series of metropolitan improvements which were to transform central Paris. Besides straight roads like the Rue de Rivoli (from 1802), triumphal arches expressed the power and panoply of the Napoleonic 'Empire Style'. The Arc du Carrousel, marking the gateway to Napoleon's main Paris residence, the Tuileries Palace (now demolished), was based on the Arch of Septimius Severus in Rome. Its sculptured whiteness was further enriched, however, by polychrome columns and frieze.

tecture had evolved as a form of writing favoured novel, eclectic effects which presented buildings as forms of 'work done'.[11] Such was the implication of the remarkable Bibliothèque Ste Geneviève, Paris, with its names of 810 authors (from Moses to the modern chemist who had evolved the chemical symbols, the Swede Berzelius) carved in vertical panels on the façade, 7,000 letters in all. Inside, the building continued the roll of history, exposing the classical round arch in cast iron (Fig. 70).

By the time of the Paris Library, habits derived from the Enlightenment of re-drawing lines round government through law, and round nature through science, were deep at work within a changed society, helping to change it fur-

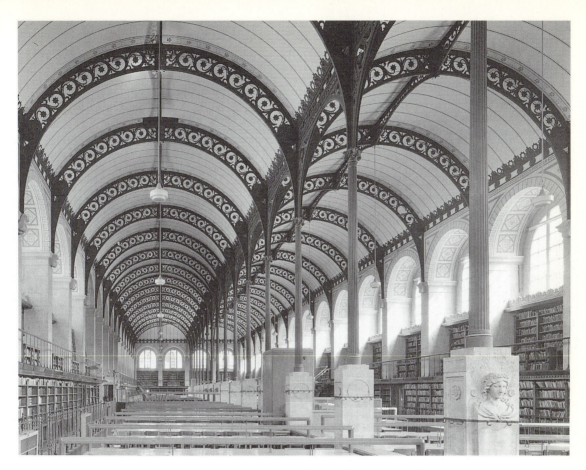

Figure 70: P.F.H. Labrouste (1801–75). Interior, Library of Sainte-Geneviève, Paris (designed 1838–39; built 1843–50). Photograph James Austin Fine Art.

The learned classical style, much associated with libraries, was again on display in the 85-metre-long facade. Inside, however, was the highly-innovative single-space reading-room, with twin naves and slim cast-iron columns and arches, forming their own support system, independent of the walls.

ther. The philosopher G.F.W. Hegel (1770–1831), scanning cultural high-points from Sumer and Akkad through Greek, Roman and Christian societies to the present, had written of a dialectical interplay of opposites in nature which he discerned in world history, and which led, he believed, to the spiritual fulfilment of the state (and the greatness of Prussia in his own day). Karl Marx (1818–83), whose *Communist Manifesto*, written with Friedrich Engels (1820–95), appeared in London in January 1848, made this principle of dynamic interplay, applied to modes of production, a corner-stone of his theory of class struggle which, he contended, would lead to the victory of Socialism. The study of sociology, introduced in the 1830s by the Frenchman Auguste Comte (1798–1857), invited the scrutiny of human society on the model of inductive science – drawing conclusions from personally-gathered, particular evidence.

The social upheavals of 1848 in the streets of Paris ushered in the Second Republic and the political enfranchisement of nine million Frenchmen (no women). Europe was in revolt from Sicily to the Baltic. The arts were following their own manifold paths – including, as we have seen, that of an artists' Bohemia on society's edges. But the French woman novelist George Sand (1804–76), campaigner for women's rights, friend of Polish patriots (Chopin and Mickiewicz), had already advanced working class themes, often to do with French rural life and labour (*La Mare au Diable, The Devil's Pool*, 1846). The painter Gustave Courbet (1819–77) depicted the back-breaking subject of the *Stonebreakers* (1849). Its earthy realism, rejecting the classical heroes of David, as well as the inner eye, literary sources, all fantasy aspects of Romantic art, uncompromisingly marked a new age.

Epilogue: Breaks and Continuities

Wordsworth died in 1850, Turner in 1851; the younger generation of composers, Mendelssohn, Schumann and Chopin, all before the end of middle age in the decade 1846–56. With their deaths the first vigour of Romantic self-discovery passed away; in Wordsworth's case, indeed, its original stirrings among the Lakeland fells of his childhood and in the Paris of his youth had long come to seem remote. Rousseau had written that 'man is truly free who desires what he is able to perform and does what he desires'.[12] It seems a perfect epitaph for Mozart or Schubert; but here was a testing agenda for artists pushing out beyond the 'rules', or emerging from dependence on the old Baroque courts or fixed employment: each had to work out such implications for himself.

In strenuous times of social protest after Waterloo, it was a matter of concern, especially in lands where populist movements were gaining strength – Greece, Poland, Portugal, Ireland, Italy – that individual desire should take some form of action.[13] Beethoven personified the ideal of freedom in his music, life and attitudes. In France Hugo transferred sympathy from the restored monarchy to ideals of social reform that had been voiced by Saint-Simon and his followers, and proclaimed Greek freedom in his poems. Shelley, shocked by the 'Peterloo' massacre of 1819 in Manchester into denouncing Castlereagh's government, urged the masses in *The Mask of Anarchy* to 'shake your chains to earth like dew'. In 1830 Auber's opera *La Muette de Portici* (*Masaniello*, 1828), with its revolutionary plot, ignited a Belgian uprising against the Dutch. In Italy the young Verdi applied Beethoven's combativeness to his own patriotic operas.

THE LEGACY OF BYRON

Byron, however – incomparably – had proved a very particular kind of 'lone' voice. The Polish poet Adam Mickiewicz (1798–1855), who translated Byron into his language, thought that he 'was the first to show the people that poetry

is not a futile pursuit, that it does not end in desires, that one should live up to one's writings'.[14] Indeed, bold attempts to convert desire into action, together with a capacity to identify with the hopes and sufferings he met with ('the songs of Byron appealed to the broad European masses', wrote Mickiewicz), made Byron's death in 1824 from marsh fever in Greece a loss felt by all Europe. For this the element of danger in his introspection, which had fascinated artists everywhere, was also in part responsible. In Part Two of *Faust*, Goethe based the restless character of Euphorion, Faust's son, on him: in Goethe's poem the character is mourned as Goethe had mourned Byron. Delacroix, echoing an entry in his journal on 11 May, 1824, drew continued inspiration from him. Turner had Byron in mind when he visited Waterloo in 1817 and frequently, later, in Italy. Berlioz (*Memoirs* 35) followed Byron's Corsair 'on his audacious journeys'. If Carlyle, in 1828, thought that Byron had been too aware of being watched, he made an exception of *Don Juan*, where the poet, he felt, had become 'so intent on his subject as, for moments, to forget himself'.[15] Byron's fatalistic, lonely hero Manfred drew from Schumann in 1840 a marvellously eloquent overture and other music, and was to attract Tchaikovsky later. In Russia Pushkin had embedded part of Byron in Onegin (p. 89). The young Mikhail Lermontov (1814–41) translated him, read Moore's edition of the letters and journals, and wrote *A Hero of our Time* (1840), a novel conceived from five standpoints with a central character, Pechorin, whose Byronic nature was to be hailed by Tolstoy.

A culturally-minded balloonist of sufficient longevity, surveying the Western World from 1700 to 1850, would find his attention continuously stretched. In Europe after 1700, while the Baroque arts of Italy pervaded the Catholic courts, the unique achievement of J.S. Bach was raised in Protestant Germany. After 1750, as post-Rococo France sought again for the classical order which was to culminate in David and reach forward to Ingres, the non-Latin, less painting-orientated cultures of Britain and Germany were building on the arts of time: the novel, music, Shakespeare. Conspicuously, after 1800, the Western cultural map was becoming coloured not only by Byron but by Scott, as his poems and novels were turned over and over again into painting and music. Throughout the period, a vast, international spread of literacy and the printed word, eastwards and westwards, gave the West European cultural world itself a new look. The importation of European traditions into America was to meet with home-grown American initiatives, of which the ambitious bridges that we looked at earlier (Interlude) are one clear sign. The great spaces of the New World became the setting of European novels like Chateaubriand's *Atala* (1801) and *René* (1805). This was a two-way process by the 1820s, when Fenimore Cooper's stories of new beginnings became popular in Europe, influencing the French adventure story called the *roman maritime*. Even Goethe found it easier to carry his novel *Wilhelm Meisters Wanderjahre* forward during an appreciative reading of Cooper's frontier tales.[16]

Russia was also to preoccupy certain Western Enlightenment figures, especially Herder, in 1769, and Diderot, who visited Catherine the Great in 1773.

In turn, while making the Russian language into a unique literary instrument (p. 00), Pushkin closely studied Western models, notably Sterne and Byron, and wrote his own version of the Faust legend. By the early 1840s English translations from Pushkin, Lermontov and others were running in *Blackwood's Edinburgh Magazine*.[17] Russian music was not to make its international reputation until later in the century: but Glinka's exquisite early love-songs, setting Pushkin's poetry to music, dated from the early 1830s, and the first landmark in Russian opera, Glinka's *A Life for the Tsar* – in which the life that was surrendered was that of a peasant – from 1836. Gogol's fantastic short stories (Chapter Five, p. 241) were also appearing; his major novel, *Dead Souls*, in 1837. Together with the realism of much of the character-drawing in this story of a swindle perpetrated on Russian landlords by a picaresque hero, the strong element of the comic grotesque readily related to the worlds of Goya and even Hugo's Quasimodo the hunchback. There were to be a number of existing areas of Western art which this influx of energy would enrich.

It has been claimed that the late nineteenth-century Russian novelists mark the ultimate development of a Western form which, as we saw (Chapter Two, p. 77f.), had taken such powers to itself since 1700. Such a debate is no part of this book. Together, however, with sonata form for the musician (Chapter Two, p. 101) and the enhanced role of colour for the painter (Chapter Three, p. 136), the Western novel from 1700 to 1850 must certainly be counted among the vital bridges to a modern culture. It had notably increased the reading public, and it had advanced the cause of women writers. In obliging poetry to give up a large part of its literary supremacy to prose – the less form-conscious but more reality-probing medium – the novel had exceeded every hope that could in 1700 have been placed in it. In his 'prosaic poem' *Tom Jones*, Fielding had broadcast the high art of the epic across the common way of his hero. Marivaux had purveyed the ambiguities of the mask in the prose comedy of manners. Richardson, Rousseau and Laclos, students of inward motivation expressed through letters, had taken the pulse of their respective societies. Sterne noticed the human pulse's irregularities and recorded them. Goethe, in a 'one character' novel (*Werther*) explored prose's power to enable readers to identify with that character; in another (*Wilhelm Meister*) he conjured with his chief character's whole world and culture (the aim of the specifically German *Bildungsroman*, descending to Thomas Mann). Pushkin wrote a novel in verse (*Onegin*), which gave up none of prose's expository intimacy. Austen diagnosed the world in which she moved in novels which developed character from the inside, offered objective criticism, balanced the clear-headed major of Sense against the heart-stopping minor of Sensibility. The imaginative insights of Scott, Stendhal, Manzoni, Balzac, Dickens, George Sand and Hawthorne added to a prodigal inheritance.

The older devices of classical design, which had meanwhile continued to determine or influence so much of poetry, drama, music and painting, were by 1850 – notwithstanding the protest expressed in Courbet's realism – open to the play of further Romantic desires. These, fundamentally expressed in music-

drama, the mature creation of Wagner, were to have transforming implications for all the arts.

NOTES

1. Rousseau, *Emile*, trans. Barbara Foxley, introd. A. Boulot de Monval (1974), p. 108
2. James Bowen, *A History of Western Education* (3 vols 1981), vol. III 'The Modern West: Europe and the New World', p. 340
3. Robert Owen, *Report to the County of Lanark* (1820), p. 283. Cf. Bowen, *A History of Western Education*, vol. III, p. 379
4. Saint-Simon, *The Doctrine of Saint-Simon: An Exposition* (1828–29), Ninth Session, p. 140. Eng. edn, trans. G.G. Iggers (1958, reprint New York 1972). Cf. also p. 207 above
5. Fourier, *Théorie de l'unité universelle*, vol. 4 (second edn Paris 1838). See also Frank Manuel, *The Prophets of Paris* (Cambridge, Mass. 1962), pp. 195–248
6. Thomas Kelly, *George Birkbeck, Pioneer of Adult Education* (Liverpool 1957); T.L. Jarman, *Landmarks in the History of Education* (1951, 1963), ch. XV
7. Notably, *Tales of Fashionable Life* (1809 and 1812), which included *The Absentee*
8. On the Lyons school see Quentin Bell, *The Schools of Design* (1963), pp. 47, 84, 154–5
9. See Angelika Wesenberg, 'Art and Industry', in *Karl Friedrich Schinkel: A Universal Man*, ed. Michael Snodin (New Haven and London 1991), pp. 57f.
10. Quentin Bell, *The Schools of Design* (1963), ch. iv
11. Hugo, *Notre Dame de Paris* (second edn Paris 1832), cited in David Watkin, *A History of Western Architecture* (1986), pp. 382–3
12. Rousseau, *Emile*, trans. Foxley, p. 48
13. The German writer Georg Büchner (1813–37) emerged as advocate of outright revolution: his doubts about the people's ability to affect the balance of power in Germany in the 1830s gave his unfinished social drama *Woyzeck* (1836) a prophetic force
14. Mickiewicz, lecture of 1842, cited in P.G. Trueblood, ed., *Byron's Political and Cultural Influence in Nineteenth-Century Europe: A Symposium* (1981), p. 130
15. Carlyle, review of J.G. Lockhart's *Life of Robert Burns*, in *Edinburgh Review* **48** (1828), p. 275
16. Goethe's diary, 24–26 June 1827. Eric A. Blackall, *Goethe and the Novel* (Ithaca and London 1976), pp. 213–14
17. The translations were by Thomas Shaw, who had taught English to the Russian Imperial family

Further Reading

Place of publication is London unless otherwise stated.

Primary Material

It would be impossible to list all recommendable editions of the original writings of artists and critics of the period 1700–1850. Donald F. Bond's edn of *The Spectator* (5 vols, Oxford 1965) is useful, and the following deserve special note:

BERLIOZ, Hector, *The Memoirs of Hector Berlioz*, tr. and ed. David Cairns (1969)

BURKE, Edmund, *A Philosophical Inquiry into the Origin of our Ideas of the Sublime and the Beautiful* (1757), ed. J.T. Boulton (1958)

BURNEY, Charles, *Music, Men and Manners in France and Italy 1770*, ed. and introd. by H. Edmund Poole (1969, 1974)

COLERIDGE, Samuel Taylor, *Inquiring Spirit: A New Presentation of Coleridge from his Published and Unpublished Prose Writings*, ed. Kathleen Coburn (1951)

DELACROIX, Eugène, *The Journal of Eugène Delacroix: A Selection*, ed. and introd. by Hubert Wellington (Oxford 1980)

DE STAËL, Germaine, *Major Writings of Germaine de Staël*, tr. and introd. by Vivian Folkenflik (New York and Oxford 1987)

DIDEROT, Denis, *Diderot on Art*, ed. J. Goodman and T. Crow, 2 vols (New Haven and London 1995)

GOETHE, *Goethe on Art and Literature*, ed. John Gearey, tr. Ellen and Ernst von Nardroff (Princeton, N.J. 1994)

HOGARTH, William, *The Analysis of Beauty* (1753), ed. R. Paulson (New Haven and London 1997)

JEAN PAUL, *Jean Paul: A Reader*, tr. Erika Casey, ed. Timothy J. Casey (Baltimore and London 1992)

REYNOLDS, Sir Joshua, *Discourses on Art*, ed. Robert Wark (edn New Haven and London 1997)

SCHILLER, Friedrich, *On the Aesthetic Education of Man*, trs. and ed. E.M. Wilkinson and L.A. Willoughby (Oxford 1967; pbk 1982)

STENDHAL, *Stendhal on the Arts*, ed. D. Wakefield (1973)

The following anthologies of texts are also recommended:

BATE, Jonathan, ed., *The Romantics on Shakespeare* (1992)

CROCKER, Lester G., ed., *The Age of Enlightenment* (1969) (philosophy, science, morals, politics)

DENVIR, Bernard, ed., *A Documentary History of Taste in Britain. The Eighteenth Century: Art, Design and Society 1689–1789* (1983); *The Early Nineteenth Century: Art, Design and Society 1789–1852* (1984)

EITNER, Lorenz, ed., *Neo-Classicism and Romanticism 1750–1850*, 2 vols (Englewood Cliffs, N.J. 1970) (visual arts)

ELIOT, Simon and STERN, Beverley, eds, *The Age of Enlightenment*, 2 vols (Open University 1979)

GAY, Peter, ed., *The Enlightenment* (New York 1973)

HOLT, Elizabeth G., ed., *A Documentary History of Art*, vol. II (New York 1958), part III 'The Eighteenth Century'. (contains Goethe's *On German Architecture*)

LE HURAY, Peter and DAY, James, eds, *Music and Aesthetics in the Eighteenth and Early-Nineteenth Centuries* (Cambridge 1981; abridged edn 1988)

RUSSELL, Terence M., *Architecture in the* Encyclopédie *of Diderot and D'Alembert: The Letterpress Articles and selected engravings* (Aldershot 1993)

See also:

RUSSELL, Terence M., *The Encyclopaedic Dictionary in the Eighteenth Century: Architecture, Arts and Crafts* (5 vols, Aldershot 1997) (reproduces and examines entries for these subjects in the major British reference works, including Chambers's *Cyclopaedia* and Johnson's *Dictionary*)

Secondary Material

a) EXHIBITION CATALOGUES

The Romantic Movement (Arts Council), Tate Gallery, London (1959)

The Age of Neo-Classicism (Arts Council), Royal Academy of Arts, London (1972)

De David à Delacroix, Galeries Nationales du Grand Palais, Paris, and Detroit Institute of Art, Detroit (1974)

The Eye of Thomas Jefferson, ed. William H. Adams, National Gallery of Art, Washington, D.C. (1976)

Watteau 1684–1721, National Gallery of Art, Washington, D.C., Galeries Nationales du Grand Palais, Paris, Schloss Charlottenburg, Berlin (1984–85)

William Wordsworth and the Age of English Romanticism, text by Jonathan Wordsworth, Michael C. Jaye and Robert Woof, exhibition organized by Rutgers State University of New Jersey in Newark and the Wordsworth Trust, Dove Cottage, Grasmere, England (1987)

Goya, Truth and Fantasy: The Small Paintings, Museo del Prado, Madrid, Royal Academy of Arts, London, Art Institute of Chicago (1994)

b) BOOKS

GENERAL HISTORY

BLACK, Jeremy, *An Illustrated History of Eighteenth-Century Britain* (1996)

BRIDENBAUGH, C., *Cities in Revolt: Urban Life in America 1743–1776* (1971)

COBBAN, Alfred, *A History of Modern France*, vol. I (1963)

COBBAN, Alfred, ed., *The Eighteenth Century: Europe in the Enlightenment* (1969) (includes 569 illustrations)

GARRARD, J.G., ed., *The Eighteenth Century in Russia* (Oxford 1973)

HELLMUTH, E., *The Transformation of Political Culture* (Oxford 1990)

HOBSBAWM, E.J., *The Age of Revolution: Europe 1789–1848* (1962)

McKENDRICK, Neil, BREWER, John and PLUMB, J.H., *The Birth of a Consumer Society: The Commercialization of Eighteenth-Century England* (1982)

PORTER, Roy, *English Society in the Eighteenth Century* (1982, 1990)

SCHAMA, Simon, *Citizens: A Chronicle of the French Revolution* (1989)

ZELDIN, Theodore, *An Intimate History of Humanity* (1994)

THE ENLIGHTENMENT

CHISICK, Henry, *The Limits of Reform in the Enlightenment: Attitudes towards the Education of the Lower Classes in Eighteenth-century France* (Princeton, N.J. 1981)

COBBAN, Alfred, *In Search of Humanity: The Role of the Enlightenment in Modern History* (1960)

DARNTON, Robert, *Mesmerism and the End of the Enlightenment in France* (Cambridge, Mass. 1968)

DUNTHORNE, Hugh, *The Enlightenment* (New Appreciations in History 24, 1991) (good introductory booklet)

FRAYLING, Christopher and WOKLER, Robert, 'From the Orang-utan to the Vampire: Towards an Anthropology of Rousseau', in R.A. Leigh, ed., *Rousseau after Two Hundred Years* (Cambridge 1982), pp. 109–29

GAY, Peter, *Age of Enlightenment* (Great Ages of Man, Time-Life, Netherlands 1996) (good introduction)

GAY, Peter, *The Enlightenment: An Interpretation*, 2 vols (New York 1967, 1969)

GAY, Peter, *The Party of Humanity: Studies in the French Enlightenment* (1964)

GREENE, Donald, 'Voltaire and Johnson', in Alfred J. Bingham and Virgil W. Topazio, eds, *Enlightenment Studies in Honour of Lester G. Crocker* (Voltaire Foundation at the Taylor Institute, Oxford 1979), pp. 111–31

HAMPSON, Norman, *The Enlightenment: An Evaluation of its Assumptions, Attitudes and Values* (1968) (excellent introduction)

HANKINS, T.L., *Science and the Enlightenment* (Cambridge 1985)

HAZARD, Paul, *The European Mind: The Critical Years, 1680–1715* (Harmondsworth 1964). Publ. as *La Crise de la Conscience Européenne* (Paris 1935)

HAZARD, Paul, *European Thought in the Eighteenth Century from Montesquieu to Lessing* (Harmondsworth 1965). Publ. as *La Pensée Européenne au XVIIIe Siècle* (Paris 1946)

HOUSTON, R.A., *Literacy in Early Modern Europe* (1988)

LEIGH, R.A., ed., *Rousseau after Two Hundred Years* (Cambridge 1982)

LEVINE, Lawrence W., *Highbrow/Lowbrow: The Emergence of Cultural Hierarchy in America* (Cambridge, Mass. 1988)

MANUEL, F.E., *The Eighteenth Century confronts the Gods* (Cambridge, Mass. 1959) (sociology of religion)

MARSHALL, P.J. and WILLIAMS, Glyndwr, *The Great Map of Mankind: British Perceptions of the World in the Age of Enlightenment* (Cambridge, Mass. 1982)

MAY, Henry F., *The Enlightenment in America* (New York 1976)

NICOLSON, Marjorie Hope, *Newton demands the Muse: Newton's 'Opticks' and the Eighteenth-Century Poets* (Princeton, N.J. 1946)

O'BRIEN, Karen, *Narratives of Enlightenment: Cosmopolitan History from Voltaire to Gibbon* (Cambridge 1997) (includes America)

PLUMB, J.H., 'The new world of children in eighteenth-century England', *Past and Present* **67** (1975), pp. 65–95; also in N. McKendrick and others, *The Birth of a Consumer Society* (1982); see under General History

PORTER, Roy, *The Enlightenment* (Basingstoke 1990) (useful introductory pamphlet)

PORTER, Roy and TEICH, Mikulas, eds, *The Enlightenment in National Context* (Cambridge 1981) (includes Enlightenment in Russia)

ROUSSEAU, G.S. and PORTER, Roy, eds, *The Ferment of Knowledge* (Cambridge 1980) (scientific thought)

ROUSSEAU, G.S. and PORTER, Roy, eds, *The Languages of Psyche: Mind and Body in Enlightenment Thought* (Berkeley, Los Angeles and Oxford 1990) (health and medicine)

SAISSELIN, R.G., *Taste in Eighteenth Century France* (Syracuse, N.Y. 1965)

SCHNEIDERS, Werner, ed., *Lexikon der Aufklärung: Deutschland und Europa* (Munich 1995)

SCOTT, H.M., ed., *Enlightened Absolutism: Reform and Reformers in Later Eighteenth-Century Europe* (1990)

STAROBINSKI, Jean, *Jean-Jacques Rousseau: Transparency and Obstruction* (Chicago 1988)

TOMASELLI, Sylvana, 'The Enlightenment Debate on Women', *History Workshop Journal* **20** (1985), pp. 101–24

VENTURI, Franco, *Utopia and Reform in the Enlightenment* (Cambridge 1971) (politics and ideas across whole of Europe)

WASSERMAN, Earl R., ed., *Aspects of the Eighteenth Century* (Baltimore and London 1965) (includes important essays by Isaiah Berlin and others)

WELLEK, Rene, *A History of Modern Criticism: The Later Eighteenth Century* (1955)

YOLTON, John W. and others, *The Blackwell Companion to the Enlightenment* (Oxford 1991; pbk 1995)

ROMANTICISM

This short section is confined to treatments of Romanticism as an international and multi-cultural phenomenon. Other relevant works appear under the headings of the separate arts.

FRYE, Northrop, ed., *Romanticism Reconsidered* (New York 1963)

JONES, Howard Mumford, *Revolution and Romanticism* (Cambridge, Mass. 1974) (Europe and America)

PRAZ, Mario, *The Romantic Agony* (1933, rev. edn 1960)

SUTHERLAND, Donald, *On Romanticism* (New York 1971)

WELLEK, Rene, *A History of Modern Criticism: The Romantic Age* (1955)

YARRINGTON, Alison and EVEREST, Kelvin, eds, *Reflections of Revolution: Images of Romanticism* (London and New York 1993)

GENERAL CULTURAL HISTORY

BERLIN, Isaiah, *Against the Current: Essays in the History of Ideas*, ed. H. Hardy (1979; Oxford 1981)

BERMAN, Eleanor D., *Thomas Jefferson among the Arts* (New York 1947)

BREWER, John, *The Pleasures of the Imagination: English Culture in the Eighteenth Century* (1997)

BROOKNER, Anita, *The Genius of the Future: Studies in French Art Criticism* (1971) (chs on Diderot, Stendhal)

FORD, Boris, ed., *The Cambridge Cultural History*: vol. 5, *Eighteenth-Century Britain* (Cambridge 1991); vol. 6, *The Romantic Age in Britain* (Cambridge 1992)

HEMMINGS, F.W.J., *Culture and Society in France 1789–1848* (Leicester 1987)

KEENER, Frederick M. and LORSCH, Susan E., eds, *Eighteenth-Century Women and the Arts* (New York, Westport, Conn. and London 1988)

NEIL, J. Meredith, *Towards a National Taste: America's Quest for Aesthetic Independence* (Honolulu 1975)

NEWMAN, Gerald, *The Rise of English Nationalism: A Cultural History 1740–1830* (1987)

NYE, R.B., *The Cultural Life of the New Nation 1776–1830* (New York 1960)

ROGERS, Pat, ed., *The Eighteenth Century* (The Context of English Literature, 1978) (chs on writers; politics; religion; science; visual arts)

SEKORA, John, *Luxury: The Concept in Western Thought, Eden to Smollett* (Baltimore and London 1977)

TIMES, THE, *The German Romantics*, Report, 24 Sept. 1994, to accompany the Festival *Deutsche Romantik* in London, Sept.–Nov. 1994

LITERATURE AND DRAMA

ABRAMS, M.H., *Natural Supernaturalism: Tradition and Revolution in Romantic Literature* (New York and London 1971)

BAYLEY, John, *Pushkin: A Comparative Commentary* (Cambridge 1971)

BIRN, Raymond, 'Publishing', article in *The Blackwell Companion to the Enlightenment*, ed. John W. Yolton and others (Oxford 1991), pp. 432–7

BOTTIGHEIMER, Ruth, *Grimms' Bad Girls and Bold Boys: The Moral and Social Vision of the Tales* (New Haven and London 1987)

BOYLE, Nicholas, *Goethe: The Poet and the Age*, vol. I (Oxford 1991)

BROWN, David, *Walter Scott and the Historical Imagination* (London, Boston and Henley 1979)

BRUFORD, W.H., *Culture and Society in Classical Weimar 1775–1806* (Cambridge 1962)

BRUFORD, W.H., *The German Tradition of Self-Cultivation: 'Bildung' from Humboldt to Thomas Mann* (Cambridge 1975)

BUTLER, Marilyn, *Romantics, Rebels and Reactionaries: English Literature and its Background 1760–1830* (Oxford 1981)

BYRD, Max, *Tristram Shandy* (Exeter 1985, 1988)

BYSVEEN, Josef, *Epic Tradition and Innovation in James Macpherson's* Fingal (Uppsala 1982)

CRANE, Verner W., ed., *Benjamin Franklin's Letters to the Press 1758–1775* (Chapel Hill 1950)

CRANSTON, Maurice, *Jean-Jacques: The Early Life of Jean-Jacques Rousseau 1712–1754* (Harmondsworth 1983)

CRANSTON, Maurice, *The Noble Savage: Jean-Jacques Rousseau 1754–1762* (Harmondsworth 1991)

CRANSTON, Maurice, *The Solitary Self: Jean-Jacques Rousseau in Exile and Adversity 1762–1778* (Harmondsworth 1997)

DARNTON, Robert, *Forbidden Bestsellers of Pre-Revolutionary France* (1996)

DARNTON, Robert, *The Great Cat Massacre and other Episodes in French Cultural History* (1984)

DARNTON, Robert, *The Literary Underground of the Old Regime* (Cambridge, Mass. 1982)

DARTON, F.J. Harvey, *Children's Books in England: Five Centuries of Social Life* (3rd edn rev. Brian Alderson, Cambridge 1958, 1982: first publ. 1932)

DELON, Michel and MALADAIN, Pierre, *Littérature française du dixhuitième siècle* (Paris 1996)

FEATHER, John, 'The Commerce of Letters: The Study of the Eighteenth Century Book Trade', *Eighteenth-Century Studies* XVII (Davis, Cal., 1983–84), pp. 405–24

FURBANK, P.N., *Diderot: A Critical Biography* (New York 1992)

FURET, François and OZOUF, Jacques, *Reading and Writing: Literacy in France from Calvin to Jules Ferry* (Cambridge 1982)

FURST, L.R., *Romanticism in Perspective* (1969) (French, German and English literature)

GRAY, Ronald, *Goethe: A Critical Introduction* (Cambridge 1967)

GREEN, Martin, *The Robinson Crusoe Story* (Pennsylvania State University Press, University Park and London 1990)

HATFIELD, Henry, *Aesthetic Paganism in German Literature from Winckelmann to the Death of Goethe* (Cambridge, Mass. 1964)

HERDMAN, John, *The Double in Nineteenth-Century Fiction* (1990)

HÜRLIMANN, Bettina, *Three Centuries of Children's Books in Europe*, tr. and rev. Brian W. Alderson (1967)

ISHERWOOD, Robert M., *Farce and Fantasy: Popular Entertainment in Eighteenth-Century Paris* (New York 1986)

JACK, Ian, *Keats and the Mirror of Art* (Oxford 1967)

KELLY, Laurence, *Lermontov: Tragedy in the Caucasus* (1977)

KELSALL, Malcolm, *The Great Good Place: The Country House and English Literature* (New York 1993)

KING-HELE, Desmond, *Erasmus Darwin and the Romantic Poets* (1986)

KONTJE, Todd, *The German* Bildungsroman: *History of a National Genre* (Columbia, S. Carolina 1993)

LEHMANN, Andrew G., *Sainte-Beuve: A Portrait of the Critic 1804–1842* (1962)

LOUGH, John, *Writer and Public in France: From the Middle Ages to the Present Day* (Oxford 1978): ch. IV, The Eighteenth Century

MASON, Haydn, *Voltaire* (1975)

MENHENNET, Alan, *Order and Freedom: Literature and Society in Germany from 1720 to 1805* (1973)

RIVERS, Isabel, ed., *Books and their Readers in Eighteenth-Century England* (Leicester 1982)

ROGERS, Pat, *The Augustan Vision* (1974)

ROGERS, Pat, *Grub Street: Studies in a Sub-culture* (1972)

ROGERS, Pat, *Literature and Popular Culture in Eighteenth-Century England* (Sussex 1985)

SAMBROOK, James, *The Eighteenth Century: The Intellectual and Cultural Context of English Literature* 1700–1789 (second edn, 1993)

SAMMONS, Jeffrey L., *Heinrich Heine: A Modern Biography* (Princeton, N.J. 1979)

SHOWALTER, Elaine, *The Evolution of the French Novel* (Princeton, N.J. 1972)

SHRODER, Maurice Z., *Icarus: The Image of the Artist in French Romanticism* (Cambridge, Mass. 1961)

SPENCER, Jane, *The Rise of the Woman Novelist from Aphra Behn to Jane Austen* (Oxford 1986)

STONE, George W. and KAHRL, George M., *David Garrick: A Critical Biography* (Carbondale 1979)

TRUEBLOOD, Peter G., ed., *Byron's Political and Cultural Influence in Nineteenth-Century Europe: A Symposium* (1981)

WAIN, John, *Samuel Johnson* (1974, 1980, 1988, 1994)

WATT, Ian, *The Rise of the Novel: Studies in Defoe, Richardson and Fielding* (1957)

WILLIAMS, Simon, *Shakespeare on the German Stage* (Cambridge 1990)

VISUAL ARTS INCLUDING ARCHITECTURE

ANTAL, Frederick, *Classicism and Romanticism* (1966) (Marxist standpoint)

BARRELL, John, *The Dark Side of the Landscape: The Rural Poor in English Painting 1730–1840* (Cambridge 1980)

BARRELL, John, ed., *Painting and the Politics of Culture: New Essays on British Art 1700–1850* (Oxford 1992)

BINDMAN, David, ed., *The Shadow of the Guillotine: Britain and the French Revolution* (1989) (very good on topical illustration and caricature)

BROOKNER, Anita, *Greuze* (London and Boston, Mass. 1972)

BROOKNER, Anita, *Jacques-Louis David* (1980)

CLARK, Kenneth, *The Romantic Rebellion: Romantic versus Classical Art* (1973)

CLAY, Jean, *Romanticism* (Oxford 1981)

CONISBEE, Philip, *Painting in Eighteenth-Century France* (Oxford 1981)

CRASKE, Matthew, *Art in Europe 1700–1830* (Oxford 1997)

CROW, Thomas, *Painters and Public Life in Eighteenth-Century Paris* (New Haven and London 1985)

DRAKARD, David, *Printed English Pottery: History and Humour in the Reign of George III 1760–1820* (1992)

FORD, John, *Ackermann, 1783–1983: The Business of Art* (1983) (Rudolph Ackermann, the famous German-born, London-based art publisher)

FRIED, Michael, *Absorption and Theatricality: Painting and the Beholder in the Age of Diderot* (Berkeley and Los Angeles 1980)

FRIEDLAENDER, Walter, *David to Delacroix* (Cambridge, Mass. 1952)

HASKELL, Francis, *Patrons and Painters: A Study in the Relations between Italian Art and Society in the Age of the Baroque* (1971): ch. 12, 'The Enlightenment' – Conclusion

HASKELL, Francis, *Rediscoveries in Art: Some Aspects of Taste, Fashion and Collecting in England and France* (1976)

HASKELL, Francis, and PENNY, Nicholas, *Taste and the Antique: The Lure of Classical Sculpture 1500–1900* (New Haven and London 1981)

HAWLEY, Henry, *Neo-Classicism: Style and Motif* (1964)

HIMMELHEBER, Georg, ed., *Biedermeier 1815–1835* (in English) (Munich 1989)

HONOUR, Hugh, *Neo-Classicism* (Harmondsworth 1968)

HONOUR, Hugh, *Romanticism* (Harmondsworth 1979)

HUNT, J.D. and WILLIS, P., eds, *The Genius of the Place: The English Landscape Garden 1660–1820* (1975)

KAUFMANN, E., *Architecture in the Age of Reason* (Cambridge, Mass. 1955)

KING, David, *The Complete Works of Robert and James Adam* (Oxford 1991)

KLINGENDER, Francis D., *Art and the Industrial Revolution* (1947, 1968)

LEITH, J.A., *The Idea of Art as Propaganda in France, 1750–1799* (Toronto 1965)

LESLIE, C.R., *Memoirs of the Life of John Constable, R.A.* ed. J. Mayne (1951)

LEVEY, Michael, *Rococo to Revolution* (1966) (painting only)

LOCQUIN, J., *La Peinture d'histoire en France de 1747 à 1785* (Paris 1912; reprinted 1978)

PAULSON, Ronald, *Emblem and Expression: Meaning in English Art of the Eighteenth Century* (Cambridge, Mass. 1975)

PAULSON, Ronald, *Hogarth*, 3 vols (Cambridge 1991–93)

PAULSON, Ronald, *Popular and Polite Art in the Age of Hogarth and Fielding* (Notre Dame and London 1979)

PAULSON, Ronald, *Representations of Revolution 1789–1820* (New Haven and London 1983)

PEARS, Iain, *The Discovery of Painting: The Growth of Interest in the Arts in England, 1680–1768* (New Haven and London 1988)

REILLY, Robin, *Josiah Wedgwood 1730–1795* (1992)

RIBEIRO, Aileen, *The Art of Dress: Fashion in England and France 1750–1820* (New Haven and London 1995)

ROSEN, Charles and ZERNER, Henri, *Romanticism and Realism: The Mythology of Nineteenth-Century Art* (1984)

ROSENBLUM, Robert, *Transformations in Late Eighteenth-Century Art* (Princeton, N.J. 1967)

SCOTT, Katie, *The Rococo Interior: Decoration and Social Spaces in Early Eighteenth-Century Paris* (New Haven and London 1995)

SHACKELFORD, George Green, *Thomas Jefferson's Travels in Europe 1784–1789* (Baltimore and London 1995)

SHANES, Eric, *Turner's Human Landscape* (1990)

SHAWE-TAYLOR, Desmond, *The Georgians: Eighteenth-Century Portraiture and Society* (1990)

SNODIN, Michael, ed., *Karl Friedrich Schinkel: A Universal Man* (New Haven and London 1991, in association with the Victoria and Albert Museum)

SOLKIN, David H., *Painting for Money: The Visual Arts and the Public Sphere in Eighteenth-Century England* (New Haven and London 1992)

VAUGHAN, William, *German Romantic Painting* (New Haven and London 1980)

WAINWRIGHT, Clive, *The Romantic Interior: The British Collector at Home, 1750–1850* (New Haven and London 1989)

WRIGLEY, Richard, *The Origins of French Art Criticism: From the Ancien Régime to the Restoration* (Oxford 1993)

MUSIC

ABRAHAM, Gerald, *The Age of Beethoven 1790–1830* (The New Oxford History of Music) (Oxford 1982)

BARFORD, Philip, *The Keyboard Music of C.P.E. Bach* (1965)

CAPELL, Richard, *Schubert's Songs* (second rev. edn 1957)

CONE, Edward T., ed., *Hector Berlioz: Fantastic Symphony: An Authoritative Score, Historical Background, Analysis, Views and Comments* (New York and London 1971)

COOPER, Barry, ed., *The Beethoven Compendium: A Guide to Beethoven's Life and Music* (1991)

DEAN, Winton, 'Opera under the French Revolution', *Proceedings of the Royal Musical Association* XCIV (1967–68), pp. 77–96

FISKE, Roger, *English Theatre Music in the Eighteenth Century* (London, New York, Toronto 1973; rev. edn 1986)

FORD, Charles, *Così? Sexual Politics in Mozart's Operas* (Music and Society Series) (Manchester 1991)

HEARTZ, Daniel, 'From Garrick to Gluck: The Reform of Theatre and Opera in the Mid-Eighteenth Century', *Proceedings of the Royal Musical Association* XCIV (1967–68), pp. 111–27

HEARTZ, Daniel, *Haydn, Mozart and the Viennese School: 1740–1780* (New York, *c.* 1995)

LEPPERT, Richard, *Music and Image: Domesticity, Ideology and Socio-cultural Formation in Eighteenth-Century England* (Cambridge 1988)

RINGER, Alexander, ed., *Man and Music. The Early Romantic Era, between Revolutions: 1789 and 1848* (1990)

ROBINSON, Michael F., *Naples and Neapolitan Opera* (Oxford 1972)

ROSEN, Charles, *The Classical Style: Haydn, Mozart, Beethoven* (1971)

ROSEN, Charles, *The Romantic Generation* (1996)

ROSEN, Charles, *Sonata Forms* (New York, *c.* 1980)

RUSHTON, Julian, *Classical Music: A Concise History from Gluck to Beethoven* (1986)

SCHROEDER, David P., *Haydn and the Enlightenment: The Late Symphonies and their Audience* (Oxford 1990)

STEPTOE, Andrew, *The Mozart-Da Ponte Operas: The Cultural and Musical Background to* Le Nozze di Figaro, Don Giovanni *and* Così fan Tutte (Oxford 1988)

TEMPERLEY, Nicholas, *Haydn*: The Creation (Cambridge 1991)

WELLESZ, Egon and STERNFELD, Frederick, *The Age of Enlightenment 1745–1790* (The New Oxford History of Music) (Oxford 1973)

WHITTALL, Arnold, *Romantic Music: A Concise History from Schubert to Sibelius* (1987)

YORKE-LONG, Alan, *Music at Court: Four Eighteenth-Century Studies* (1954) (courts of Parma, Württemberg, Munich, Berlin)

ZASLAW, Neal, ed., *Man and Music. The Classical Era: from the 1740s to the end of the 18th century* (1989)

Index

Numbers following n. refer to notes, f. to figures, and pl. to colour plates